antoni
GAUDÍ

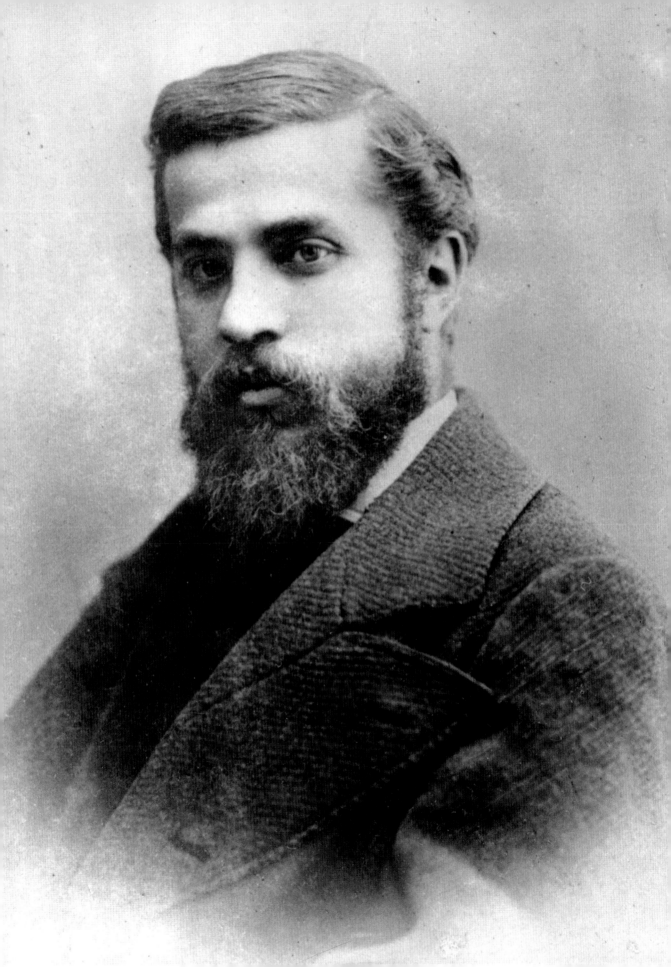

Isabel Artigas

antoni
GAUDÍ

Complete works
Das gesamte Werk
L'œuvre complète

Volume I, 1852-1900
Band I, 1852-1900
Tome I, 1852-1900

Cover Vol. 1 and slipcase: Sagrada Família after Gaudí (1926-2006), detail (see p. 486). Photo: Miquel Tres

Umschlag Bd. 1 und Schuber: Die Sagrada Família nach der Ära Gaudí (1926-2006), Detail (siehe S. 486). Foto: Miquel Tres

Couverture tome 1 et étui : La Sagrada Família après Gaudí (1926-2006), détail (voir p. 486). Photo : Miquel Tres

EVERGREEN is an imprint of
TASCHEN GmbH

© 2007 TASCHEN GmbH
Hohenzollernring 53, D-50672 Köln
www.taschen.com

Editor Editor Éditeur
Isabel Artigas

Art director Art Director Directeur artistique
Mireia Casanovas Soley

Layout Layout Maquette
Elisabet Rodríguez

English translation Englische Übersetzung Traduction en anglais
Ana G. Cañizares

German translation Deutsche Übersetzung Traduction en allemand
André Höchemer for LocTeam, S. L., Barcelona

French translation Französische Übersetzung Traduction en français
Annabelle Labbé for LocTeam, S. L., Barcelona

Typesetting and text editing Satz und Textbearbeitung Composition et rédaction
LocTeam, S. L., Barcelona

Printed in China
ISBN 978-3-8228-5654-3

Contents Volume I
Inhaltsverzeichnis Band I
Sommaire Tome I

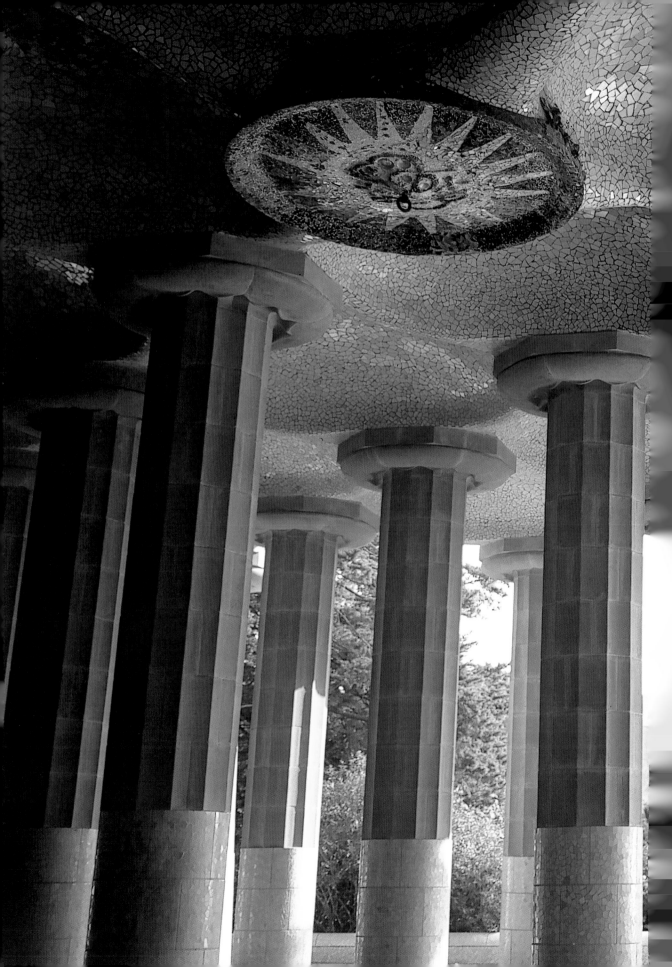

introduction

einführung

introduction

introduction

Francesc Fontbona

Director of the Graphics Unit of the Library of Catalonia

The arrival of Gaudí constituted an unprecedented phenomenon not only in the history of Catalan art, but also in the rest of the world, which for many decades failed to realise the magnitude of the architect.

Gaudí represented the birth of a brilliant artist who from the start effortlessly created a markedly unique and personal style that evolved into one of the most remarkable of his time. Rather than simply taking architecture a step forward, Gaudí took it even further by completely redefining styles and structures. He did not do so, however, out of an ambition to seek originality or display aesthetic subversion, as would the militant avant-garde artists of the 20th century—some of whom, including Apollinaire, Breton, Dalí, Man Ray and Éluard, bowed to Gaudí's work and even declared him a Surrealist after his death—but out of a genuine and unbridled flow of enormous creativity. An artist who sits at his desk and deliberately states "I am going to innovate" often yields less positive results than an exceptionally talented artist who, without premeditation, gives free rein to his faculties in the process of creating a work of art. In this way, the avant-garde—which contrary to popular thought is not the *sine qua non* of art, although this is another issue—surges naturally from the artwork, while in other cases the work is scarcely more than a pretext for an often predictable type of avant-garde.

It is also important to stress that Gaudí did not come from nowhere, as has been repeatedly claimed by those unaware of the situation in Catalonia at that time. His contribution took place within a complex cultural movement—artistic, literary and musical—that occupied the last two decades of the 19th and the beginning of the 20th century. This movement was called *Modernisme*, simply because its leaders explicitly promoted the modernisation of Catalan culture, which they believed to be excessively conformist. Gaudí agreed with *Modernisme* and his work evolved parallel to it, which is why decades later it came to be perceived as the prime example of this movement. However, the solitary Gaudí did not take an active part in the circles of the new movement. Despite having been a colleague of architect Domènech i Montaner and friend of painter Lluís Graner, he only had sporadic contact with some of the most distinguished *Modernistes*, who were often taken by surprise and at times even disconcerted by the extreme singularity of Gaudí's work.

In contrast to Gaudí's originality, his practice was deeply rooted in tradition. He constructed the Sagrada Família following in the footsteps of the Gothic masters who built their cathedrals, yet he paradoxically tended to speak negatively of Gothic art, a style which is nevertheless clearly reflected in much of his work. In turn, he claimed to be a fervent admirer of classical Greek art, echoes of which can hardly be traced in any of his buildings, with the exception of the Column Room in Park Güell, and even here, his interpretation of Greek classicism is such that scarcely any note of neoclassicism can be perceived. In addition, Gaudí's traditionalism was not only professional but also ideological. In his private life, the unabashedly different and brilliant Gaudí was a devout Catholic, to the extent that even to this very day there is an intense, far-reaching movement to beatify and ultimately, canonise the architect.

All of the exceptions and nuances that can be alleged, however, do not conceal the fact that Gaudí's work clearly shared some of the most representative traits of *Modernisme* in Catalonia. These include the predominance of the curved line, the virtually constant presence of colour, the respect for forms inspired by nature, the near disappearance of classical models and the glorious renaissance in the applied arts such as wrought iron, ceramic, mosaic, stained glass, carpentry and even mural paintings executed by other artists under the architect's supervision. These elements can often be evaluated independent of the building itself.

At the same time, Gaudí's architecture in Catalonia coexisted parallel to that of many other architects, who, albeit less distinctively, were also forging a new way of constructing that was either very different or extremely similar to Gaudí's. They included Domènech i Montaner, Vilaseca, Puig i Cadafalch, Granell, Sagnier, the Bassegodas, Gallisà, Grases Riera in Madrid, Salvador Valeri, Ruiz Casamitjana, Soler i March, the Martorells, Muncunill, Falguera, Monguió in Teruel, Nieto in Melilla, Rafael Masó, Pericas, Ferrés

and others who have gone unnoticed until now, such as Antoni Millàs, as well as the Majorcan and Valencian artists like Roca i Simó, Forteza-Rey, Peris Ferrando, Demetri Ribes and Francesc Mora, who were also influenced by *Modernista* movement. Aside from these names, there were other architects that emerged directly from the influence of Gaudí, who while never a teacher in the conventional sense was undoubtedly a great master. They included Jujol, Rubió i Bellver, Martinell, Berenguer, Sugrañes, Sayrach and other younger architects later on whose "Gaudianism" was displayed more in their fascination for Gaudí and his oeuvre than in a clear influence of his work in their architectural designs.

What distinguishes Gaudí from many of these Catalan *Modernistes* is their affiliation with international schools of thought and their partiality to Art Nouveau, which permeated fashionable Western art at the time. Gaudí, however, despite showing a certain influence from the British Aesthetic Movement, had no specific foreign model, nor did he harbour any interest in trends. This is most likely related to the fact that Gaudí, a descendant of the romantic *Renaixença* movement and a political-cultural advocate of local culture, was an ardent Catalanist, willing to defend his Catalan language in the presence of the king of Spain himself, who represented the centralist power wary of and often hostile towards the non-Castilian Spanish cultures.

Gaudí himself is the origin of his tremendously personal art, and he would have undoubtedly been the head of an international school had he not practiced his profession in a city like Barcelona, which at that time accorded only unvoiced respect within the art world. Indeed, it was hardly acknowledged as playing a key role in the general artistic revival, even though precisely the presence of Gaudí and figures like ingenious painter Joaquim Mir or radical groups like Els Quatre Gats did play this role. It was precisely this breeding ground that gave birth to Pablo Picasso, one of the most innovative and influential painters of the 20th century, as well as other great acclaimed international artists like sculptors Pau Gargallo and Juli González.

Gaudí's extravagant style was surprisingly well received by Catalan society. In fact, the architect undertook commissions for the Catalan bourgeoisie (Vicens, Calvet, Batlló and Milà, and in some cases recently ennobled families such as the Güells), who accepted living amidst his peculiar creations and stone structures with a certain stoicism, as did the anonymous masses of Christian devotees in their support of the construction of the colossal Sagrada Família temple in Barcelona, largely funded by the donations of a humble community that would have otherwise been expected to express bewilderment face with such a rare creation. It is also surprising that some of his commissions would take Gaudí to places so distant from his Catalan personality deep into Spain, such as Comillas, León or Astorga. However, they all had some sort of Catalan connection; in Astorga, for instance, the project was commissioned by the Catalan bishop that presided over the diocese of León.

Antoni Gaudí, who always practised his profession independently and never worked as a civil servant, was not awarded honours by any academy, nor did he –like his colleagues—participate in any political organisation. Gaudí was a magnificent artist, unclassifiable and always astonishing, who exercised his craft with an extreme precision that seemed to be the result of a fevered imagination. It is the result of this imagination that, even today, eighty years after his death, he continues to be regarded as one of the main attractions of Barcelona, the city that contains the most and best examples of Gaudí's spectacular and exceedingly creative work.

einführung
Francesc Fontbona

Leiter der Grafischen Abteilung der Nationalbibliothek Kataloniens

Die Figur Antoni Gaudí stellt ein außergewöhnliches Phänomen dar, nicht nur in der Geschichte der katalanischen Kunst, sondern – wie sich mit der Zeit herausstellte – in der gesamten Weltkunst, die sich zunächst jahrzehntelang der Größe des Architekten nicht bewusst war.

Gaudí war ein genialer Künstler, der unbeabsichtigt, das heißt völlig natürlich, schon mit seinen ersten Werken einen eigenen, stark ausgeprägten Stil schuf, der durch eine stetige – anfangs ganz offensichtliche und später geradezu verblüffende – Weiterentwicklung glänzte. Gaudí unternahm nicht nur einfach einen Schritt vorwärts in der Architekturentwicklung: Er veränderte Stile und Strukturen von Grund auf, doch nicht etwa, um dem Drang nach Originalität oder dem Wunsch nach ästhetischer Subversion nachzugeben, wie dies später die Avantgardisten des 20. Jahrhundert aus Überzeugung taten – von denen sich einige, wie Apollinaire, Breton, Dalí, Man Ray oder Éluard vor dem Werk Gaudís verneigten und zum Teil den Architekten noch posthum zum Surrealisten erhoben. Nein, er handelte so, wie es seinem Geist und seiner enormen Kreativität entsprach. Wenn sich ein gewöhnlicher Künstler an den Arbeitstisch setzt, konzentriert und bekräftigt: „Ich will Avantgarde schaffen", erzielt er meist keine annähernd so positiven Ergebnisse wie ein wirklich außergewöhnliches Talent, das seiner Begabung ohne Vorsatz oder Hintergedanken freien Lauf lässt, während es geschickt seine Werke schafft. Auf diese Weise entsteht anhand einer Neuschöpfung der Avantgardismus, der keine *Conditio sine qua non* für die Kunst darstellt, doch das ist eine andere Sache. In anderen Fällen dagegen ist ein Werk meist kaum mehr als ein Vorwand, um einem oft allzu vorhersehbaren Avantgardismus Ausdruck zu verleihen.

Zudem muss betont werden, dass Gaudí nicht etwa aus dem Nichts auftauchte, wie oft von Leuten behauptet wird, die nicht mit der katalanischen Realität seiner Zeit vertraut sind. Gaudís Beitrag ist einer vielschichtigen kulturellen Strömung der Kunst, Literatur und Musik zuzuschreiben, die ab den achtziger Jahren die katalanische Jahrhundertwende bereicherte. Diese Bewegung wurde als *Modernismo* bezeichnet, da sich ihre Begründer ausdrücklich vorgenommen hatten, die von ihnen als überaus konformistisch erachtete katalanische Kultur zu modernisieren. Gaudí lebte in der Zeit des Modernismus und entwickelte sein Werk parallel dazu. Zu Recht wurde er später sogar als bestes Beispiel für diese Bewegung empfunden. Gaudí war jedoch ein Einzelgänger und beteiligte sich nicht allzu aktiv an den Kunstzirkeln, in denen die neue Bewegung entstand. Wenngleich er in seinen Jugendjahren mit dem Architekten Domènech i Montaner zusammengearbeitet hatte und ein Freund des Malers und Förderers innovativer Schauspiele, Lluís Graner, war, suchte er nur sporadisch den Kontakt mit einigen der herausragenden Modernisten. Außerdem zeigten sich selbst die Modernisten von der extremen Originalität seines Werks überrascht und sogar verwirrt.

Im Gegensatz zu dieser Originalität war Gaudís Praxis in der Tradition verwurzelt. Er errichtete die Sagrada Familia so, wie die gotischen Baumeister die Kathedralen erbaut hatten. Paradox ist, dass Gedanken seiner Lehre überliefert sind, in denen er stets missbilligend von der gotischen Kunst sprach, mit der sein Werk teilweise Ähnlichkeit aufwies. Dagegen finden sich in seinem Werk von der griechischen Klassik, als deren begeisterter Bewunderer er sich erklärte, nur schwer erkennbare Spuren. Eine Ausnahme bildet der Säulengang im Parc Güell, doch selbst hier lässt die Nachahmung des dorischen Stils jede mögliche neoklassizistische Neigung zurückstehen. Darüber hinaus war der Traditionalismus des Architekten nicht nur beruflicher, sondern auch ideologischer Natur. Jener umwälzend neue, grundverschiedene und brillante Gaudí war im Privatleben ein derart strenger Katholik, dass gegenwärtig eine eindringliche und nicht eben marginale Bewegung versucht, die Kirche zu seiner Seligsprechung und künftigen Heiligsprechung zu veranlassen.

Alle eventuellen Vorbehalte und Nuancen dürfen nicht verbergen, dass Gaudís Werk mit einigen der Grundzüge des plastischen Modernismus in Katalonien übereinstimmte. Dafür sprechen seine vorherrschend gekrümmten Linien, die beinahe konstante Farbpräsenz, die Übernahme von Formen aus der Natur, der Verzicht auf fast alle Anflüge der klassischen Ordnungen und die glorreiche Renaissance der angewandten Kunst, darunter Schmiedearbeiten, Keramiken, Mosaike, Glaskunst, Schreinerarbeiten und sogar Wandmalereien aus der Hand anderer Künstler, die der Architekt selbst beaufsichtigte. Diese Elemente lassen sich oft unabhängig von dem zugehörigen Bauwerk bewerten. Eng damit verbunden entwickelte sich Gaudís Stil in Katalonien gleichzeitig mit dem vieler anderer

Architekten, die zwar nicht seinen offensichtlichen Umbruch mitvollzogen, jedoch eine neue Baukunst schufen, die sich deutlich von der traditionellen Architektur abhob und Gaudís Werk bisweilen sehr ähnlich war. Hierzu zählten Domènech i Montaner, Vilaseca, Puig i Cadafalch, Granell, Sagnier, die Bassegodas, Gallissà, der in Madrid tätige Grases Riera, Salvador Valeri, Ruiz Casamitjana, Soler i March, die Martorell, Muncunill, Falguera, Monguió in Teruel, Nieto in Melilla, Rafael Masó, Pericas, Ferrés usw. sowie einige weitere Architekten, wie Antoni Millàs, die erstaunlicherweise bis heute kaum Beachtung gefunden haben. Hinzu kommen mallorquinische und valencianische Baumeister, die ebenfalls unter dem Einfluss des Modernismus standen, zum einen Roca i Simó und Forteza-Rey, zum anderen Peris Ferrando, Demetri Ribes und Francesc Mora. Andere Architekten, für die Gaudí zwar kein Lehrmeister im eigentlichen Sinne, jedoch in jedem Fall ein Meister war, folgten direkt seinem Beispiel. Dies trifft auf Jujol, Rubió i Bellver, Martinell, Berenguer, Sugrañes und Sayrach und Vertreter jüngerer Generationen zu, deren *Gaudinismo* stärker von der Faszination für den Meister und dem Studium seines Werks geprägt war als von seinem stilistischen Einfluss auf ihre jeweiligen Bauwerke.

Was Gaudí von vielen dieser katalanischen modernistischen Architekten abhebt, ist die Tatsache, dass sich diese zumeist bestimmten internationalen Schulen und Strömungen verbunden fühlten und mehr oder weniger von der Mode der *Art Nouveau* beeinflusst waren, welche gleichzeitig die modische abendländische Kunst erfüllte. Gaudí dagegen hatte – ungeachtet eines gewissen Einflusses des englischen *Aesthetic Movement* in seinen ersten Werken – kein bestimmtes ausländisches Vorbild und machte sich nichts aus der Mode. Dies mag sicher auf den Umstand zurückzuführen sein, dass er ein Sohn der romantischen *Renaixença*-Bewegung und ein politisch-kultureller Verfechter der einheimischen Kultur war. Er galt als erbitterter katalanischer Nationalist – beinahe ein Extremist – und verteidigte den Gebrauch seiner Sprache, des Katalanischen, selbst in Gegenwart des Königs von Spanien, dem Repräsentanten jener zentralistischen Macht, die den „spanischen" Kulturen der nicht kastilischen Peripherien reserviert, wenn nicht gar feindlich gegenüberstand.

Der Ursprung seiner ausgeprägt persönlichen Kunst ist in Gaudí selbst zu suchen. Zweifellos hätte er zu Lebzeiten eine internationale Schule begründet, wenn er seine Tätigkeit nicht in einer Stadt wie Barcelona ausgeübt hätte. Barcelona fand in jener Zeit kaum Beachtung in der Kunstwelt, die der Stadt keine größere Bedeutung für den allgemeinen künstlerischen Aufschwung beimaß. Nichtsdestotrotz kam gerade der Präsenz Gaudís und höchst origineller Maler, wie Joaquim Mir, oder Gruppen mit einem radikalen Engagement, wie Els Quatre Gats, ebendiese Bedeutung zu. So darf nicht vergessen werden, dass in ebendiesem Umfeld der innovativste und einflussreichste plastische Künstler des 20. Jahrhunderts – Pablo Picasso – aufkam, noch bevor er in Paris weltweiten Ruhm erlangte. Das Gleiche gilt für weitere anerkannte große Neuerer der internationalen Kunst, wie die Bildhauer Pau Gargallo und Juli González.

Der vermeintlich extravagante Stil Gaudís fand erstaunlicherweise großen Anklang bei der katalanischen Gesellschaft. Der große Architekt war auch für das katalanische Bürgertum – wie die Familien Vicens, Calvet, Batlló, Milà usw. und einige Vertreter des Neuadels, wie die Güells – tätig, die mit gewissem Stoizismus hinnahmen, die seltsamen Ergebnisse seiner Konzepte und Gestaltungen in Stein buchstäblich zu bewohnen. Ebenso wurde Gaudís Werk von der Masse der anonymen Christen akzeptiert, die den Bau des kolossalen Tempels der Sagrada Familia in Barcelona zu ihrem Anliegen machte. Die Errichtung wurde (und wird) größtenteils mit den Spenden des einfachen Volkes finanziert, das eigentlich verstört auf ein solch ungewöhnliches Werk hätte reagieren müssen. Ebenfalls erstaunlich ist, dass Gaudís Kundschaft zum Teil aus einer seinem Charakter entgegengesetzten Landschaft Spaniens stammte, nämlich aus dem Landesinneren, aus Comillas, León und Astorgas. In allen Fällen bestand allerdings eine mehr oder weniger direkte Verbindung zu Katalonien. So handelte es sich bei dem Auftraggeber in Astorga um einen katalanischen Bischof, der jene Diözese bei León leitete.

Antoni Gaudí, der stets freiberuflich tätig war und keinem Beamtenapparat angehörte, kam weder in den Genuss akademischer Ehren noch beteiligte er sich aktiv an der Politik, ganz im Gegensatz zu einigen seiner Kollegen. Er war ein kolossaler Künstler und ein nicht zuordenbarer Mensch, der seinen Beruf mit äußerster Präzision ausübte, die mitunter den Anschein erweckte, seiner wahnsinnigen Vorstellungskraft entsprungen zu sein. Die Früchte dieser Vorstellungskraft bilden noch heute, achtzig Jahre nach Gaudís Tod, mit ihrer großartigen, extremen Kreativität einen der wesentlichen Reize der Stadt Barcelona, in der sich ein Großteil seiner Werke befindet.

introduction

Francesc Fontbona

Conservateur de la section des arts graphiques de la bibliothèque de Catalogne

L'avènement du phénomène Antoni Gaudí marqua une étape exceptionnelle non seulement dans l'évolution de l'art catalan, mais aussi, comme l'histoire le prouva par la suite, dans le reste du monde, qui ne réalisa qu'après plusieurs décennies la transcendance de l'architecte.

Avec Gaudí naissait un esprit artistique de génie qui se forgea, tout naturellement et dès ses débuts, un style propre à la personnalité très marquée, en perpétuelle évolution, jugé d'abord tout simplement remarquable et plus tard proprement incroyable. Plus que faire avancer l'architecture, Gaudí alla au-delà et modifia radicalement les styles et les structures. Il accomplit son œuvre non pas dans un souci d'originalité ni de subversion esthétique, comme le firent plus tard les artistes avant-gardistes militants du XXᵉ siècle (dont certains, comme Apollinaire, Breton, Dalí, Man Ray ou Éluard, s'inclinèrent devant l'œuvre de Gaudí et allèrent jusqu'à le déclarer surréaliste après sa mort), mais bien grâce à l'élan débridé et inégalé de son immense créativité. Un artiste qui s'assoit à sa table de travail, se concentre et affirme « je vais faire de l'avant-garde » obtient en général des résultats beaucoup moins positifs qu'un artiste véritablement doté d'un talent exceptionnel qui, sans préméditation, donne libre cours à ses facultés et exécute son œuvre avec aisance. De cette manière, l'avant-gardisme qui, contrairement aux idées reçues, n'est pas une vertu *sine qua non* de l'art (mais ceci est un autre débat) surgit naturellement avec l'œuvre créée, tandis que, dans d'autres cas, l'œuvre n'est parfois plus qu'un prétexte pour incarner un avant-gardisme souvent trop prévisible.

De plus, il faut souligner que Gaudí n'a pas surgi de nulle part, comme il a souvent été affirmé par des personnes mal informées sur la réalité catalane de cette époque. Son apport s'inscrit en effet dans un mouvement culturel complexe (artistique, littéraire, musical) qui baigna la fin de siècle en Catalogne, dès les années 1880 et jusqu'au début du XXᵉ siècle. Ce mouvement fut baptisé *modernisme*, car ses promoteurs se proposaient précisément de moderniser la culture catalane qu'ils jugeaient excessivement conformiste. L'œuvre de Gaudí coïncida avec cette période et évolua en parallèle. Postérieurement, elle fut même perçue, non sans raison, comme la meilleure illustration de ce mouvement. Homme solitaire, Gaudí ne fut toutefois pas très actif dans les hautes sphères du nouveau mouvement. Dans sa jeunesse, il avait travaillé avec l'architecte Domènech i Montaner et fut l'ami de Lluís Graner, peintre et promoteur de spectacles novateurs. Il n'entretenait cependant que des contacts sporadiques avec quelques-uns des modernistes les plus réputés, qui étaient souvent surpris, voire déconcertés, par l'extrême originalité de son œuvre.

Contrastant avec son originalité, la pratique de Gaudí était profondément ancrée dans les traditions. Il construisit la Sagrada Familia comme les maîtres gothiques avaient bâti les cathédrales. Paradoxalement, il exprima toujours des pensées critiques sur l'art gothique, alors qu'une partie de son œuvre était assez proche de ce style. En revanche, il se voulait fervent admirateur de l'art classique grec, difficilement perceptible dans son œuvre, à l'exception de la colonnade du Parc Güell (même dans ce cas, le dorique est recréé de manière à écarter toute velléité néoclassique qui eût pu lui être attribuée). Par ailleurs, le traditionalisme de l'architecte n'était pas seulement professionnel, mais aussi idéologique. Ce Gaudí démesurément novateur et différent était dans sa vie privée un fervent catholique, à tel point qu'il existe aujourd'hui un mouvement actif en faveur de sa béatification, puis de sa canonisation.

Malgré toutes les exceptions et les nuances pouvant être invoquées, l'œuvre de Gaudí n'en partage pas moins certains des grands traits du modernisme artistique en Catalogne. Tel est le cas de la prédominance de la courbe, de la présence quasi constante de la couleur, du respect des formes inspirées de la nature, de la disparition de presque tout indice de facture classique et de la renaissance prodigieuse des arts décoratifs (fer forgé, céramique, mosaïque, vitraux, menuiserie voire fresques murales, éléments travaillés par d'autres artistes sous la supervision de l'architecte) formant souvent des œuvres à part entière indépendamment de l'ensemble auquel ils appartiennent.

En Catalogne, l'œuvre de Gaudí s'étend sur la même période que celle de nombreux autres architectes lesquels, sans atteindre le degré de rupture avérée de Gaudí, instaurèrent peu à peu une nouvelle manière de construire, plus ou moins proche de la sienne

et tranchant nettement avec la tradition. Il s'agit d'architectes comme Domènech i Montaner, Vilaseca, Puig i Cadafalch, Granell, Sagnier, les Bassegoda, Gallissà, Grases Riera (ce dernier à Madrid), Salvador Valeri, Ruiz Casamitjana, Soler i March, les Martorell, Muncunill, Falguera, Monguió (à Teruel), Nieto (à Melilla), Rafael Masó, Pericas, Ferrés, etc., sans oublier Antoni Millàs, curieusement passé inaperçu jusqu'à présent. Il faut aussi citer les artistes de Majorque et de Valence tels Roca i Simó ou Forteza-Rey, d'une part, et Peris Ferrando, Demetri Ribes ou Francesc Mora, d'autre part, également influencés par le modernisme.

D'autres architectes furent directement dans le sillage de Gaudí qui, sans jamais avoir été un professeur ordinaire, incarna sans aucun doute un grand maître : Jujol, Rubió i Bellver, Martinell, Berenguer, Sugrañes, Sayrach, etc. Vint ensuite une nouvelle généra-tion d'architectes, dont le « gaudinisme » obéit davantage à une fascination envers le maître et l'étude de son œuvre qu'à une nette influence de son style dans leurs projets architecturaux.

La différence entre Gaudí et nombre des architectes modernistes catalans est l'affiliation de la plupart d'entre eux à des écoles et des mouvances internationales concrètes, ainsi que leur sensibilité à l'art nouveau, très en vogue à cette époque et qui s'impose dans l'art occidental. Même si ses premières œuvres révèlent une certaine influence de l'*Aesthetic Movement* anglais, Gaudí n'adhéra à aucun modèle étranger précis et ne fit preuve d'aucun intérêt pour la mode. Ceci est sans doute lié au fait que, descendant du mouvement romantique de la *Renaixença* et partisan du soutien à la culture autochtone, il était un fervent catalaniste (pouvant même être qualifié d'extrémiste). Il était ainsi capable de défendre l'usage du catalan en présen-ce du roi d'Espagne, incarnation du pouvoir centraliste réticent, voire hostile, envers les cultures espagnoles périphériques non castillanes.

Gaudí puisait en lui cet art qui lui est si incroyablement personnel, et il aurait sans doute pris la tête d'une école internationale de son vivant s'il n'avait pas exercé dans une ville comme Barcelone. En effet, à cette époque, la ville n'était que timidement respectée dans le monde de l'art et ne jouissait pas d'un rôle clé dans le renouveau artistique, alors que celui-ci était précisément incarné par Gaudí, des peintres originaux comme Joaquim Mir et des groupes radicaux comme Els Quatre Gats. Ce fut précisément ce bouillon de culture qui donna naissance à l'un des peintres les plus novateurs et influents du XXᵉ siècle, à savoir Pablo Picasso (il forgea ensuite sa renommée internationale à Paris), ainsi qu'à d'autres grands artistes internationaux réputés, tels que les sculpteurs Pau Gargallo et Juli González.

L'extravagance du style de Gaudí fut étonnamment bien accueillie par la société catalane. D'ailleurs, le grand architecte travailla amplement pour la bourgeoisie locale (familles Vicens, Calvet, Batlló, Milà, etc.), parfois récemment anoblie (les Güell), qui accepta avec un certain stoïcisme de cohabiter avec ses étranges concepts et ses étonnantes créations de pierre. De même, les masses chré-tiennes anonymes acceptèrent et épaulèrent la construction du temple colossal de la Sagrada Familia, financé en grande partie par les dons d'un peuple qui aurait plutôt dû être déconcerté face à une œuvre aussi insolite. De manière tout aussi surprenante, cer-tains travaux entraînèrent Gaudi dans l'Espagne profonde, à l'opposé de sa personnalité (Comillas, León et Astorga), même si ces projets avaient tous un lien plus ou moins direct avec la Catalogne. À Astorga par exemple, un évêque catalan, régissant ce diocè-se de León, fut à l'origine de la commande.

Antoni Gaudí, qui pratiqua toujours le libre exercice de sa profession et n'appartint jamais à aucun corps de métier, ne reçut les honneurs d'aucune académie et ne participa à aucune organisation politique, à la différence de plusieurs collègues. Ce fut un artis-te formidable et un être inclassable, toujours surprenant, qui exerçait son activité avec une extrême précision, même lorsque celle-ci semblait née d'une imagination débordante. Les fruits de cette imagination sont devenus et demeurent encore aujourd'hui, quatre-vingts ans après sa mort, des attraits majeurs de la ville de Barcelone, qui abrite les plus grandes et les plus belles incarna-tions de la créativité spectaculaire et magistrale de Gaudí.

modernisme

A Major Cultural Phenomenon in Late 20th Century Europe

In the second half of the 19th century, industrial development in Europe had important social and political consequences. The changes brought about by the Industrial Revolution entailed significant technological advances such as the advent of the railroad, the discovery of electricity and the exploitation of oil, which triggered the transformation of society and one of the most important phenomena of the late 19th century: the massive rural exodus towards cities. The rapid concentration of peasants in large cities generated a series of unforeseen social problems. The lack of space in cities caused the new working class to settle in slums outside the city, creating what came to be known as the new peripheral cities. The inability of these new areas to cover certain basic necessities such as electricity, drinking water, health services and food supply required cities to adapt to the new situation and apply measures to aid the newcomers.

Industrial growth, however, was also responsible for the emergence of a new middle class comprised of industrialists, bankers and merchants who had largely profited from the Industrial Revolution and become an economic pillar of European society at the time. Eager to participate in the political arena, members of the middle class began promoting cultural and social initiatives that by the last quarter of the 19th century had generated a new artistic and cultural movement in Europe that was given a different name depending on its country of origin: Art Nouveau in France and Belgium with Henry Van der Velde and Victor Horta as the major proponents; the Modern Style in England and Ireland with Charles Rennie Mackintosh as one of its most interesting exponents; *Sezession* in Austria, represented by the Viennese painter Gustav Klimt and by architects including Otto Wagner, Joseph Olbrich and Joseph Hoffman; *Jugendstil* in Germany; Liberty in Italy; and *Modernismo* in Spain, which in Catalonia, Valencia and the Balearic Islands was called *Modernisme*.

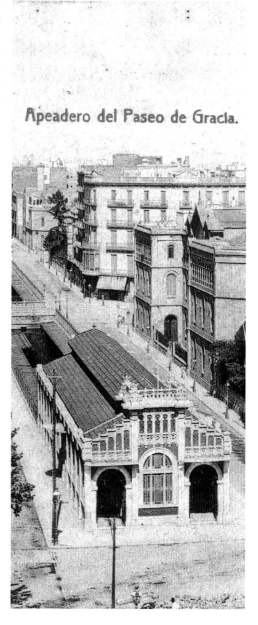

Apeadero del Paseo de Gracia.

Through this movement, the bourgeoisie found an effective way of publicly and overtly exhibiting its elevated economic status, thus turning this social class into the prime consumer of *Modernista* art by commissioning the construction, renovation and decoration of some of the most emblematic buildings of that time period.

Despite the fact that the movement bore some similarities from country to country, a single style cannot be defined given the aesthetic features particular to each one, although the essence underlying all of them was the same. They shared a common interest in ornamental details through the presence of undulant forms. They strove to downplay classical forms by instating the predominance of curved lines, floral motifs and a blend of sinuous shapes, solutions that strove to flee from expressive austerity and postulated a type of decoration using a wide variety of materials in which a clear sense of fantasy prevailed. The various artistic focal points also had in common an interest in the decorative arts, following the driving forces behind the Arts and Crafts movement.

Modernisme means "a taste for modern things," which points to the turn-of-the-century society's willingness to break with the past and embrace the novelties spawned by the Industrial Revolution. At odds with the classical art forms imposed by art academies at the time, the new creators discovered a new artistic vernacular whose spontaneity proved stronger than the imposed norms. This yearning for renewal led to the rejection of industry and technology in the artistic realm, compelling historians, critics and artists to promote the value of handmade products, and thus generating a complete reform of the arts and crafts. Characterised by the prevailing view of art as a unique and supreme creative force that could be expressed through diverse techniques, the *Modernista* movement saw the emergence of single works that integrated various disciplines such as music, poetry, architecture, sculpture, painting and graphic art.

PARIS - Opéra.

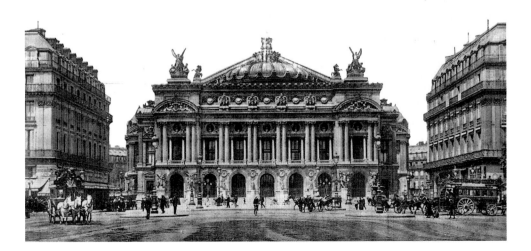

der modernismus

Ein bedeutendes kulturelles Phänomen im Europa des ausgehenden 19. Jahrhunderts

In der zweiten Hälfte des 19. Jahrhunderts hatte die industrielle Entwicklung in Europa erhebliche gesellschaftliche und politische Auswirkungen. Die Veränderungen im Rahmen der industriellen Revolution umfassten wichtige technologische Beiträge, wie die Erfindung der Eisenbahn, die Entdeckung der Elektrizität und die Nutzung von Erdöl. Diese Umstände sorgten für einen Wandel der Gesellschaft und waren zugleich eng mit einem der bedeutendsten Phänomene des ausgehenden 19. Jahrhunderts verbunden: der Landflucht, die die Landbevölkerung massenweise in die Städte trieb. Diese Konzentration ländlicher Zuwanderer in den Großstädten vollzog sich sehr schnell und brachte eine Reihe sozialer Probleme mit sich, die man nicht berücksichtigt hatte. Da es an Raum für alle diese Einwohner mangelte, schuf die neue Arbeiterklasse die Vorstädte und so genannte „neue Außenstädte", in denen nicht einmal die elementaren hygienischen Anforderungen und Bedürfnisse – wie Strom, Trinkwasser, ärztliche Versorgung, Nahrung etc. – gedeckt waren, um als bewohnbar zu gelten. So waren die Städte gezwungen, sich den neuen Gegebenheiten anzupassen und Maßnahmen zu ergreifen, um die Lebensbedingungen der Neuankömmlinge zu verbessern.

Die industrielle Entwicklung brachte aber auch ein neues Bürgertum aus Industriellen, Bankiers und Händlern hervor, die sich an der industriellen Revolution bereichert hatten und zur wirtschaftlichen Stütze der damaligen europäischen Gesellschaft wurden. Das Bürgertum wollte am politischen Leben jener Zeit teilhaben und gründete kulturelle und gesellschaftliche Vereinigungen. Dies wiederum begünstigte im letzten Viertel des 19. Jahrhunderts die Entstehung einer neuen künstlerisch-kulturellen Bewegung in Europa, einer Bewegung, die je nach ihrem Ursprungsland einen anderen Namen erhielt: In Frankreich und Belgien sprach man vom *Art Nouveau*, deren Hauptvertreter Henry Van der Velde und Victor Horta waren. Der *Modern Style* in England und Irland besaß mit Charles Rennie Mackintosh einen seiner interessantesten Exponenten. Österreichs *Sezession* wurde von dem Wiener Maler Gustav Klimt sowie von Architekten wie Otto Wagner, Joseph Olbrich und Joseph Hoffman repräsentiert. In Deutschland bezeichnete man die Bewegung als Jugendstil, in Italien als *Liberty*, in Spanien als *Modernismo*, während man in Katalonien, Valencia und auf den Balearen vom *Modernisme* sprach.

Dem Bürgertum bot dieser Trend eine ideale Gelegenheit, seinen Wohlstand öffentlich und demonstrativ zur Schau zu stellen. So wurde jene neue Gesellschaftsklasse zum wichtigsten „Konsumenten" modernistischer Kunst, indem sie die Errichtung, Renovierung oder Dekoration der damals repräsentativsten Gebäude in Auftrag gab.

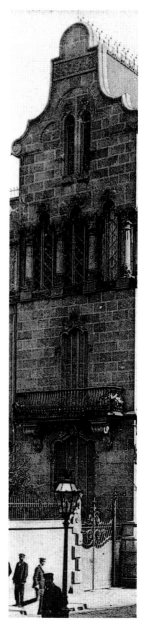

Wenngleich diese Tendenz in allen Ländern ähnlich war, kann man nicht von einem einzigen Stil sprechen, da jedes Land individuelle ästhetische Eigenheiten aufwies. Im Wesentlichen handelte es sich aber um die gleiche Mode mit einem gemeinsamen Interesse an einer Dekoration mit Wellenlinien und dem Verzicht auf die klassischen Formen durch Einführung der gekrümmten Linie, der floralen Vielfalt und der Mischung aus Schlangenlinien. Dahinter stand die Absicht, eine nüchterne Ausdrucksweise zu vermeiden und eine deutlich fantasievolle Dekoration mit einer Vielzahl von Materialien einzusetzen. Die verschiedenen künstlerischen Ausprägungen teilten ebenfalls ein gemeinsames Interesse für die angewandte Kunst und folgten den Reformimpulsen der *Arts-and-Crafts*-Bewegung.

Modernismo bedeutet „Geschmack für Modernes" und zeigt den Wunsch der Gesellschaft um die Jahrhundertwende, die von der industriellen Revolution beigesteuerte Neuheit, die Moderne, zu suchen. Im Gegensatz zur klassisch-archaischen Kunst, die von den zeitgenössischen Kunstschulen auferlegt wurde, fanden die modernistischen Schöpfer eine neue künstlerische Ausdrucksform, die der Spontaneität mehr Bedeutung beimaß als den vorgeschriebenen Normen. Mit dem Erneuerungsdrang wurde die Einflussnahme von Industrie und Technik auf die Kunst abgelehnt. Diese Empfindung veranlasste Historiker, Kritiker und Künstler, die Bedeutung der kunsthandwerklichen Erzeugnisse zu unterstreichen, und bewirkte eine vollständige Reform des kunsthandwerklichen Schaffens. Im Modernismus setzte sich die These durch, Kunst sei eine einzige höchste und kreative Einheit, die sich mittels verschiedenster Techniken ausdrücken lasse. Daher entstand zu jener Zeit der klare Wunsch, verschiedene Disziplinen wie Musik, Poesie, Architektur, Bildhauerei, Malerei und Grafik in einem einzigen Werk zu vereinen.

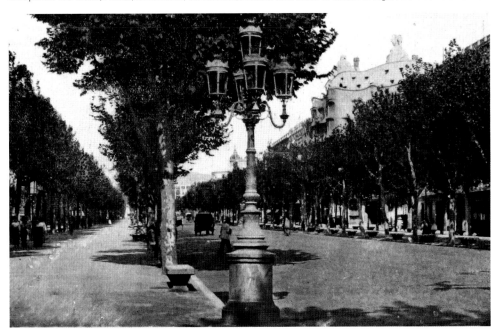

le modernisme

Un phénomène culturel majeur dans l'Europe de la fin du XIX^e siècle

Le développement industriel de la seconde moitié du XIX^e siècle en Europe eut un impact considérable sur le plan social et politique. Les bouleversements introduits par la révolution industrielle entraînèrent de grands progrès technologiques, comme l'apparition du chemin de fer, la découverte de l'électricité et l'exploitation du pétrole. Ces avancées, véritables amorces de la transformation de la société, étaient étroitement liées à l'un des phénomènes majeurs de la fin du XIX^e siècle : l'exode rural, qui poussait des masses de paysans à émigrer vers les centres urbains. Cette concentration rapide de population d'origine rurale dans les grandes villes engendra une série de problèmes sociaux inattendus. Le manque d'espace urbain força la nouvelle classe ouvrière à s'installer dans des bidonvilles, qu'on nomma plus tard « nouvelles villes » périphériques, incapables de répondre aux besoins élémentaires de la population (hygiène, électricité, eau potable, services de santé, alimentation, etc.). Les villes durent par conséquent s'adapter à cette nouvelle situation et prendre des mesures pour améliorer les conditions de vie des nouveaux venus.

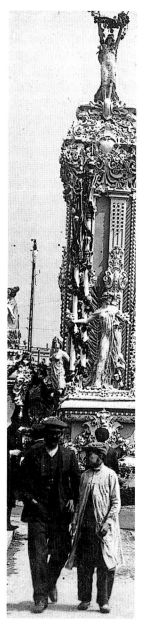

En parallèle, la croissance industrielle favorisa l'émergence d'une nouvelle bourgeoisie, composée d'industriels, de banquiers et de commerçants, qui s'était enrichie grâce à la révolution industrielle et érigée en pilier économique de la société européenne de l'époque. Désireux de prendre part à la vie politique du moment, les membres de cette bourgeoisie commencèrent à soutenir une variété d'initiatives culturelles et sociales, d'où l'émergence au cours des deux dernières décennies du XIX^e siècle d'un nouveau mouvement artistique et culturel en Europe. Ce mouvement fut baptisé différemment selon les pays : Art nouveau en France et en Belgique, avec Henry Van de Velde et Victor Horta pour chefs de file ; *Modern Style*, en Angleterre et en Irlande, avec notamment Charles Rennie Mackintosh ; *Sezessionstil*, en Autriche, représenté par le peintre viennois Gustav Klimt et des architectes tels qu'Otto Wagner, Joseph Olbrich et Joseph Hoffman. En Allemagne, on l'appela *Jugendstil*, en Italie, *Stile Liberty*, en Espagne, *modernismo* et en Catalogne, à Valence et aux Baléares, *modernisme*.

À travers ce mouvement, la bourgeoisie découvrit la façon d'afficher ostensiblement son statut économique élevé, et cette classe sociale devint la première consommatrice d'art moderniste en commandant la construction, la restauration ou la décoration de quelques-uns des édifices les plus emblématiques de l'époque.

Malgré les similitudes du mouvement entre les pays, il n'existait pas un style unique à proprement parler, car chaque territoire présentait des caractéristiques

esthétiques particulières. L'essence était toutefois la même, et un intérêt commun pour les détails ornementaux (lignes ondulées, courbes, motifs floraux et mélange de formes sinueuses) illustrait une volonté de fuir les formes classiques et l'austérité expressive pour concevoir une décoration où dominait un sens aigu de la fantaisie. Une vaste gamme de matériaux était employée dans ce but. Les différents penchants artistiques partageaient également le goût pour les arts décoratifs, éveillé par l'élan réformateur du mouvement *Arts and Crafts*.

Le *modernisme*, le « goût pour les choses modernes », prouve le désir de cette société de rompre avec le passé, au tournant du siècle, et d'adopter les innovations apportées par la révolution industrielle. Se démarquant des formes d'art classique alors prescrites par les académies, ces créateurs découvrirent un nouveau langage artistique, dont la spontanéité l'emportait sur les normes imposées. Ce désir ardent de renouveau suscita le rejet du rôle de l'industrie et de la technologie dans le domaine artistique, sentiment qui conduisit les historiens, les critiques et les artistes à promouvoir la valeur des produits faits à la main, et qui favorisa par conséquent une réforme complète des arts et métiers. Se caractérisant par une thèse dominante selon laquelle l'art est une force créatrice, unique et suprême pouvant être exprimée à partir de techniques très diverses, le mouvement moderniste vit ainsi naître des œuvres uniques intégrant des disciplines aussi diverses comme la musique, la poésie, l'architecture, la sculpture, la peinture et le graphisme.

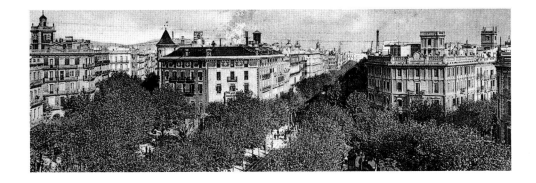

modernisme in catalonia

During the second half of the 19th century, Barcelona was at its economic and social peak. The old part of the city, surrounded by walls and bounded by the sea, had become too small to accommodate the large buildings that were being put up by the new emerging society. To solve this lack of space, the town hall decided to initiate an urban development plan that began by tearing down the walls in order to gain more space, clearing the way for the area known as the Eixample (expansion). Designed by Ildefons Cerdà, the Eixample was organized as a grid system formed by residential blocks with spacious, interior courtyards designed to improve residents' quality of life. In 1859, the decision was taken to annex the neighbouring towns of Gràcia, Les Corts, Sants and Sant Gervasi, which until then had been summer destinations where the middle class had constructed enormous mansions that still stand today.

The beginnings of *Modernisme* in Spain can be traced back to 1878, when architect Lluís Domènech i Montaner published an article in the Catalan newspaper *La Renaixensa* entitled "The quest for a national architecture," in which he expressed the need for Catalonia to develop its own individual style. From that moment on, buildings were constructed based on history yet characterised by the personality of the architect who transformed classical notions into new architectural interpretations. Examples of this are Casa Vicens (1878-1880) designed by Antoni Gaudí, and the building for the Montaner Simó publishing house (1881) designed by Lluís Domènech i Montaner.

If indeed the year of 1878 was key, it was not until 1888 that the *Modernista* style came into its own. The 1888 Universal Exhibition held in Barcelona provided a platform for promoting and exhibiting the artistic novelties that would not take long to spread throughout society as a whole. The Barcelona Exhibition

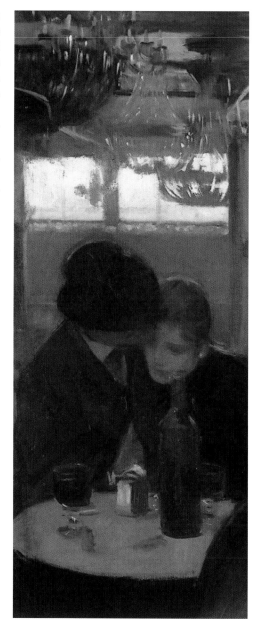

served to demonstrate the power of the middle class, who believed they were fulfilling the dream of modernisation thanks to the economic prosperity they had attained in what was known as the Gold Fever. After the exhibition, the nobility and especially the middle class wanted to move to the Eixample, where they would take up residence and commission the construction of spectacular works of architecture.

A few years later, *Modernisme* had become wildly popular. Between 1892 and 1899, the coastal town of Sitges located south of Barcelona would host the five *Modernista* festivals, events promoted by painter and writer Santiago Rusiñol who wisely merged literary and artistic *Modernisme*. During the same decade, Catalan *Modernisme* was turning into a collective expression of the community, penetrating the most popular levels of society: choirs, group excursions, theatre troupes, music, literature, painting… This was when art began influencing the design of functional, everyday objects, creating an expansion in the field of art that primarily affected the applied arts.

Due to the socio-political conditions in Catalonia between the end of the 19th and beginning of the 20th centuries, the *Modernista* movement reached levels unlike anywhere else in Spain. Notwithstanding, it would be an error to assume that *Modernisme* solely took place in Catalonia, as it also played an important and varied role in Spanish cities like Madrid, Valencia, Zaragoza and Melilla, among others.

It is more difficult to pinpoint the exact date marking the end of *Modernisme*. There are factors indicating the onset of an aesthetic shift away from *Modernista* ideas, one of these being the articles by Eugeni d'Ors, who since 1906 had pioneered the term *Noucentisme* through *La Veu de Catalunya*. Other notable articles indicative of this shift in aesthetic tastes were those published between 1907 and 1911 in the *Almanach dels Noucentistes*, a collection of writings that set the aesthetic and cultural ideals advocated by this new movement, characterised by an adamant rejection of anything related to *Modernisme*. Despite these dates, however, *Modernisme* cannot be placed within an exact time period given that works displaying a distinct *Modernista* style continued to be built after 1906, including Gaudí's renowned Casa Milà.

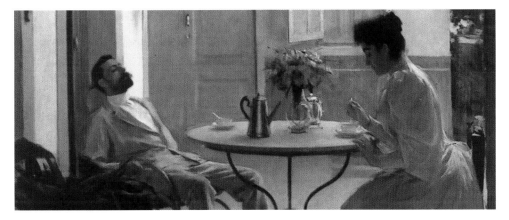

der modernismus
in katalonien

In der ersten Hälfte des 19. Jahrhunderts erlebte die Stadt Barcelona eine wirtschaftliche und soziale Blütezeit. Die von Stadtmauern und Meer begrenzte Altstadt war zu klein geworden, um die großen Neubauten der aufkommenden neuen Gesellschaft zu beherbergen. Als Lösung für den Raummangel wurde von der Stadtverwaltung eine Stadterweiterung beschlossen, deren erste Maßnahme die Öffnung der Stadtmauern war, um so Fläche hinzuzugewinnen. Dabei entstand das als „L'Eixample" bekannte Neubaugebiet, das im Wesentlichen auf den Stadtplaner Ildefons Cerdà zurückzuführen ist. Er entwarf eine rasterförmig angeordnete Stadt aus Häuserblocks, in deren Mitte Freiräume, die großen Hinterhöfe, belassen wurden, welche die Lebensqualität ihrer Bewohner verbessern sollten. 1859 wurde entschieden, Barcelonas Vororte einzugliedern. Die heute vollständig integrierten Stadtviertel, wie Gràcia, Les Corts, Sants und Sant Gervasi, waren bis zu jener Zeit Sommerurlaubsorte gewesen, in denen das Bürgertum riesige Villen besaß, von denen heute noch einige erhalten sind.

Der Beginn des Modernismus lässt sich in Spanien auf das Jahr 1878 datieren, als der Architekt Lluís Domènech i Montaner in der katalanischen Zeitung *La Renaixensa* einen Artikel mit dem Titel „Auf der Suche nach einer Nationalarchitektur" veröffentlichte und einen eigenen Stil für Katalonien forderte. Von da an wurden Gebäude auf der Grundlage des Historismus errichtet, wobei der individuelle Charakter des Architekten dominierte, der jene klassischen Ausdrucksformen veränderte und eine neue Architektur hervorbrachte. Beispiele hierfür sind die Casa Vicens (1878-1880) nach einem Entwurf von Antoni Gaudí oder das Gebäude des Verlags Montaner i Simó (1881), ein Werk von Lluís Domènech i Montaner.

Das Jahr 1878 war zwar grundlegend, doch erst ab 1888 wurde der modernistische Stil vollkommen umgesetzt. Einmal mehr bot eine Weltausstellung,

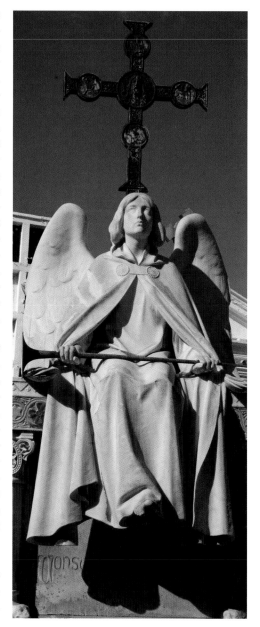

diesmal in Barcelona, Gelegenheit, die künstlerischen Neuheiten vorzustellen und sie fast umgehend allen Gesellschaftskreisen bekannt zu machen. Die Weltausstellung in Barcelona wurde vom Bürgertum genutzt, um seine Macht zur Schau zu stellen. Diese Gesellschaftsschicht glaubte, sie habe dank des Wirtschaftsaufschwungs, der auf eine als „Goldfieber" bekannte Zeit folgte, den Modernisierungstraum verwirklicht. Nach der genannten Ausstellung zog es den Adel und vor allem das katalanische Bürgertum in die neuen Stadtviertel des L'Eixample, wo sie sich niederließen und Aufsehen erregende Bauwerke errichteten.

Wenige Jahre später erfreute sich der Modernismus bereits größter Beliebtheit. Zwischen 1892 und 1899 fanden in Sitges, einem südlich von Barcelona gelegenen Küstenort, fünf so genannte *Festes Modernistes* statt. Diese Feierlichkeiten wurden auf Initiative des Malers und Literaten Santiago Rusiñol abgehalten, dem damit eine intelligente Verbindung des literarischen mit dem künstlerischen Modernismus gelang. Darüber hinaus entwickelte sich der katalanische Modernismus im gleichen Jahrzehnt zum kollektiven Ausdruck eines Volkes, in dem sich diese Bewegung auf einer höchst volkstümlichen Ebene – in Chören, Wandervereinigungen, Volkstheatergruppen, Musik, Literatur, Malerei – stark verbreitete. Gleichzeitig wandte sich die Kunst praktischen Gebrauchsgegenständen zu und erfasste alle Arten von Alltagsobjekten. Auf diese Weise erweiterte sich der Kunstbereich, insbesondere der der angewandten Kunst.

Aufgrund der politischen und gesellschaftlichen Lage im ausgehenden 19. und frühen 20. Jahrhundert erreichte die modernistische Bewegung in Katalonien einen höheren Stellenwert als auf der übrigen Iberischen Halbinsel. Trotzdem wäre es ein Fehler anzunehmen, der spanische Modernismus sei allein auf Katalonien beschränkt gewesen. Vielfältige und interessante Beispiele für diese Bewegung finden sich in unter anderem in den Städten Madrid, Valencia, Zaragoza und Melilla, in denen der Modernismus ebenfalls eine herausragende Rolle spielte.

Schwierigkeiten bereitet der Versuch, das Ende des Modernismus zeitlich festzulegen. Einige Faktoren zeigen das Aufkommen eines ästhetischen Wandels an, der eine Abkehr von den modernistischen Ideen einleitete. Dazu zählen beispielsweise die Artikel von Eugeni d'Ors, mit denen er ab 1906 in der Tageszeitung *La Veu de Catalunya* den Begriff *Noucentisme* verbreitete. Weitere bedeutende Artikel, die uns die Veränderung der ästhetischen Vorlieben nahe bringen, wurden zwischen 1907 und 1911 im Almanach *Almanach dels noucentistes* veröffentlicht. Sie bestimmten die neuen ästhetischen und kulturellen Ideale des *Noucentisme*, einer kulturellen Bewegung, die sich gegen alle Aspekte des Modernismus wandte. Trotz dieser Abgrenzung lässt sich der Modernismus zeitlich nicht genau beschränken, da noch nach 1906 deutlich modernistische Werke, beispielsweise Gaudís Casa Milà, geschaffen wurden.

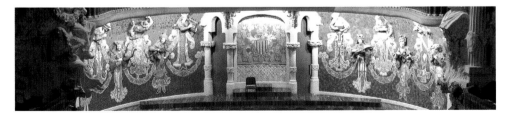

le modernisme en catalogne

Dans la seconde moitié du XIXe siècle, Barcelone était une ville à son apogée sur le plan économique et social. La vieille ville, entourée de fortifications et bordée par la mer, était devenue trop petite pour accueillir les grands bâtiments que construisait la nouvelle société émergente. Pour résoudre ce manque d'espace, la mairie décida de mettre sur pied un plan de développement urbain. Sa première intervention, la démolition des remparts afin d'obtenir plus d'espace, donna naissance à l'Eixample (l'agrandissement), œuvre d'Ildefons Cerdà. Cet ingénieur conçut une ville en damier composée d'îlots d'habitations, au centre desquels était aménagé un espace ouvert, le patio, dans le but d'améliorer la qualité de vie de ses habitants. On décida en 1859 d'annexer les localités voisines de Gràcia, Les Corts, Sants et Sant Gervasi, qui avaient été jusqu'alors des lieux de villégiature où la bourgeoisie avait construit de vastes hôtels particuliers, dont certains existent encore de nos jours.

La naissance du modernisme en Espagne remonte à 1878, année au cours de laquelle l'architecte Lluís Domènech i Montaner publia, dans le journal catalan *La Renaixensa*, un article intitulé « À la recherche d'une architecture nationale » exprimant le besoin de trouver un style propre à la Catalogne. Dès lors, la construction de bâtiments, reposant sur l'histoire, laissait transparaître la personnalité de l'architecte qui transformait les notions classiques pour ouvrir la voie à une nouvelle architecture. La Casa Vicens (1878-1880), conçue par Antoni Gaudí, et le bâtiment des éditions Montaner i Simó (1881), œuvre de Lluís Domènech i Montaner, en sont de bons exemples.

Même si l'année 1878 est décisive pour le style moderniste, celui-ci ne se développa pleinement qu'en 1888. Une fois de plus, une exposition universelle, celle de Barcelone, permit de découvrir et de divulguer les nouveautés artistiques qui ne tardèrent pas à conquérir l'ensemble de la société. L'Exposition universelle de Barcelone servit à démontrer le pouvoir de la classe moyenne qui pensait concrétiser le rêve de la modernisation grâce à la prospérité économique qu'elle avait atteinte lors de la « fièvre de l'or ». Après l'exposition, la ville connut une vague de déplacements vers l'Eixample, où la noblesse et surtout la classe moyenne choisirent d'élire domicile et commandèrent la construction d'œuvres architecturales spectaculaires.

Le modernisme atteignit sa plus grande cote de popularité quelques années plus tard. Entre 1892 et 1899, cinq festivals modernistes se déroulèrent à Sitges, village côtier situé au sud de Barcelone, à l'initiative du peintre et écrivain Santiago

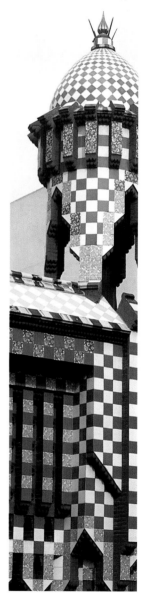

Rusiñol, qui réunit judicieusement des personnalités du modernisme littéraire et artistique. Au cours de cette décennie, le modernisme catalan devint peu à peu l'expression collective d'un peuple, en représentant un large spectre de la société : chorales, groupes excursionnistes, troupes de théâtre populaire, musique, littérature, peinture… C'est à cette époque que l'art commença à s'imposer dans les objets courants et fonctionnels. Un élargissement du champ artistique s'ensuivit, stimulant notamment les arts appliqués.

En raison de la situation politique et sociale de la Catalogne à la fin du XIXe siècle et au début du XXe, le mouvement moderniste y exerça un plus grand impact que dans le reste de la péninsule. Cependant, il serait erroné de croire que le modernisme en Espagne se limita à la Catalogne. Il existe des illustrations variées et intéressantes de ce mouvement dans des villes espagnoles telles que Madrid, Valence, Saragosse ou Melilla, entre autres, où le modernisme joua également un rôle prépondérant.

Il est plus difficile de déterminer avec certitude l'année marquant la fin du modernisme. Certains facteurs semblent indiquer l'avènement d'une nouvelle ère esthétique qui rompt avec les pensées modernistes. Dans une série d'articles, Eugeni d'Ors évoqua dès 1906, à travers *La Veu de Catalunya*, le terme de *noucentisme*. D'autres articles notables, révélateurs du changement de goût, furent publiés entre 1907 et 1911 dans l'*Almanach dels noucentistes*. Ils présentaient les nouveaux idéaux esthétiques et culturels proposés par le *noucentisme*, nouveau mouvement caractérisé par son rejet de tout ce qui avait un lien avec le modernisme. Cependant, en dépit de ces dates, il est difficile de cantonner le modernisme à une période concrète, des œuvres de tendance nettement moderniste, telles que la Casa Milà de Gaudí, ayant été édifiées après 1906.

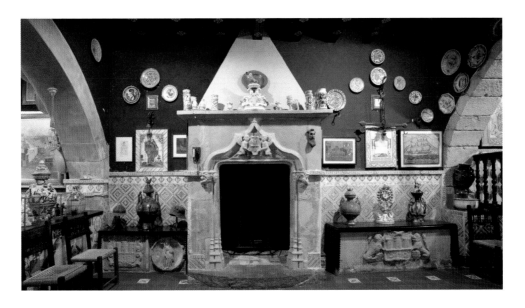

biography

Antoni Gaudí i Cornet was born in Reus (Tarragona) on 25 June 1852. Son of a working-class family, he manifested his passion for art from a very young age, and in 1867 he completed a series of drawings for the magazine *El Arlequín* published in his hometown by himself and his school friends Eduard Toda and Josep Ribera, with whom he would end up sharing parallel careers. In 1869, after completing secondary school, he moved to Barcelona where his brother was studying medicine. There he attended classes in the Institut d'Ensenyament Mitjà and later took the preparatory courses needed to enrol in the School of Architecture. His interest in architecture was already very evident when in 1868 he initiated, along with his two friends Toda and Ribera, the almost utopian project of restoring the abandoned Monastery of Santa Maria de Poblet, aiming to convert it into a common space for craftsmen, artists and people devoted to fostering the arts and sciences. In 1873, he began his architectural studies in the fine arts school Escola de Nobles Arts de Llotja, which later became the Escuela Provincial de Arquitectura de Barcelona (Barcelona School of Architecture) two years later, with classes held at the University of Barcelona. The need for financial means to pay for his studies led him to work as a draughtsman in various workshops. During his first year, he was commissioned to collaborate on architect Josep Fontseré's designs for the Parc de la Ciutadella and the Born market. Throughout his years as a student, Gaudí executed a number of designs such as the Torre de les Aigües (Water Tower) in the aforementioned park, and he worked with renowned architects such as Francesc de Paula del Villar, whom he aided in designing the sanctum and apse of the Montserrat monastery.

On 4 January 1878, Antoni Gaudí presented his final project, which earned him the degree of architect awarded on 15 March in Madrid. From then on, he would design and build a vast number of works.

Ever since his early years as a professional, he demonstrated the attributes of a well-rounded artist. His are works as diverse as the lampposts in Barcelona's Plaça Reial, the furniture designs for the chapel of the Marquis of Comillas mausoleum, a wrought iron, wood and glass display cabinet for gloves in the Casa Esteve Comella in the Paris Exhibition, and a flower stand.

Not given to writing about his aesthetic preferences, Gaudí is known to have published only one article in 1881 in the newspaper *La Renaixensa*. During the late 1870s, he met Eusebi Güell, who over the years would become his perfect patron, giving him total freedom in designing and executing the projects that he was commissioned. In 1882, the first stone of the Sagrada Família temple was laid. At that time, the young Gaudí was not yet associated with the project, although one year later he was commissioned to perform a study of the columns in the crypt. During those years, the architect rendered designs for buildings that over time have come to be known as paradigms of the *Modernista* movement.

Gaudí's intense love of nature served as a main source of inspiration in practically all of his works. The Casa Vicens in Barcelona (1883-1888) stands out for its façade which is almost entirely covered with tiles depicting small yellow flowers. In 1883 he also began constructing the Villa Quijano, also known as "El Capricho" (The Whim) in the town of Comillas in Santander, and in 1884 he embarked on one of his most important ventures, as he was appointed official architect of the Sagrada Família, which he would never see completed and which to date, despite its increasingly rapid

Design realised in 1876 by Antoni Gaudí for the refurbishment of the Gothic courtyard of the Diputació (provincial council) building, where the Barcelona town hall is currently located.

Der 1876 von Antoni Gaudí angefertigte Entwurf zur Renovierung des gotischen Innenhofs im Abgeordnetenhaus, das heute Barcelonas Rathaus beherbergt.

Projet réalisé en 1876 par Antoni Gaudí pour la rénovation de la cour gothique du bâtiment de la Diputació (administration provinciale de Barcelone), qui abrite aujourd'hui la mairie de Barcelone.

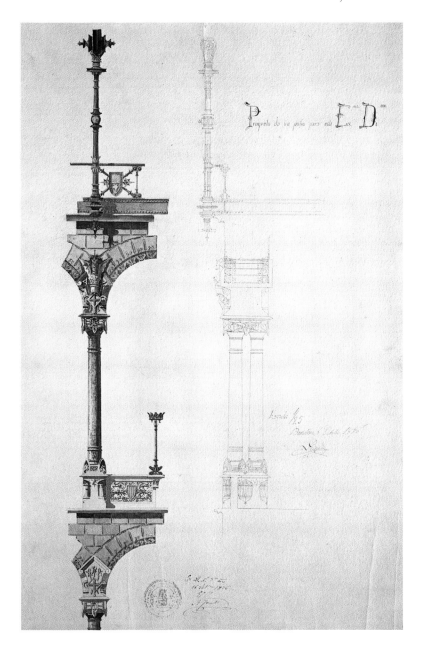

evolution, is still far from completion. The construction of this temple, however, was not the only commission received by the architect during this decade. The Church, private clients and especially Count Güell, asked Gaudí to collaborate in their new projects. For the noble Catalan, Gaudí designed a multitude of projects such as a hunting pavilion (1882), the Finca Güell (Güell estate) (1884-1887), and the Cellers Güell (wine cellars) in Garraf (1895). The most notable commission was that of the Palau Güell (Güell palace) (1886), a large building situated very close to Barcelona's Rambla.

Gaudí never hesitated to accept commissions. For this reason, the architect also worked outside Catalonia and constructed eminent buildings such as the Episcopal Palace of Astorga in León. The 1894 death of the archbishop of Astorga, Joan Baptista Grau i Vallespinós, who had commissioned this project from Gaudí, aroused a great deal of controversy within the organisation as to the continuation of the project, leading the artist to resign his position as director. The 1888 Universal Exhibition held in Barcelona featured one of Gaudí's projects: the Pavilion for the Transatlantic Company, property of Antonio López y López, another of Gaudí's major clients. During the 1890s, Gaudí initiated the work on the Casa Botines in León as well as the peculiar and personal El Capricho for Güell in Comillas, Santander.

In the early 1890s, Gaudí travelled to Tangier to visit the site on which he was to build a Catholic temple that he would never see completed. In 1894 he initiated the project for the future church of the Güell colony in Santa Coloma de Cervelló. Four years later he would begin working on the crypt, a project that would continue until 1915. During the last years of the 19th century and the beginning of the next, the architect undertook noteworthy commissions, including the Casa Calvet which he began in 1898 and earned him a prize for the best building in Barcelona in the year 1900. He also designed Casa Bellesguard (1900-1909); the design for the first glorious mystery of the monumental rosary on Montserrat; and the decoration of the house of the Marchioness of Castelldosrius. At the turn of the century, Count Güell commenced one of his most ambitious projects, once again in conjunction with Gaudí: the development of the Park Güell in Barcelona and the distribution of plots, porches, galleries and residences fully integrated with the landscape. Gaudí was once again able to demonstrate his love of nature as one of the major features of his project. Despite the major efforts made by Count Güell and the architect to make their dream come true, the project was terminated in 1914 without having reached the objective of creating a garden city.

In 1903 he travelled to Palma de Majorca to carry out the restoration of the city's Gothic cathedral. In 1905, he returned to Barcelona to undertake the complete renovation of the house of Lord Batlló, and that of Casa Milà, also known as "La Pedrera" (The Stone Quarry), in 1906, which would not be finished until 1911.

In 1909 Gaudí developed a project for a skyscraper in New York City, a building that despite its originality was never constructed. Throughout all these years, the architect continued his work on the Sagrada Família, and in 1925 he completed one of the belfries.

Within European Art Nouveau architecture, Antoni Gaudí emerged as a unique and exceptional figure. Unlike any other architect, Gaudí had the capability of utilizing and interpreting mediaeval architecture, and he offered

a personal interpretation that achieved its own unique expressiveness and went far beyond the source of inspiration, taking the structural principles of Gothic architecture to extremes.

Some of Gaudí's characteristic styles include parabolic and catenary arches, tilted columns, curved and even irregular apertures and undulating walls. Other exceptional contributions are his use of levelled and counterweighted vaults that eliminate the need for buttresses, as well as his treatment of rooftops in which he opts for textured surfaces and non-figurative sculptural forms in lieu of flat planes.

Gaudí found geometry in nature. His manipulation of stone and iron, based on natural elements, was unlike anything else found until that time. The imitation of natural forms such as rocks, stalactites and tree trunks was patent in many of Gaudí's works, perhaps most notably in La Pedrera, which he conferred with a unique artistry, integrating the dynamic shapes of architectural structures with the use of decorative materials such as wrought iron and ceramic.

The brilliant architect died on 10 June 1926 as a result of injuries suffered after being hit by a tram three days earlier between Bailèn Street and Gran Via, in the heart of Barcelona. His body was buried in the Carme chapel inside the crypt of the Sagrada Família.

On the left, a drawing Gaudí made when he was a child. On the right, Gaudí's 1876 pier designs for the School of Architecture.

Links eine Zeichnung, die Gaudí als Kind anfertigte. Rechts die Entwürfe für eine Landungsbrücke, die Gaudí im Jahr 1876 für die Hochschule für Architektur erstellte.

À gauche, un dessin réalisé par Gaudí dans son enfance. À droite, les projets d'embarcadères conçus par Gaudí en 1876 pour l'école d'architecture.

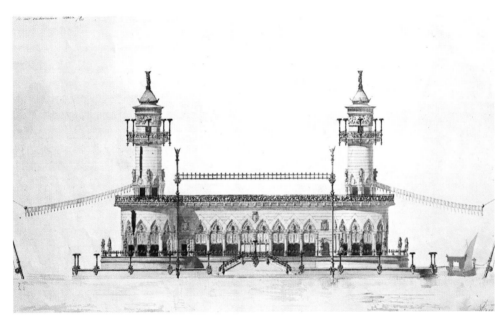

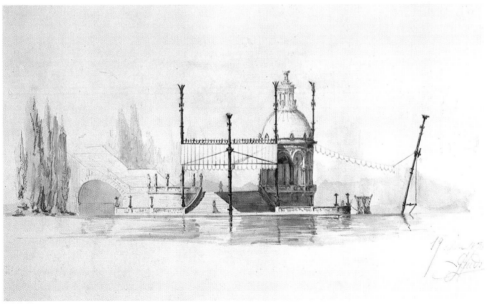

biografie

Antoni Gaudí i Cornet wurde am 25. Juni 1852 in Reus (Tarragona) geboren. Er wuchs in einer Handwerkerfamilie auf und zeigte schon von klein auf seine Begeisterung für Kunst. 1867 erstellte er eine Reihe von Illustrationen für die Zeitschrift *El Arlequín*, die Gaudí zusammen mit seinen Schulkollegen Eduard Toda und Josep Ribera, die viele Jahre lang ähnliche Wege gingen, in seiner Heimatstadt herausbrachte. Nach Abschluss der Mittleren Reife zog er im Jahr 1869 nach Barcelona, wo sein Bruder lebte und Medizin studierte. Dort besuchte er ein Gymnasium und belegte später die vorbereitenden Fächer für den Eintritt in die Hochschule für Architektur. Sein Interesse an der Welt der Architektur war offensichtlich, da er bereits 1868 gemeinsam mit seinen beiden Freunden Toda und Ribera das nahezu utopische Projekt begann, das verlassene Klostergebäude in Santa Maria de Poblet zu renovieren. Gaudí schlug vor, die Räumlichkeiten für eine Gemeinschaft von Kunsthandwerkern, Künstlern und Förderern der Künste und Wissenschaften herzurichten. Im Jahr 1873 nahm er sein Architekturstudium an der Kunsthochschule Llotja auf, die zwei Jahre später die Hochschule für Architektur Barcelona hervorbrachte. Zur Finanzierung seines Studiums arbeitete Gaudí als technischer Zeichner in verschiedenen Betrieben. Während seines ersten Studienjahres erhielt er den Auftrag, bei Projekten des anerkannten Baumeisters Josep Fontseré mitzuwirken, die den Parc de la Ciutadella und die Markthalle des Mercat del Born in Barcelona betrafen. Im Laufe seiner Studienzeit erstellte Gaudí verschiedene Entwürfe, z.B. für den Wasserturm – Torre de les Aigües – des genannten Parks, und arbeitete mit illustren Architekten, wie Francesc de Paula del Villar, zusammen, dem er bei seinem Projekt für den Reliquienschrein und die Apsis des Klosters Montserrat behilflich war.

Am 4. Januar 1878 präsentierte Antoni Gaudí seine Abschlussarbeit, mit der er sein Architekturdiplom, ausgestellt am 15. März in Madrid, erlangte. Von da an widmete er sich unaufhörlich dem Entwerfen und der Verwirklichung einer Vielzahl von Werken.

Schon in den ersten Berufsjahren erwies sich Gaudí als höchst vielseitiger Künstler. Von ihm stammen so unterschiedliche Werke wie die Straßenlaternen auf der Plaça Reial in Barcelona, das Möbeldesign für die Kapelle am Familiengrab des Markgrafen von Comillas, eine aus Schmiedeeisen, Holz und Glas gefertigte Ausstellungsvitrine für die Handschuhe des Hauses Esteve Comella auf der Weltausstellung in Paris und ein Blumenstand.

Gaudí schrieb seine ästhetischen Vorstellungen selten nieder, so dass nur ein einziger Artikel von ihm bekannt ist, der 1881 in der Zeitung *La Renaixensa* veröffentlicht wurde. Gegen Ende der siebziger Jahre lernte Gaudí Eusebi Güell kennen, der sich im Laufe der Jahre zu einem perfekten Mäzen entwickelte, da er ihm völlig freie Hand beim Entwurf und bei der Umsetzung seiner Auftragsprojekte ließ. 1882 wurde der Grundstein für den Tempel der Sagrada Família in Barcelona gelegt. Zu dieser Zeit hatte der junge Gaudí noch keinerlei Bezug zu diesem Projekt, wurde jedoch bereits ein Jahr später mit einer Studie über die Säulen der Krypta beauftragt. Während all dieser Jahre fertigte der Architekt Entwürfe für Gebäude an, die sich mit der Zeit zu paradigmatischen Werken der neuen ästhetischen Bewegung – des Modernismus – entwickelten.

Gaudí war sehr naturverbunden und bediente sich in beinahe all seinen Projekten der Natur als Hauptinspirationsquelle. Die Casa Vicens in Barcelona (1883-1888) zeichnet sich durch ihre fast vollständig mit Kacheln verkleidete

Fassade aus, auf der kleine gelbe Blüten zu sehen sind. Ebenfalls im Jahr 1883 wurde in dem kantabrischen Ort Comillas mit dem Bau der Villa Quijano – bekannt als „El Capricho" („Die Laune") – begonnen. 1884 war ein bedeutendes Jahr für Gaudí, da er offiziell zum Architekten der Sagrada Família ernannt wurde und sich damit auf ein Abenteuer einließ, das er nie zum Abschluss brachte und das auch noch heute trotz eines immer rascheren Ausbaus weit von seiner Fertigstellung entfernt ist. Der Bau des Tempels war jedoch nicht der einzige Auftrag, den der Architekt in den achtziger Jahren erhielt. Die Kirche, Privatkunden und vor allem Graf Güell beanspruchten Gaudís Mitarbeit an ihren neuen Projekten. Für den katalanischen Adeligen entwarf Gaudí eine Vielzahl von Bauwerken, wie den Jagdpavillon (1882), die Finca Güell (1884-1887) und den Celler Güell (1895) in Garraf. Der wichtigste Auftrag aber war der Palau Güell (1886), ein großes Gebäude ganz in der Nähe der Rambla de Barcelona.

Gaudí zögerte nicht, Aufträge anzunehmen, wo immer seine Dienste gefragt waren. Daher war der Architekt auch außerhalb Kataloniens tätig und schuf bedeutende Werke wie den Bischofspalast im leonesischen Astorga. 1894 starb der Bischof von Astorga, Joan Baptista Grau i Vallespinós, der Gaudí mit dem Bau des Palastes betraut hatte. Dieser Verlust sorgte im Bistum für große Diskrepanzen hinsichtlich der Kontinuität des Bauvorhabens, die dazu führten, dass der Künstler letztlich die Bauleitung ablehnte. Auf der Weltausstellung 1888 in Barcelona konnte man mit dem Pavillon der Compañía Transatlántica ein Projekt Gaudís bewundern, dessen Eigentümer Antonio

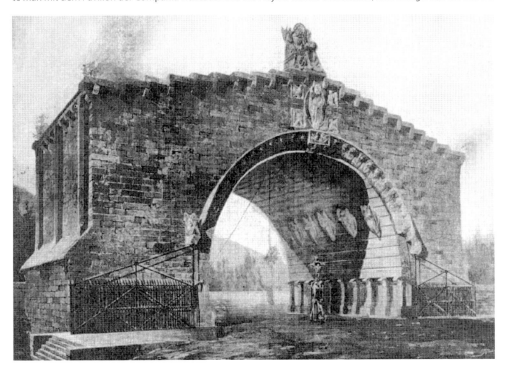

López y López ein weiterer Stammkunde des Architekten war. Anfang der neunziger Jahre begann Gaudí die Bauarbeiten für die Casa Botines in León und entwarf für die Familie Güell die eigentümliche und charakteristische Villa Quijano in Comillas, Santander.

Ebenfalls zu Beginn der neunziger Jahre reiste Gaudí nach Tanger, um den Baugrund zu besichtigen, auf dem er eine katholische Kirche errichten sollte, die er jedoch nie vollendet sah. 1894 nahm er das Projekt für die Kirche der Colònia Güell in Santa Coloma de Cervelló an und leitete vier Jahre später die Bauarbeiten für die Krypta ein, die bis ins Jahr 1915 andauerten.

In den Jahren vor und nach der Jahrhundertwende bearbeitete der Architekt herausragende Aufträge. 1898 wurde mit den Bauarbeiten zur Casa Calvet begonnen, für die Gaudí im Jahr 1900 den Preis für Barcelonas bestes Gebäude erhielt. Weitere bedeutende Unternehmungen dieser Zeit sind die Casa Bellesguard (1900-1909), der Entwurf für das erste Glorreiche Geheimnis des so genannten monumentalen Rosenkranzes auf dem Weg zur Santa-Cova-Kirche auf dem Berg Montserrat und die Einrichtung des Hauses der Markgräfin von Castelldosrius. Der Jahrhundertwechsel leitete eines der ehrgeizigsten Projekte des Grafen Güell ein, der einmal mehr auf Gaudís Mitarbeit zählte. Es handelte sich um die Erschließung des Park Güell in Barcelona, in deren Rahmen Grundstücke, Laubengänge, Galerien und Wohnungen in perfekter Harmonie mit dem Gelände angeordnet wurden. Gaudí brachte erneut seine Naturverbundenheit zum Ausdruck, die er als einen festen Bestandteil seines Projekts erachtete. Trotz der intensiven Bemühungen des Grafen Güell und des Architekten, diesen Traum wahr zu machen, wurde das Projekt im Jahr 1914 abgebrochen, ohne sein Ziel – die Einrichtung einer Gartenstadt – erreicht zu haben.

1903 reiste Gaudí nach Palma de Mallorca, um Renovierungsarbeiten an der gotischen Kathedrale der Stadt durchzuführen. Nach seiner Rückkehr nach Barcelona beschäftigte er sich 1905 mit dem vollständigen Umbau der Casa Batlló und 1906 mit der Umgestaltung der als „La Pedrera" bekannten Casa Milà, die erst 1911 fertig gestellt wurde.

Im Jahr 1909 schuf Gaudí den Entwurf für einen Wolkenkratzer in New York, der trotz seiner originellen Gestaltung nie errichtet wurde. Während all dieser Jahre arbeitete er weiter an der Sagrada Família und vollendete 1925 einen ihrer Glockentürme.

In der europäischen modernistischen Architektur sticht Antoni Gaudí als besondere, außergewöhnliche Persönlichkeit hervor. Wie kein anderer Architekt vermochte er es, die mittelalterliche Bauweise zu nutzen und zu verstehen und eine persönliche, weit über die Inspirationsquelle hinausgehende Interpretation von eigener Ausdrucksstärke zu erzielen, indem er die Strukturprinzipien der gotischen Architektur bis zur letzten Konsequenz anwandte.

Charakteristisch für Gaudís Stil sind die Parabel- und Kettenbogen, die schrägen Säulen, die Lichtöffnungen mit gebogenen und sogar unregelmäßigen Konturen sowie die gekrümmten Mauerflächen. Ein ebenfalls genialer Beitrag des Architekten ist die Verwendung flacher, auf Gegendruck basierender Gewölbe, bei denen die Strebepfeiler

weggelassen wurden. Ferner findet sich ein weiteres originelles Merkmal bei den Dächern, wo er auf ebene Flächen verzichtete und den Gebäuden stattdessen eine unebene Dachtextur verlieh oder aber ihre Dächer mit abstrakten plastischen Elementen bedeckte.

Für Gaudí lag die Geometrie in der Natur begründet. So verhalf er sowohl Stein als auch Eisen zu einer damals völlig neuen Ausdrucksmöglichkeit, die auf Elementen der Natur basierte. In vielen seiner Werke kann man eine Nachahmung der natürlichen Formen – Felsen, Stalaktiten, Baumstämme usw. – erahnen. Das beste Beispiel ist vermutlich die Casa Milà, die einem einzigartigen plastischen Kriterium folgte, welches die dynamische Form des Raumes geschickt mit Dekorationsmaterialien wie Schmiedeeisen und Keramik verband.

Der geniale Architekt verstarb am 10. Juni 1926 an den Verletzungen, die er drei Tage zuvor erlitten hatte, als er in Barcelonas Innenstadt von einer zwischen der Carrer Bailèn und der Gran Via verkehrenden Straßenbahn erfasst worden war. Sein Leichnam wurde in der Carme-Kapelle der Krypta in der Sagrada Família beigesetzt.

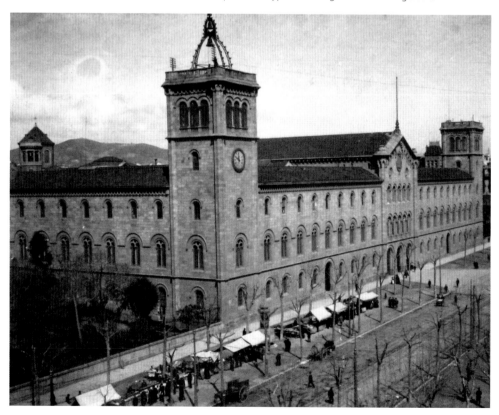

In 1907 Gaudí designed a monument dedicated to James I for Plaça del Rei, situated behind the cathedral of Barcelona, which was never built.

1907 plante Gaudi für die hinter Barcelonas Kathedrale gelegene Plaça del Rei ein Denkmal für Jakob I. von Aragón, ein interessantes Projekt, das letztlich jedoch nicht umgesetzt wurde.

En 1907, Gaudi dessina, pour la place del Rei située derrière la cathédrale de Barcelone, un monument dédié à Jacques Iᵉʳ d'Aragon, qui ne fut finalement pas érigé.

biographie

Antoni Gaudí i Cornet est né le 25 juin 1852, à Reus (Tarragone). Issu d'une famille d'artisans, il fit preuve dès son plus jeune âge d'une véritable passion pour l'art. En 1867, il réalisa une série de dessins pour illustrer le magazine *El Arlequín*, édité dans sa ville natale par lui-même et ses camarades d'école Eduard Toda et Josep Ribera, qui suivront pendant de longues années des trajectoires similaires. En 1869, après avoir terminé ses études secondaires, il s'installa à Barcelone, où son frère étudiait en médecine. Dans cette ville, il s'inscrit à l'Institut d'Ensenyament Mitjà, puis suivit les cours préparatoires d'accès à l'école d'architecture. Son intérêt pour l'architecture était déjà très évident lorsqu'il lança, en 1868, avec ses deux amis Toda et Ribera, le projet presque utopique de restaurer le monastère abandonné de Santa Maria de Poblet. Ils proposaient de le transformer en un espace communautaire pour les artisans, artistes et quiconque se consacrait aux arts et aux sciences. En 1873, il débuta ses études d'architecture à l'école des beaux-arts Llotja, qui prit le nom, deux années plus tard, d'école d'architecture de Barcelone, et dont les cours se déroulaient à l'université de Barcelone. Pour financer ses études, Gaudí travailla comme dessinateur pour divers ateliers. Au cours de sa première année d'études, il fut chargé de collaborer avec le célèbre maître d'œuvre Josep Fontseré pour les projets du parc de la Ciutadella et du marché du Born à Barcelone. Au fil de sa vie d'étudiant, Gaudí ébaucha divers projets, comme la Torre de les Aigües dudit parc, et travailla avec des architectes de renom comme Francesc de Paula del Villar, qu'il assista dans son projet d'oratoire et d'abside du monastère de Montserrat.

Le 4 janvier 1878, Antoni Gaudí passa son évaluation finale avec succès et obtint ainsi son diplôme d'architecte, émis à Madrid le 15 mars. Dès lors, il se consacra pleinement à la conception et à la réalisation de son œuvre prolifique.

Dès ses débuts en tant que professionnel, il se révéla être un artiste complet. Il exécuta des travaux aussi divers que les réverbères de la place Reial à Barcelone, la conception de meubles pour la chapelle du panthéon du marquis de Comillas, une vitrine en fer forgé, bois et verre pour exposer les gants de la Casa Esteve Comella à l'Exposition universelle de Paris et même un kiosque à fleurs.

Peu enclin à coucher sur le papier ses réflexions esthétiques, on ne lui connaît qu'un seul article, publié en 1881 par le journal *La Renaixensa*. À la fin des années 1870, Gaudí rencontra Eusebi Güell, qui devint au fil des ans son mécène modèle. Celui-ci accordait en effet à l'architecte une liberté totale dans la conception et dans l'exécution de ses projets. En 1882, la première pierre du temple de la Sagrada Família de Barcelone fut posée. À cette période, le jeune Gaudí n'avait encore aucun lien avec ce projet, mais on le chargea un an plus tard de mener une étude sur les colonnes de la crypte. Au cours de ces années, il réalisa plusieurs projets d'édifices qui deviendraient, avec le temps, les archétypes du mouvement moderniste.

L'amour de Gaudí pour la nature fut sa principale source d'inspiration dans presque tous ses projets. La Casa Vicens, à Barcelone (1883-1888), se distingue par sa façade, presque entièrement recouverte d'azulejos ornés de petites fleurs jaunes. En 1883, il entreprit également la construction de la Villa Quijano, connue comme « El Capricho », dans la localité de Comillas, non loin de Santander. L'année 1884, décisive pour Gaudí, fut marquée par sa

nomination officielle en tant qu'architecte en chef de la Sagrada Família. Il se lançait ainsi dans l'une de ses plus grandes aventures, dont il ne vivrait pas l'achèvement et qui se poursuit encore de nos jours, en dépit de l'avancée toujours plus rapide des travaux. Outre la construction du temple, l'architecte reçut d'autres commandes au cours des années 1880. L'Église, des clients particuliers et surtout le comte Güell requirent sa collaboration pour leurs nouveaux projets. Gaudí dessina de nombreux projets pour ce noble catalan, dont le pavillon de chasse (1882), la Finca Güell (1884-1887) et les caves Güell (1895), à Garraf. La commande la plus notable fut celle du palais Güell (1886), grand bâtiment situé à proximité de la Rambla de Barcelone.

Gaudí n'hésitait pas à se rendre là où il était sollicité. Pour cette raison, il travailla également hors de Catalogne et exécuta des œuvres aussi remarquables que le palais épiscopal d'Astorga, à León. En 1894, la mort de l'évêque d'Astorga, Joan Baptista Grau i Vallespinós, qui avait chargé Gaudí de la construction du palais, provoqua des dissensions au sein de l'évêché sur la poursuite du projet, ce qui conduisit l'artiste à renoncer à la direction des travaux.

L'Exposition universelle de Barcelone de 1888 présenta l'une des réalisations de Gaudí : le pavillon de la Compagnie Transatlantique, détenue par Antonio López y López, autre bon client de l'architecte. Au début des

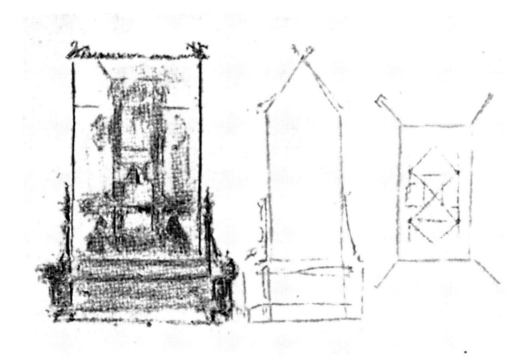

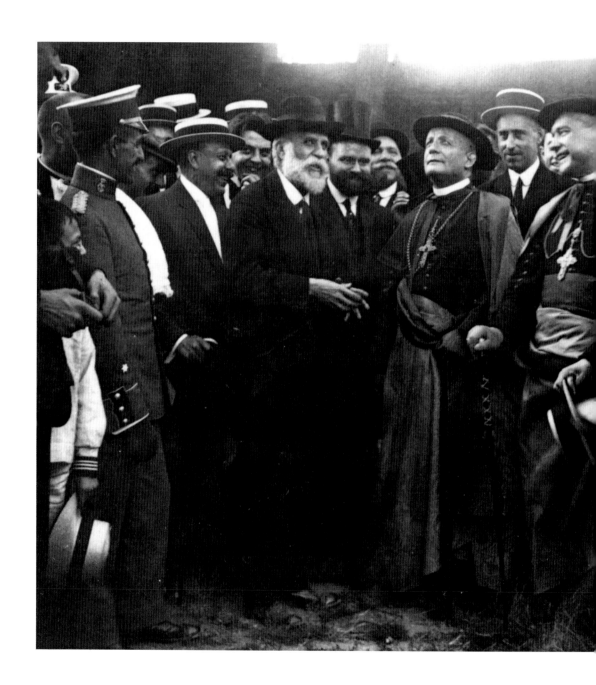

Proud of his Sagrada Família temple, Gaudí never hesitated to indulge
illustrious guests with guided tours during their visits to Barcelona.

Gaudí war so stolz auf den Tempel der Sagrada Familia, dass er
nichts dagegen einzuwenden hatte, Führungen für illustre
Persönlichkeiten bei ihrem Besuch in Barcelona durchzuführen.

Gaudí, fier de son œuvre de la Sagrada Familia, n'hésitait pas à la
faire visiter aux personnages illustres de passage à Barcelone.

années 1890, Gaudí débuta les travaux de la Casa
Botines, à León, ainsi qu'une œuvre personnelle et
singulière pour le comte Güell : la villa El Capricho, à
Comillas (Santander).

À la même époque, Gaudí se rendit à Tanger pour
découvrir le terrain sur lequel il devait bâtir une église
catholique, qui ne vit finalement pas le jour. En 1894, il
entama le projet de la future église de la colonie Güell,
à Santa Coloma de Cervelló. Quatre ans plus tard, il se
lança dans les travaux de la crypte, qui se poursuivirent
jusqu'en 1915.

Dans les dernières années du XIXᵉ siècle et au début
du siècle suivant, l'architecte accepta plusieurs com-
mandes phares. L'année 1898 marqua le lancement
des travaux de la Casa Calvet, qui lui valut en 1900 le
prix au meilleur bâtiment de Barcelone. Puis vinrent la
Casa Bellesguard (1900-1909), le projet du premier
mystère glorieux du rosaire, sur le chemin de la Santa
Cova dans la montagne de Montserrat, et la décora-
tion de la maison de la marquise de Castelldosrius.
À l'aube du nouveau siècle, le comte Güell fit une fois
de plus appel à Gaudí pour l'un de ses projets les
plus ambitieux : l'aménagement du parc Güell de Bar-
celone, où la répartition des terrains, des porches, des
galeries et des résidences devait être en parfaite har-
monie avec le paysage. Gaudí démontra une fois de
plus son amour pour la nature, en la considérant
comme élément à part entière du projet. Malgré tous
les efforts déployés par le comte Güell et par l'archi-
tecte pour faire de ce rêve une réalité, le projet s'acheva
en 1914 sans avoir atteint son but : la création d'une
cité-jardin.

En 1903, Gaudí se rendit à Palma de Majorque pour
se consacrer à la restauration de la cathédrale gothique
de la ville. En 1905, de retour à Barcelone, il se chargea

de l'entière rénovation de la maison de M. Batlló, et en 1906, de la Casa Milà, également appelée « La Pedrera », qui ne fut achevée qu'en 1911.

En 1909, Gaudí ébaucha un projet de gratte-ciel à New York, mais ce bâtiment ne vit jamais le jour en dépit de son originalité. Tout au long de ces années, l'architecte poursuivit son travail dans la Sagrada Família et en termina l'un des clochers en 1925.

Antoni Gaudí se démarqua dans l'architecture moderniste européenne comme une personnalité unique et exceptionnelle. Il sut utiliser et comprendre l'architecture médiévale comme aucun autre architecte. Il y apporta son interprétation personnelle, avec une expressivité particulière au-delà de la source d'inspiration, en poussant les principes structurels de l'architecture gothique à leurs limites.

Les structures caractéristiques du style de Gaudí sont les arcs paraboliques et en chaînette, les colonnes inclinées, les ouvertures aux contours arrondis, voire irréguliers, et les murs ondulés. L'une de ses contributions exceptionnelles fut l'emploi d'arcs paraboliques et de piliers obliques pour éviter l'utilisation d'arcs-boutants classiques. Autre originalité : sa conception des toits où, loin de se contenter de plans unis, il emploie des surfaces texturées et des formes sculpturales non figuratives.

Pour Gaudí, la géométrie trouvait son essence dans la nature. Son maniement de la pierre et du fer, reposant sur des éléments propres à la nature, était très éloigné de ce que l'on connaissait jusqu'alors. L'imitation de formes naturelles telles que rochers, stalactites, troncs d'arbres, etc., se manifeste dans nombre de ses œuvres. L'exemple le plus frappant est sans doute la Casa Milà, où la forme dynamique des volumes est admirablement associée à l'emploi de matériaux décoratifs, tels que le fer forgé et la céramique.

Cet architecte de génie s'éteignit le 10 juin 1926 des suites de ses blessures, trois jours après avoir été renversé par un tramway entre la rue Bailèn et la Gran Via, en plein centre de Barcelone. Sa dépouille repose dans la chapelle du Carme dans la crypte de la Sagrada Família.

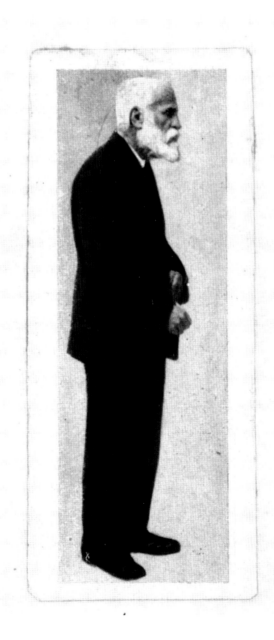

influences

During his stint as a student, Gaudí was influenced by the two pre-*Modernista* trends that dominated the European scene of the day: Gothic architecture, for its capacity to create solid architectural structures, and the Oriental aesthetic that was attracting the attention of European artists. At the Barcelona School of Architecture Gaudí was able to examine, as he noted in his diary from 1876-1877, the *Album Laurent*, a collection of images of monuments and works of art taken by the renowned French photographer. Among the many prints he pored over, there was a decisive bias towards Gothic works and diverse perspectives of the mosque of Córdoba and the Alhambra of Granada.

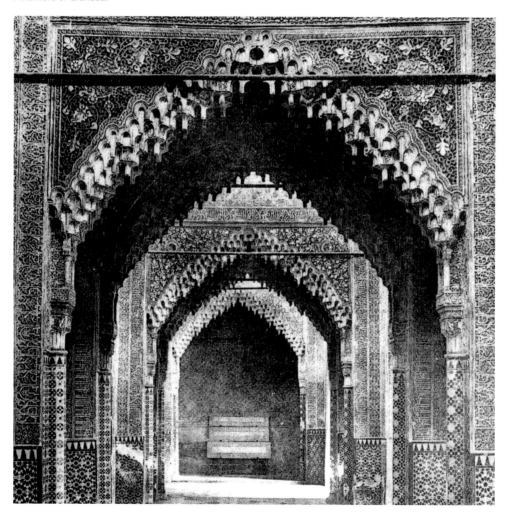

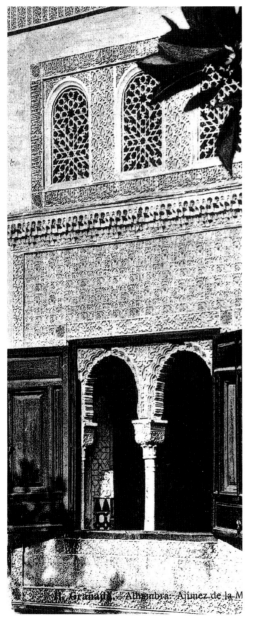

The influence of great Gothic cathedrals can be observed in some of his Neo-Gothic works: the altarpiece for the nuns at Jesús-Maria of Tarragona; the furniture for the chapel of the Jesús-Maria School of Sant Andreu de Palomar in Barcelona; the chapel of the Santíssim in Alella (1883); and the furnishings for the chapel of the Comillas palace in Cantabria (1878-1880). However, it can most clearly be seen in his collaborations with Joan Martorell, such as the church for the Benedictine monks of Villaricos (Almeria) in 1882, the sketch façade of the cathedral of Barcelona (1882), and the Salesian school on Passeig de Sant Joan (1885). In the midst of this leaning towards the medieval appeared the earliest designs for the Sagrada Família temple, of which he became the director thanks to Martorell's recommendation to the person in charge of the temple, Lord Bocabella, after the resignation of Francesc de Paula del Villar.

Gaudí was an exceptional architect who is difficult to pigeonhole into any of the artistic and architectural currents of his time. As mentioned before, the Neo-Gothic style proved a strong influence during his first years as an architect, but it was not long before new ideals set in, like those represented by Middle Eastern art or the Moorish constructions from southern Spain, which is present in works like the Finca Güell in Les Corts (1884-1887), El Capricho in Comillas (1883-1888), and the Casa Vicens in Barcelona (1883-1888). We do know that at this time the architect possessed a series of photographs from Great Britain of buildings in India and Egypt.

During the last years of the 19th century, Gaudí exhibited a far more naturalistic style, with works like the Güell cellars in Garraf (1895-1897) or the project for the Catholic Missions of Africa in Tangier (1892-1912). This was followed by what could be considered his most *Modernista* period, illustrated by the Nativity scene façade on the Sagrada Família, the Casa Calvet

and the door of the Finca Miralles. The works which best represent Gaudí's unique style include the Casa Batlló (1904-1906) and the Casa Milà (1906-1912).

Over the years, Gaudí continued to perfect the structural and decorative forms of the Sagrada Família temple, with nature being his greatest inspiration for this project. His early sketches had a clearly defined Neo-Gothic influence, up until the proliferation of decorative elements in the Nativity scene that were closer to the *Modernista* style. This stylistic evolution was also evident in the varied symbolic repertoire used in the decoration of his works: classical, mediaeval heraldry, ecclesiastical symbolism and realistic imagery of nature in the form of plants and animals.

Despite the great admiration for Gaudí's work today, his contemporaries were very critical of the innovative works by the Catalan architect. Barcelona society with close ties to the aesthetics of the Ecole des Beaux Arts displayed clear rejection of the architect's works through their own incomprehension, and another group known as the *Noucentistes* expressed revulsion and indifference to Gaudí's unclassifiable style.

einflüsse

In seiner Studentenzeit wurde Gaudí von den beiden vorherrschenden prämodernistischen Tendenzen der europäischen Kultur beeinflusst: der gotischen Architektur mit ihrer Fähigkeit, große, stabile Baustrukturen hervorzubringen, und der orientalischen Ästhetik, die so sehr die Aufmerksamkeit der europäischen Künstler weckte. Wie Gaudí in seiner dritten Agenda (1876-1877) notierte, konnte er in Barcelonas Hochschule für Architektur in das *Album Laurent* Einblick nehmen, die Sammlung des anerkannten französischen Fotografen, in der Denkmäler und Kunstwerke abgebildet waren. Unter den vielen eingesehenen Bildtafeln galt seine besondere Vorliebe den gotischen Werken sowie den verschiedenen Ansichten der Moschee in Córdoba und der Alhambra in Granada.

Der von den großen gotischen Kathedralen ausgehende Einfluss findet sich in einigen seiner neugotischen Projekte, wie dem Retabel für den Jesús-Maria-Orden in Tarragona, dem Mobiliar für die Kapelle der Jesús-Maria-Schule in Barcelonas Vorort Sant Andreu de Palomar, die Allerheiligsten-Kapelle in Alella (1883) und die Möbel der Palastkapelle im kantabrischen Comillas (1878-1880). Dies gilt besonders für die Projekte, an denen er als Mitarbeiter von Joan Martorell beteiligt war, darunter die Kirche der Benediktinerklöster in Villaricos (Almería) aus dem Jahr 1882, der Entwurf für die Fassade der Kathedrale von Barcelona (1882) oder die Schule der Salesianerinnen im Passeig de Sant Joan (1885). Innerhalb dieser Rückbesinnung auf das Mittelalter stechen die ersten Entwürfe hervor, die Gaudí für die Sagrada Família erstellte. Man hatte ihm die Bauleitung auf eine gegenüber dem Verantwortlichen, José María Bocabella, ausgesprochene Empfehlung Martorells hin übertragen, nachdem Francesc de Paula del Villar zurückgetreten war.

Gaudí war ein außergewöhnlicher Architekt, der sich nur schwer einer Kunst- oder Architekturströmung seiner Zeit zuordnen lässt. Wie bereits angemerkt, waren seine ersten Berufsjahre stark von einem neugotischen Stil geprägt, der jedoch schon bald neuen Idealen aus der Kunst des Mittleren Ostens und den südspanischen Bauten im Mudejarstil wich. Diese Merkmale finden sich in der Finca Güell in Les Corts (1884-1887), in der Villa „El Capricho" in Comillas (1883-1885) und in der Casa Vicens in Barcelona (1883-1888). Außerdem ist bekannt, dass Gaudí in dieser Zeit eine Reihe von aus Großbritannien stammenden Fotografien von Gebäuden in Indien und Ägypten besaß.

Während der letzten Jahre des 19. Jahrhunderts zeigte Gaudí bereits einen sehr viel naturalistischeren Einfluss, wie der Celler Güell in Garraf (1895-1897) und der Entwurf für die katholischen Missionen im afrikanischen Tanger (1892-1912) belegen. Darauf folgte die am stärksten modernistische Epoche mit der Geburtsfassade der Sagrada Família, der Casa Calvet und dem Tor der Finca Miralles. Zuletzt entstehen die für Gaudís Stil repräsentativsten Werke, wie die Casa Batlló (1904-1906) und die Casa Milà (1906-1912).

In der Sagrada Família verfeinerte Gaudí im Laufe der Jahre die strukturellen und dekorativen Formen. Die Natur war bei diesem Vorhaben seine größte Inspirationsquelle. Die ersten Entwürfe zeigten seine neugotische Ausrichtung, später jedoch kamen immer mehr Dekorationselemente hinzu, wie man an der eher modernistisch gehaltenen Geburtsfassade feststellen kann. Diese stilistische Entwicklung wird auch an dem abwechslungsreichen Symbolrepertoire deutlich, das Gaudí zur Ausschmückung seiner Werke verwendete. Dazu zählen Elemente aus

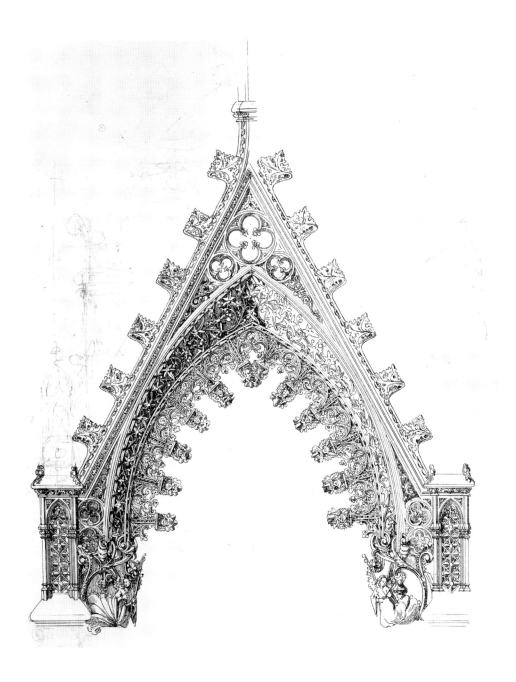

dem Klassizismus, der mittelalterlichen Wappenkunde sowie der Kirchen- und der Natursymbolik, wobei sich letztere realistisch aus natürlichen Tier- und Pflanzenformen ableiteten.

 Trotz der heute großen Bewunderung für Gaudís Werk reagierten seine Zeitgenossen sehr kritisch auf die innovativen Arbeiten des katalanischen Architekten. Bei den Anhängern der Ästhetik der École des Beaux-Arts stießen sie aufgrund von Unverständnis auf klare Ablehnung, und eine weitere Gruppe, bekannt als die *Noucentistes*, bekundete angesichts der Schwierigkeit, sein Werk zuzuordnen, ihre Abneigung und Gleichgültigkeit.

44. BARCELONA - Convento de Las Salesas
L. Roisin. fot. Barcelona

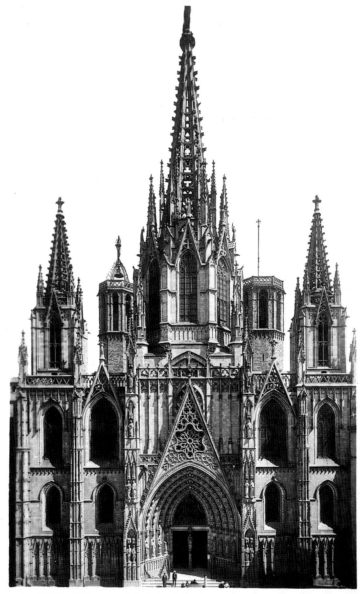

6. BARCELONA. Catedral - Cathédrale - Cathedral Fot. L. Roisin.

influences

Au cours de ses études, Gaudí fut influencé par les deux tendances pré-modernistes qui dominaient le paysage culturel européen : l'architecture gothique, capable de créer de grandes structures architecturales robustes, et l'esthétique orientale, qui attirait l'attention des artistes européens. Comme il l'expliqua dans son journal de 1876-1877, Gaudí consulta à l'école d'architecture de Barcelone l'*Album Laurent*, un recueil de monuments et d'œuvres d'art du célèbre photographe français. Des nombreuses planches examinées, il préféra les œuvres gothiques, ainsi que diverses vues de la mosquée de Cordoue et de l'Alhambra de Grenade.

L'influence des grandes cathédrales gothiques se manifeste dans certains de ses projets néogothiques, tels que le retable accompli pour les religieuses de Jesús-Maria de Tarragone, le mobilier de la chapelle de l'école Jesús-Maria de Sant Andreu de Palomar à Barcelone, la chapelle du Santíssim d'Alella (1883), l'ameublement de la chapelle du palais de Comillas en Cantabrie (1878-1880) et, tout particulièrement, dans les projets menés avec Joan Martorell, dont l'église des monastères bénédictins de Villaricos (Almeria) en 1882, la façade de la cathédrale de Barcelone (1882) ou encore l'école salésienne du Passeig de Sant Joan (1885). Les premiers projets de la Sagrada Família s'inscrivent aussi dans cette même tendance néogothique. Gaudí en obtint la direction des travaux grâce à la recommandation de Martorell au promoteur du temple, Josep Bocabella, après la démission de Francesc de Paula del Villar.

Gaudí était un architecte exceptionnel, difficile à classifier dans l'un des courants artistiques et architecturaux du moment. Comme souligné auparavant, le style néogothique l'influença beaucoup à ses débuts comme architecte. Cependant, il fit bientôt place à de nouveaux idéaux, comme ceux incarnés par l'art du Moyen-Orient ou par les constructions mauresques du sud de l'Espagne. Ces aspects se retrouvent dans la Finca Güell de Les Corts (1884-1887), la Villa El Capricho de Comillas (1883-1885) et la Casa Vicens de Barcelone (1883-1888). On sait qu'à cette époque l'architecte disposait d'une série de photographies provenant de Grande-Bretagne et représentant certains d'édifices d'Inde et d'Égypte.

Dans les dernières années du XIXᵉ siècle, Gaudí démontrait déjà un style beaucoup plus naturaliste, comme pour les caves Güell, à Garraf (1895-1897) et le projet pour les Missions catholiques d'Afrique, à Tanger (1892-1912). Vint ensuite une période considérée comme la plus moderniste et illustrée par la façade de la Nativité de la Sagrada Família, la Casa Calvet et la porte de la Finca Miralles.

Enfin, il produisit les œuvres les plus représentatives de son style : la Casa Batlló (1904-1906) et la Casa Milà (1906-1912).

Dans la Sagrada Família, Gaudí épura au fil des ans les formes structurelles et ornementales ; la nature fut toujours sa plus grande source d'inspiration pour ce projet. Ses premiers croquis présentaient une nette tendance néogothique, puis le style évolua jusqu'à atteindre la prolifération d'éléments décoratifs qui caractérisent la façade de la Nativité, plus proche du modernisme.

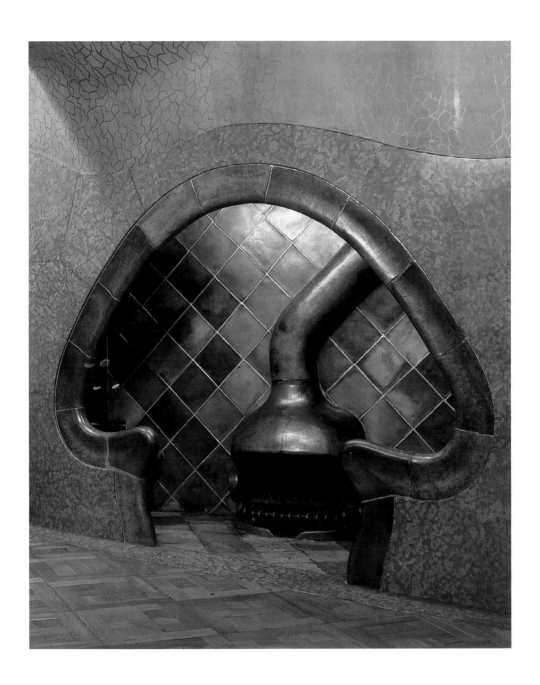

Cette évolution à travers les styles est également palpable dans le répertoire symbolique varié qu'il employait pour agrémenter ses œuvres : on y trouve du classicisme, de l'héraldique médiévale, du symbolisme religieux et une imagerie réaliste de la nature sous la forme de plantes et d'animaux.

En dépit de la grande admiration que l'œuvre de Gaudí suscite aujourd'hui, ses contemporains furent très critiques quant aux travaux novateurs de l'architecte catalan. La société barcelonaise très proches de l'esthétique de l'école des Beaux-arts rejetèrent ouvertement cette œuvre qu'ils ne comprenaient pas. Un autre groupe, connu sous le nom de *Noucentistes*, manifesta une certaine répulsion mêlée d'indifférence quant au style impossible à classifier de Gaudí.

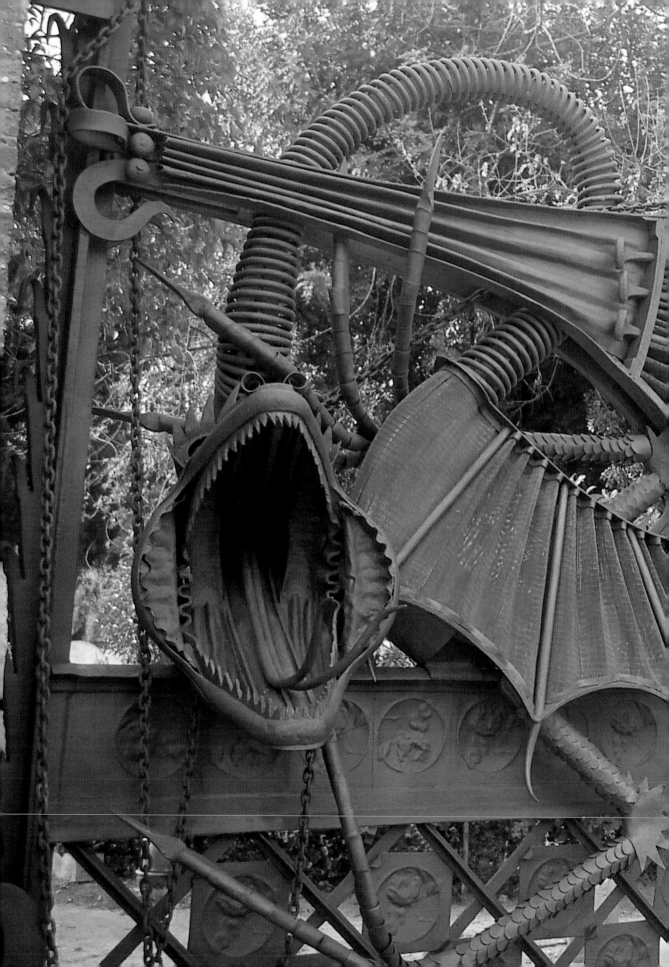

early works
die ersten projekte
premières œuvres

EVEN AS A STUDENT, GAUDÍ HAD BECOME INVOLVED IN IMPORTANT PROJECTS, THE MAJORITY INVOLVING INTERIOR DESIGN AND COLLABORATIONS WITH LEADING ARCHITECTS OF THE DAY.

NOCH ALS STUDENT BEGANN ANTONI GAUDÍ, AN EINIGEN WICHTIGEN ENTWÜRFEN ZU ARBEITEN, DIE MEIST FÜR INNENEINRICHTUNGEN GEDACHT WAREN ODER IN ZUSAMMENARBEIT MIT NAMHAFTEN ARCHITEKTEN JENER ZEIT ENTSTANDEN.

ENCORE SIMPLE ÉTUDIANT, GAUDÍ SE LANÇA DANS CERTAINS PROJETS IMPORTANTS, NOTAMMENT DES DÉCORATIONS D'INTÉRIEURS ET DES COLLABORATIONS AVEC DE GRANDS ARCHITECTES DE L'ÉPOQUE.

early works
die ersten projekte
premières œuvres

Even as a student in the School of Architecture, Antoni Gaudí had already brought his first projects to fruition. In conjunction with Francesc de Paula del Villar, in 1876 Gaudí worked on the sanctum of the Montserrat monastery; drawings of this project which are attributed to Gaudí are kept in the Archive of the Official Architects Association in Barcelona.

One of the first commissions received by Gaudí came from the Barcelona town hall in 1878 to design streetlamps to illuminate and beautify the Plaça Reial for the 1888 Universal Exhibition. The commission was one of the most important in Gaudí's future professional career, as at Eudald Puntí's workshop, where the lampposts were made, he met figures as prominent as the owner of the Comella glove shop, Eusebi Güell, and sculptor Llorenç Matamala, who would become future clients and collaborators on his most emblematic works. Gaudí designed six-armed streetlamps for the Plaça Reial, as well as others with three arms for the Pla de Palau.

In 1878 he also designed a series of public toilets and flower stalls for Enrique Girossi de Sanctis which were to be placed at twenty points around Barcelona. As a result of the client's economic problems, however, they were ultimately never built. Other renowned works also date from this year, such as the writing desk Gaudí designed for himself.

Bereits während seiner Studienzeit an der Hochschule für Architektur fertigte Antoni Gaudí seine ersten Entwürfe an. Zusammen mit Francesc de Paula del Villar arbeitete er 1876 an dem Konzept für den Reliquienschrein des Klosters Montserrat, von dem verschiedene Zeichnungen im Archiv der Architektenkammer Barcelona erhalten sind, die Gaudí zugeschrieben werden.

Einer seiner ersten Aufträge stammte aus dem Jahr 1878 von Barcelonas Stadtverwaltung, die Gaudí anlässlich der Weltausstellung 1888 mit der Gestaltung von Straßenlaternen zur Beleuchtung und Ausschmückung der Plaça Reial betraute. Dieser Auftrag stellte sich als sehr bedeutend für die weitere Laufbahn des jungen Architekten heraus. So lernte er in der Werkstatt Eudald Puntís, wo die Straßenlaternen zwischen 1878 und 1880 hergestellt wurden, relevante Persönlichkeiten wie den Eigentümer der Handschuhfabrik Comella, Eusebi Güell und den Bildhauer Llorenç Matamala kennen, die später seine wichtigsten Kunden und Mitarbeiter einiger seiner herausragendsten Werke waren. Gaudí entwarf sechsarmige Straßenlaternen für die Plaça Reial und dreiarmige Modelle für die Pla de Palau.

Im Laufe des Jahres 1878 plante er zudem für Enrique Girossi de Sanctis Blumenstände, die an rund zwanzig Standorten in Barcelona platziert werden sollten, jedoch letztendlich aufgrund

Alors qu'il n'était encore qu'étudiant à l'école d'architecture, Antoni Gaudi avait déjà réalisé ses premiers projets. En 1876, il travailla avec Francesc de Paula del Villar sur le projet d'oratoire du monastère de Montserrat, dont divers croquis attribués à Gaudí sont conservés dans les archives de la chambre des architectes de Barcelone.

La mairie de Barcelone fut à l'origine de l'une des premières commandes de Gaudí : elle le chargea, en 1878, de concevoir des réverbères pour éclairer et embellir la place Reial, en vue de l'Exposition universelle de 1888. Cette commande revêt une importance particulière pour l'avenir professionnel du jeune architecte. En effet, ce fut dans l'atelier d'Eudald Puntí, où les réverbères furent fabriqués entre 1878 et 1880, que Gaudí rencontra certaines personnalités déterminantes pour sa carrière : le gantier Comella, Eusebi Güell et le sculpteur Llorenç Matamala deviendraient par la suite les clients et les partenaires privilégiés de ses plus grands travaux. Gaudí conçut des réverbères à six bras pour la place Reial et d'autres à trois bras pour l'esplanade Pla de Palau.

Au cours de l'année 1878, il dessina en outre pour Enrique Girossi de Sanctis des toilettes publiques et des kiosques à fleurs destinés à une vingtaine d'endroits dans Barcelone. Cependant, suite aux problèmes financiers du client, ce projet ne vit pas le jour. Cette même

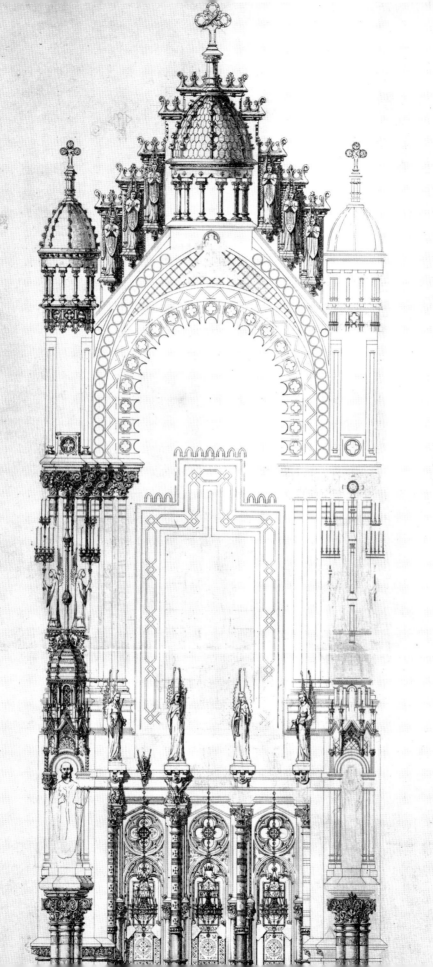

But the most ambitious commission Gaudí received early in his career was that of creating a working class neighbourhood in Mataró, a city near Barcelona located on the Mediterranean coast. Salvador Pagès, a member of the Reus working class who returned as a rich businessman from a spell inthe United States, was the manager of the Mataró workers' cooperative La Obrera Mataronense. In response to the need to create homes for the workers, Pagès commissioned Gaudí to design an urban development project that would meet these requirements. Between 1878 and 1882, only a small portion of the project was completed, though Gaudí had planned to build thirty low-cost home, a casino, a machinery hangar, a building with a parabolic structure and a health services pavilion.

The architect was so proud and convinced of the quality of his work that he decided to submit it for the 1878 Universal Exhibition to be held in Paris. That very same year he completed the furniture on which to display the products for the Esteve Comella glove shop, which was showcased in the Spanish Pavilion at the same exhibition and forged the ties between Gaudí and Eusebi Güell, who was so enchanted by this

finanzieller Schwierigkeiten des Kunden nie errichtet wurden. Aus dem gleichen Jahr stammen weitere bekannte Werke, wie der berühmte Schreibtisch für Gaudís Eigengebrauch.

Sein ehrgeizigster Auftrag während der ersten Berufsjahre war allerdings die Planung eines Arbeiterviertels in Mataró, einer unweit von Barcelona an der Mittelmeerküste gelegenen Stadt. Salvador Pagès, der aus einer Arbeiterfamilie in Reus stammte und nach einem Aufenthalt in den USA als reicher Unternehmer zurückkehrte, war Geschäftsführer der Genossenschaft La Obrera Mataronense. Da Arbeiterwohnungen erforderlich wurden, beauftragte er Gaudí mit einem Städtebauprojekt, das diesen Bedarf decken sollte. Zwischen 1878 und 1882 wurde nur ein Bruchteil des gesamten Projekts umgesetzt, für das Gaudí dreißig kostengünstige Wohnungen, ein Kasino, eine Maschinenhalle, ein parabelförmiges Gebäude und einen Pavillon für sanitäre Einrichtungen vorgeschlagen hatte.

Der Architekt war stolz auf seine Arbeit und so sehr von ihrer Qualität überzeugt, dass er sich entschloss, sie auf der Weltausstellung

année, l'architecte exécuta d'autres ouvrage célèbres, dont son propre bureau.

Le projet le plus ambitieux confié à Gaud dans les premières années de sa vie profes sionnelle fut la construction d'un quartie ouvrier à Mataró, une ville sur la Méditerrané près de Barcelone. À cette époque, le gérant d la coopérative La Obrera Mataronense étai Salvador Pagès, un homme d'affaires issu de l classe ouvrière de Reus et ayant fait fortun aux États-Unis. Face à l'impératif de construir des logements pour les travailleurs, Pagè chargea Gaudi d'exécuter un projet urbain cette fin. Entre 1878 et 1882, seule une petit partie du projet fut achevée, bien que Gauc ait proposé l'édification de trente logement économiques, d'un casino, d'un hangar pou les machines, d'un bâtiment à structure para bolique et d'un pavillon de soins de santé.

L'architecte était tellement fier et persuadé d la qualité de son travail qu'il décida de le pré senter lors de l'Exposition universelle de 1878 Paris. La même année, il réalisa la vitrine desti née à exhiber les créations du gantier Estev Comella et présentée au pavillon espagnol d

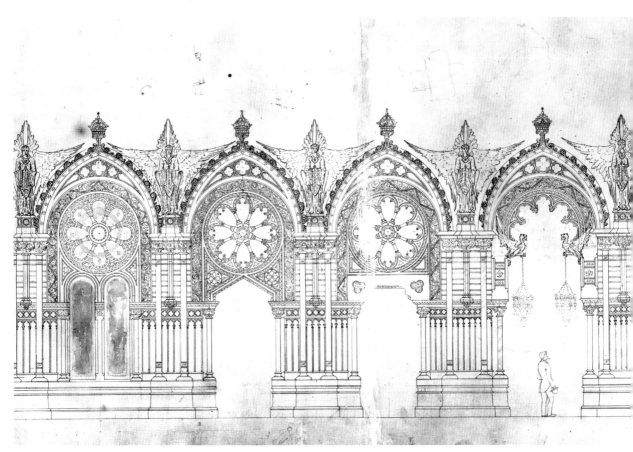

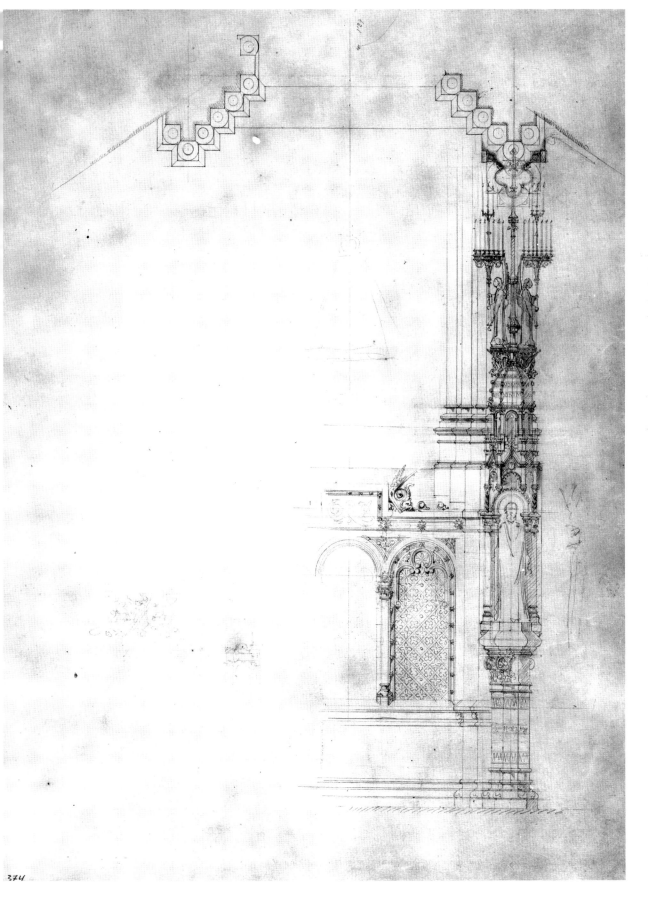

374

work on his visit to Paris that demanded to meet the creator in person.

Gaudí had always showed a keen interest in the creation of spaces, which he demonstrated early on in 1879 in the decoration and renovation of the Gibert Pharmacy on Passeig de Gràcia in Barcelona. The furnishings display a marked arabesque influence, a recurring feature in his earliest works.

Other projects that, for one reason or another, were never realised were also of great importance, most notably that of the electric lighting of the Muralla del Mar (Sea Wall) in conjunction with engineer Josep Serramalera. Gaudí devised impressive twenty metre high streetlamps decorated with symbols and the names of various Catalan admirals from the Middle Ages. Other important projects include the one submitted for the tender to build the San Sebastian Casino (1880-1881), though it did not win, and the hunting pavilion in Garraf for Eusebi Güell (1882).

In 1888 Gaudí received a commission to decorate the Saló de Cent and the staircase of honour

1878 in Paris zu präsentieren. Aus dem gleichen Jahr stammt das Möbelstück, in dem die Produkte des Handschuhherstellers Esteve Comella ausgestellt wurden. Die Vitrine schmückte den Spanischen Pavillon jener Ausstellung, die Gaudí und Eusebi Güell zusammenbrachte. Güell war bei seinem Besuch in Paris vom Anblick dieses Werks entzückt und wollte seinen Schöpfer kennen lernen.

Gaudí zeigte sich stets an der Gestaltung von Räumen interessiert und konnte in seinen Anfängen sein Können mit einer Einrichtung unter Beweis stellen, die er 1879 für den Umbau der Gibert-Apotheke in Barcelonas Passeig de Gràcia entwarf. Genauer gesagt handelte es sich um Mobiliar mit deutlich arabeskem Stil, den viele seiner frühen Werke aufwiesen.

Wichtige Projekte waren auch jene, die letztlich aus diversen Gründen nicht zustande kamen, darunter der Vorschlag für die elektrische Beleuchtung einer als Muralla de Mar bezeichneten Stadtmauer Barcelonas. In diesem gemeinsam mit dem Ingenieur Josep Serramalera erarbeiteten Entwurf hatte Gaudí beeindruckende, zwanzig Meter hohe

l'exposition. Cette vitrine fut le motif de la rencontre entre Gaudí et Eusebi Güell, qui, de passage à Paris, fut séduit par l'ouvrage et voulut connaître son auteur.

Gaudí fit toujours preuve d'un grand intérêt pour l'aménagement des espaces, comme il en ressort de la décoration qu'il effectua, en 1879, pour la restauration de la pharmacie Gibert du Passeig de Gràcia de Barcelone. Le mobilier conçu présentait une nette influence de style arabesque, récurrent dans les premières œuvres de l'architecte.

Il y eut d'autres projets remarquables, mais qui n'aboutirent pas pour des raisons diverses. Tel fut le cas de l'éclairage électrique de la Muralla del Mar (muraille de la mer) de Barcelone, conçu en collaboration avec l'ingénieur Josep Serramalera : Gaudí imagina d'imposants réverbères de vingt mètres de haut, ornés d'éléments symboliques et sertis du nom de divers amiraux catalans du Moyen Âge. Par ailleurs, le projet présenté au concours du Casino de Saint-Sébastien (1880-1881), bien que non récompensé, fut également notable, tout comme

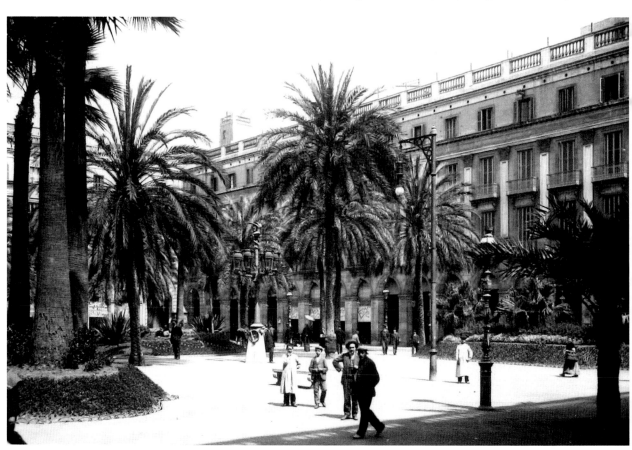

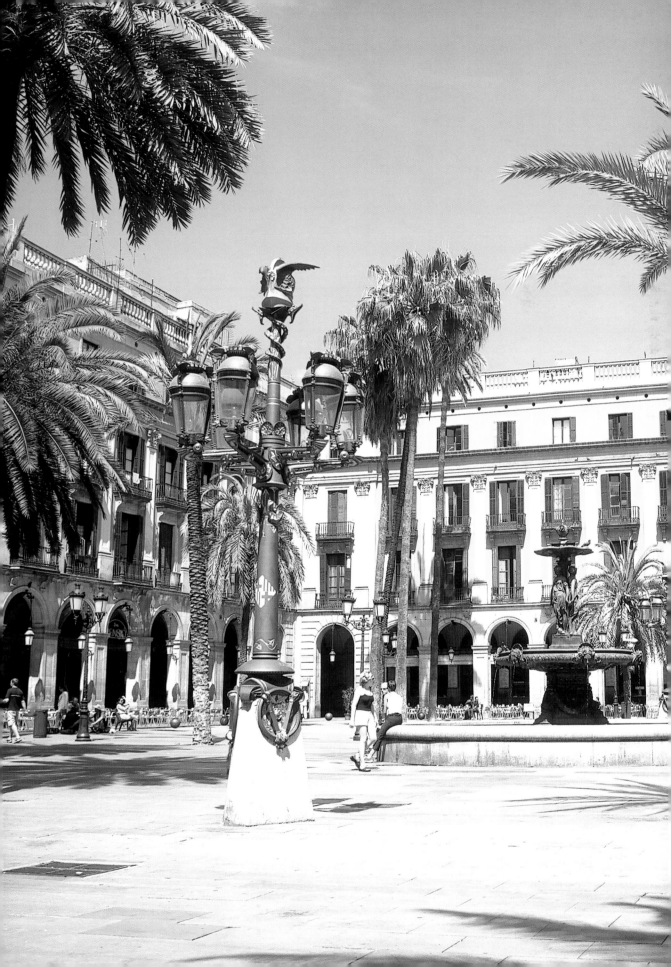

in the Barcelona town hall. He was also asked to design an armchair for the reigning queen who was to officially open the Universal Exhibition to be held in Barcelona that same year. These projects, too, were never brought to fruition.

Straßenlaternen vorgesehen, die mit symbolischen Elementen und den Namen verschiedener katalanischer Admirale aus dem Mittelalter verziert werden sollten. Ähnlich bedeutend waren das Projekt, mit dem er sich vergeblich für die Bauausschreibung des Kasinos in San Sebastián (1880-1881) bewarb, und der für Eusebi Güell geplante Jagdpavillon in Garraf (1882).

1888 wurde Gaudí mit dem Dekorationsentwurf für den Saló de Cent und die Ehrentreppe in Barcelonas Rathaus sowie mit der Gestaltung eines Sessels für die Königin beauftragt, die die Weltausstellung des gleichen Jahres in Barcelona eröffnen sollte. Am Ende wurde jedoch keines dieser Projekte verwirklicht.

celui du pavillon de chasse pour Eusebi Güell au Garraf (1882).

En 1888, Gaudí fut chargé d'entreprendre la décoration du Saló de Cent et de l'escalier d'honneur de l'hôtel de ville de Barcelone, ainsi que de la conception d'un fauteuil pour la reine régente, qui devait inaugurer l'année même l'Exposition universelle de Barcelone. Cependant, aucun de ces projets ne fut finalement mené à bien.

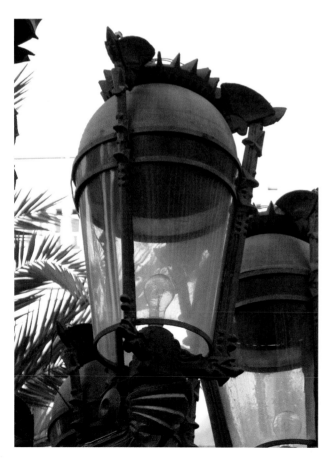
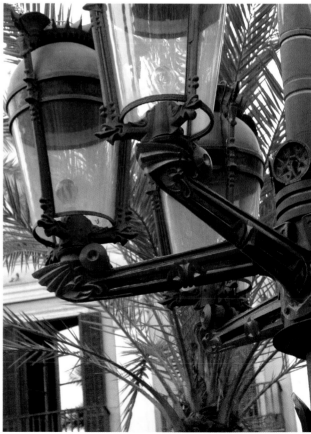

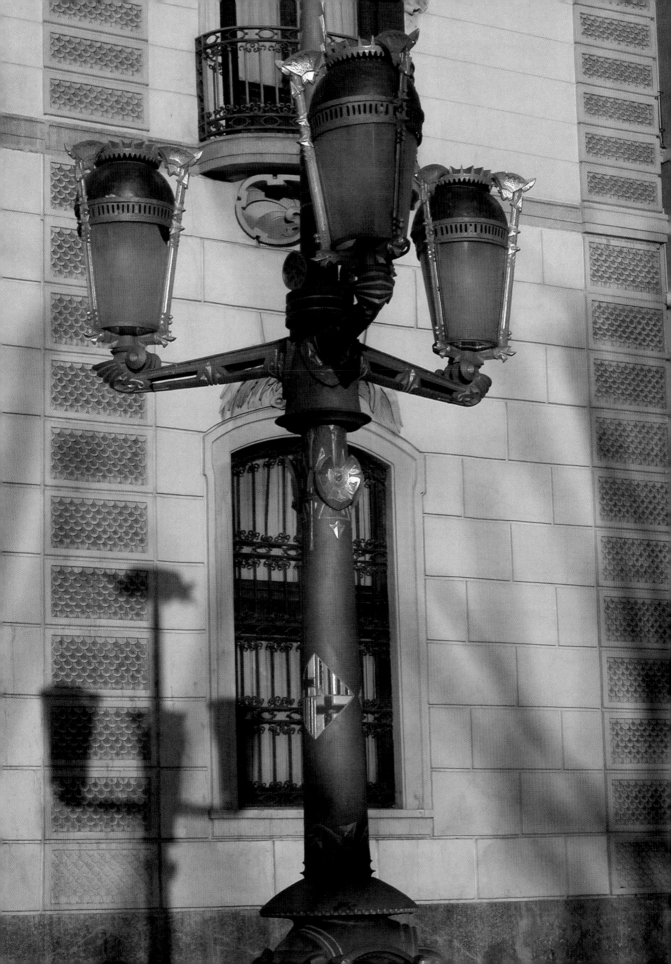

Original appearance of the main warehouse of the factory commissioned by the Mataró workers' cooperative La Obrera Mataronense completed in 1878.

Ursprünglicher Zustand der Hauptfabrikhalle, die 1878 im Auftrag der Genossenschaft La Obrera Mataronense errichtet wurde.

Aspect d'origine de l'entrepôt principal de l'usine commandée par la coopérative La Obrera Mataronense, achevée en 1878.

After its restoration, visitors can once again enter this interesting structure composed of arches created by Gaudí.

Seit der Restaurierung können die Besucher erneut diese interessante, von Gaudi geschaffene Bogenhalle betreten.

Depuis sa restauration, les visiteurs peuvent de nouveau visiter cette intéressante structure d'arcs conçue par Gaudí.

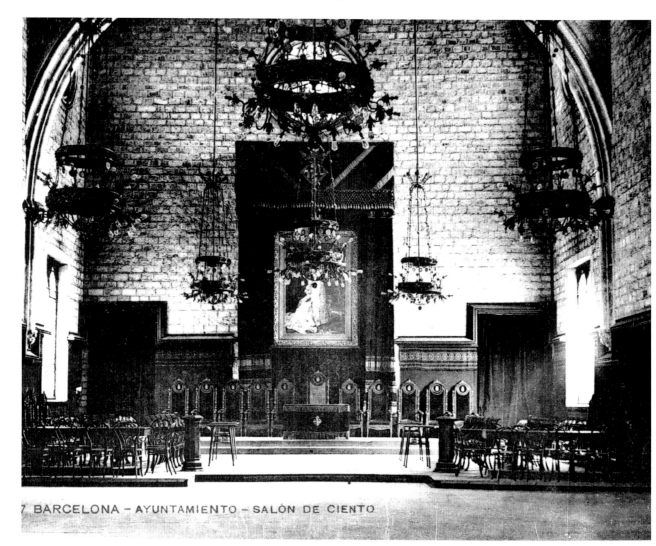

7 BARCELONA – AYUNTAMIENTO – SALÓN DE CIENTO

In 1888, Gaudí produced the designs for the decoration of the Saló de Cent and the main stairway of the Barcelona town hall.

Im Jahr 1888 fertigte Gaudí einen Dekorationsentwurf für den Saló de Cent und die Ehrentreppe in Barcelonas Rathaus an.

En 1888, Gaudí ébaucha un projet de décoration pour le Saló de Cent et l'escalier d'honneur de l'hôtel de ville de Barcelone.

These images display one of the lampposts designed by Gaudí as part of what would have been one of the greatest public works in the city of Barcelona at the end of the 19th century: the artificial illumination of the Muralla del Mar. The architect, who devised a different decoration for each piece, submitted the drawing along with a map indicating the location of each lamppost.

Die Bilder zeigen eine der Straßenlaternen, die Gaudí für ein Projekt präsentierte, das eines der größten öffentlichen Bauvorhaben der Stadt im ausgehenden 19. Jahrhundert hätte werden sollen: die elektrische Beleuchtung einer als Muralla del Mar bezeichneten Stadtmauer. Der Architekt hatte unterschiedlich dekorierte Elemente ersonnen und fügte dem Entwurf für die große Straßenlaterne einen Plan bei, auf dem ihr Standort angegeben war.

Ce croquis présente l'un des réverbères conçus par Gaudí pour ce qui aurait dû être l'un des plus grands travaux publics de la ville de Barcelone de la fin du XIXᵉ siècle : l'éclairage électrique de la Muralla del Mar. L'architecte, qui envisageait une décoration distincte pour chaque pièce, joignit un plan afin d'en indiquer l'emplacement.

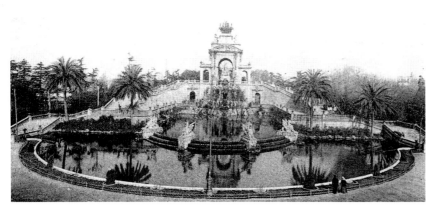

parc de
LA CIUTADELLA

1871-1888

As a student, Gaudí had a unique opportunity to work on the Parc de la Ciutadella with Joan Fontseré, one of the most influential Catalan architects of the late 19th century.

Noch als Student bekam Gaudí die grosse Gelegenheit, mit einem der einflussreichsten katalanischen Architekten des ausgehenden 19. Jahrhunderts, Joan Fontseré, bei der Erschliessung des Parc de la Ciutadella zusammenzuarbeiten.

Encore étudiant, Gaudí eut la chance de travailler à l'aménagement du parc de la Ciutadella avec l'un des architectes catalans les plus influents de la fin du XIXᵉ siècle, Joan Fontseré.

The 1888 Universal Exhibition was held on the grounds occupied by what only a few years earlier had been the Ciutadella, or citadel, of Barcelona, constructed by Philip V in 1715 during the War of the Spanish Succession.

Master builder Josep Fontseré i Mestres (1829-1897) was in charge of transforming this enormous 30-hectare site, which was repressive and military in nature, into a green zone designated for public use. For many years, it was the only large park in the city of Barcelona and was thus referred to at that time as "the Park." The architectural and artistic complex is of great value, as it contains works by some of the most important architects of that time, including Lluís Domènech i Montaner's café-restaurant and Hotel Internacional, and Josep Vilaseca's Triumphal Arch, main entrance to the Exhibition.

The earliest projects date back to 1871, when Josep Fontseré won the tender issued by the town hall. This decision provoked much controversy among architects, who felt insulted by it and claimed that a simple construction supervisor was incapable of submitting a better design than a licensed architect. The first commissions received by Fontseré were basically landscaping projects, but once the initial organisation phase was concluded, the construction of the park's most iconic spaces began. In 1887, work began on the monumental cascade,

Die Weltausstellung 1888 wurde auf einem Gelände abgehalten, das noch wenige Jahre zuvor Barcelonas ehemalige Zitadelle – errichtet von Philipp V. im Jahr 1715 nach dem Spanischen Erbfolgekrieg – eingenommen hatte.

Der Baumeister Josep Fontseré i Mestres (1829-1897) wurde damit betraut, dieses 30 Hektar große und zur militärischen Kontrolle der Stadt bestimmte Gelände in eine öffentliche Grünanlage zu verwandeln. Viele Jahre war sie die einzige große Park in der Stadt, der damals den bezeichnenden Namen „El Parc" trug. Es handelt sich um ein architektonisches und künstlerisches Ensemble von großer Bedeutung, da sich darin Werke wichtiger Architekten jener Zeit befinden, darunter das Café-Restaurant und das Hotel Internacional von Lluís Domènech i Montaner oder der Triumphbogen, der von Josep Vilaseca geschaffene Haupteingang der Weltausstellung.

Die ersten Entwürfe stammen aus dem Jahr 1871, in dem Josep Fontseré das von der Stadtverwaltung ausgeschriebene Projekt zugesprochen wurde. Diese Entscheidung rief eine große Kontroverse bei den Architekten hervor, die verärgert bestritten, dass ein einfacher Baumeister ein besseres Projekt als ein Hochschulabsolvent konzipieren konnte. Die ersten Aufträgen Fontserés betrafen im Wesentlichen die Grünanlagen und die Bauvorbereitung; anschließend wurde die Errichtung der charakteristischen

L'Exposition universelle de 1888 se déroula à l'emplacement qu'occupait encore quelques années auparavant la citadelle de Barcelone, bâtie en 1715 par le futur roi Philippe V d'Espagne durant la guerre de Succession.

Le maître d'œuvre Josep Fontseré i Mestres (1829-1897) fut chargé de transformer cet immense site de 30 hectares, au passé militaire et répressif, en un espace vert public. Pendant de nombreuses années, ce fut l'unique grand parc de Barcelone, raison pour laquelle il était alors simplement appelé « le parc ». Il s'agit d'un complexe architectural et artistique d'une grande valeur, en ce qu'il abrite les œuvres de grands architectes de l'époque, telles que le café-restaurant et l'Hotel Internacional de Lluís Domènech i Montaner, ainsi que l'arc de triomphe (entrée principale de l'exposition, de Josep Vilaseca.

Les premiers projets remontent à 1871 lorsque la soumission de Josep Fontseré remporta l'appel d'offres de la mairie. Cette décision fut très controversée parmi les architectes qui se sentirent insultés et étaient convaincus que le projet d'un simple maître d'œuvre ne pouvait être supérieur à celui d'un architecte diplômé. Les premières tâches assignées à Fontseré furent essentiellement des travaux de paysagisme. Au terme de cette étape d'aménagement initial, l'érection des espaces les plus représentatifs du parc put commencer

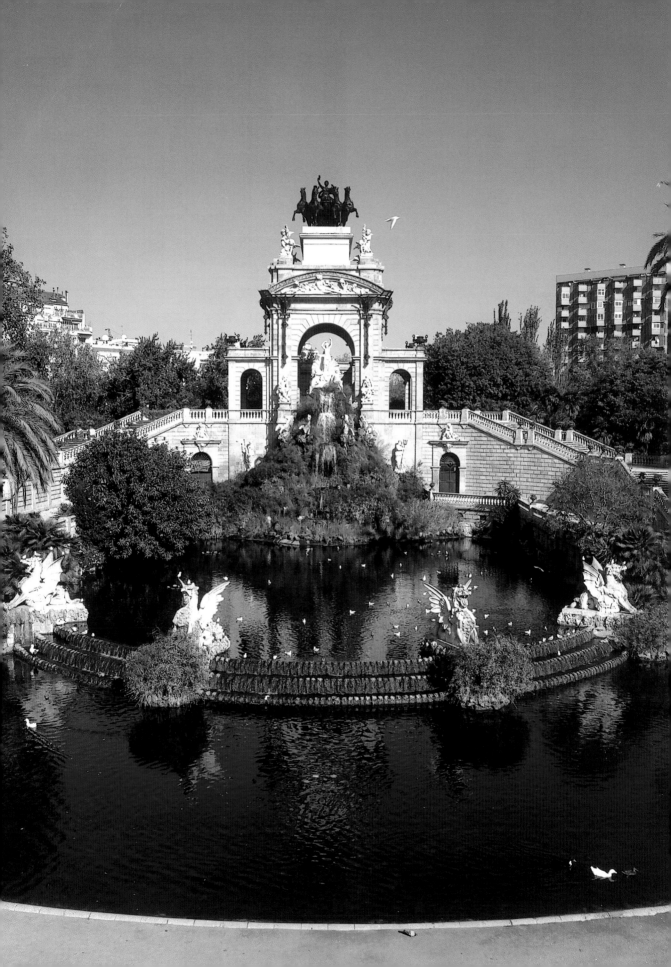

buildings, fences, walls and various monuments. These designs were executed by Fontseré and a very young Antoni Gaudí, who worked as a draughtsman for the construction supervisor. Gaudí came up with an innovative structure for the cascade's water supply tank, the mechanical calculations of which earned him a pass grade in a class taught by Joan Torras Guardiola. Ràfols, Gaudí's first biographer, explains how Fontseré purposely met with the professor to obtain his opinion of young Gaudí's proposal.

Another of Gaudí's unquestionable contributions to the park is the design of the fountain's decorative elements placed along the edge of the pond under the cascade, which feature interesting figures such as dragons and medallions portraying salamanders. The rear of the cascade sits on huge stones, and an artificial cave was created, bordered by a curved bench. Both the decorative motifs chosen by the architect as well as the constructive elements herald Gaudí's later works, including the dragon at Finca Güell, the Artigas Gardens in La Pobla de Lillet and Park Güell. Gaudí was also responsible for the balustrade in the small

Bereiche des Parks in Angriff genommen. 1887 begannen die Bauarbeiten für die eindrucksvolle Kaskade, die Gebäude, die Umfriedungen, die Zäune und verschiedene Denkmäler. Die entsprechenden Vorlagen wurden von Fontseré und einem sehr jungen Antoni Gaudí erstellt, der in jenen Jahren als technischer Zeichner für den Bauleiter tätig war. Von dem genialen Architekten stammte die Baulösung für den großen Tank, der die Kaskade mit Wasser versorgte. Mit der entsprechenden mechanischen Berechnung bestand er das von Joan Torras Guardiola erteilte Lehrfach. Ràfols, Gaudís erster Biograf, erklärt, dass Fontseré den Professor aufsuchte und ihn um seine Meinung zu dem vom jungen Gaudí übergebenen Vorschlag bat.

Ein weiterer unbestreitbarer Beitrag des Architekten im Park ist die Gestaltung der Dekorationselemente rund um den zur Kaskade gehörigen Teich, unter denen die interessanten Drachenfiguren und die Medaillons mit der Abbildung eines Salamanders hervorstechen. Die Rückseite der Kaskade ruht auf riesigen Steinen; außerdem wurde eine künstliche Grotte angelegt, die von einer geschwungenen Bank gesäumt wird. Sowohl die Thematik der

En 1887, les chantiers de la cascade monumentale, des bâtiments, des enceintes, des clôtures et de divers monuments furent lancés. Les tracés furent effectués par Fontseré et un tout jeune Antoni Gaudí, qui travaillait alors comme dessinateur pour le responsable des travaux Gaudí est ainsi à l'origine de la solution utilisée pour la construction du grand réservoir approvisionnant la cascade en eau, dont le calcul mécanique lui valut la note de passage dans un cours donné par Joan Torras Guardiola. Ràfols, premier biographe de Gaudí, explique que Fontseré rencontra le professeur pour lui demander son avis sur la proposition du jeune Gaudí.

Autre contribution incontestable de Gaudí au parc : la conception des éléments décoratifs sur les bords du bassin de la cascade, dont d'intéressantes sculptures de dragons et des médaillons ornés d'une salamandre. L'arrière de la cascade repose sur d'énormes pierres. Une grotte artificielle, bordée d'un banc arrondi, y a été aménagée. Tant les thèmes choisis pour la décoration que ces éléments structurels rappellent des travaux postérieurs de Gaudí, comme le dragon de la Finca Güell, les

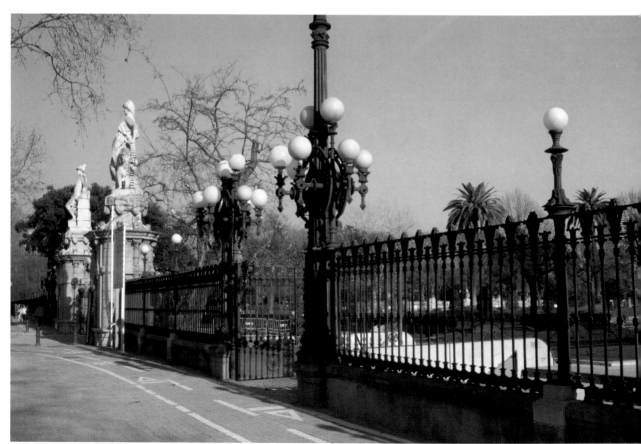

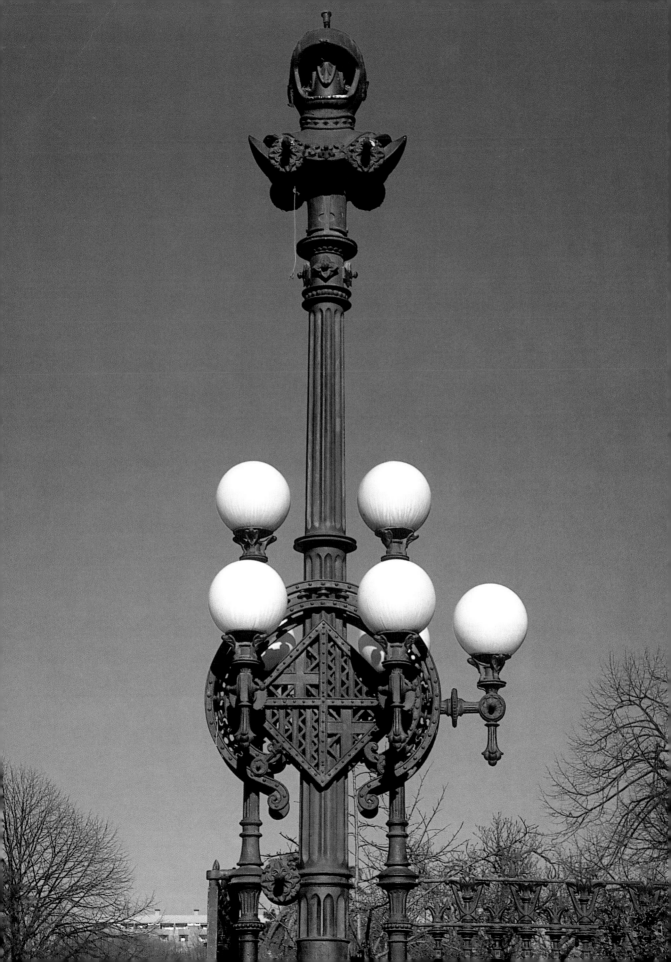

square (1875), where a sculpture in honour of poet Bonaventura Carles Aribau was placed years later.

His trademark style can be clearly seen in the wrought-iron fences and gates, which display decorative elements that the architect would apply to future works, such as epigraphs, the use of organic ornamental motifs, sculptural wrought-iron streetlamps and the image of the dragon. This one kilometre long fence opens through seven gates, including those of Passeig de Sant Joan and Passeig de la Duana, for which Gaudí designed grand pedestals on which impressive sculptures were placed. Gaudí's hand in building the Parc de la Ciutadella was undoubtedly very important to the architect's future, as it gave him an early outlet for his architectural ideas.

Dekoration als auch die Bauelemente erinnern an Gaudís spätere Arbeiten, wie den Drachen der Finca Güell, die Grünanlage Jardins Artigas in La Pobla de Lillet oder den Park Güell. Auch die Balustrade des Platzes (1875), wo Jahre später das Denkmal zu Ehren des Dichters Carles Aribau aufgestellt wurde, war ein Beitrag Gaudís.

Eindeutige Anzeichen für seine Mitarbeit finden sich auch im Gitterwerk und den gusseisernen Toren mit ihren Dekorationselementen, die der Architekt in seinen späteren Werken erneut aufgriff. Gemeint sind beständige Merkmale in Gaudís Stil, wie die Inschriften, die Verzierung mit Naturmotiven, die plastische Gestaltung der Schmiedearbeiten und Straßenlaternen sowie die Drachenfigur. Das Gitterwerk des Parks erstreckt sich über einen Kilometer und weist sieben Eingänge auf, unter denen besonders die Tore zum Passeig de Sant Joan und zum Passeig de la Duana hervorstechen, die Gaudí mit großen Sockeln für beeindruckende Skulpturen abrundete. So erwies sich seine Mitwirkung bei den Bauarbeiten zum Parc de la Ciutadella als sehr wichtig für seine berufliche Zukunft, da er dort seine ersten architektonischen Experimente anstellen konnte.

jardins Artigas à la Pobla de Lillet et le parc Güell. De même, la balustrade de la place (1875), qui accueillit des années plus tard une sculpture en hommage au poète Bonaventura Carles Aribau, fut également une création de Gaudí.

Son style caractéristique est évident dans les grilles et les portes en fonte, qui affichent des éléments décoratifs que l'architecte utilisera dans ses œuvres ultérieures, tels que l'épigraphe, les motifs inspirés de la nature, les sculptures ornementales des réverbères, ou encore la figure du dragon. L'enceinte s'étend sur un kilomètre et compte sept portes, dont celles s'ouvrant sur le Passeig de Sant Joan et le Passeig de la Duana, pour lesquelles Gaudí dessina de grands piédestaux pour supporter d'imposantes sculptures. La participation de Gaudí aux travaux du parc de la Ciutadella fut donc décisive pour sa carrière d'architecte, car celle-ci lui fournit un premier débouché pour ses idées architecturales.

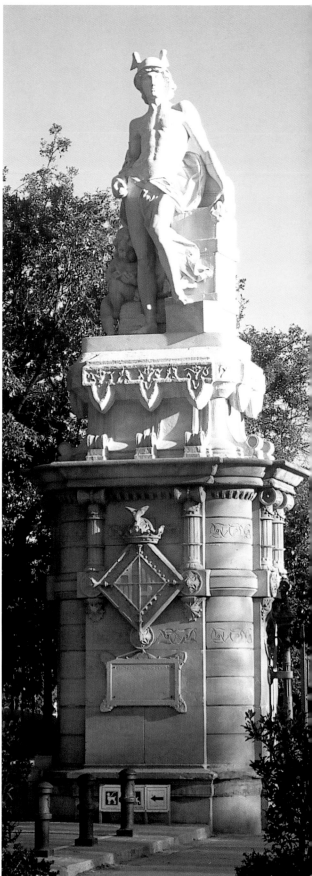

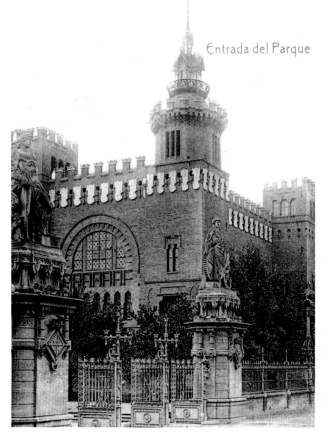

Entrada del Parque

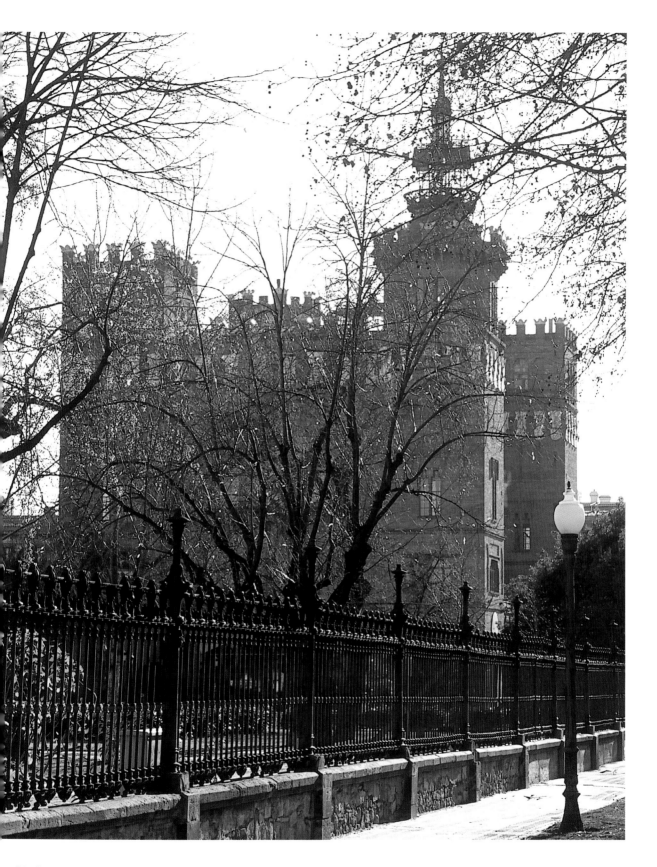

One of Gaudí's most significant contributions was designing the fence that encloses the park.

Einer der wichtigsten Beiträge Gaudís war der Entwurf für das Gitterwerk rund um das Parkgelände.

Une des interventions majeures de Gaudí fut le projet de grilles du parc.

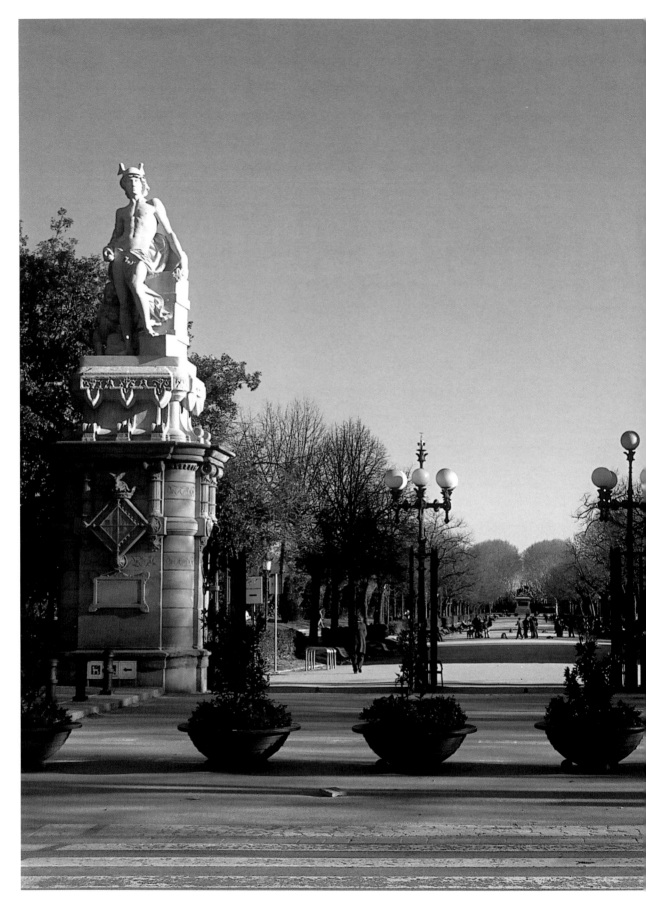

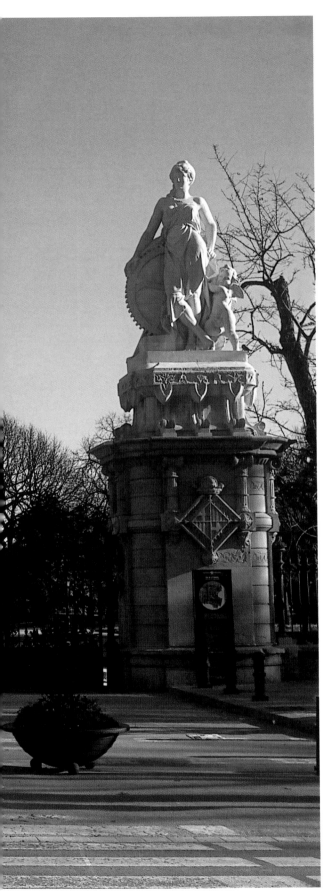

Antoni Gaudí designed monumental pedestals for the sculptures situated at the two main entrances to the Parc de la Ciutadella, designed by the Vallmitjana brothers as allegorical depictions of commerce and industry (in the photo), agriculture and the navy (at the other gate). Gaudí decided to play to nationalist sentiments by including reliefs of Barcelona's coat-of-arms.

Für die beiden Haupteingänge zum Parc de la Ciutadella entwarf Antoni Gaudí riesige Sockel für die von den Brüdern Vallmitjana geschaffenen großen Skulpturen, die allegorische Figuren aus den Bereichen Handel und Industrie an dem einen Tor (siehe Foto) sowie aus der Architektur und der Marine am anderen Tor darstellten. In seinem Bestreben, nationalistische Gefühle zu verherrlichen, zögerte Gaudí nicht, Barcelonas Wappen in Form von Reliefs zu integrieren.

Antoni Gaudí dessina d'imposants socles pour les deux entrées principales du parc de la Ciutadella, pour les grandes sculptures des frères Vallmitjana : des représentations allégoriques du commerce et de l'industrie (sur la photo), et de l'agriculture et de la marine (pour l'autre porte). Dans sa volonté d'honorer le sentiment nationaliste, Gaudí n'hésita pas à inclure des reliefs ornés du blason de Barcelone.

Gaudí's touch is clear in the iron and sculptural decorative elements.

Gaudís Mitwirkung zeigt sich auch in der Gestaltung der eisernen und plastischen Dekorationselemente.

La patte de l'artiste Gaudí se retrouve dans la conception des éléments décoratifs, tant en fer qu'en pierre.

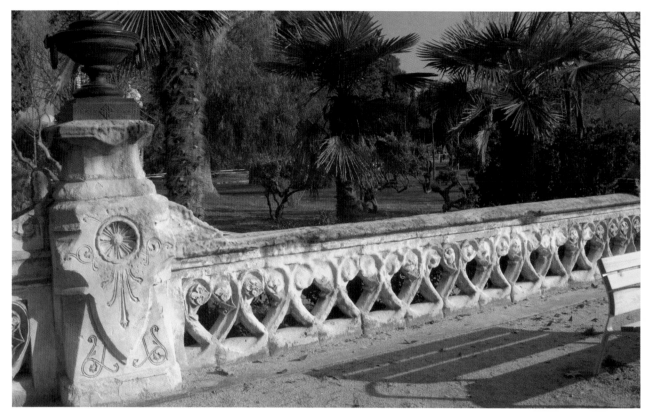

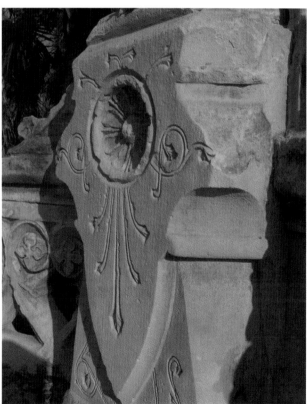

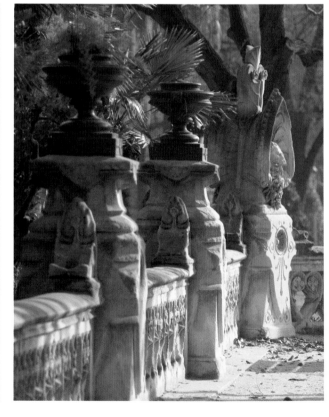

The northernmost part of the park features this small square with an original balustrade designed by Gaudí.

Im Norden des Parks befindet sich dieser Platz, dessen originelle Balustrade Gaudís Werk ist.

La balustrade originale de cette place, située dans la zone nord du parc, est une création de Gaudí.

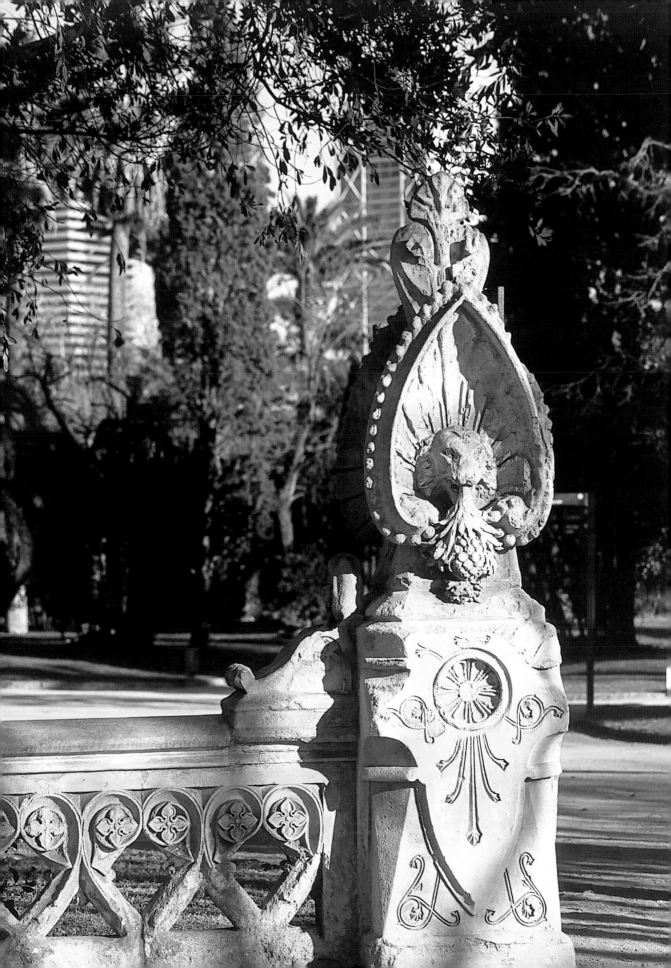

TOWARDS THE END OF THE 19TH CENTURY, GAUDÍ RECEIVED HIS FIRST PRIVATE COMMISSION FROM MANEL VICENS I MONTANER TO CONSTRUCT A SMALL HOUSE ON A PLOT IN GRÀCIA, WHICH IS NOW A DISTRICT OF BARCELONA.

GAUDÍS ERSTER PRIVATAUFTRAG STAMMTE VON MANEL VICENS I MONTANER UND BEZOG SICH AUF DEN BAU EINES KLEINEN HAUSES AUF EINEM GRUNDSTÜCK, DAS ENDE DES 19. JAHRHUNDERTS NOCH ZUR ORTSCHAFT GRÀCIA, HEUTE EIN STADTVIERTEL BARCELONAS, GEHÖRTE.

VERS LA FIN DU XIX' SIÈCLE, GAUDÍ REÇUT SA PREMIÈRE COMMANDE PRIVÉE DE MANEL VICENS I MONTANER, QUI LE CHARGEA DE CONSTRUIRE UNE PETITE MAISON SUR UN TERRAIN AU VILLAGE DE GRÀCIA, AUJOURD'HUI UN QUARTIER DE BARCELONE.

casa VICENS

1883-1888

The birth of *Modernisme* in Spain can be dated back to 1878, when architect Lluís Domènech i Montaner published an article in the newspaper *La Renaixensa* entitled "The quest for a national architecture," expressing the need for Catalonia to develop its own style. From that moment on, buildings were constructed based on history, yet characterised by the personality of the architect, who transformed classical vernaculars and began to display a new architecture. It was during 1878 when Antoni Gaudí received a commission from Manel Vicens i Montaner, a tile manufacturer, to design a summer residence on Carolines Street in what is now the Barcelona neighbourhood of Gràcia. Construction began in 1883 and did not finish until 1888.

This original home, considered to be the young architect's first major assignment, demonstrates some of the most distinctive features of Gaudí's earliest works, such as the use of traditional Arabic and Mediterranean construction methods, diverse textures and the application of tiles on the building's exterior.

The result displays an eclectic historicism inspired by both mediaeval and oriental cultures. The grandeur of this home is reflected in the profuse decoration, which Gaudí applied both on the façade and in the home's interior design.

Der Beginn des Modernismus in Spanien lässt sich auf 1878 datieren, als der Architekt Lluís Domènech i Montaner in der Zeitung *La Renaixensa* einen Artikel mit dem Titel „Auf der Suche nach einer Nationalarchitektur" veröffentlichte und darin die Notwendigkeit eines eigenen Stils für Katalonien zum Ausdruck brachte. Von diesem Moment an entstanden auf der Grundlage des Historismus Bauten, bei denen jedoch die Persönlichkeit des Architekten vorherrschte, denn dieser veränderte jene klassischen Ausdrucksformen und brachte eine neue Architektur hervor. Im Jahr 1878 erhielt Antoni Gaudí von dem Fliesenhersteller Manel Vicens i Montaner den Auftrag, ein Sommerhaus in der Carrer de les Carolines, in Barcelonas heutigem Stadtviertel Gràcia, zu entwerfen. Die Bauarbeiten begannen 1883 und wurden 1888 abgeschlossen.

Dieses originelle Wohnhaus, das als erstes größeres Bauwerk des jungen Architekten gilt, weist einige der für Gaudís frühe Arbeiten charakteristischen Merkmale auf. Dazu zählen die traditionellen Baumethoden der mediterranen und arabischen Kultur, die Mauerwerke aus unterschiedlichen Materialien und die Verkachelung in der Außendekoration des Gebäudes.

Das Bauwerk basiert auf einem historizistischen Eklektizismus aus zwei Strömungen, einer mediävistischen und einer orientalistischen. So beruht die Bedeutung dieses Werks

La naissance du modernisme en Espagne peut être datée de 1878, année où l'architecte Lluís Domènech i Montaner publia, dans le journal *La Renaixensa*, un article intitulé « À la recherche d'une architecture nationale », exprimant le besoin pour la Catalogne de définir son propre style. Dès lors, les bâtiments furent construits en se basant sur l'histoire, tout en étant caractéristiques de la personnalité de l'architecte, qui transformait les standards en laissant présager les signes d'une nouvelle architecture. Ce fut en 1878 qu'Antoni Gaudí reçut la commande de Manel Vicens i Montaner, fabricant d'azulejos, pour le projet d'une résidence d'été rue Carolines, dans l'actuel quartier barcelonais de Gràcia. Les travaux débutèrent en 1883 et ne s'achevèrent qu'en 1888.

Cette demeure originale, considérée comme le premier travail d'envergure du jeune architecte, présente certaines des caractéristiques clés de ses créations initiales : le recours à des méthodes de construction traditionnelles méditerranéennes et arabes, ainsi que les textures mixtes et l'emploi d'azulejos dans la décoration extérieure du bâtiment.

Cette œuvre a été conçue selon un éclectisme historiciste à deux visages, médiéval et oriental. Ainsi, sa grandeur réside dans la profusion de la décoration, que Gaudí adopta tant pour la façade que pour l'aménagement intérieur de la résidence.

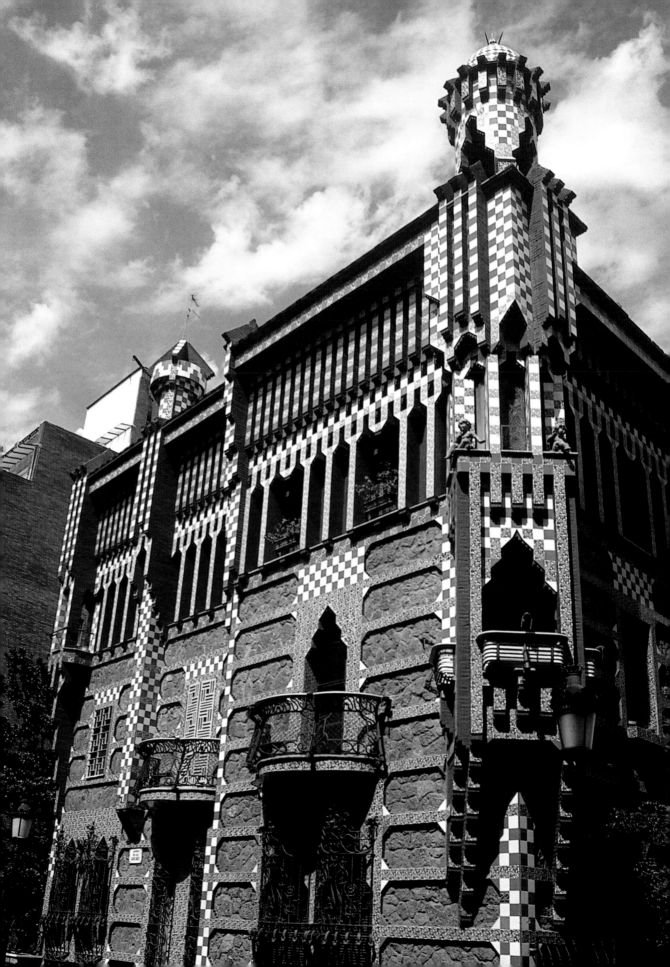

The façade is almost entirely covered with tiles featuring small yellow flowers. It is said that when the architect visited the plot on which he was to build the house, he marvelled at the presence of thousands of flowers and claimed that although he had to remove them, he would incorporate them into the exterior decoration so they would endure both winter and summer. The building shares an organically influenced ornamentation with an inclination towards Islamic styles, characterised by the chromatic effect obtained through alternating white and green tiles combined with exposed brick and stone, and the expressivity conferred by the ornamental borders, geometric lattices, mixtilinear arches, lookout points, turrets and rooftops. In short, it is the elaborately detailed work of a craftsman.

The lush garden surrounding the house was delimited by a beautiful wrought-iron fence furnished with representations of fronds of the palm tree which previously shared the plot with the yellow flowers.

The inside of the house, too, was decorated with great exactness and exuberance. A mural

auf der Dekorationsfülle, mit der Gaudí sowohl die Fassade als auch den Innenbereich des Wohnhauses gestaltete.

Die Fassade ist fast vollständig mit Fliesen verkleidet, auf denen kleine gelbe Blüten zu sehen sind. Es heißt, dass der Architekt beim Besuch des Baugrunds von dem dort befindlichen Blumenmeer verzaubert war. Daher entschied er, dass, wenngleich diese Blumen dem Hausbau weichen mussten, die gelben Blüten mit der Außendekoration Winter wie Sommer überdauern sollten. Die von Pflanzen inspirierte Verzierung wurde mit einer eher islamisch geprägten Ausrichtung kombiniert, die sich ebenso durch die Farbwirkung der abwechselnd angeordneten weißen und grünen Kacheln in Verbindung mit unverputzten Steinen und Mauerziegeln auszeichnet wie durch die plastische Wirkung der Muster, Leisten, geometrischen Gitter, Zackenbogen, Erker, Türmchen und Abschlüsse. Zweifellos handelt sich um ein aufs Detail bedachtes, ausgefeiltes Werk eines Kunsthandwerkers.

Den dicht bewachsenen Garten rund um das Haus umschließt ein herrliches schmiedeeiser-

La façade est presque entièrement recouverte d'azulejos ornés de petites fleurs jaunes. On raconte que lorsque l'architecte visita le terrain sur lequel devait s'élever la maison, il fut émerveillé par la multitude de fleurs qui y poussaient. Amenées à disparaître pour permettre la construction de la demeure, Gaudí décida de les incorporer dans la décoration extérieure pour qu'elles perdurent été comme hiver. Les ornements d'influence végétale se mêlent à un style davantage oriental, caractérisé par l'effet chromatique de l'alternance d'azulejos blancs et verts combinés à la brique et à la pierre apparente, et par l'expressivité conférée par les trames, les frises, les entrelacs géométriques, les arcs mixtilignes, les miradors, les tourelles et les toitures. Il s'agit en somme d'un travail recherché et minutieux d'artisans.

Le jardin luxuriant entourant la maison était délimité par une magnifique grille travaillée en fer forgé, parée d'une reproduction des feuilles des palmiers qui, tout comme les fleurs jaunes, occupaient l'emplacement d'origine de la maison.

Il ne faut pas oublier l'intérieur de la maison, décoré avec exubérance et sens du détail.

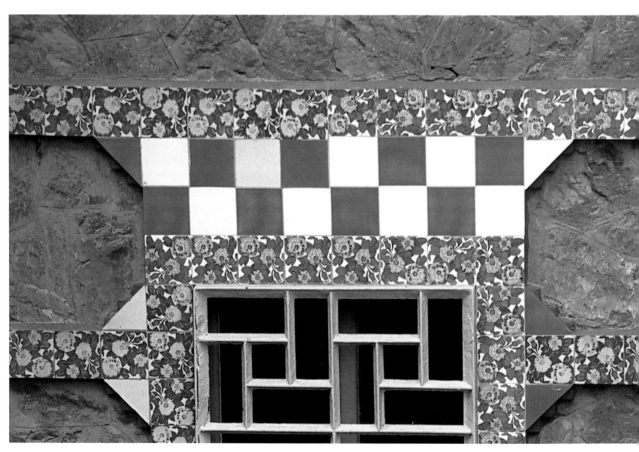

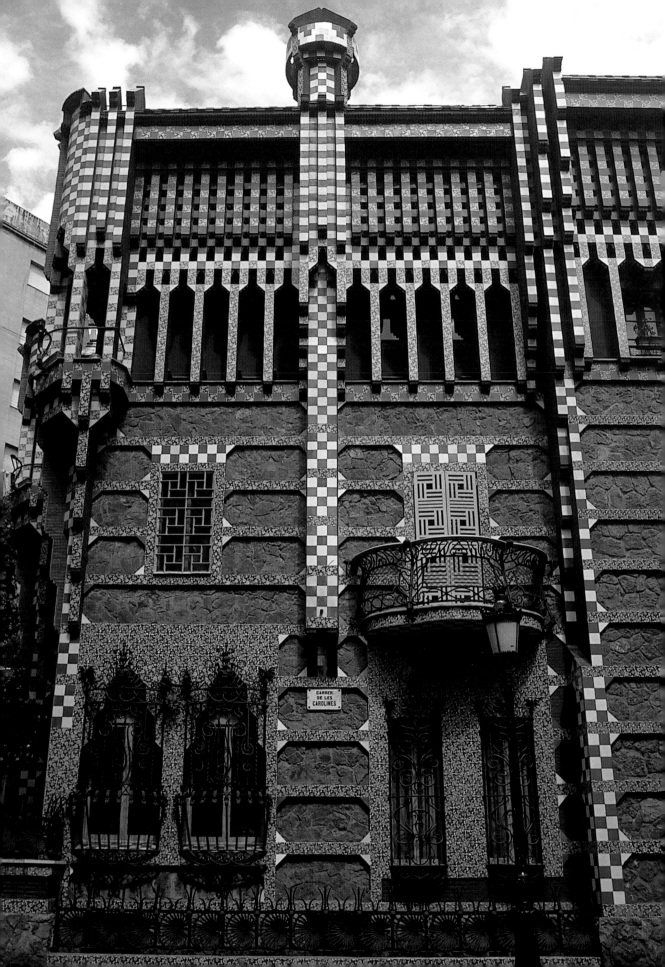

CARRER
DE LES
CAROLINES

by the artist Josep Torrescassana out in the dining room, dominated by fruit motifs produced by the pressed cardboard technique. The wall features depictions of climbing ivy. In keeping with his idea of creating a building as a complete work of art, Gaudí also designed the bedroom furniture, the Arabic-style smoking room, the Japanese-style veranda, the wooden screens and the dining area immersed in rural motifs.

The house was expanded and modified in 1925 by architect Joan Baptista Serra de Martínez, who followed in the footsteps Gaudí's original project with his consent. It was during this extension that important garden elements were lost, including the arbour and the fountain.

nes Gitter, in dem Palmenblätter abgebildet sind. Diese verweisen auf die Bäume, die wie die gelben Blumen auf dem ehemaligen Baugrund des Hauses wuchsen.

Nicht zu vergessen ist das Hausinnere mit einer präzisen, üppigen Einrichtung. Im Esszimmer, in dem das Wandgemälde des Künstlers Josep Torrescassana hervorsticht, überwiegen die aus Presspappe gefertigten Fruchtmotive. An der Wand ist ein rankender Efeu abgebildet. Mit dem Gedanken, ein Gebäude als Gesamtkunstwerk zu schaffen, entwarf Gaudí auch die Schlafzimmermöbel sowie das arabisch eingerichtete, so genannte „Rauchzimmer", die japanisch anmutende Veranda, die hölzernen Paravents und das mit ländlichen Motiven geschmückte Esszimmer.

Das Haus wurde 1925 von dem Architekten Joan Baptista Serra de Martínez erweitert und umgebaut, der deutlich dem Originalentwurf Gaudís folgte und dessen Zustimmung zu seinen Änderungen erhielt. Während dieser Ausbauarbeiten gingen jedoch bedeutende Bestandteile des Gartens, wie das Gartenhäuschen und der Brunnen, verloren.

Dans la salle à manger, dominée par la peinture murale de l'artiste Josep Torrescassana, les motifs de fruits réalisés en carton pressé abondent et un lierre grimpant orne le mur. Fidèle à sa conception personnelle des édifices comme œuvres d'art intégrales, Gaudí dessina également les meubles de la chambre à coucher, ainsi que le fumoir d'ambiance arabe, la véranda de style japonais, les panneaux de bois et la salle à manger, garnie de motifs champêtres.

La maison fut agrandie et modifiée en 1925 par l'architecte Joan Baptista Serra de Martínez, dans la ligne du projet original de Gaudí et avec le consentement de celui-ci. Au cours de ces travaux d'agrandissement, certains éléments notables du jardin, tels que la tonnelle et la fontaine, disparurent.

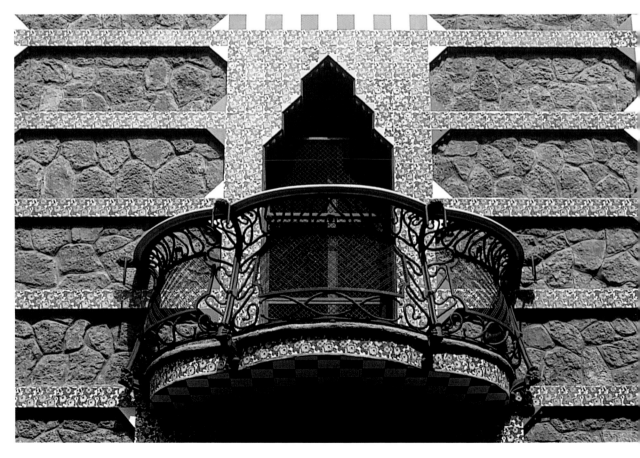

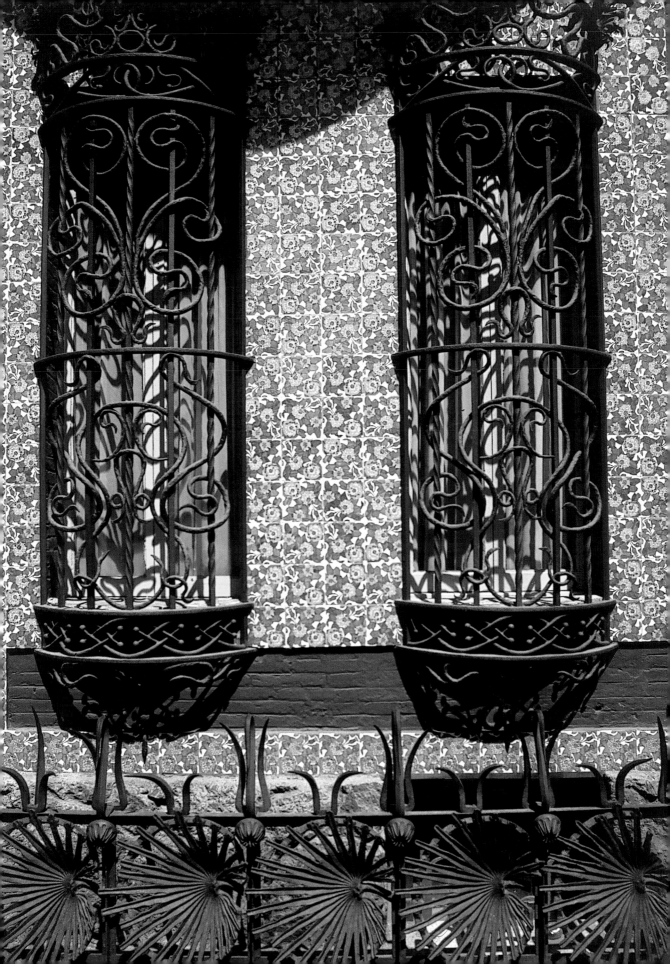

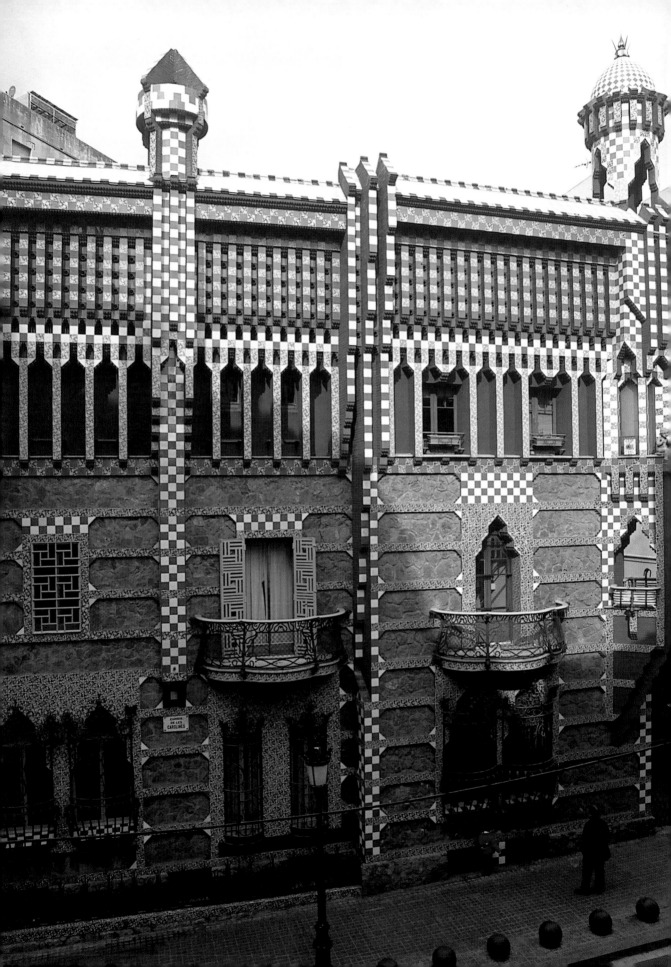

Gaudí's works are filled with unexpected details, such as these beautiful classical sculptures depicting two small angels situated on the corner of the building.

Gaudís Werke stecken voller unerwarteter Details, wie diese schönen klassischen Skulpturen, zwei kleine Engel an der Ecke des Gebäudes.

Les œuvres de Gaudí étaient parsemées de détails surprenants, comme ces belles sculptures de style classique : deux petits anges placés au coin du bâtiment.

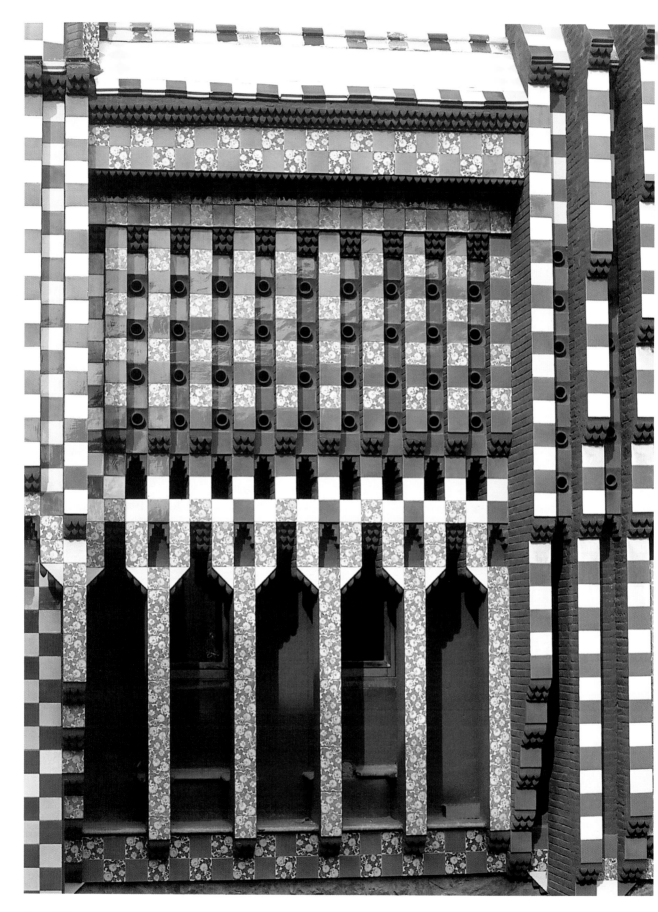

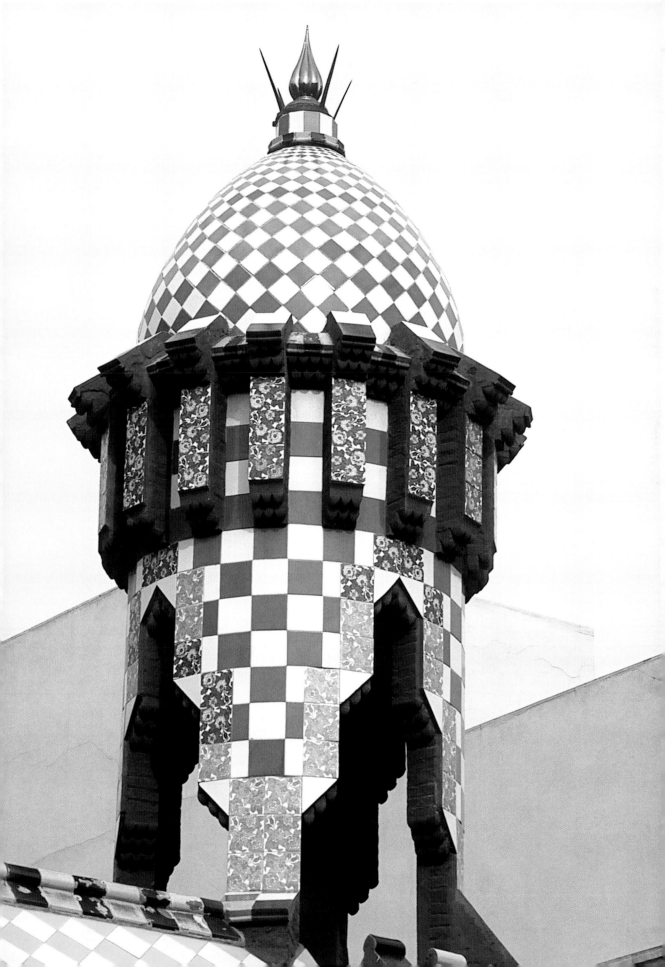

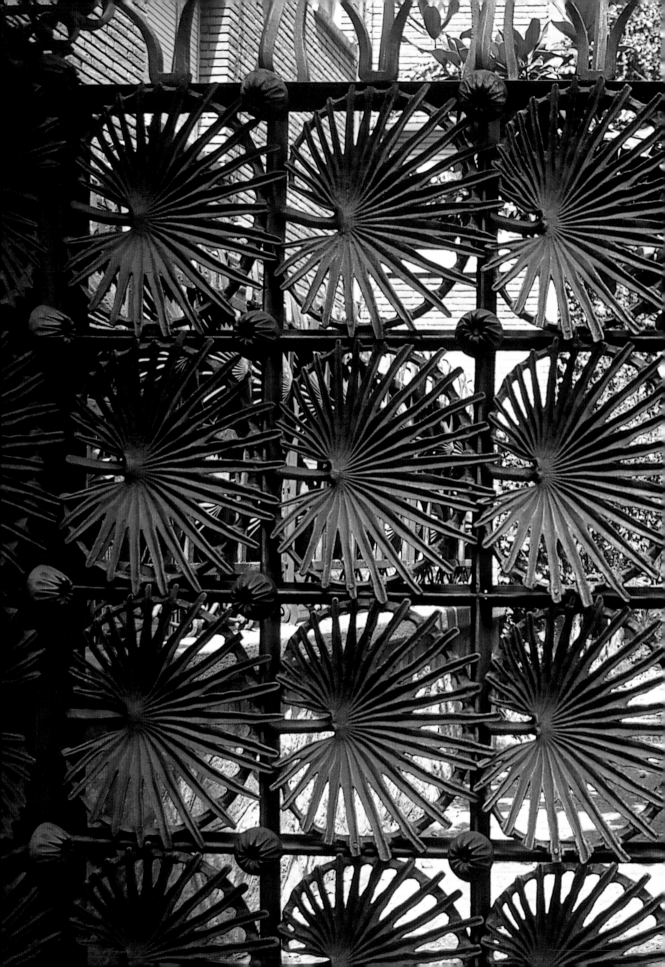

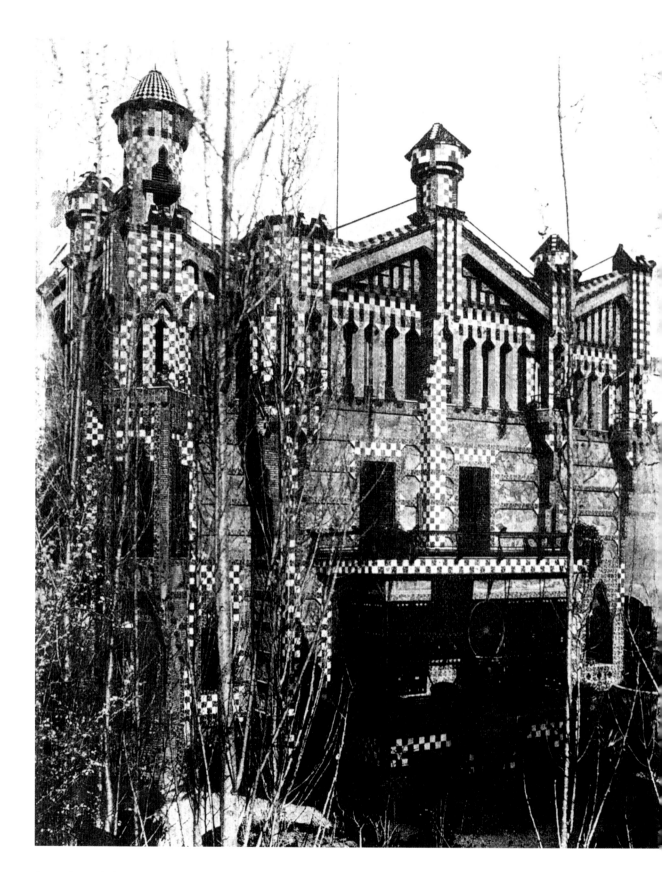

Antique photograph of the rear of the house and gallery known as the "Smoking Room," a space common in Arab homes.

Ein altes Foto zeigt die Rückseite des Gebäudes mit einer Loggia, die als „Rauchzimmer" – eine für arabische Häuser typische Räumlichkeit – bekannt ist.

Photographie ancienne de l'arrière de la résidence, où se trouvait la galerie connue sous le nom de « fumoir », un espace typique des intérieurs arabes.

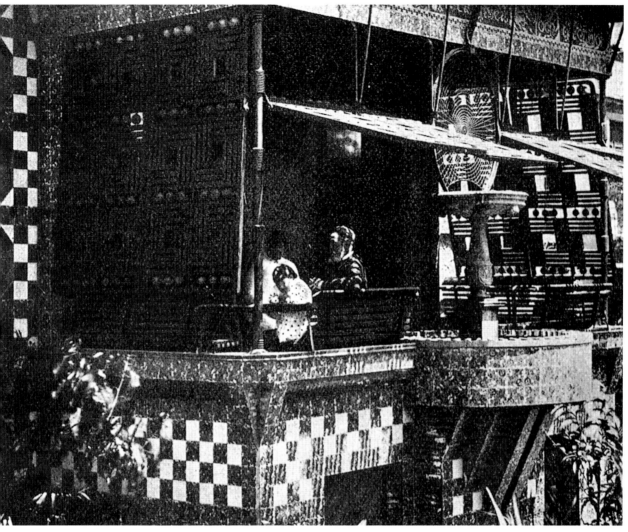

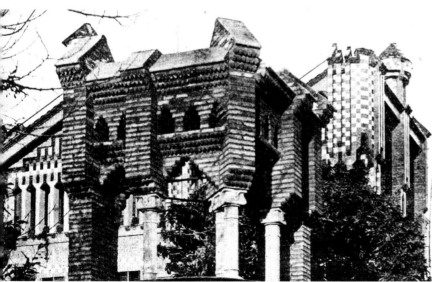

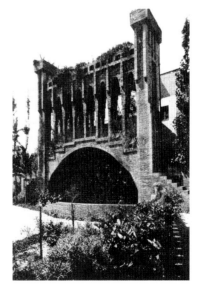

Before undergoing refurbishment, the house was endowed with a beautiful garden featuring an arbour and a fountain.

Vor seiner Renovierung besaß das Haus einen prächtigen Garten, in dem besonders ein Gartenhäuschen und eine Kaskade hervorstachen.

Avant sa rénovation, la maison comportait un splendide jardin, agrémenté d'une tonnelle et d'une fontaine.

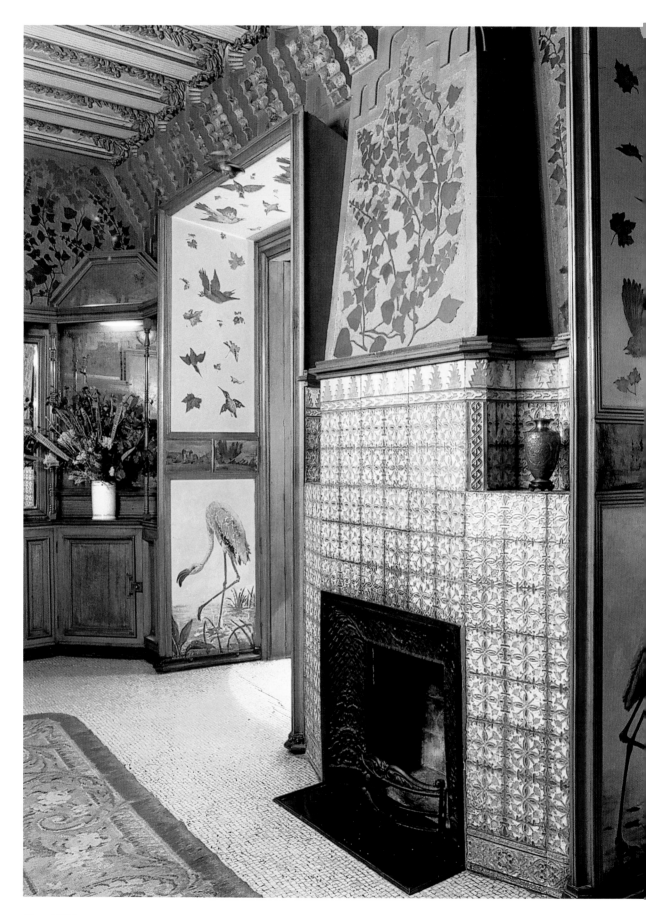

Inside the Casa Vicens, the lush depictions of nature give the sensation of a magical wonderland. Gaudí surrounded himself with great Catalan artists to aid him in beautifying the main living areas of the home, which feature works such as the murals by Josep Torrescassana.

Im Inneren der Casa Vicens hat man das Gefühl, sich in einem Wunderland zu befinden, da hier „falsche" Naturelemente im Mittelpunkt stehen. Für die Einrichtung der Haupträumlichkeiten des Hauses zählte Gaudí auf die Unterstützung großer katalanischer Künstler, deren Kunstfertigkeit für die Gestaltung dieses herrlichen Raums entscheidend war. Besonders auffällig sind die Wandgemälde von Josep Torrescassana.

À l'intérieur de la Casa Vicens, la profusion d'éléments calqués sur la nature donne la sensation de pénétrer dans un monde merveilleux. Pour la décoration des pièces principales de la demeure, Gaudí s'entoura de grands artistes catalans, dont le talent fut déterminant pour parvenir à ce bel assortiment, notamment les peintures murales de Josep Torrescassana.

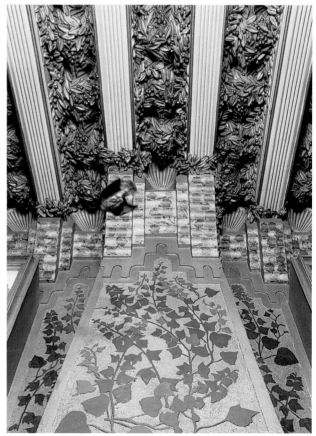

The Casa Vicens is one of the best examples of Gaudí's vision of a building as a complete work of art. The Smoking Room features baroque decorations on the walls and ceiling, made using small slabs of pressed cardboard that allowed for greater detail. These slabs are the handiwork of Hermenegildo Miralles, who later commissioned Gaudí to build the fence surrounding his estate.

Die Casa Vicens ist eines der besten Beispiele für Gaudís Gebäudekonzept im Sinne eines Gesamtkunstwerks. Im Inneren des Wohnhauses befindet sich das „Rauchzimmer", ein kleiner Salon mit Loggia, der durch die barocke Wand- und Deckengestaltung aus kleinen Presspappeplatten besticht, mit denen eine feinere Ausarbeitung möglich war. Schöpfer dieser Platten war Hermenegildo Miralles, der Gaudí Jahre später mit dem Entwurf für die Umzäunung seines Grundstücks beauftragte.

La Casa Vicens illustre parfaitement la vision de Gaudí d'un édifice en tant qu'œuvre d'art intégrale. Le fumoir dont les murs et le plafond présentent une décoration baroque créée à l'aide de petits carreaux de carton pressé permettaient un niveau poussé de détail. L'auteur de ces carreaux, Hermenegildo Miralles, commanda plus tard à Gaudí l'érection d'une clôture autour de sa propriété.

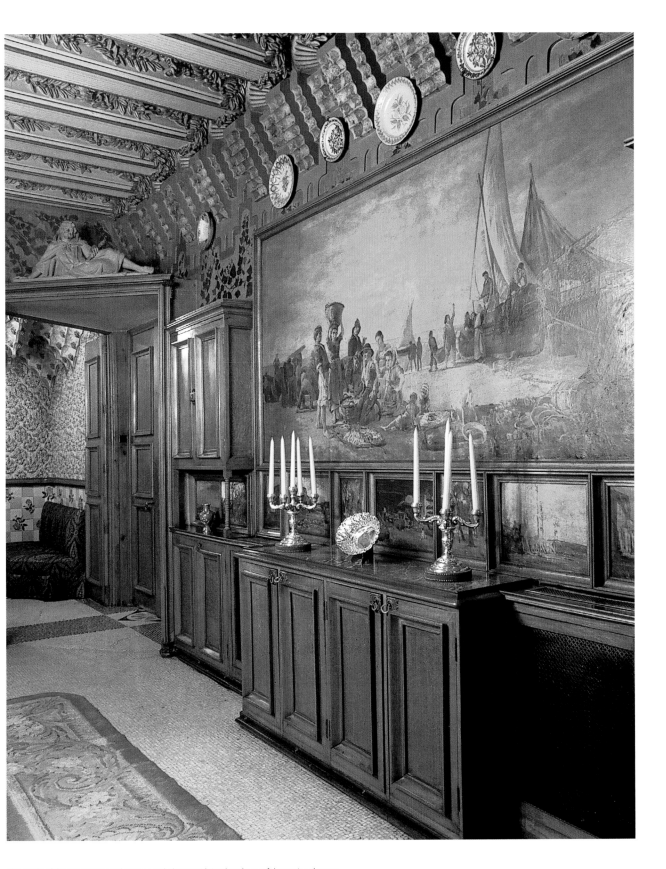

The inside of the Casa Vicens is almost overwhelming with its abundance of decorative elements.

Die Innenansicht der Casa Vicens kann wegen der unzähligen Dekorationselemente ein beklemmendes Gefühl hervorrufen.

L'intérieur de la Casa Vicens est presque écrasant en raison de l'abondance des éléments décoratifs.

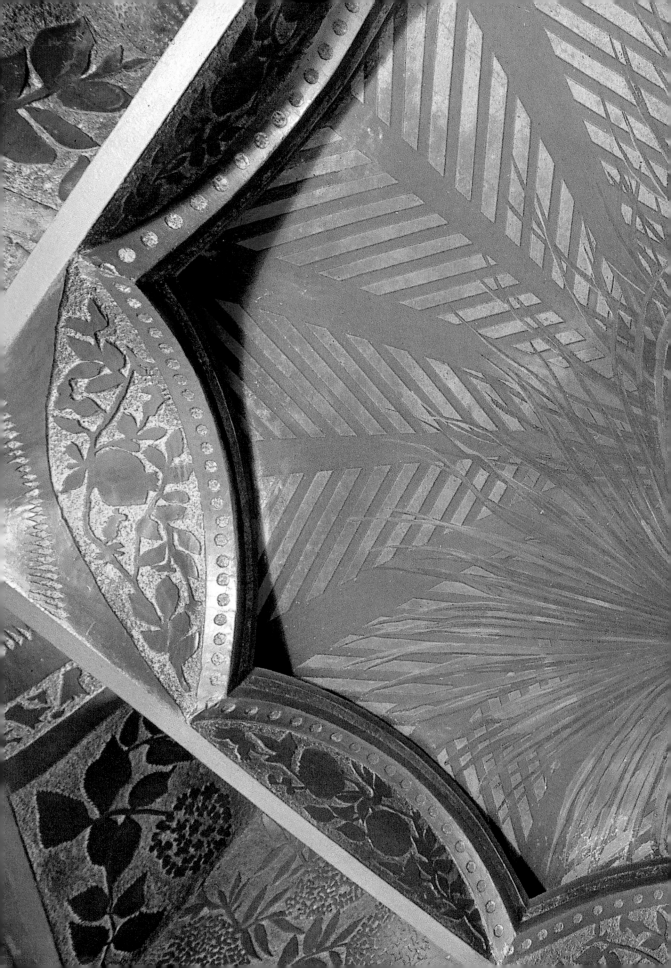

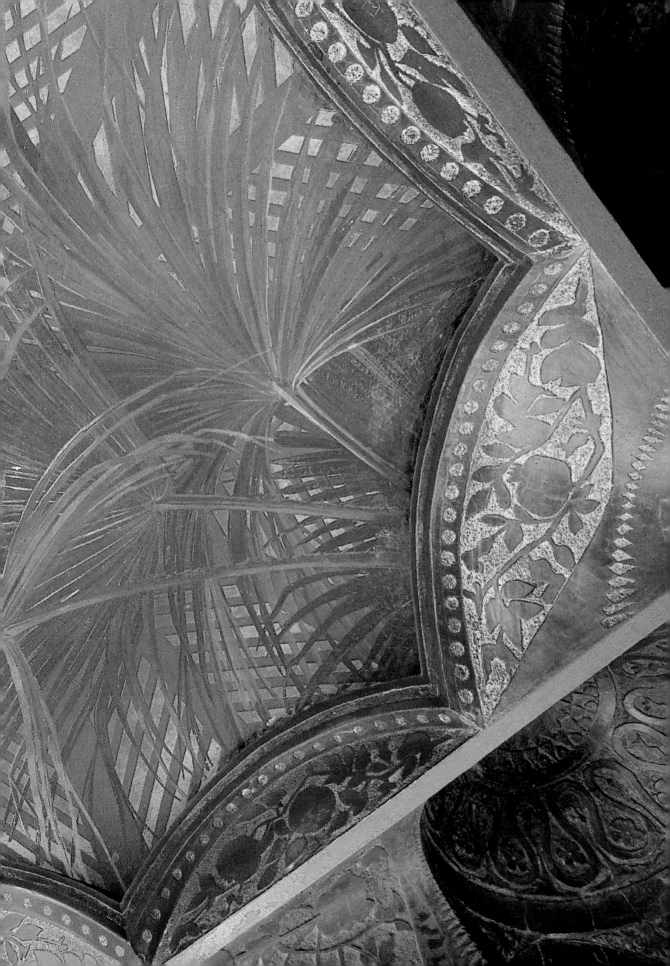

GAUDÍ RARELY TURNED DOWN COMMISSIONS. HIS FIRST PROJECT OUTSIDE CATALONIA WAS THIS SMALL BUILDING SITUATED ON THE OUTSKIRTS OF THE TOWN OF COMILLAS, NEAR SANTANDER.

GAUDÍ LEHNTE DIE IHM VORGESCHLAGENEN PROJEKTE NUR SELTEN AB. SEIN ERSTES WERK AUSSERHALB VON KATALONIEN WAR DIESES KLEINE GEBÄUDE IN DER NÄHE DER ORTSCHAFT COMILLAS BEI SANTANDER.

GAUDÍ NE REFUSAIT QUE RAREMENT LES PROJETS QUI LUI ÉTAIENT COMMANDÉS. LA PREMIÈRE ŒUVRE QU'IL RÉALISA HORS DE CATALOGNE FUT CETTE PETITE MAISON SITUÉE EN BORDURE DU VILLAGE DE COMILLAS, NON LOIN DE SANTANDER.

güell pavilion and EL CAPRICHO
der güell-pavillon und EL CAPRICHO
pavillon güell et EL CAPRICHO

1883-1885

Prior to El Capricho, Gaudí constructed a pavilion in 1881 for the garden of the house belonging to Eusebi Güell's father-in-law, Antonio López y López, located in the town of Comillas. In conjunction with his newfound mentor, Eusebi Güell, the architect decided to incorporate the decorative trends they had seen at the 1878 Paris Universal Exhibition.

This small building was created for King Alfonso XII's stay in Comillas, as guest of the owner. In light of such an illustrious guest, López decided to dignify his summer house with the help of Gaudí and his son-in-law. Within two months they had created luxurious living spaces fit to welcome the visitors that would soon occupy them, including an ephemeral structure recalling the epic tale of the *Arabian Nights*.

Máximo Díaz de Quijano, son-in-law of the Marquis of Comillas and brother-in-law of Eusebi Güell, commissioned Gaudí to design a small house, also in the town of Comillas. However, Gaudí did not travel to the construction site and left the project in the hands of architect Cristóbal Cascante.

Commonly known as "El Capricho" (The Whim), and built between 1883 and 1885, the house was conceived as a summer residence, and once completed, it became part a beautiful complex that Catalan architects like

Vor dem Entwurf für El Capricho errichtete Gaudí 1881 einen Pavillon im Garten des Hauses, das Eusebi Güells Schwiegervater, Antonio López y López, in dem kantabrischen Ort Comillas besaß. In diesem Bau wandte der Architekt unter Mitwirkung seines kurz zuvor gewonnenen Mentors Eusebi Güell jene Dekorationstrends an, die er auf der Weltausstellung 1878 in Paris kennen gelernt hatte.

Das kleine Bauwerk wurde anlässlich eines Besuchs von König Alfons XII., der einer Einladung des Bauherrn folgte, in Comillas errichtet. Angesichts eines derart erlauchten Urlaubsgastes entschied López, sein Sommerhaus angemessen herzurichten, und zählte dabei auf die Mitarbeit Gaudís und seines Schwiegersohns. In zwei Monaten wurden luxuriöse Gemächer geschaffen, die des kurz bevorstehenden Besuchs würdig waren, darunter kurzlebige Konstruktionen in deutlich orientalischem Stil, die an die Märchen aus *Tausendundeiner Nacht* erinnern.

Von Máximo Díaz de Quijano, dem Schwiegersohn des ersten Markgrafen von Comillas und Eusebi Güells Schwager, erhielt Gaudí den Auftrag, ebenfalls in Comillas ein kleines Haus zu planen. Gaudí begab sich jedoch nicht vor Ort, sondern überließ dem Architekten Cristóbal Cascante die Bauleitung.

En 1881, avant de se lancer dans le projet d'El Capricho, Gaudí construisit un pavillon dans le jardin de la maison du beau-père d'Eusebi Güell, Antonio López y López, à Comillas (Cantabrie). En collaboration avec son récent protecteur Eusebi Güell, l'architecte décida d'incorporer les tendances de décoration découvertes à l'Exposition universelle de Paris en 1878.

La petite construction fut édifiée en vue du séjour du roi Alphonse XII à Comillas, sur invitation du propriétaire. Pour recevoir dignement un hôte si illustre, M. López décida de donner de la dignité à sa résidence d'été et obtint, à cette fin, le concours de son gendre et de Gaudí. En deux mois, ils créèrent de luxueux appartements, à la hauteur des visiteurs qui les occuperaient sous peu. La construction comprenait des éléments éphémères de style oriental rappelant les contes des *Mille et une nuits*.

Par ailleurs, Máximo Díaz de Quijano, gendre du premier marquis de Comillas et beau-frère d'Eusebi Güell, demanda à Gaudí de lui dessiner une petite maison également à Comillas Gaudí ne se rendit pas sur place et confia la direction des travaux à l'architecte Cristóba Cascante.

La maison, bâtie entre 1883 et 1885 et communément appelée « El Capricho » (le caprice)

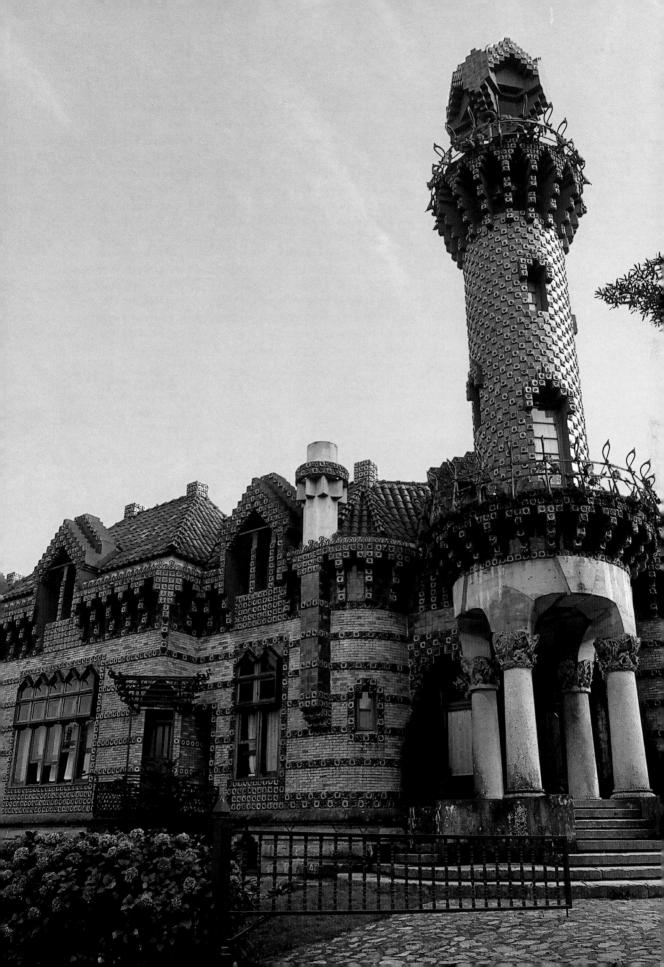

Domènech i Montaner and Joan Martorell built in Comillas.

Despite its diminutive size and more pronounced use of curved lines, El Capricho appears quite similar to Barcelona's Casa Vicens. The Moorish influence again becomes evident in the architectural style and the decorative elements contrived by Gaudí, who opted for an irregular layout with no regard for geometry. Although seemingly comprised of a main floor and a loft, the slope of the land allowed the architect to create a half-basement that turns into the ground floor at the rear of the building and connects to the adjoining garage.

The façade is composed of three superimposed sections: the lowest made of stone; the middle section, slightly wider and clad in light-coloured brick with ceramic pieces; and the roof, an interplay of geometric forms with chimneys the cylindrical forms of the main entrance, where there is a free-standing stone portico crowned by a cylindrical tower resembling a minaret. This tower, like a column shaft, is clad in green ceramic. Atop it is a small shrine

Das Haus, das gemeinhin als „El Capricho" („Die Laune") bekannt ist und zwischen 1883 und 1885 errichtet wurde, war als Sommerresidenz gedacht und fügte sich in eine Reihe von prächtigen Bauten ein, die katalanische Architekten wie Domènech i Montaner und Joan Martorell in Comillas schufen.

Trotz seiner kleinen Abmessungen ähnelt das Gebäude stark der Casa Vicens in Barcelona, wenngleich in El Capricho die gekrümmten Linien stärker im Vordergrund stehen. Erneut weisen der Baustil und die von Gaudí entworfenen Dekorationselemente einen klaren Einfluss des Mudejarstils auf. Der unregelmäßige Gebäudegrundriss ohne geometrische Linienführung scheint auf den ersten Blick aus einer Hauptetage und einem Dachboden zu bestehen. Das abschüssige Baugelände ermöglichte es jedoch dem Architekten, ein Halbsouterrain anzulegen, das auf der Rückseite des Hauses zum Erdgeschoss wird und mit der angebauten Remise verbunden ist.

Die Fassade setzt sich aus drei übereinander liegenden Streifen zusammen: der unterste ist ein steinernes Bossenwerk; der mittlere, etwas

fut pensée comme résidence d'été. Une fois achevée, elle rejoignit le bel ensemble architectural bâti à Comillas par des architectes catalans tels que Domènech i Montaner et Joan Martorell.

En dépit des dimensions réduites du bâtiment et de la place particulière accordée aux courbes, El Capricho ressemble beaucoup à la Casa Vicens de Barcelone. Là encore, le style architectural et les éléments décoratifs pensés par Gaudí révèlent une influence mauresque évidente. Le bâtiment est de forme irrégulière, étrangère aux règles de la géométrie, et ne compte en apparence qu'un rez-de-chaussée et un grenier. Toutefois, le dénivelé du terrain permit à l'architecte de créer une sorte de sous-sol à mi-hauteur, qui devient rez-de-chaussée à l'arrière et est relié au garage adjacent.

La façade est composée de trois segments superposés : le plus bas, en pierre bosselée ; celui du milieu, plus large, en brique claire agrémentée de céramiques à motifs végétaux ; le toit, jalonné d'une série de formes géométriques assorties aux cheminées et aux formes

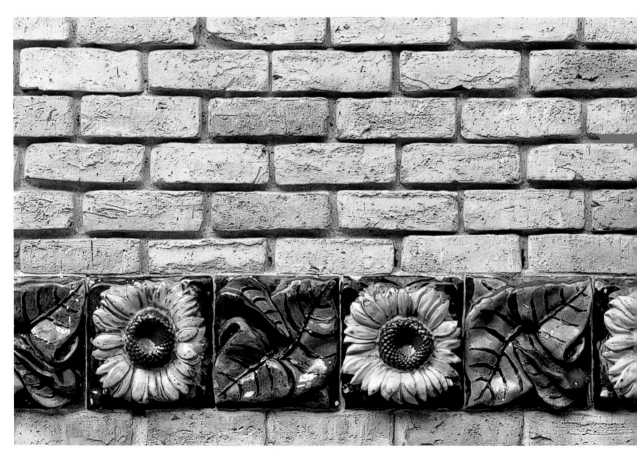

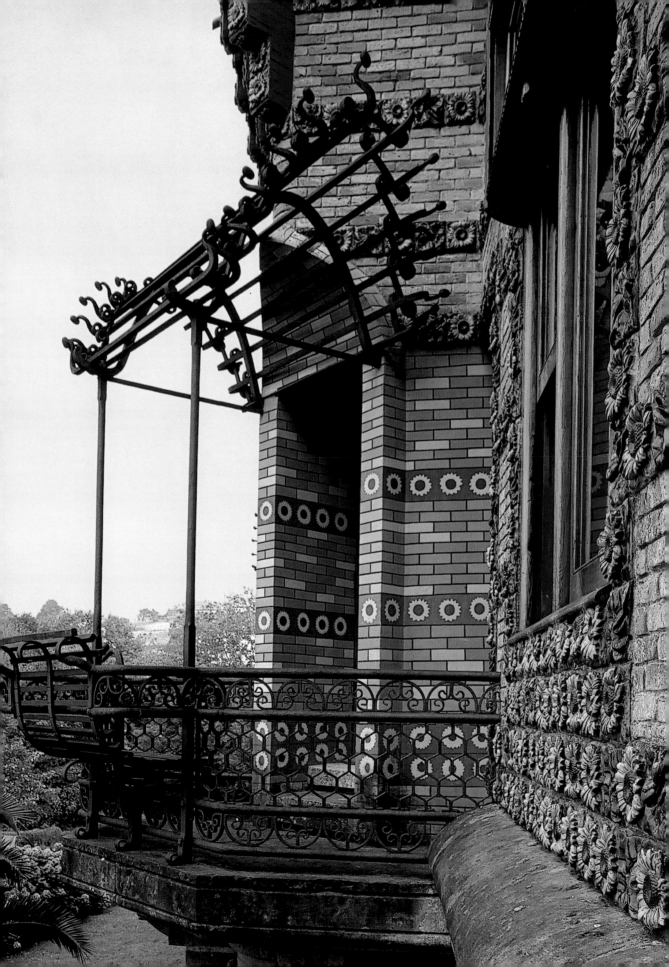

supported by four monolithic Romanesque pillars made of iron.

In keeping with his interest in mimicking nature through architecture, Gaudí covered the façade with small ceramic strips embossed with leaves and sunflowers, creating a chromatic play of green and yellow.

An original feature Gaudí used in this house is the constant reference to music, evoked by the decorative elements chosen to adorn the windows, such as the bee with a guitar or the bird on a piano, as well as the original piece made of metallic tubes used as a counterweight on the sash windows to make a pleasant sound as they open and close.

breitere Teil besteht aus hellen Ziegeln mit pflanzenförmigen Keramikstücken; das Dach besticht durch ein geometrisches Formenspiel aus den Schornsteinen und den zylindrischen Elementen des Haupteingangs, an dem sich auch der steinlose Portikus mit einem minarettartigen zylindrischen Turm befindet. Dieser Festungsturm, der einem Säulenschaft ähnelt, ist mit grüner Keramik verkleidet und trägt einen kleinen Pavillon aus vier romanisch inspirierten, eisernen Monolithsäulen.

Seinen Bestrebungen um die Verschmelzung von Architektur und Natur folgend bedeckte Gaudí die Fassade mit kleinen Keramikstreifen, die Blatt- und Sonnenblumenreliefs in einem gelbgrünen Farbenspiel aufweisen.

Ein originelles Element, das Gaudí für die Dekoration des Hauses wählte, ist der ständige Verweis auf die Musik. Dies zeigt sich in den Schmuckelementen der Verglasung – wie der Biene mit einer Gitarre und dem Vogel am Piano – ebenso wie in der originellen Struktur aus Metallrohren, die als Gegengewicht für die Schiebefenster dient und beim Öffnen und Schließen einen angenehmen Klang erzeugt.

cylindriques de l'entrée principale, où se trouve le porche en pierre, dominé par une tour ronde ressemblant à un minaret. Cette tourelle en forme de colonne est revêtue de céramique verte et coiffée d'un pinacle reposant sur quatre piliers monolithiques en fer d'inspiration romane.

Dans sa recherche de mimétisme avec la nature, Gaudí recouvrit la façade de petites bandes de céramique ornées de feuilles et de tournesols en relief, en jouant avec les couleurs vert et jaune.

L'une des originalités de la décoration de la maison est la référence constante à la musique. Celle-ci est évoquée par les éléments décoratifs choisis pour les vitraux, tels que l'abeille à la guitare ou l'oiseau au piano, ainsi que par la structure originale de tubes métalliques, qui servent de contrepoids pour les fenêtres à guillotine et émettent un son agréable lorsqu'on les ouvre ou les ferme.

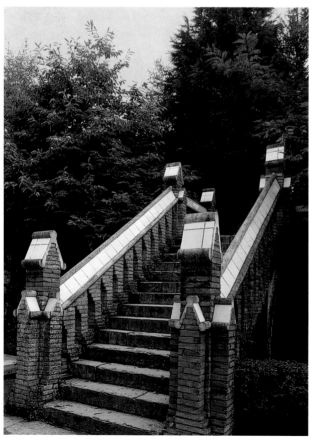 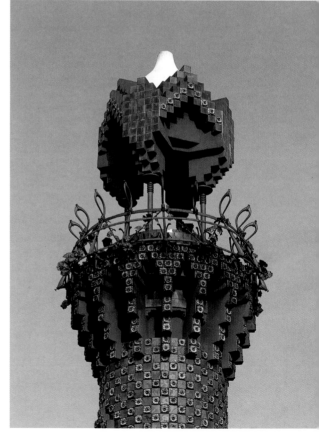

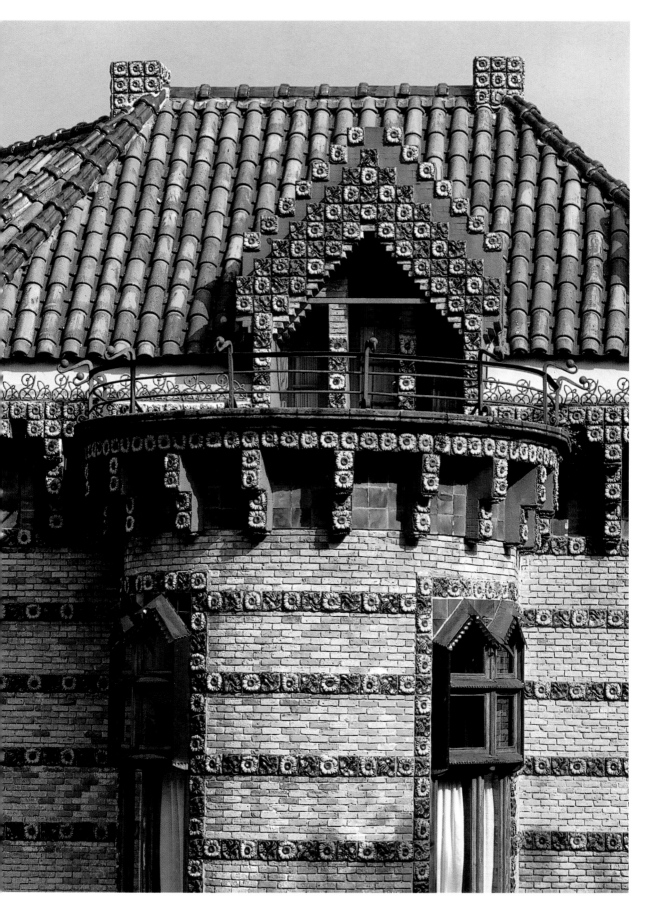

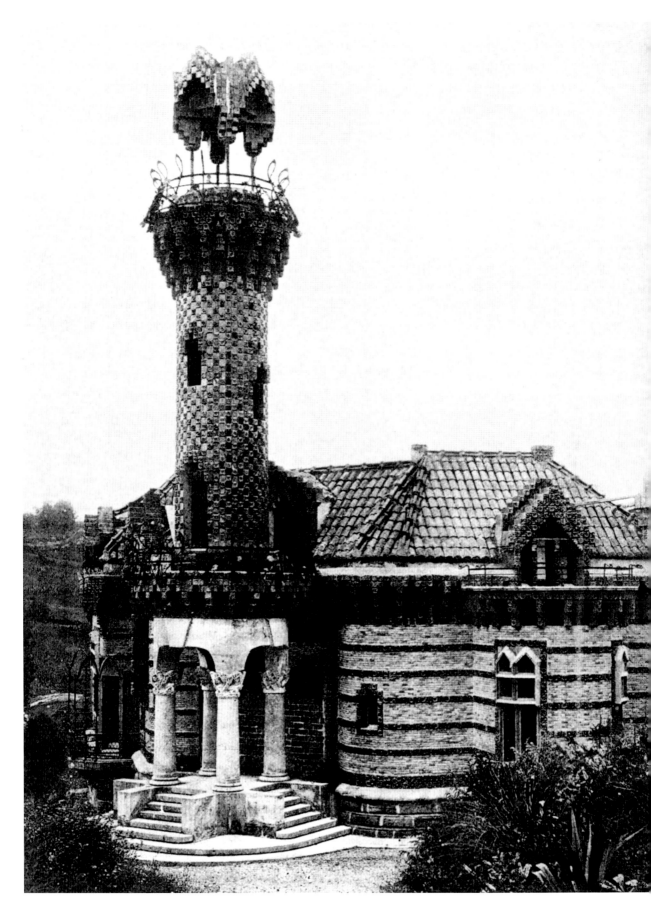

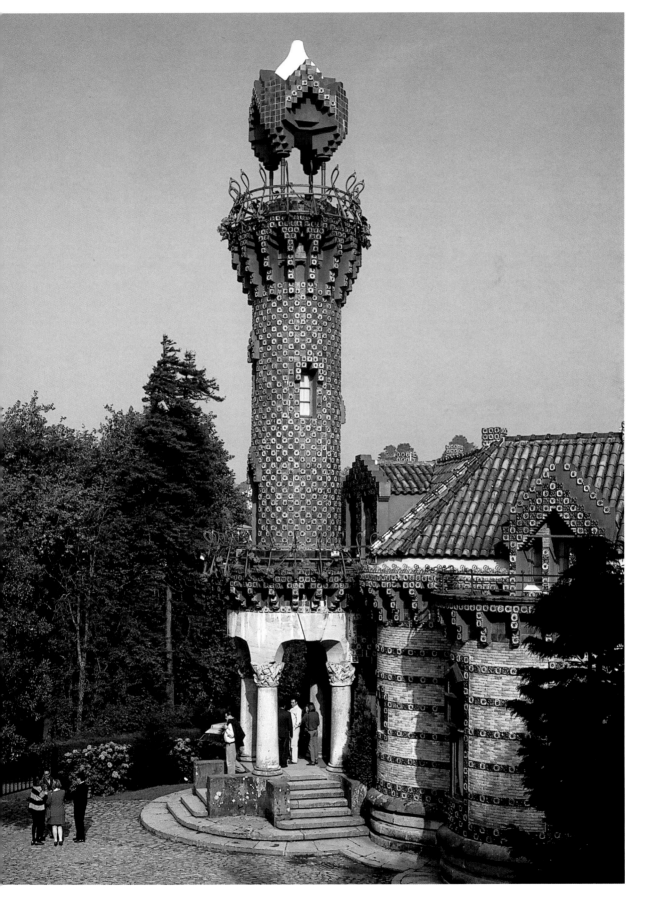

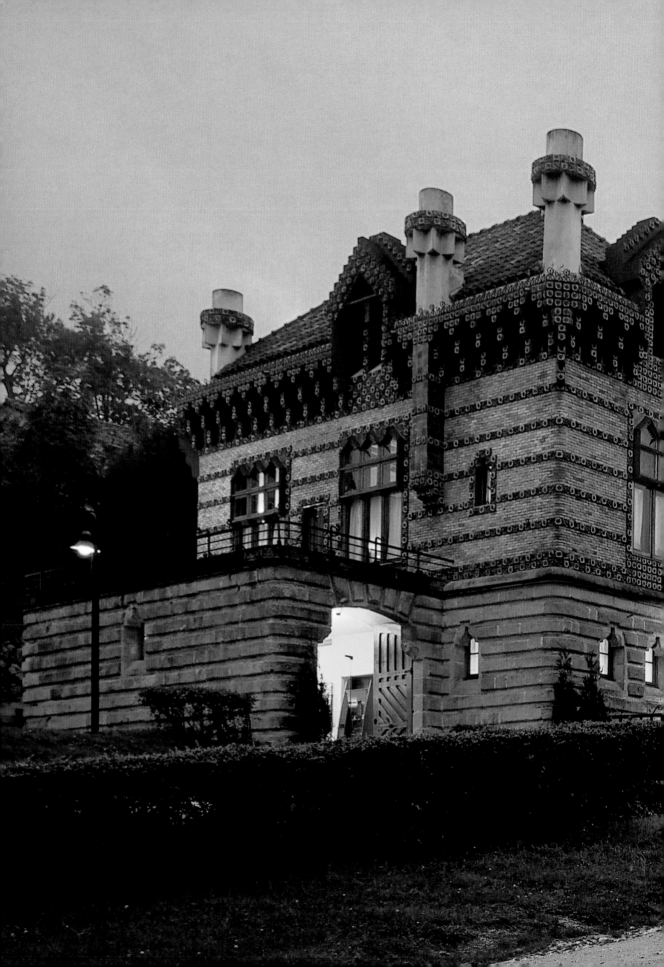

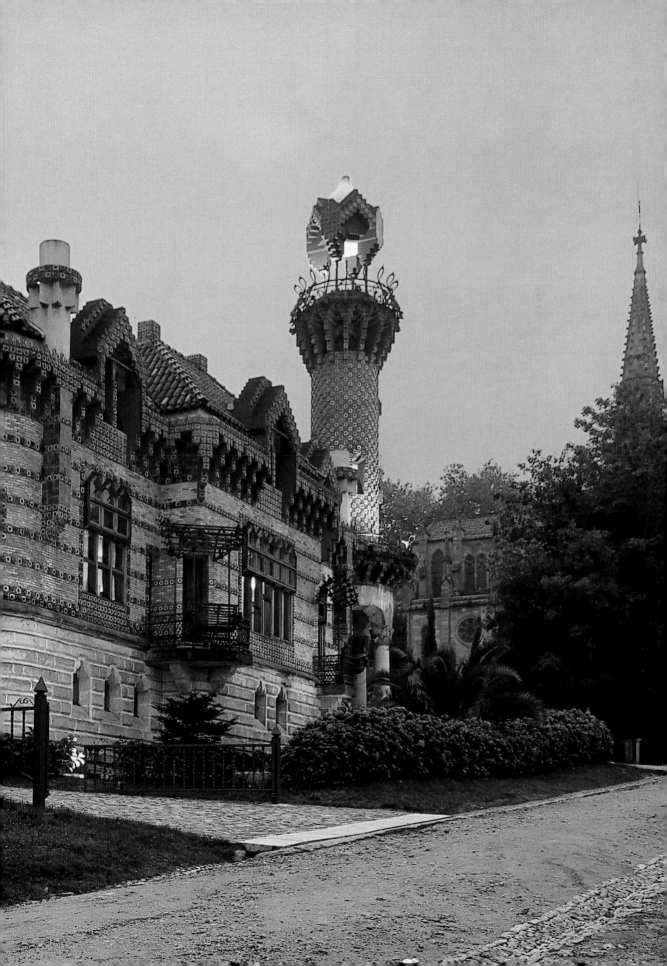

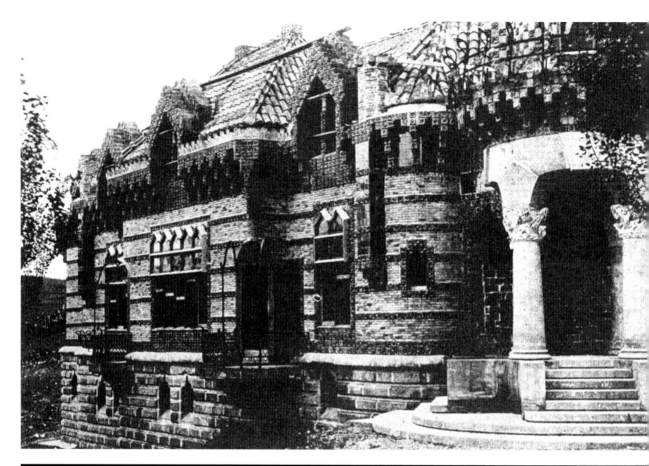

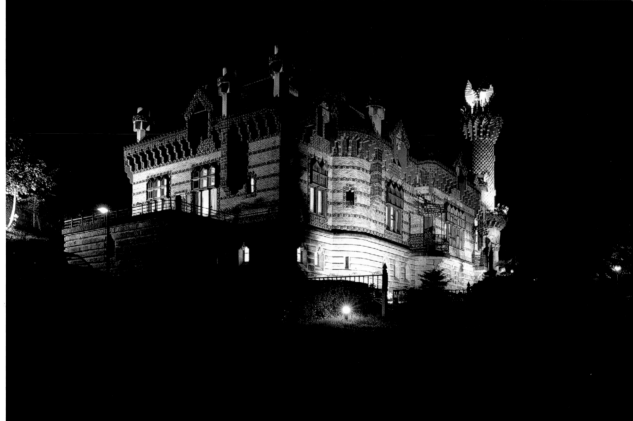

Despite the scope of the project, Gaudí never travelled to Comillas to monitor the construction work.

Trotz der außergewöhnlichen Beschaffenheit dieses Projekts begab sich Gaudí nie nach Comillas, um die Bauarbeiten zu beaufsichtigen.

Malgré l'envergure du projet, Gaudí ne se rendit jamais à Comillas pour superviser les travaux.

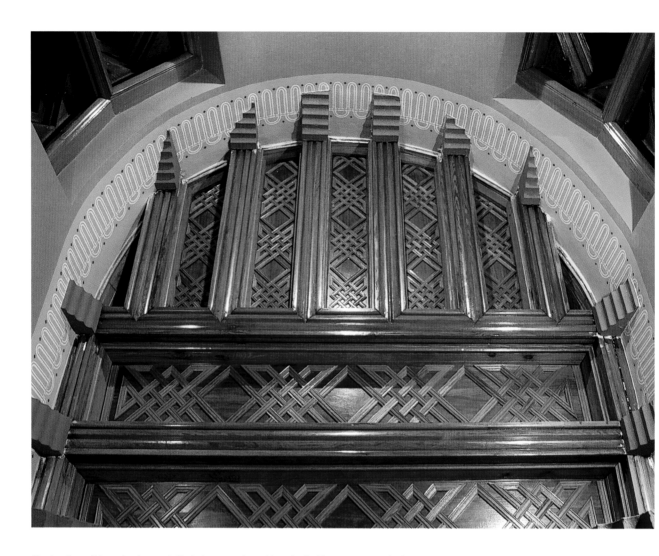

The abundance of decorative elements inside the house transforms this modest building into a great work of art.

Das Hausinnere besticht durch eine Vielzahl von Dekorationselementen, die dieses kleine Gebäude zu einem großartigen Werk machen.

La maison renferme une multitude d'éléments décoratifs, qui font de ce modeste bâtiment une œuvre majestueuse.

Today, El Capricho is a restaurant, which has ensured that its inside has been painstakingly preserved.

Gegenwärtig beherbergt El Capricho ein Restaurant. Dieser neue Verwendungszweck hat zum Erhalt des Hausinneren beigetragen.

De nos jours, El Capricho héberge un restaurant, ce qui a permis la conservation minutieuse de l'intérieur du bâtiment.

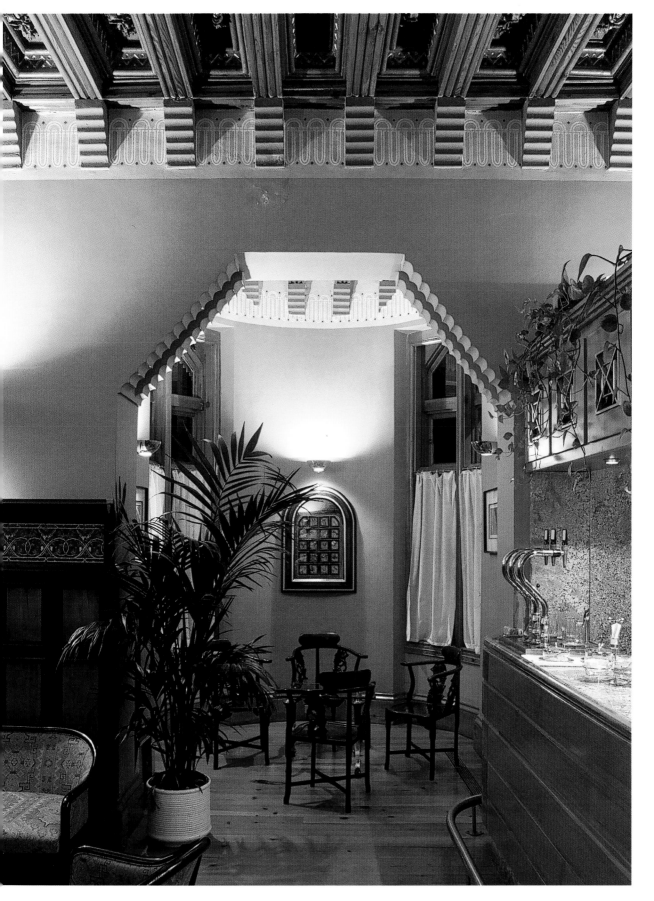

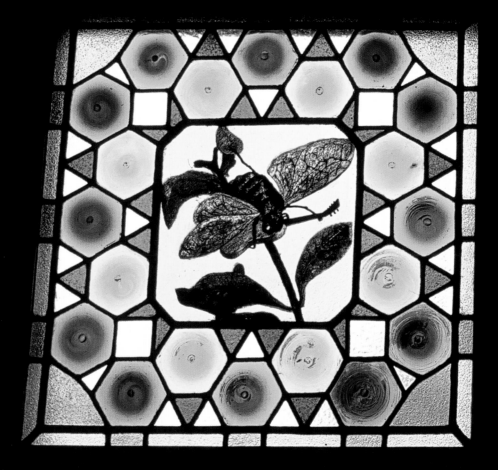

THE FINCA GÜELL IS A SPACE BRIMMING WITH MYSTERY AND ADVENTURE, STARTING AT THE VERY ENTRANCE WITH THE MAGNIFICENT PRESENCE OF THE DRAGON WATCHING OVER IT. IT IS THE FIRST WORK BY THE GAUDÍ-GÜELL DUO.

DIE FINCA GÜELL IST EINE GEHEIMNISVOLLE ANLAGE. BEI EINEM BESUCH BEGINNT DAS ABENTEUER BEREITS AM TOR, DAS VON EINEM PRÄCHTIGEN DRACHEN – DEM ERSTEN WERK DES DUOS GAUDÍ/GÜELL – BEWACHT WIRD.

LA FINCA GÜELL EST UN ENDROIT PLEIN DE MYSTÈRE, OÙ L'AVENTURE COMMENCE DÈS LA PORTE DE LA PROPRIÉTÉ AVEC L'IMPOSANTE PRÉSENCE DU DRAGON QUI LA GARDE. CETTE ŒUVRE FUT LA PREMIÈRE DU TANDEM GAUDÍ-GÜELL.

finca GÜELL, les corts

1884-1887

One of the first commissions that Antoni Gaudí received directly from his great friend Eusebi Güell was the renovation of the family's estate in Barcelona's Les Corts neighbourhood. Begun in 1884, the style and period chosen coincided with the architect's work on the Casa Vicens. Along with another project commissioned by Güell for the Transatlantic Company pavilions in the 1887 Cadiz Exhibition and the 1888 Barcelona Exhibition, the construction of the estate marked the close of Gaudí's Arabian-inspired works.

Antonio López y López, first marquis of Comillas and father-in-law of Eusebi Güell, spent long periods of time in the Finca Güell. This eminent personage was one of the patrons of poet Jacint Verdaguer, author of the renowned epic poem L'Atlàntida, which the poet dedicated to López himself. The poem narrates the mythological legend of Eurystheus, King of Mycenae, who entrusted Hercules with a series of tasks, one of which consisted of planting the Garden of the Hesperides in Spain after stealing the fruit from the real garden. The Hesperides garden was protected by a powerful dragon, Ladon, which was conquered and enchained by the Greek hero and turned into a constellation, while the three Hesperides nymphs, Aegle, Arethusa and Hesperia, were punished by the gods for their carelessness and turned into trees: a willow, an elm and a poplar.

Einer der ersten Aufträge, den Antoni Gaudí direkt von seinem guten Freund Eusebi Güell erhielt, war die Renovierung des Landguts der Familie in Barcelonas Stadtteil Les Corts. Die Bauarbeiten begannen 1884 und fielen zeitlich und stilistisch mit einem bekannten Jugendwerk des Architekten – der Casa Vicens – sowie mit einem anderen Projekt Güells zusammen: den Pavillons der Compañía Transatlántica für die Maritime Ausstellung 1887 in Cádiz und für die Weltausstellung 1888 in Barcelona. Mit den Bauarbeiten auf dem als „Finca Güell" bekannten Landgut in Les Corts beschloss Gaudí seine orientalisch geprägte Phase.

Der Schwiegervater Eusebi Güells und erster Markgraf von Comillas, Antonio López y López, verbrachte viel Zeit auf der Finca Güell. Er war einer der Schirmherren des Dichters Jacint Verdaguer, Autor des bekannten epischen Gedichts Atlantis, das López gewidmet war. Es erzählt die mythologische Legende des Eurystheus, König von Mykene, der Herkules eine Reihe von Aufgaben auferlegte. Die elfte Aufgabe lautete, den Garten der Hesperiden in Spanien anzulegen, weshalb er zuvor die Früchte des echten Gartens stehlen musste. Der Garten der Hesperiden besaß einen mächtigen Wächter, den Drachen Ladon, der von dem griechischen Helden besiegt, angekettet und in ein Sternbild verwandelt wurde. Die Hesperiden-Schwestern Aigle, Arethusa und Hesperusa wurden von den Göttern dafür bestraft, sich der „Äpfel und eines

L'un des premiers projets qu'Eusebi Güell déjà grand ami de l'architecte, commanda directement à Gaudí fut la rénovation de la propriété que la famille possédait dans le quartier de Les Corts à Barcelone. Lancés en 1884 les travaux coïncidèrent, en temps et en style avec l'autre grande œuvre de l'architecte, la Casa Vicens. Avec un autre projet que Güell confia à Gaudí pour les pavillons de la Compagnie Transatlantique à l'Exposition de Cadix en 1887 et de Barcelone en 1888, les travaux de la propriété de Les Corts furent les dernières œuvres à tendance orientale de Gaudí.

Le beau-père d'Eusebi Güell, Antonio López y López, premier marquis de Comillas, séjourna à plusieurs reprises à la Finca Güell. Cet illustre personnage était l'un des protecteurs du poète Jacint Verdaguer, auteur du fameux poème épique L'Atlantide, dédié à López. Ce poème relate la légende mythologique d'Eurysthée, roi de Mycènes, qui imposa une série de travaux à Héraclès, dont le onzième consistait à planter le jardin des Hespérides sur la péninsule ibérique après avoir dérobé les fruits du vrai jardin. Le jardin des Hespérides était défendu par un puissant dragon, Ladon qui fut battu et enchaîné par le héros grec, puis transformé en constellation ; les trois nymphes qu'abritait le jardin, Aeglé, Érythie et Hespéra, furent punies par les dieux pour leur négligence et changées toutes trois en arbres : un saule, un orme et un peuplier.

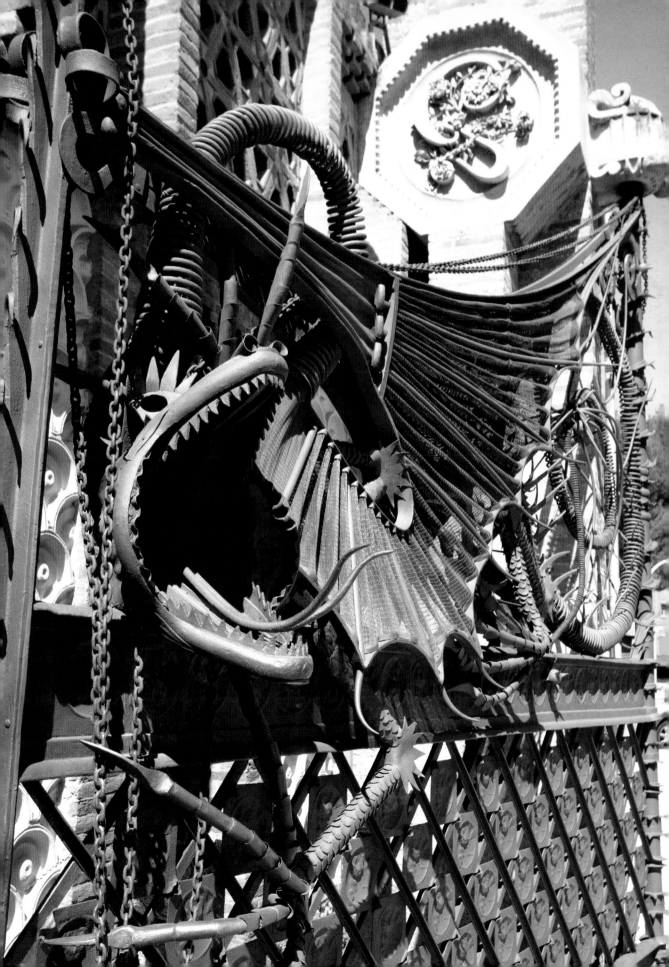

Upon the Marquis of Comillas' death in 1883, his son-in-law and Gaudí decided to honour him where he had spent so much time by converting the estate into a new Hesperides garden.

The Finca Güell (1884-1887) occupied a plot comprised of various constructions including a Caribbean-style house commissioned to Joan Martorell by Joan Güell, father of Eusebi Güell, which years later became the site of the Royal Palace of Pedralbes. Today, the only elements remaining from original property are a gate near the Les Corts cemetery and the complex built by Gaudí consisting of stables, a guarding post and a wrought iron gate that enclosed the extensive grounds on their northernmost side.

Characterised by their rectangular shape, the stables are subdivided through transversal parabolic arches that define the stalls while also performing a structural function. Made entirely of brick, these parabolic vaults rest on large arched openings that are also parabolic, making for an economic and versatile roofing system that would continue to characterise Gaudí's future works. At present it is occupied by the Càtedra Reial Gaudí, a department

Astes des Baums der goldenen Früchte" beraubt haben zu lassen, indem man sie in eine Weide, eine Pappel und eine Ulme verwandelte.

Nach dem Tod des Markgrafen von Comillas im Jahr 1883 wollten ihm sein Schwiegersohn und Gaudí an dem Ort, wo er viel Zeit verbracht hatte, ein Denkmal setzen. Daher verwandelten sie das Landgut in einen neuen Hesperiden-Garten.

Die Finca Güell (1884-1887) war ein Anwesen mit verschiedenen Bauten, darunter ein Haus im karibischen Stil, das Joan Martorell im Auftrag von Joan Güell, Eusebi Güells Vater und Eigentümer des Landguts, dort hatte errichten lassen, wo Jahre später der Königspalast Pedralbes erbaut wurde. Vom ursprünglichen Besitztum sind heute lediglich ein Tor in der Nähe des Friedhofs von Les Corts sowie ein von Gaudí entworfener Gebäudekomplex – bestehend aus den Stallungen, der Reithalle, dem Pförtnerhäuschen und dem schmiedeeisernen Tor, welches dieses große Grundstück auf der Nordseite abschloss – erhalten geblieben.

Der Aufbau der Stallungen zeichnet sich durch die rechteckigen Grundrisse und die Unter-

À la mort du marquis de Comillas, en 1883 son gendre et Gaudí voulurent lui rendre un dernier hommage à l'endroit où il avait passé de longues périodes de sa vie. Ainsi, la propriété fut transformée en un nouveau jardin des Hespérides.

La Finca Güell (1884-1887) s'étendait sur un terrain occupé par divers bâtiments, dont une maison de style caribéen que Joan Güell, père d'Eusebi et propriétaire des lieux, commanda à Joan Martorell, et qui se dressait à l'emplacement du futur palais royal de Pedralbes. De nos jours, il ne subsiste de la propriété d'origine qu'une porte à proximité du cimetière de Les Corts et le complexe dessiné par Gaudí, qui se compose des écuries, du manège, de la conciergerie et de la porte en fer forgée qui fermait la partie nord de cette vaste enceinte.

Caractérisées par leur forme rectangulaire, les écuries sont subdivisées au moyen d'arcs paraboliques transversaux, qui délimitent les stalles tout en soutenant la structure du bâtiment. Ces voûtes paraboliques, entièrement de brique, reposent sur des arcs à grand angle également paraboliques. Il s'agit d'un système

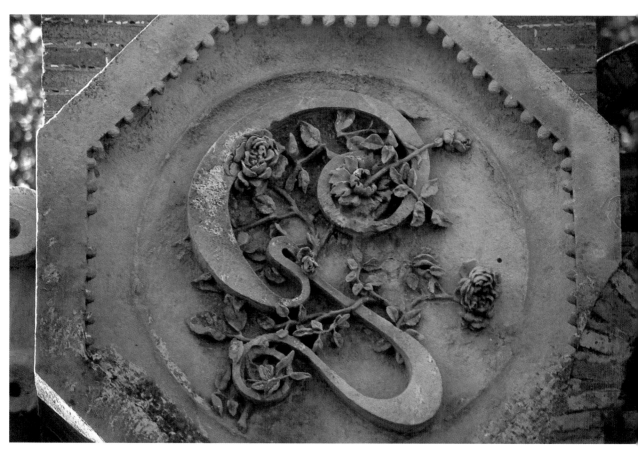

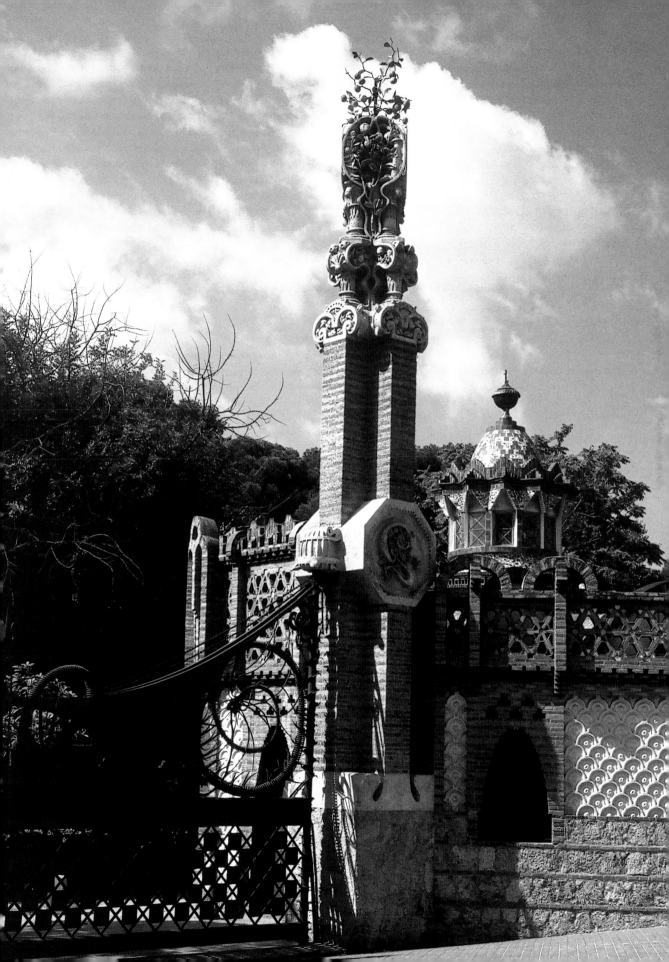

within the Polytechnic University of Catalonia that houses the largest archive on Gaudí and Modernisme. The stable is covered by a hyperboloidal dome crowned by a small oriental-style shrine. The small guarding post is topped off by three domes that house chimney-shaped ventilators.

The exterior wall features a pink and yellow striped brick wall with trefoil mouldings. The fake tiles laid on the blind wall can be viewed as a liberal interpretation of the Moorish traditional style. The upper levels of the buildings are adorned with glazed ceramic pieces from Valencia, lending a multicoloured composition to the complex. It was here that Gaudí used his renowned *trencadís* technique for the first time, although the most remarkable element of all is the spectacular gate created by the wrought-ironsmith Joan Oñós, with whom Gaudí continued to work in future projects. Measuring five meters in width, the door displays meticulous craftwork in its portrayal of the dragon Ladon. The gate is supported by a pinnacle adorned with a "G," Eusebi Güell's initial, and crowned by a structural element representing the tree and golden fruits

teilung mit transversalen Parabelbogen aus, welche die Boxen begrenzen und gleichzeitig eine tragende Funktion erfüllen. Die vollkommen aus Ziegelsteinen gefertigten Parabelgewölbe ruhen auf Parabelbogen mit großer Spannweite und bilden eine günstige, vielseitige Deckentechnik, die auch spätere Bauten Gaudís kennzeichnet. Derzeit beherbergt das Gebäude den Königlichen Gaudí-Lehrstuhl der Polytechnischen Universität Kataloniens, die das größte Archiv über Gaudí und den Modernismus beinhaltet. Die Reithalle wird von einer als Hyperboloid angelegten Kuppel überspannt, die ein stark orientalisch geprägter Pavillon abschließt. Das Pförtnerhäuschen ist von drei Kuppeln gekrönt, in denen schornsteinartige Lüfter angebracht wurden.

Im Außenbereich stechen die Ziegelmauern hervor, die aus rosarot-gelb gestreiften und verputzten Wandflächen mit Kleeblattbogen bestehen. Die Verkleidung der Blindmauer in Mosaikoptik kann als eine freie Auslegung des Mudejarstils betrachtet werden. Der obere Teil der Gebäude ist mit glasierten Keramikstücken aus Valencia verziert, die ihnen zu einer großen Farbenpracht verhelfen. Dabei machte Gaudí

de charpente économique et polyvalent que Gaudí utilisa à nouveau dans ses constructions ultérieures. Ce lieu accueille de nos jours la Chaire Gaudí de l'Université Polytechnique de Catalogne, qui renferme les plus importantes archives sur Gaudí et le modernisme. Le manège est couvert d'une coupole hyperbolique, couronnée d'un pinacle au style oriental marqué. La petite conciergerie est coiffée de trois coupoles, percées de bouches d'aération en forme de cheminées.

Les murs extérieurs sont revêtus de briques disposées en bandes de couleur rose et jaune, et de crépi décoré de motifs en alvéoles. La fausse mosaïque sur le mur aveugle peut être perçue comme une libre interprétation du style mauresque traditionnel. La partie supérieure des bâtiments est ornée de morceaux de céramique de Valence, prêtant à l'ensemble une grande polychromie. C'est dans cette construction que Gaudí utilisa pour la première fois sa fameuse technique du *trencadís*. Cependant, dans l'ensemble de l'œuvre, l'élément le plus frappant est la spectaculaire porte en fer forgée réalisée par l'artisan Joan Oñós, avec lequel Gaudí travailla plus tard sur

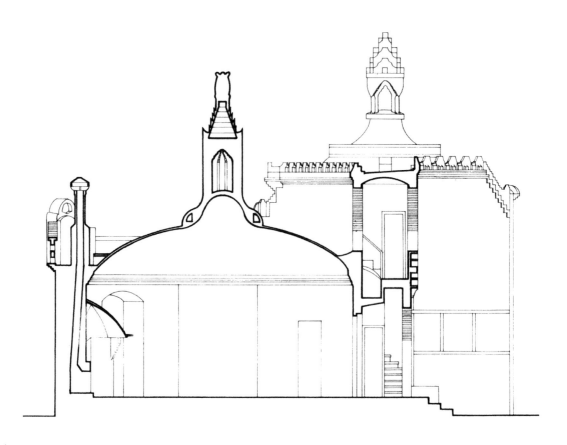

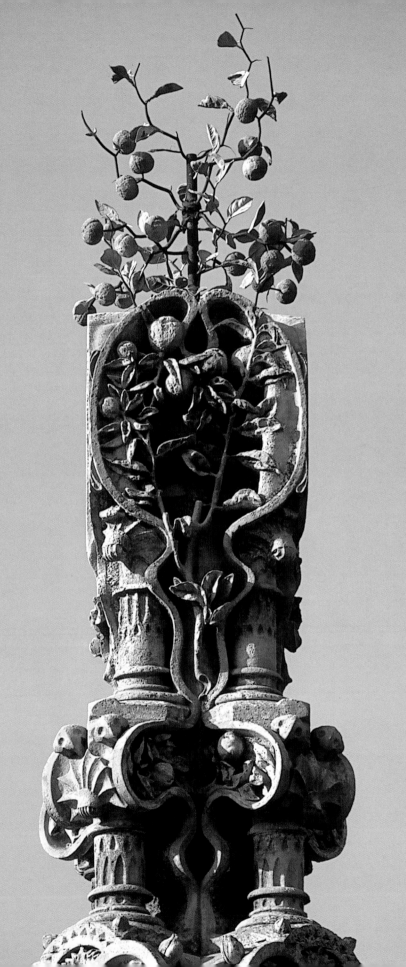

referred to in the legend. The dragon was originally polychrome, and it moved thanks to a complex mechanical system.

The eldest son of Eusebi Güell, Claudi Güell i López, donated his grandfather's Caribbean house as a present to the royal family. Between 1919 and 1925, the Barcelona town hall converted this mansion into the present-day Royal Palace of Pedralbes. It was during this conversion that many of Gaudí's interventions in the Finca Güell disappeared.

erstmals von seiner bekannten *Trencadís*-Technik Gebrauch. Aus der gesamten Anlage hebt sich vor allem das prächtige Tor des Kunstschmieds Joan Oñós ab, mit dem Gaudí auch bei späteren Projekten zusammenarbeitete. Das Tor ist fünf Meter breit und zeigt den in minutiöser Handarbeit gefertigten Drachen Ladon. Es wird von einem Türmchen getragen, das mit dem Buchstaben G, der Initiale Eusebi Güells, geschmückt und von einer Skulptur gekrönt ist, die mit einem Baum und goldenen Früchten auf die Legende des Hesperiden-Gartens anspielt. Ursprünglich war die eiserne Drachenskulptur mehrfarbig gestaltet und konnte anhand einer komplizierten Mechanik in Bewegung gesetzt werden.

Eusebi Güells ältester Sohn, Claudi Güell i López, verschenkte das karibisch anmutende Haus seines Großvaters an die Königsfamilie. Zwischen 1919 und 1925 gestaltete die Stadtverwaltung Barcelona diese große Villa in den heutigen Königspalast von Pedralbes um. Während des Umbaus verschwand ein Großteil der Werke, die Gaudí auf dem Landgut der Familie Güell geschaffen hatte.

d'autres projets. Cette pièce de cinq mètres de large, minutieusement travaillée, représente le dragon Ladon. La porte est flanquée d'une colonne parée de la lettre G, initiale d'Eusebi Güell, couronnée par une sculpture représentant l'arbre et les fruits d'or évoqués par la légende. À l'origine, le dragon était polychrome et, grâce à un système mécanique complexe, entrait en mouvement.

Le fils aîné d'Eusebi Güell, Claudi Güell i López, offrit la maison caribéenne de son grand-père à la famille royale. Entre 1919 et 1925, la mairie de Barcelone fit de cette grande bâtisse l'actuel palais royal de Pedralbes. Ce fut au cours de ces modifications qu'une grande partie des œuvres que Gaudí avait exécutées dans la propriété des Güell disparut.

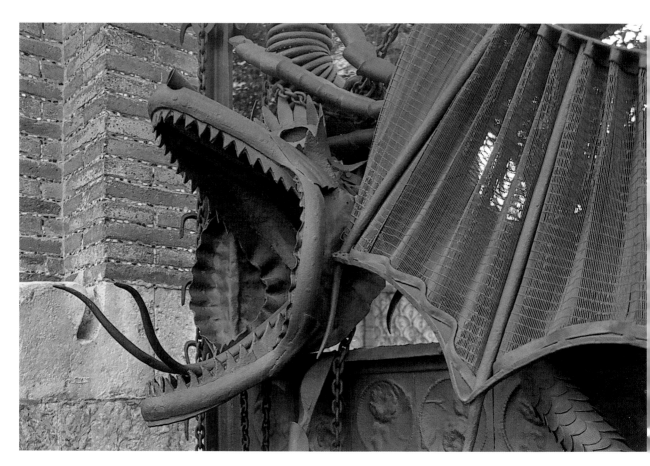

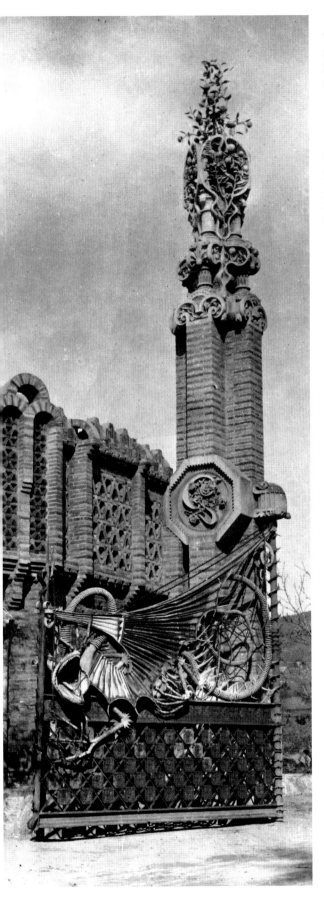

In decorating the wall surrounding the estate, Gaudí was inspired by the mythological Hesperides garden, a story that the poet Jacint Verdaguer, a close friend of López and frequent visitor to the house, included in one of his works. The dragon was charged with ensuring that nobody entered or left the beautiful garden where the three nymphs resided.

Bei der Anfertigung der Dekorationselemente an der Außenmauer des Landguts ließ sich Gaudí von der mythologischen Geschichte des Hesperiden-Gartens inspirieren, die der Dichter Jacint Verdaguer, ein enger Freund López', des Schwagers Eusebi Güells, und häufiger Gast dieses Anwesens, in einem seiner Werke behandelte. Der Drache hatte darüber zu wachen, dass niemand diesen herrlichen Garten betrat oder verließ, in dem die drei Hesperiden-Schwestern lebten.

Pour les éléments décoratifs du mur entourant la propriété, Gaudí s'inspira de l'histoire mythologique du jardin des Hespérides, légende que le poète Jacint Verdaguer, grand ami de M. López, beau-père d'Eusebi Güell et hôte assidu de la maison, évoqua dans l'une de ses œuvres. Le dragon avait pour mission d'empêcher quiconque d'entrer ou de sortir de ce beau jardin où vivaient trois nymphes.

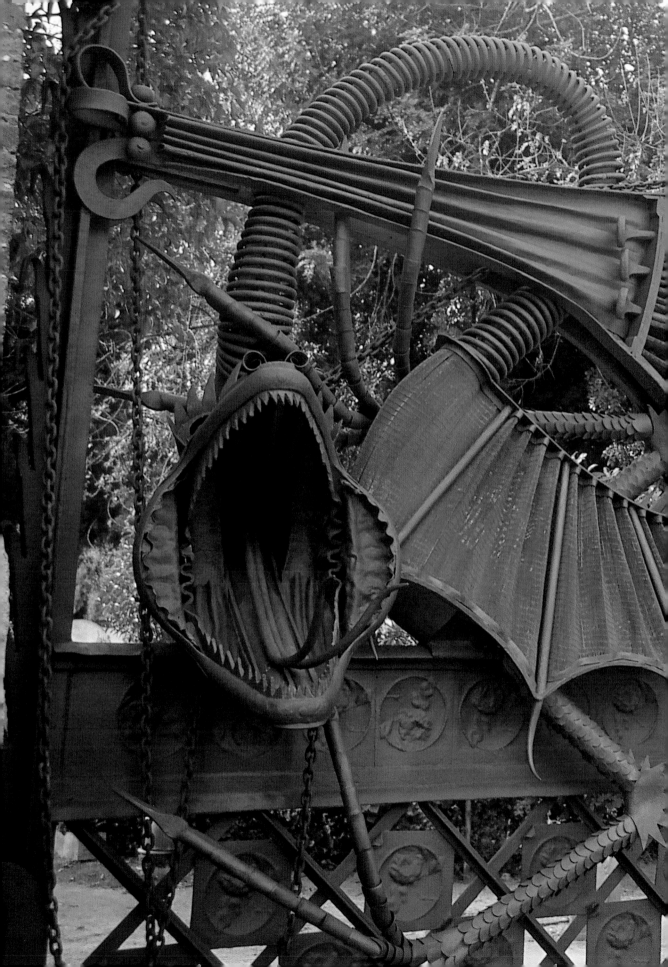

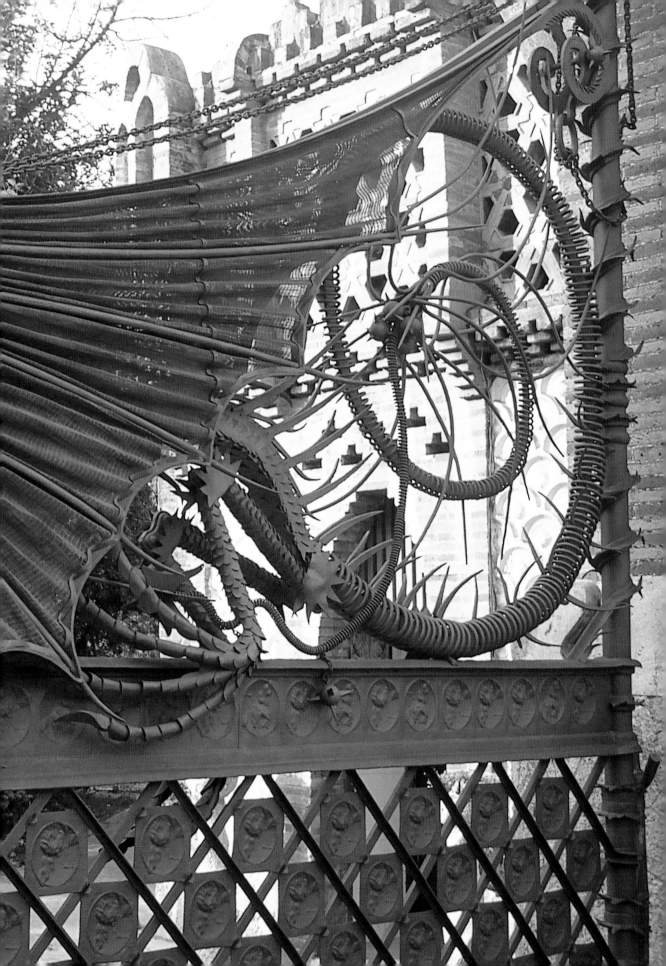

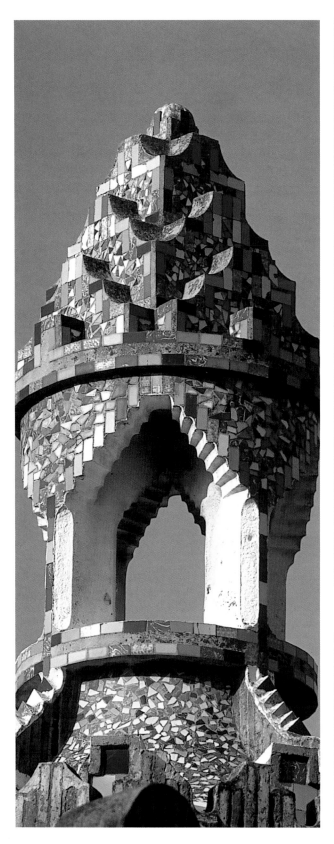
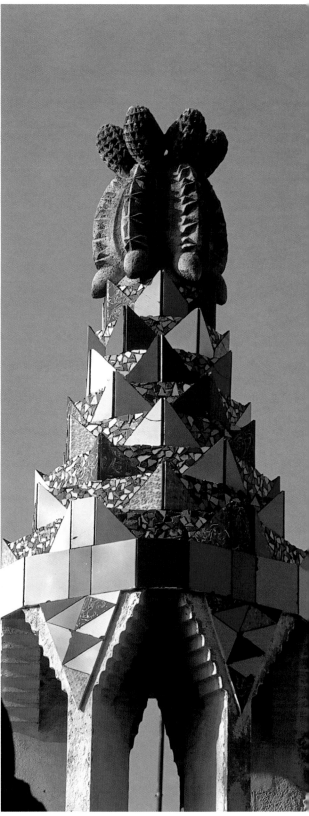

The colour blue becomes the main feature in the *trencadís*, playing with the tones found in the sky above.

Die Farbe Blau beherrscht die *Trencadís*-Arbeiten, die mit Schattierungen der Himmelsfarbe zu spielen scheinen.

La couleur bleue est devenue la protagoniste des ouvrages en *trencadís*, se fondant dans les nuances du ciel.

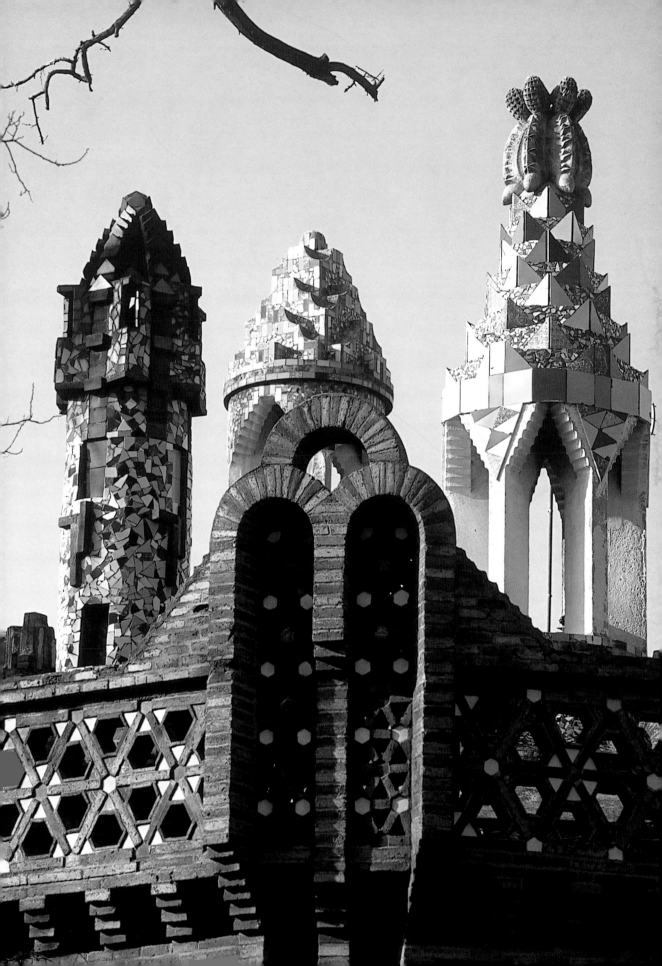

Gaudí designed all the decorative elements, including the iron grilles for the small gates leading into the estate.
Gaudí entwarf alle Schmuckelemente für die kleinen Eingangstüren des Anwesens, darunter auch die Eisengitter.
Gaudí dessina tous les éléments décoratifs (comme ces grilles de fer) des petites portes d'entrée de la propriété.

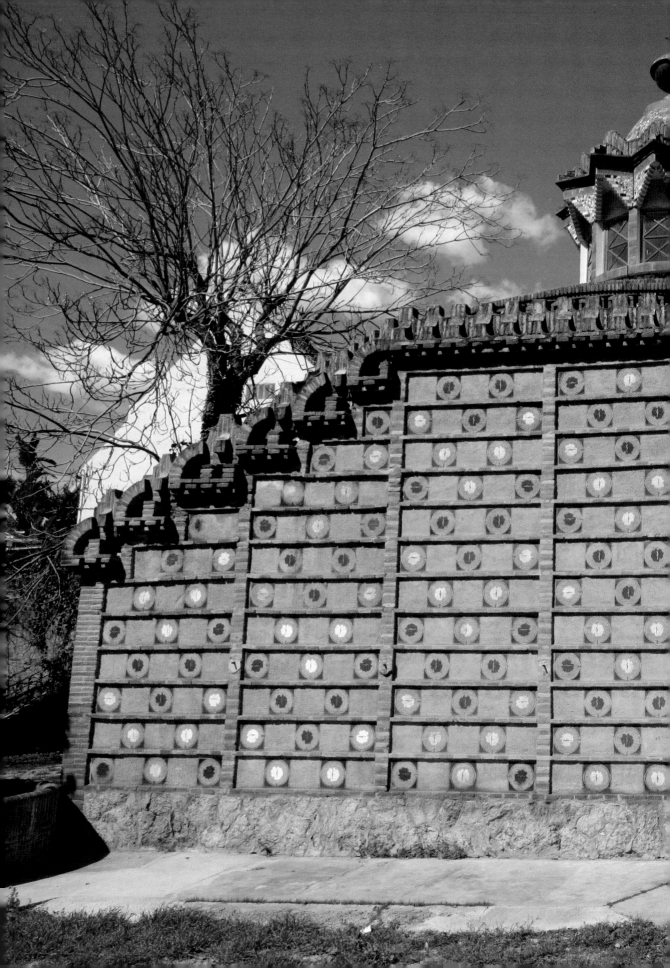

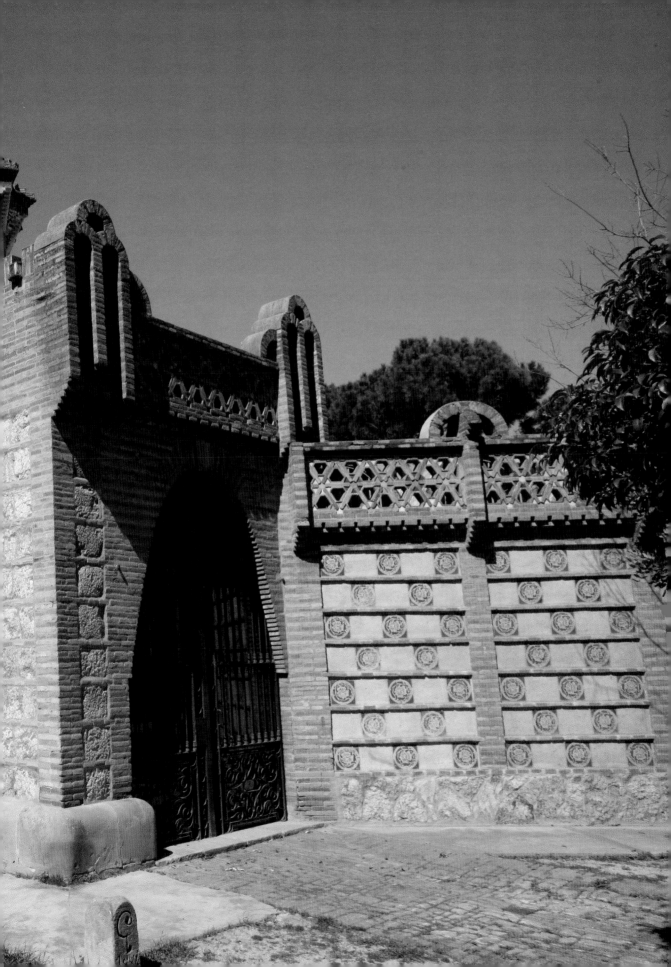

The stable pavilions have been refurbished and converted into the headquarters of the Càtedra Reial Gaudí.
Die Pavillons der Stallungen wurden renoviert und als Sitz des Königlichen Gaudi-Lehrstuhls eingerichtet.
Les pavillons des écuries ont été réaménagés pour accueillir le siège de la Chaire Gaudí.

THE LOGISTICAL AND ECONOMIC AID THAT
PATRONS PROVIDED TO ARTISTS HAS BEEN CRUCIAL
TO THE CREATION OF GREAT WORKS OF ART AND
ARCHITECTURE THROUGHOUT HISTORY.

IN DER GESCHICHTE DER KUNST UND DER
ARCHITEKTUR WAR DIE LOGISTISCHE UND
FINANZIELLE UNTERSTÜTZUNG DER KÜNSTLER
DURCH DIE MÄZENEN GRUNDLEGEND FÜR EINIGE
DER WICHTIGSTEN WERKE UND GEBÄUDE.

DANS L'HISTOIRE DE L'ART ET DE L'ARCHITECTURE,
LE SOUTIEN LOGISTIQUE ET ÉCONOMIQUE QUE
LES MÉCÈNES FOURNISSENT AUX ARTISTES A ÉTÉ
CRUCIAL POUR L'ACCOMPLISSEMENT DE CERTAINES
ŒUVRES MAJEURES.

the GÜELL family
die familie GÜELL
la famille GÜELL

The celebrated saga of the Güell family began with Joan Güell i Ferrer (1800-1872), acclaimed industrialist and mastermind of the Catalan economy. Born in Torredembarra, he moved to Cuba with his parents at a very early age. At fourteen, he returned to Barcelona as a student in the sailing school but decided to go back to the Caribbean island, where he founded a business that would earn him a fortune.

In 1836, he returned to Europe, travelling to many countries and finally settling in Barcelona, where he introduced the new industrial methods he had learned about in his travels around the continent. His status as an *indiano*, a term used to refer to those who had gone to America, especially Cuba, during the second half of the 19th century in search of fortune, led him to build a Caribbean-style house on his Les Corts estate.

After his death in 1872, his fortune and business were handed down to his son Eusebi Güell i Bacigalupi (1846-1918), who sagely followed his father's advice by preserving and creating new businesses that made him a cultivated, wealthy magnate. He studied law, economics and science in Barcelona, France and England.

His personality merged fervent religious convictions, steadfast Catalanist sentiments and a love of the arts. He founded the magazine

Begründer dieser bekannten Dynastie war Joan Güell i Ferrer (1800-1872), ein angesehener Industrieller und Verfechter der katalanischen Wirtschaftsethik. Er wurde in Torredembarra geboren und zog früh mit seinen Eltern nach Kuba. Mit vierzehn Jahren reiste er nach Barcelona, um Nautik zu studieren, kehrte jedoch auf die karibische Insel zurück, wo er eine Handelsgesellschaft, den Grundstein für sein Vermögen, gründete.

1836 kam er nach Europa, bereiste viele Länder und ließ sich schließlich in Barcelona nieder. Hier führte er neue industrielle Methoden ein, die er auf seiner Reise durch den Kontinent kennen gelernt hatte. Als „Indiano", wie man in der zweite Hälfte des 19. Jahrhunderts die Emigranten bezeichnete, die nach Amerika und vor allem Kuba auswanderten, ließ er auf seinem Anwesen in Les Corts ein Haus im karibischen Stil errichten.

Nach seinem Tod im Jahr 1872 gingen Vermögen und Geschäfte auf Sohn Eusebi Güell i Bacigalupi (1846-1918) über, der in die Fußstapfen seines Vaters trat und die Firmen erhielt und ausbaute. So wurde er zu einem reichen, kultivierten Unternehmer, der in Barcelona, Frankreich und England Jura, Wirtschaft und Naturwissenschaften studierte.

In seiner Person verbanden sich eine starke Religiosität, ein überzeugter katalanischer

La célèbre saga de la famille Güell débute avec Joan Güell i Ferrer (1800-1872), industrie de renom et cerveau de l'économie catalane Né à Torredembarra, il partit très tôt avec sa famille pour Cuba. À quatorze ans, il revint à Barcelone pour entreprendre des étude navales, mais décida bientôt de retourner à Cuba, où il fonda une société commerciale qu fera sa fortune.

En 1836, il revint en Europe et visita nombre de pays avant de s'établir à Barcelone pour de bon, où il instaura les nouvelle méthodes industrielles qu'il avait découvertes au cours de ses voyages à travers le continent. Cet « indiano », comme on appelait les personnes parties faire fortune en Amérique, et en particulier à Cuba, dans la seconde moitié du XIXᵉ siècle, se fit construire une maison de style caribéen dans sa propriété de Les Corts.

À sa mort en 1872, sa fortune et ses affaires passèrent aux mains de son fils, Eusebi Güell i Bacigalupi (1846-1918). Celui-ci, fidèle aux conseils de son père, préserva son patrimoine et créa de nouvelles entreprises, devenant ainsi un magnat riche et cultivé. Il suivit des études de droit, d'économie et de science à Barcelone, en France et en Angleterre.

Son caractère était défini par un fort sentiment religieux, associé à un catalanisme

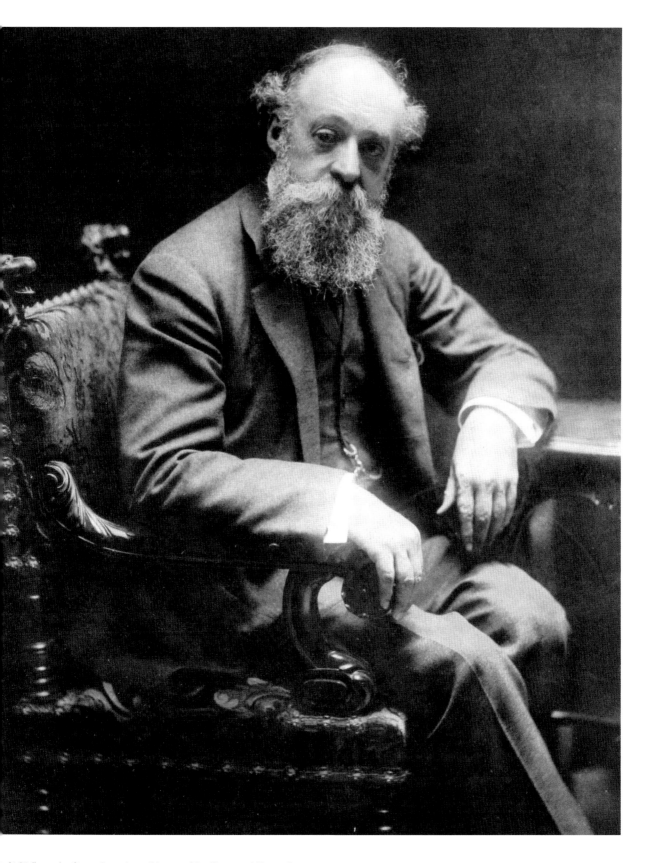

sebi Güell was a key figure who made possible some of Gaudí's most ambitious projects.

Gaudí war Eusebi Güell von ausschlaggebender Bedeutung, um einige seiner Architekturträume verwirklichen zu können.

sebi Güell fut une personne déterminante pour Gaudí, car il lui permit de concrétiser certains de ses rêves architecturaux.

La Renaixensa, dedicated to promoting the new Catalan movement.

As a highly educated man, he had a great affinity for the arts: he drew, painted, appreciated music and was familiar with European museums and monuments from his constant travels, which he embarked on for both business and pleasure. It was during one of these trips in 1878 that he travelled to Paris for the Universal Exhibition, where he came upon an exceptional display cabinet in the Spanish pavilion made of oak, wrought iron and glass, which was as beautiful as it was functional in the way it displayed the objects it contained.

Back in Barcelona, Güell visited the Comella glove shop, owners of the display cabinet he had seen, in order to find the creator of such an impressive piece. He was directed to the Puntí workshops, frequented by the young architect, and was introduced to Gaudí, with whom he would share a very close relationship for years to come until Count Güell's death in 1918. Their relationship provided Gaudí with a multitude of commissions not only from Güell, but also from other prominent industrialists including Mariano

Nationalismus und die Liebe zur Kunst. Er war Gründer der Zeitschrift *La Renaixensa*, die zur Verbreitung der neuen katalanisch-nationalistischen Strömung diente.

Güell war ein sehr gebildeter Mann und empfänglich für Kunst. Er zeichnete, malte, schätzte die Musik und kannte aufgrund ständiger Geschäfts- und Privatreisen viele europäische Museen und Sehenswürdigkeiten. Auf einer Reise besuchte er 1878 die Weltausstellung in Paris und sah eine außergewöhnliche Vitrine aus Eichenholz, Schmiedeeisen und Glas, die die darin enthaltenen Gegenstände ebenso schön wie funktional zur Schau stellte.

Wieder zurück in Barcelona suchte Güell Comella, Handschuhhersteller und Eigentümer jener Vitrine, auf, um den Schöpfer dieses beeindruckenden Möbelstücks zu ermitteln. Man verwies ihn auf die Werkstatt Puntí, wo sich der junge Gaudí regelmäßig aufhielt. Dort wurden die beiden Persönlichkeiten, deren Leben bis zum Tod des Grafen Güell im Jahr 1918 miteinander verknüpft blieben, einander vorgestellt. Diese Beziehung verhalf Gaudí zu vielen Aufträgen – von Güell selbst wie auch

convaincu et à un amour pour les arts. Il fonc le magazine *La Renaixensa*, organe de promotion du nouveau mouvement catalan.

Il s'agissait d'un érudit très versé dans le arts : il dessinait, peignait, appréciait la musiqu et connaissait une infinité de musées et de monuments européens grâce à ses nombreu voyages, motivés par des raisons tant profe sionnelles que de loisir. Ce fut au cours de l'u de ces déplacements qu'il se rendit à Paris, e 1878, pour visiter l'Exposition universelle. Da le pavillon espagnol, il fut conquis par un magnifique vitrine en bois de chêne, verre et fe forgé, dont la beauté ne l'empêchait pas d remplir à merveille son rôle de présentoir.

De retour à Barcelone, Güell se rendit chez gantier Comella, propriétaire de cette vitrine pour s'enquérir du nom de l'auteur de cet adm rable meuble. On lui recommanda de visiter le ateliers Puntí, où le jeune architecte se renda régulièrement, et où il lui fut effectiveme présenté. Dès lors, les vies de ces deux perso nages furent intimement liées, jusqu'à la mo du comte Güell en 1918. Cette relation appo ta à Gaudí de nombreuses commandes, nc

Illustrisim Sr. D. Joseph Torras y Bages

Barc. 3 juny 1914

Lo nostre amich D. Eusebi Güell

esta mal de salud y penso serel seu estat

de gravetat, parlan de aquista gravetat

al el Rnt. M. Gaspar Vilarrubias, me

ha significat tal vegada fora convenient

lo escriure á V. J., el estat del nostre

amich, com ho faig en le present, para

dir á V. J. que M. Vilarrubias y son

servidor estam á le disposició de V. J. si

creu convenient fer quelcom.

Besant l'anell y deman le benedicció

s. s. s. Antoni Gaudí

Letter sent by Gaudí notifying bishop Josep Torras i Bages of Güell's frail health.
Gaudís Brief an den Bischof Josep Torras i Bages, in dem er diesen über den bedenklichen Gesundheitszustand Güells unterrichtet.
Lettre de Gaudi envoyée à l'évêque Josep Torras i Bages pour lui communiquer le grave état de santé de Güell.

Andrés, Eduard Calvet, Josep Batlló and Pere Milà, who became his most important clients after being introduced to them by Güell.

In 1871, Eusebi Güell married Isabel López Bru, daughter of Antonio López y López, first Marquis of Comillas, thus joining the two wealthiest families of Catalonia. The couple had several children but it was the eldest son, Claudi, together with Santiago Güell i López – both of whom had taken up industrial studies in England and Germany – who were made responsible for the colony owned by the family in Santa Coloma de Cervelló.

Over the years, Eusebi Güell became a distinguished figure in late 19th and early 20th century Catalan society, to the extent that he was even bestowed a noble title from King Alfonso XIII in 1910.

Eusebi was not the only great patron of the city of Barcelona; so, too, was Claudi Güell, who donated his Caribbean-style mansion on the Güell estate to the royal family. The building, renovated by the town hall between 1919 and 1925, is now the site of the Royal Palace of Pedralbes.

von bekannten Industriellen, wie Mariano Andrés, Eduard Calvet, Josep Batlló und Pere Milà, die er dank Güell als Kunden gewann.

Im Jahr 1871 heiratete Eusebi Güell Isabel López Bru, die Tochter des ersten Markgrafen von Comillas, Antonio López y López, und vereinte damit zwei der reichsten Familien Kataloniens. Das Paar hatte mehrere Kinder, von denen Claudi, der älteste Sohn, und Santiago Güell i López – beide hatten Ingenieurwesen in England und Deutschland studiert – die Arbeitersiedlung der Familie in Santa Coloma de Cervelló weiterführten.

Im Laufe der Jahre wurde Eusebi Güell zu einer herausragenden Persönlichkeit der katalanischen Gesellschaft um die Jahrhundertwende und erhielt 1910 sogar einen Adelstitel von König Alfons XIII.

Claudi Güell war wie Eusebi Güell ein guter Mäzen für Barcelona, denn er schenkte der Königsfamilie die „karibische" Villa, welche die Stadtverwaltung zwischen 1919 und 1925 renovieren und in den heutigen Königspalast von Pedralbes umwandeln ließ.

seulement de Güell lui-même, mais aussi d'autres industriels de renom que ce dernier lui présenta, tels que MM. Andrés, Calvet, Batlló et Milà, qui devinrent ses plus importants clients.

En 1871, Eusebi Güell se maria avec Isabel López Bru, fille d'Antonio López y López, premier marquis de Comillas, unissant ainsi deux des plus riches familles de Catalogne. Le couple eut plusieurs enfants, mais ce fut Claudi, l'aîné, et Santiago Güell i López (tous deux avaient suivi des études industrielles en Angleterre et en Allemagne) qui furent chargés de la colonie que la famille possédait à Santa Coloma de Cervelló.

Au fil des ans, Eusebi Güell devint un personnage très influent de la société catalane de la fin du XIXe siècle et du début du XXe, à tel point que le roi Alphonse XIII lui accorda un titre de noblesse en 1910.

Eusebi ne fut pas le seul grand mécène de la famille à Barcelone. Claudi Güell, par exemple, céda la maison « caribéenne » de la Finca Güell à la famille royale. La mairie se chargea de la modifier entre 1919 et 1925 pour en faire l'actuel palais royal de Pedralbes.

DON EUSEBIO GÜELL Y BACIGALUPI,

Fabricante, Comerciante, Industrial, Presidente y Vice-Presidente de varias Sociedades y Compañias,

Miembro de la Academia de Medicina de Barcelona, Individuo de la Academia de Bellas-Artes

de la misma ciudad y Jefe de la Casa Industrial que gira bajo la razón social de "Güell y Compañia".

BARCELONA.

 arcelona, hermosa ciudad Catalana é importantísimo puerto español, se honra con poder contar como su ciudadano genuino desde el 15 de Diciembre de 1846 al ilustre y benemérito D. Eusebio Güell y Bacigalupi. Fueron sus padres D. Juan Güell y Ferrer, economista cuya estátua, erigida por suscricion popular, se encuentra en una de las principales vias de Barcelona, y Dª Francisca Bacigalupi. La familia Güell es oriunda de la Provincia de Tarragona (Cataluña) y la familia Bacigalupi lo es de Génova (Italia).

Al terminar sus estudios preliminares, siguió los preparatorios, visitando las aulas para los estudios generales de Ciencias sociales, Derecho, Economia politica, Ciencias fisico-quimicas y Matemáticas, estudios que efectuó en España y Francia.

D. Eusebio Güell fué concejal en 1875 y Diputado Provincial en la misma ciudad en 1878. Entre los muchos cargos honorificos que ha tenido y tiene, mencionaremos tan sólo los siguientes por no disponer de espacio suficiente para relatarlos detalladamente: fué presidente del antiguo "Centre Catalá" y presidente tambien de los "Jochs Florals de Barcelona"; en la actualidad es Presidente de la "Compañia General de Asfaltos y Portland" creada por el mismo, Vice-Presidente de la "Sociedad de Crédito Mercantil", Vice-Presidente de la Sociedad de Seguros "Banco Vitalicio", Miembro del Consejo de Administración de los "Ferrocarriles del Norte de España", de la "Compañia Trasatlántica", de la Compañia General de Tabacos de Filipinas", del "Banco Hispano-Colonial", Individuo de la Comision organizadora de los "Somatenes armados de Cataluña", Individuo de la "Comision mixta encargada de la Reforma de Barcelona", Miembro honorario de la "Academia de Medicina y Farmacia de Barcelona", Miembro de la "Academia de Bellas-Artes" de la misma ciudad y Jefe de la Casa industrial "Güell y Cia".

Se ha dado á conocer como escritor de vastos conocimientos cientificos con su obra "L'Immunité par les Leucomaïnes" publicada en Paris, la 1ᵉʳᵃ edición en 1886 y la 2ª en 1889: en este mismo año fué traducida al inglés en Nueva-York, y entre otros autores se ocupa de esta obra Mʳ Henri Soulier en su "Traité de Thérapeutique et de Pharmacologie".

Notable es tambien el discurso leido por el Sr. Güell en los "Juegos Florales de Barcelona" en 1890, en el que se estudia el origen de las lenguas romanches y particularmente del catalán, como anteriores al latin clásico.

La "Colonia Güell", fundada por nuestro biografiado, forma hoy una verdadera población y está dotada de Iglesia, Escuelas, Teatro, Servicio médico y farmaceutico, Ateneo, Cooperativa, Fonda, Café, Sociedades Corales etc etc. En dicha Colonia, situada en el término de Santa Colonia de Cervello, cerca de Barcelona, trabajan mas de mil obreros empleados en su fábrica de tejidos de algodon, corriendo su direccion á cargo de los hijos del Sr. Güell, D. Claudio y D. Santiago. Merece ser mencionado el honroso acto de caridad realizado en Abril de 1905 por dichos Directores, D. Claudio y D. Santiago, el Capellán de la Colonia y 35 de los obreros empleados en la misma, los cuales ofrecieron tiras de su piel para ingertarlas en el cuerpo de un niño de 14 años, empleado en la Colonia, que se cayo en un algibe lleno de tinte á una elevadisima temperatura y que, gracias al heroico sacrificio de los Directores, el Capellán y sus Compañeros, fué dado de

alta en perfecto estado de curacion despues de haber permanecido cerca de un año en el Hospital del „Sagrado Corazón" de Barcelona.

Además de la „Colonia Güell", débese tambien á dicho Sr. la creacion de la importante „Compañia General de Asfaltos y Portland" cuya fábrica, saltos de agua y minas de carbon y asfalto radican en el pueblo de La Pobla de Lillet, al norte de Cataluña.

El ensanche de Barcelona debe tambien al Sr. D. Eusebio Güell el Parque que lleva su nombre y que por su originalidad y hermosura llama poderosamente la atencion de cuantos lo visitan y muy especialmente de los turistas extranjeros. — El „Parque-Güell", como tambien el palacio que dicho Señor habita en la calle del Conde del Asalto, ha sido construido por el arquitecto D. Antonio Gaudi á quién deberá Barcelona la magnífica basilica de la „Sagrada Familia" hoy en construccion.

Catalán ilustre y amante de su patria, el Señor Güell, inspirado en elevados sentimientos de cultura, ha dado notable impulso al desenvolvimiento artistico del país, con la ereccion de su casa-palacio, del Parque de su nombre y otras obras, en las cuales ha empleado directores tan eminentes como el Señor Gaudi, con la cooperacion de otras distinguidas personalidades, todas catalanas, que han impreso un remarcado sello de originalidad, buen gusto y notoriedad á esas construcciones que honran tantó á la ciudad de Barcelona, por ia que siente el Señor Güell deseos inextinguibles de engrandecimiento y en la cual vive rodeado del respeto y consideracion de sus conciudadanos

The articles published in the press at that time demonstrate the social and economic importance of the Güell family.

Die in der damaligen Presse veröffentlichten Artikel verdeutlichen die gesellschaftliche und wirtschaftliche Bedeutung der Familie Güell.

Les articles publiés dans la presse de l'époque sont révélateurs de l'importance sociale et économique de la famille Güell.

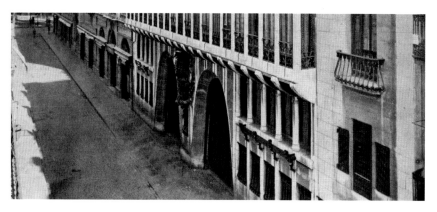

GÜELL palace
der palau GÜELL
palais GÜELL

1886-1888

THE ORIGINAL GÜELL PALACE LOCATED IN THE CENTRE OF BARCELONA IS THE RESULT OF A JOINT EFFORT AND THE MERGING OF IDEAS OF THE OWNER, EUSEBI GÜELL AND THE ARCHITECT, ANTONI GAUDÍ.

DER ORIGINELLE PALAU GÜELL IM HERZEN BARCELONAS IST DEN VEREINTEN KRÄFTEN UND IDEEN DES BESITZERS, EUSEBI GÜELL, UND DES ARCHITEKTEN, ANTONI GAUDÍ, ZU VERDANKEN.

LE PALAIS GÜELL, ÉDIFICE UNIQUE SITUÉ AU CŒUR DE BARCELONE, EST LE FRUIT D'EFFORTS CONJUGUÉS ET D'UN MARIAGE D'IDÉES ENTRE LE PROPRIÉTAIRE EUSEBI GÜELL ET L'ARCHITECTE ANTONI GAUDÍ.

Desiring a space in which to host artsy social gatherings that the Güell family so loved, they commissioned Gaudí to design an extension of their house on Comte de l'Assalt Street next to their home on the Ramblas of Barcelona. The palace, built between 1885 and 1889, became a prominent cultural centre for the Catalan upper class that attended the events organised during those years. Eusebi Güell, who longed for a building unlike any other within the noble and bourgeois late 19th century city, entrusted the project to his "dream" architect, who aided him in reaching his objective. The residential palace occupied a small plot on a very narrow street, a condition that did not impede Gaudí, who worked in conjunction with Francesc Berenguer in creating a magnificent, richly endowed building. Initially designed as a reception hall, the building had an inner courtyard joining the palace and the house on the Ramblas. From the very beginning, Gaudí displayed great enthusiasm for the project, for which he designed over 25 façades. The architect looked for inspiration in the grand palaces constructed towards the end of the mediaeval period that began to display Renaissance influences.

The building is entered through two doorways featuring catenary arches and closed by imposing wrought iron doors. The large entrance hallway is divided by a main stairwell, behind which is a coach house with two ramps

Beim Ausbau des Hauses in der Carrer Comte de l'Assalt, neben dem Familiensitz an den Ramblas von Barcelona, beauftragte die Familie Güell Gaudí mit einem fürstlich anmutenden Bauwerk für die von der Familie hoch geschätzten Künstlertreffen. Der Palast wurde zwischen 1885 und 1889 errichtet und entwickelte sich zu einem bedeutenden Kulturzentrum für die katalanische Oberschicht, die den zu jener Zeit dort abgehaltenen Veranstaltungen beiwohnte. Eusebi Güell wünschte sich ein besonderes Gebäude, ganz anders als die anderen Bauten im adeligen und bürgerlichen Barcelona des ausgehenden 19. Jahrhunderts, und setzte daher auf Antoni Gaudí, seinen „Traumarchitekten". Das Palasthaus stand auf einem kleinen Grundstück, was jedoch für Gaudí keinerlei Hindernis darstellte. So schuf er zusammen mit Francesc Berenguer einen herrlichen, reich ausgestatteten Entwurf. Da der Neubau zunächst als eine Art Empfangssaal geplant war, wurde anfangs ein nach innen gerichteter Laubengang geplant, der den Palast mit dem Haus an den Ramblas verbinden sollte. Gaudí zeigte eine solche Begeisterung für dieses Projekt, dass er über 25 Fassaden zeichnete. Der Architekt ließ sich von den großen Palästen des späten Mittelalters inspirieren, in denen sich bereits die ersten Renaissanceeinflüsse abzeichneten.

Der Zugang zum Gebäude erfolgt über zwei Portale, die aus Kettenbogen bestehen und mit eindrucksvollen schmiedeeisernen Türen

Pour l'agrandissement de sa maison de la rue Comte de l'Assalt, proche de son autre résidence sur la promenade des Ramblas de Barcelone, la famille Güell chargea Gaudí d'exécuter une œuvre somptueuse pour accueillir les rassemblements artistiques que cette famille affectionnait tant. Le palais, construit entre 1885 et 1889, devint un centre culturel de grande importance pour la haute société catalane qui fréquentait les réunions qui y étaient organisées. Eusebi Güell voulait un édifice singulier, qui ne ressemblât à aucun autre dans la Barcelone noble et bourgeoise de la fin du XIXᵉ siècle. Pour la réalisation de son « rêve », il misa sur Antoni Gaudí. Le palais résidentiel devait se dresser sur un terrain étroit, mais cet emplacement ne fut pas une entrave pour Gaudí qui, en collaboration avec Francesc Berenguer, réalisa un bâtiment magnifique et d'une grande richesse. Initialement conçu comme salle de réception, l'immeuble était doté d'une galerie intérieure le long de l'îlot pour relier le palais à la demeure des Ramblas. Gaudí fit preuve de tant d'enthousiasme pour le projet qu'il dessina plus de 25 façades différentes. L'architecte s'inspira des grands palais construits à la fin du Moyen Âge, précurseurs du style Renaissance.

Pour accéder au bâtiment, il faut franchir l'un des deux portails à voûtes paraboliques, clos par d'imposantes portes en fer forgé. À l'intérieur, le vestibule à double système de

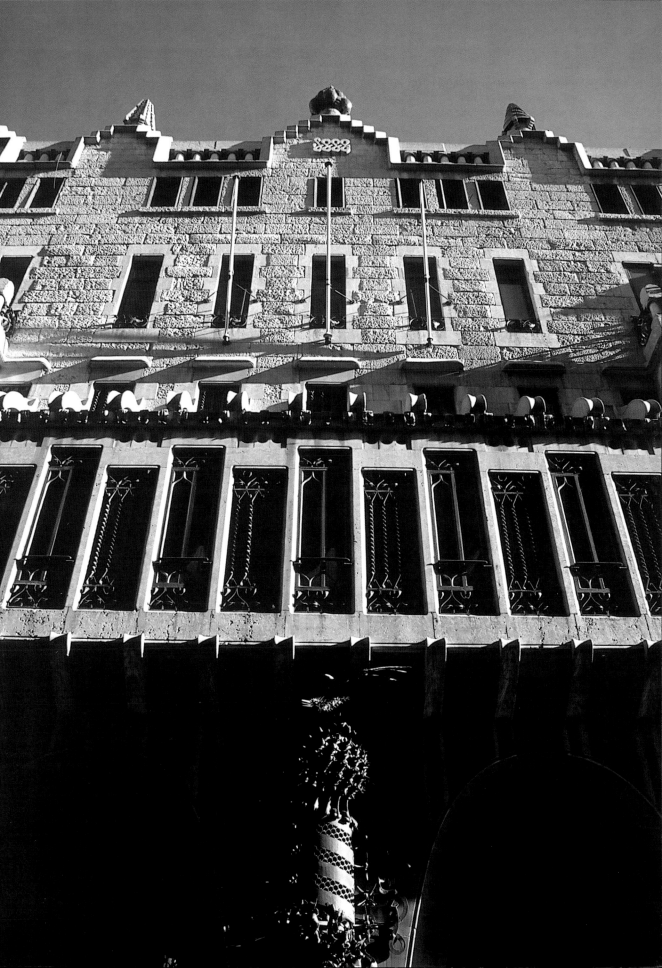

(one of which is spiral-shaped and located in the geometric centre of the floor) that descends to the stables in the basement. The flooring of the ramps was fashioned out of pine wood. The basement is dominated by the presence of solid mushroom-shaped pillars made of brick, whose robustness supports the entire building. The ground floor is characterized by a spatial sequence of halls and antechambers. The main hall, situated in the middle, occupies a grand, triple-height space intersected by lateral openings that allow for both horizontal and vertical spaces within the building. The parabolic volume, inspired by the dome of the Hagia Sofia in Constantinople, creates a blue vault that symbolizes a star-studded sky. The grand salon is furnished with a prayer cabinet and organ. The inner space also serves as a courtyard for the house: the upper floors (with bedrooms and services) look out over it, separated by balustrades and lattices which allowed the Güell family to observe their guests without being seen. The design of the main façade of the building is rectangular with a clearly asymmetric and horizontal layout. Of note are its catenary-shaped porticos and the meticulously wrought iron

verschlossen sind. Ebenso bemerkenswert ist das doppelte Vestibül, unterteilt durch eine Haupttreppe, hinter der sich die Remise mit zwei zu den Kellerstallungen führenden Rampen – darunter eine spiralförmige Rampe mit geringem Drehwinkel im geometrischen Mittelpunkt des Geschosses – befindet. Der Boden dieser Rampen wurde in Kiefernholz ausgeführt. Im Keller dominieren massive pilzförmige Ziegelpfeiler, deren stabiler Aufbau die gesamte Gebäudestruktur trägt. In der Nobeletage befinden sich die Säle und Vorsäle, die eine Abfolge von Räumen bilden. In der Mitte des Hauptsaals erhebt sich die Decke auf dreifache Geschosshöhe und erzeugt einen großen Raum mit zahlreichen Öffnungen, die das Gebäude horizontal und vertikal strukturieren. Anhand dieses Paraboloids wurde eine blaue Kuppel geschaffen, die einen Sternenhimmel symbolisiert und von der Hagia Sophia in Konstantinopel inspiriert wurde. Der große Salon enthält einen Gebetsschrank sowie eine Orgel und diente gleichzeitig als Innenhof des Hauses, da er die oberen Geschosse, in denen sich Schlafzimmer und Toiletten befinden, vertikal durchzieht. Gitter bzw. Geländer trennten diese Geschosse voneinander ab und ermöglichten

circulation est divisé par l'escalier principal. Derrière celui-ci, une porte cochère mène à deux rampes (l'une d'elles, en pente raide et de forme hélicoïdale, se trouve au centre géométrique de ce niveau) conduisant aux écuries du sous-sol et revêtues d'éléments en bois de pin. Au sous-sol, les imposants piliers en briques, en forme de champignons, soutiennent, par leur robustesse, la structure intégrale du bâtiment. À l'étage noble, les salons et les antichambres se succèdent en enfilade. Au centre du salon principal s'ouvre un vaste espace distribué sur trois niveaux, jalonné de nombreuses ouvertures latérales qui façonnent la structure horizontale et verticale du bâtiment. Ce salon est couronné d'une coupole parabolique bleutée évoquant un ciel étoilé et qui s'inspire de la coupole de la basilique Sainte-Sophie d'Istanbul. Le grand salon dispose d'un petit oratoire et d'un orgue. Cet espace intérieur fait également office de cour intérieure de la maison : les étages supérieurs (chambres et service), isolés par des treillis ou des balustrades, donnent sur ce salon, ce qui permettait aux Güell d'observer leurs invités sans être vus. La façade principale du bâtiment, de forme rectangulaire, a été conçue

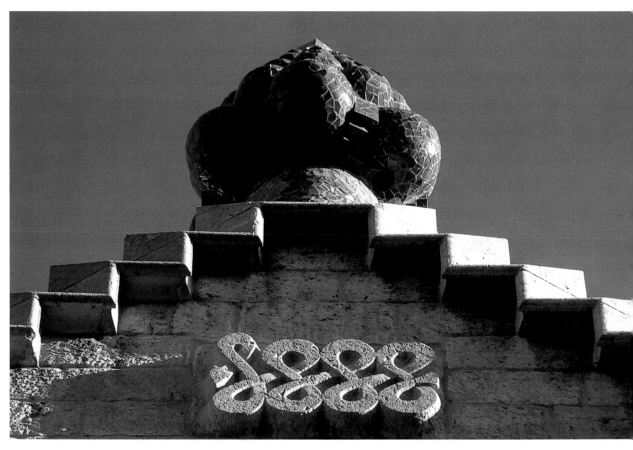

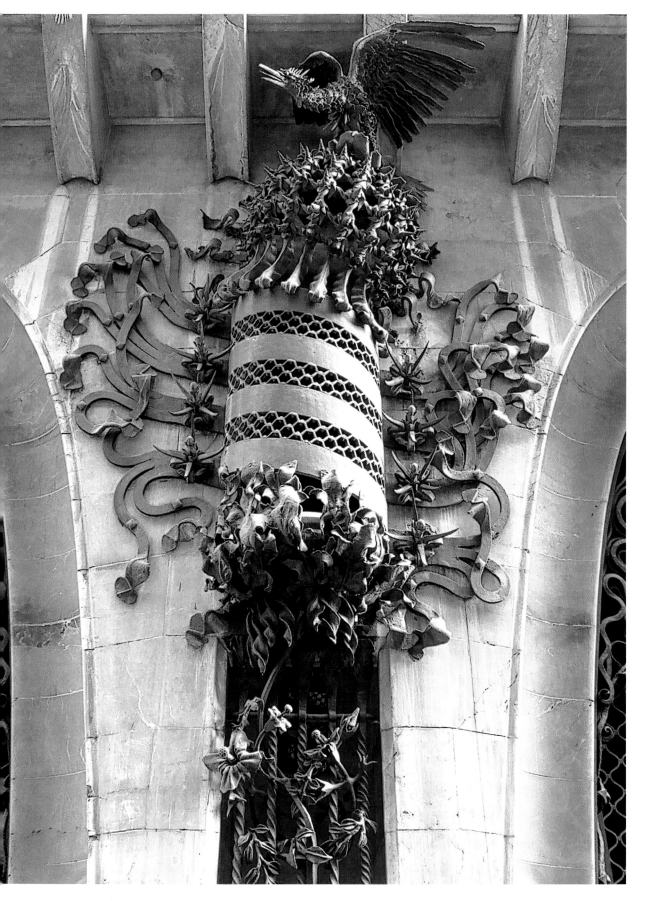

gates. Every aspect of the palace is so carefully thought out that even the gates are designed to give glimpses of the street from inside the house and not the other way around. Gaudí never neglected the façades of his buildings. In the Güell palace, Gaudí decided to accentuate the central part of the rear façade, a more irregular space, with shutters and wooden slats that give shape to the inner smoking room-courtyard. Gaudí created chimneys to ventilate the smoke and heating that wended their way through all the areas of the house until reaching the roof, a notable example of the architect's aesthetic style. The twenty chimneys, all of them unique, were extremely originally and at times whimsically decorated to resemble explosions of colour through Gaudí's advanced *trencadís* (mosaics using shards of glazed ceramic) technique. Gaudí also designed some of the original furnishings for the home that stood out for their original appearance.

der Familie Güell, ihre Gäste zu beobachten, ohne bemerkt zu werden. Die Hauptfassade des Gebäudes entspringt einem rechteckigen Raster und zeigt eine gewisse Asymmetrie sowie eine deutlich horizontale Ausrichtung. Dabei stechen die kettenlinienförmigen Säulengänge und ihre aufwändigen schmiedeeisernen Gittertüren hervor. Der gesamte Palast ist derart durchdacht, dass selbst die Gitter den Blick aus dem Gebäudeinneren auf die Straße – jedoch nicht umgekehrt – zulassen. Gaudí vergaß auch nicht die Gestaltung der hinteren Fassaden des Palau Güell und entschied, das Zentrum der Rückseite, einen eher unregelmäßigen Raum, mit hölzernen Jalousien und Zierleisten zu betonen, welche die Struktur einer als Rauchzimmer dienenden Loggia andeuten. Als Rauchabzug und zur Beheizung schuf Gaudí Kamine, die das gesamte Haus bis hinauf zur ästhetisch sehr ansprechenden Dachterrasse durchqueren. Die zwanzig unterschiedlichen Schornsteine bestechen durch ihre äußerst originelle Form und eine verspielte Dekoration, eine wahre Farbexplosion, die auf der bereits fortgeschrittenen Trencadís-Technik mit glasierter Keramik basiert. Gaudí entwarf auch einige der originellen Möbelstücke des Hauses.

avec une certaine asymétrie et selon une orientation clairement horizontale. On y remarque tout particulièrement les porches au profil parabolique et leurs grilles en fer forgé, fruits d'un méticuleux travail. Le palais a été soigneusement pensé jusque dans ses moindres détails : les grilles elles-mêmes ont été réalisées de manière à pouvoir observer la rue depuis l'intérieur de la maison, mais pas l'inverse. Gaudí soignait également les façades arrière de ses bâtiments. Pour le palais Güell, il décida de rehausser le centre de la façade arrière plus irrégulière en y plaçant des jalousies et des lattes de bois qui épousent la forme de la galerie-fumoir intérieure. Gaudí créa également des cheminées d'aération qui traversaient toute la maison pour aboutir à la terrasse, espace très soigné sur le plan esthétique. Les vingt cheminées, toutes différentes, présentaient un tracé des plus originaux et étaient parfois décorées, dans une véritable explosion de couleurs, à l'aide de la technique déjà bien avancée du *trencadís* (morceaux de faïence). Gaudí conçut également certains éléments étonnants du mobilier original de la maison.

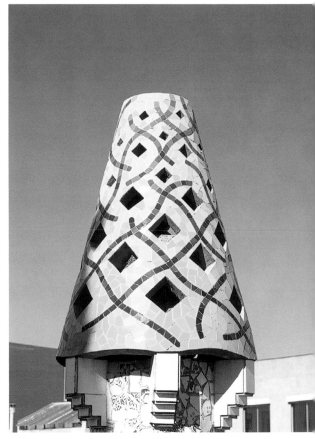

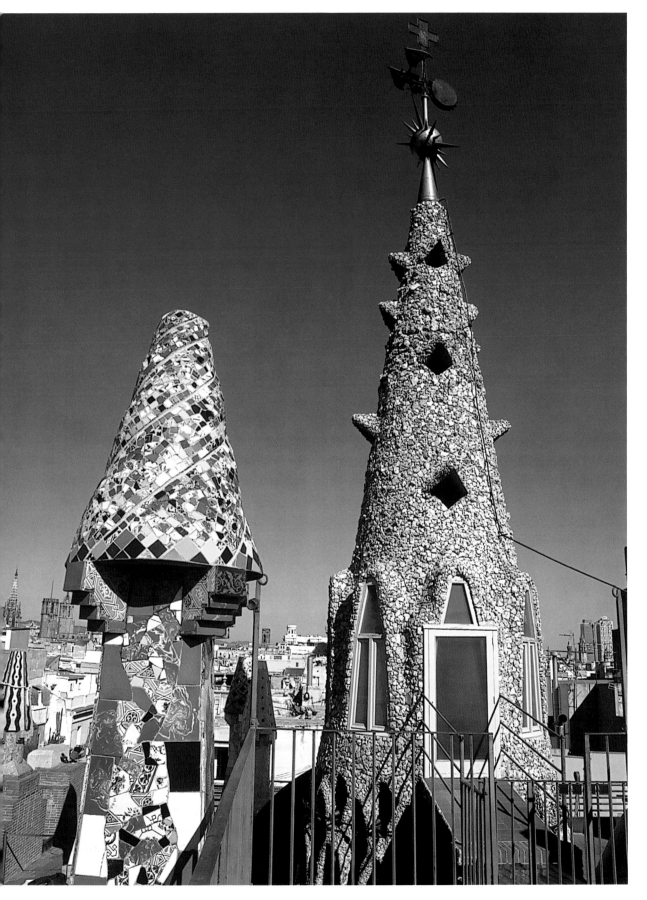

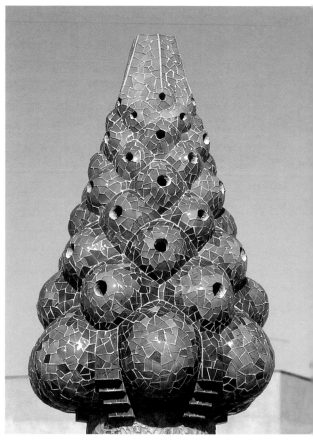
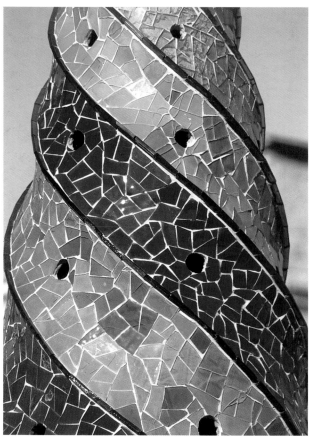

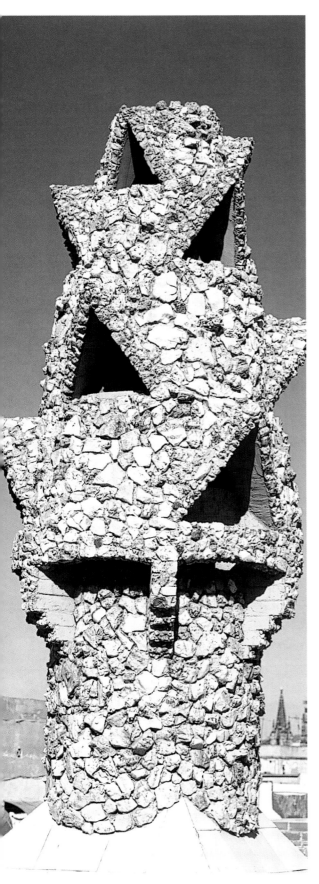

The roof features various chimneys that Gaudí designed to improve the ventilation and cooling of the building's interior. The architect executed an extremely important work of craftsmanship when decorating these simple structures, as he clad all the chimneys with tiny ceramic and glass shards, a technique known as *trencadís*, to obtain a spectacular and colourful effect.

Auf der Dachterrasse des Palau Güell sieht man die verschiedenen Schornsteine, die Gaudí für eine bessere Belüftung und Kühlung des Gebäudeinneren vorsah. Zur Ausschmückung dieser einfachen Strukturelemente bediente sich der Architekt einer bedeutenden Handwerksarbeit, der so genannten *Trencadís*-Technik: Er verkleidete alle Schornsteine mit kleinen Keramik- und Glasscherben und erzielte so ein beeindruckendes, farbenprächtiges Ergebnis.

Le toit-terrasse du palais Güell est percé de plusieurs cheminées conçues par Gaudí dans le but d'améliorer l'aération et la climatisation de l'intérieur du bâtiment. Pour décorer ses simples éléments structurels, l'architecte réalisa un véritable travail d'artisanat en les revêtant de petits morceaux de faïence et de verre. Grâce à cette technique, connue sous le nom de *trencadís*, il obtint un résultat spectaculaire et haut en couleurs.

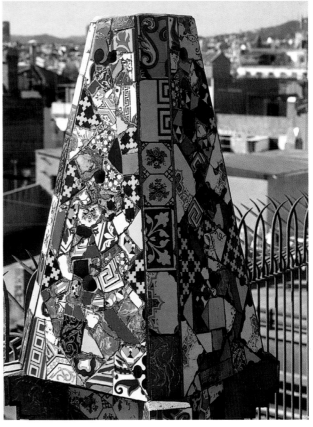

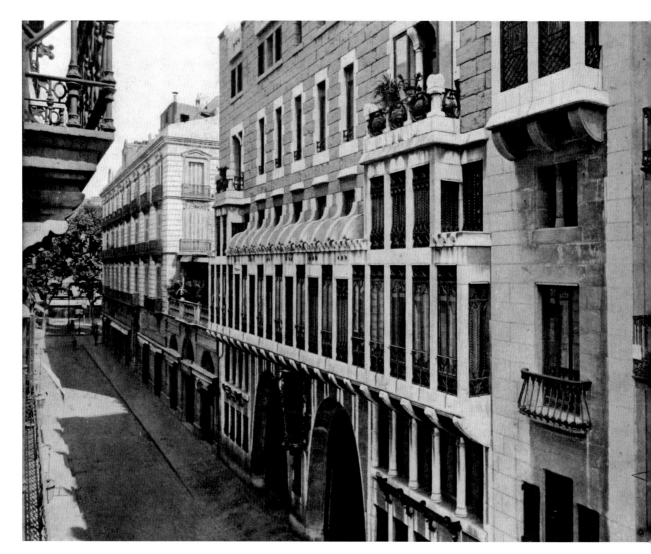

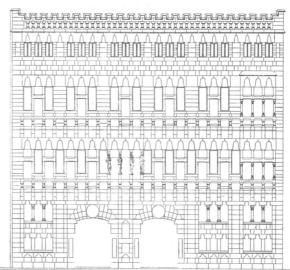

The drawing submitted by Gaudí for the façade of the Güell palace is not too different from the end result.

Der Entwurf, den Gaudí für die Fassade des Palau Güell präsentierte, unterscheidet sich kaum vom Endergebnis.

Le dessin que Gaudí présenta pour la façade du palais Güell ne diffère guère du résultat final.

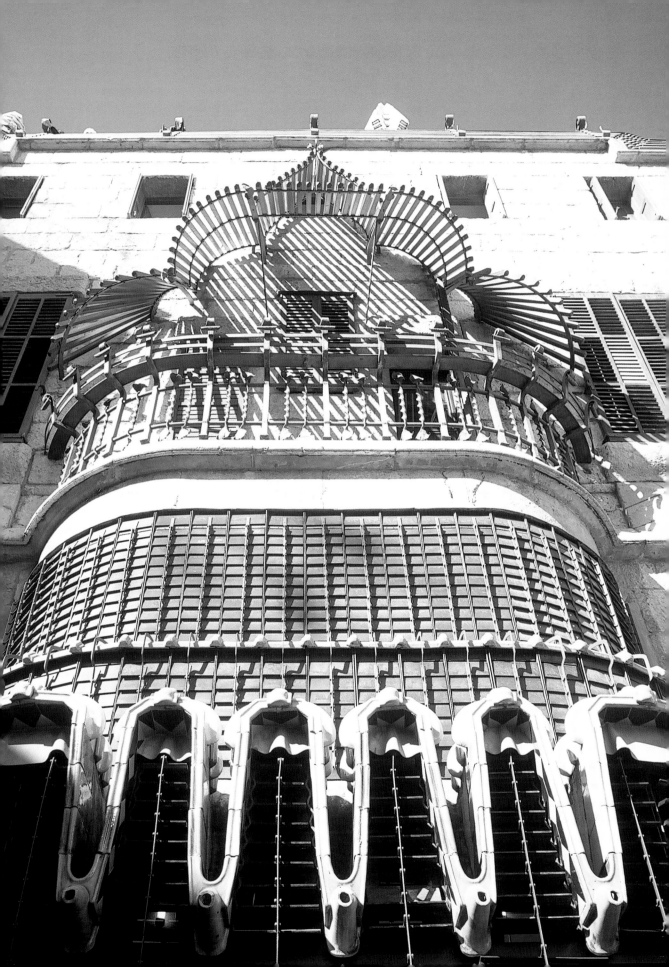

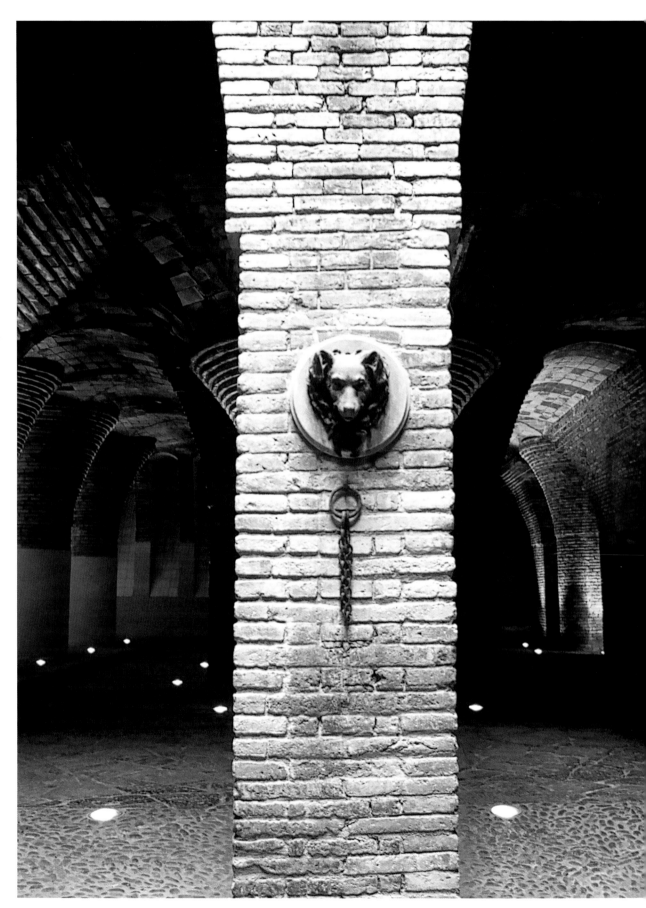

Gaudí left nothing to chance and meticulously designed each and every decorative element on the building's façade. The wrought iron is especially significant given that it was used on the entrance gates. They feature the initials of Eusebi Güell above the doors, as well as a large coat-of-arms of Catalonia in between the two openings.

Gaudí überließ nichts dem Zufall und plante jedes einzelne der für die Gebäudefassade vorgesehenen Dekorationselemente. Von großer Bedeutung sind die Schmiedearbeiten, die die Gitter an den Haupteingängen schmücken. Auffallend sind die Initialen Eusebi Güells, die den oberen Teil der Tore zieren, und das große Wappen Kataloniens zwischen den beiden Toröffnungen.

Gaudí ne laissa rien au hasard. Il conçut chacun des éléments décoratifs de la façade de l'édifice. Le fer forgé occupe une place significative, à commencer par les grilles des portes d'entrée du bâtiment qui arborent en haut les initiales d'Eusebi Güell et le grand blason de Catalogne, placé entre les deux ouvertures.

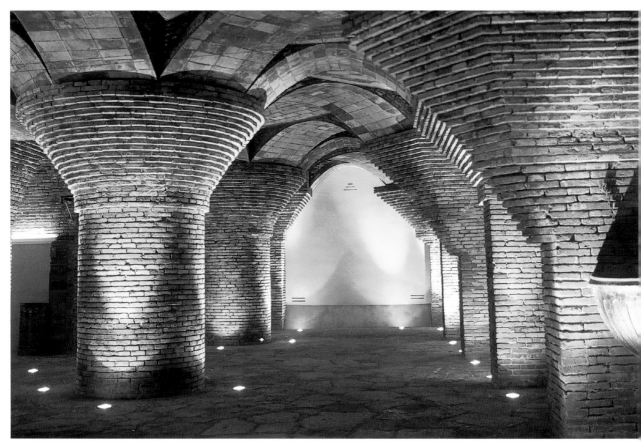

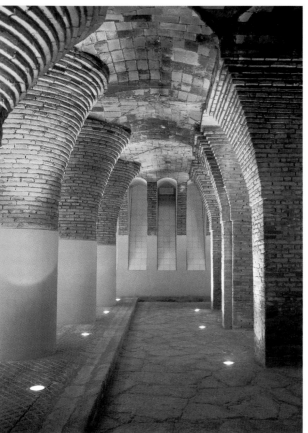

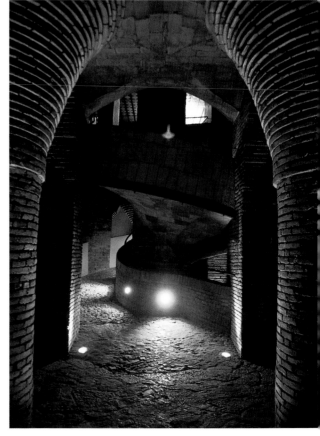

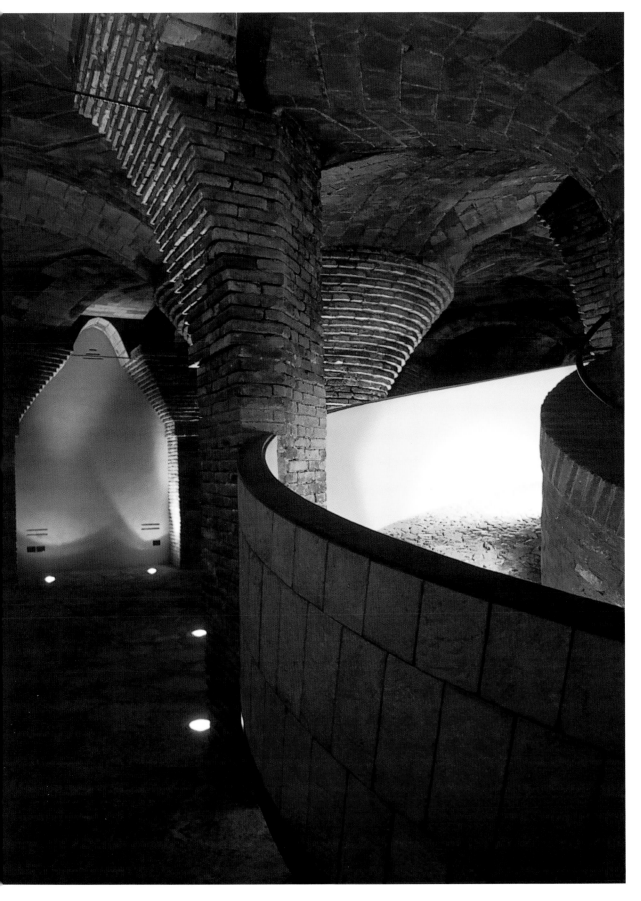

The exceptional height of the main salon on the first floor creates a unique observation point for the owners.

Die große Deckenhöhe des Hauptsaals im ersten Geschoss wurde für die Hausbesitzer zu einem originellen Observatorium.

La hauteur considérable du salon principal du premier étage permettait aux propriétaires de l'observer discrètement depuis les étages supérieurs.

On the previous page, diverse images of the interesting spiral-shaped ramp made of brick, which served as an entrance ramp for the palace coach house.

Auf der vorherigen Seite sind verschiedene Aufnahmen der interessanten spiralförmigen Rampe aus Ziegelstein zu sehen, die Zufahrt zu den Remisen des Palastes gewährte.

La page précédente présente plusieurs vues de la singulière rampe en spirale faite en briques qui permettait d'accéder au garage du palais.

The influence of Arabic architecture is manifested in the ogee arches inside the palace

Der Einfluss des arabischen Baustils, der sich durch Vielpassbogen auszeichnet, wird in der Innenausstattung des Palastes deutlich

À l'intérieur du palais, l'influence de l'architecture arabe, caractérisée par les arcs lobés, est incontestable

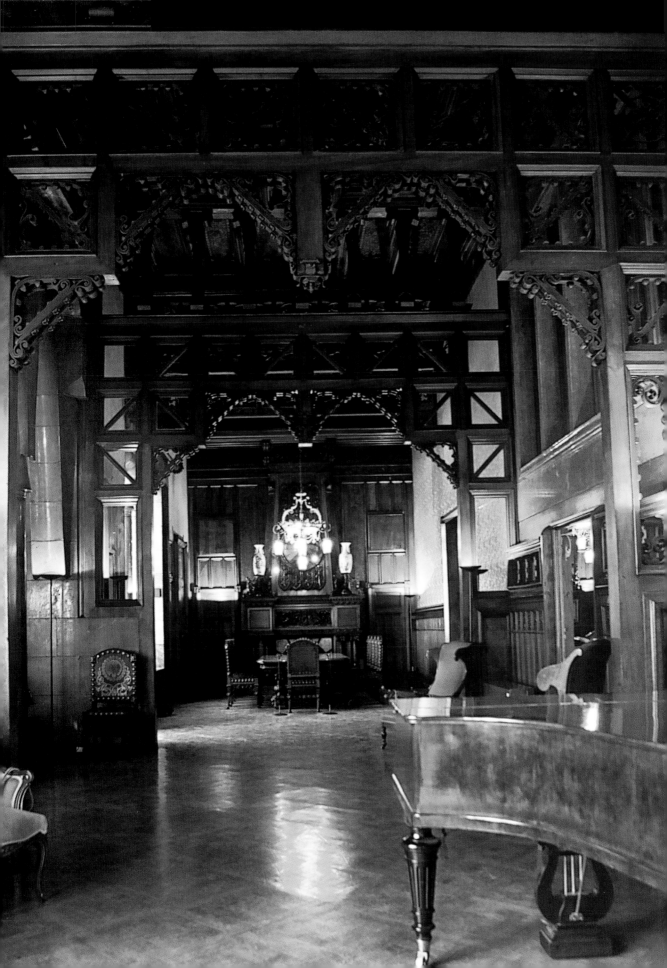

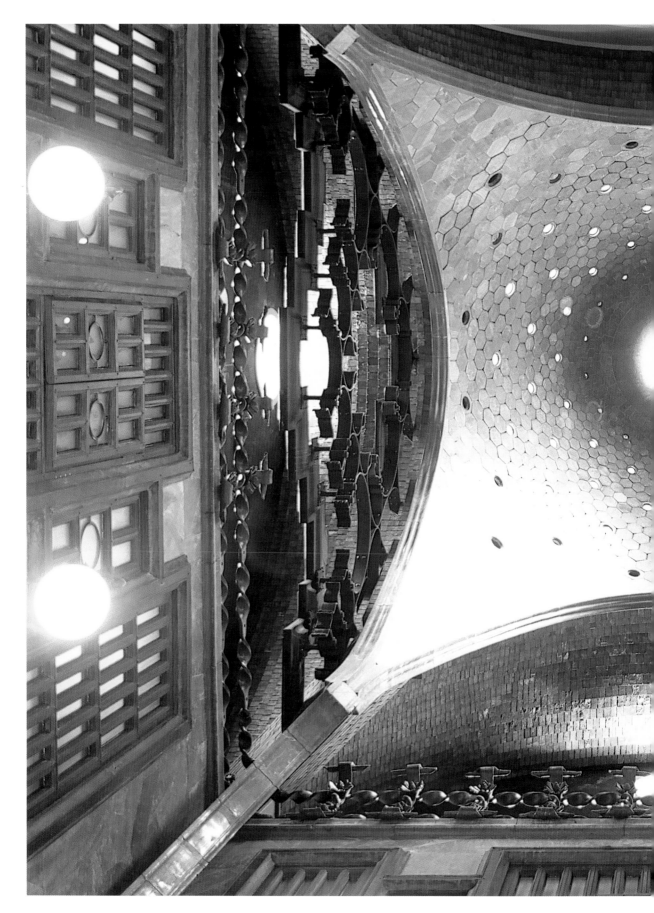

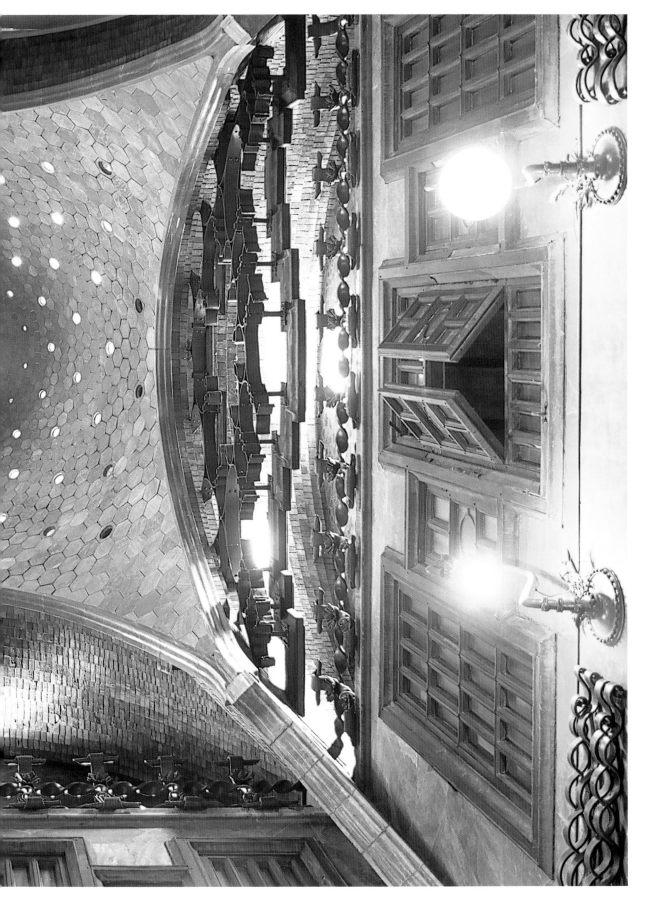

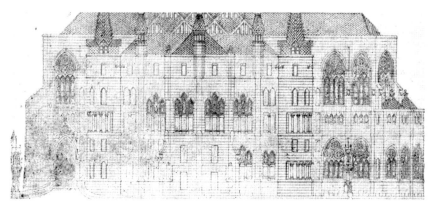

ALTHOUGH GAUDÍ'S EARLY WORKS WERE NOT FULLY UNDERSTOOD BY HIS CONTEMPORARIES, THE ARCHITECT COULD COUNT ON THE SUPPORT OF KEY FIGURES WHO COMMISSIONED IMPORTANT PROJECTS SUCH AS THIS ONE.

OBWOHL DIE ERSTEN WERKE GAUDÍS KEINEN BESONDEREN ZUSPRUCH BEI SEINEN ZEITGENOSSEN FANDEN, ERHIELT DER ARCHITEKT SCHON ZU BEGINN SEINER LAUFBAHN UNTERSTÜTZUNG VON PERSÖNLICHKEITEN, DIE IHN MIT WERKEN WIE DIESEM BEAUFTRAGTEN.

MÊME SI CERTAINES DES PREMIÈRES ŒUVRES DE GAUDÍ NE FURENT PAS TRÈS BIEN ACCUEILLIES PAR SES CONTEMPORAINS, L'ARCHITECTE OBTINT DÈS SES DÉBUTS LE SOUTIEN DE GRANDES PERSONNALITÉS QUI LUI CONFIÈRENT DES PROJETS COMME CELUI-CI.

episcopal palace of ASTORGA
der bischofspalast in ASTORGA
palais épiscopal d'ASTORGA

1889-1893

Gaudí was commissioned to create an altar for the chapel of the school of the Jesús-Maria nuns in Tarragona, and it was while executing this project between 1880 and 1882 that the architect met the General Vicar of the Archdiocese of Tarragona, Joan Baptista Grau i Vallespinós, an essential figure in Gaudí's life and who would later be named Archbishop of Astorga.

On 23 December 1886, a fire destroyed the Episcopal Palace of Astorga in León. Grau, now bishop, commissioned Gaudí to design the new building in August 1887, but construction of the Episcopal see did not begin until July 1888. Upon Bishop Grau's death in 1893, Gaudí decided to relinquish supervision of the project due to a series of disagreements stemming from the new bishop's views on how the palace should proceed.

The architect is known to have displayed a great interest in discovering the most characteristic and essential aspects of the place where he was to construct the new building. He inquired about the climate of Astorga, obtained images that illustrated the typical architecture and landscape and read many books, demonstrating his genuine interest in creating a new Episcopal Palace that fit in with its surroundings. Despite the San Fernando Royal Academy of Fine Arts' delay in approving Gaudí's design, construction proceeded rapidly

Gaudí erhielt den Auftrag, einen Altar für die Kapelle der Schule des Jesús-Maria-Ordens in Tarragona anzufertigen. Während dieser zwischen 1880 und 1882 durchgeführten Arbeit lernte der Architekt den Generalvikar der Erzdiözese Tarragona, Joan Baptista Grau i Vallespinós, kennen, der einen wichtigen Platz in Gaudís Leben einnahm und wenige Jahre später zum Bischof von Astorga ernannt wurde.

Am 23. Dezember 1886 zerstörte ein Brand den Bischofspalast im leonesischen Astorga, und Bischof Grau betraute Gaudí mit der Planung eines neuen Gebäudes. Der Architekt erhielt den Auftrag zwar schon im August 1887, die Arbeiten begannen jedoch erst im Juli 1888. Als Bischof Grau im Jahr 1893 starb, entschied Gaudí aufgrund einer Reihe von Unstimmigkeiten, die rund um die Entscheidung für den weiteren Projektverlauf mit dem neuen Domkapitel entstanden waren, die Bauleitung abzugeben.

Es ist bekannt, dass der Architekt großes Interesse an einigen der ortstypischen und grundlegenden Merkmale des Baugrunds für sein neues Projekt zeigte. So erkundigte er sich nach dem Klima in der Stadt Astorga, sammelte Aufnahmen von der Architektur und den markantesten einheimischen Landschaften und las die entsprechenden Bücher, um den neuen Bischofspalast harmonisch auf die Umgebung abzustimmen. Trotz des verspäteten Baubeginns, der von der langen Wartezeit auf die

Gaudí fut chargé de réaliser un autel pour la chapelle de l'école des religieuses de Jesús-Maria à Tarragone. Lors de ce chantier mené entre 1880 et 1882, l'architecte rencontra un personnage déterminant : le vicaire général de l'archidiocèse de Tarragone, Joan Baptista Grau i Vallespinós, qui sera nommé plus tard archevêque d'Astorga.

Le 23 décembre 1886, un incendie ravagea le palais épiscopal d'Astorga, à León. Grau, alors évêque, confia à Gaudí la conception du nouveau bâtiment en août 1887, mais les travaux du siège épiscopal ne débutèrent qu'en juillet 1888. À la mort de l'évêque Grau, en 1893, Gaudí décida d'abandonner la direction du projet, en raison d'une série de désaccords au sein de l'évêché sur la marche à suivre pour la poursuite des travaux.

On sait que l'architecte fit preuve d'un grand intérêt pour connaître les aspects les plus caractéristiques et essentiels du lieu où il devait réaliser son nouveau projet. Il s'enquit du climat d'Astorga, se documenta à l'aide de reproductions de l'architecture et des paysages typiques de l'endroit et consulta un grand nombre de livres traitant du sujet, pour que le nouveau palais épiscopal fût en harmonie avec son environnement. Malgré le retard avec lequel l'Académie Royale des Beaux-Arts de San Fernando approuva le projet de Gaudí les travaux progressèrent rapidement grâce à

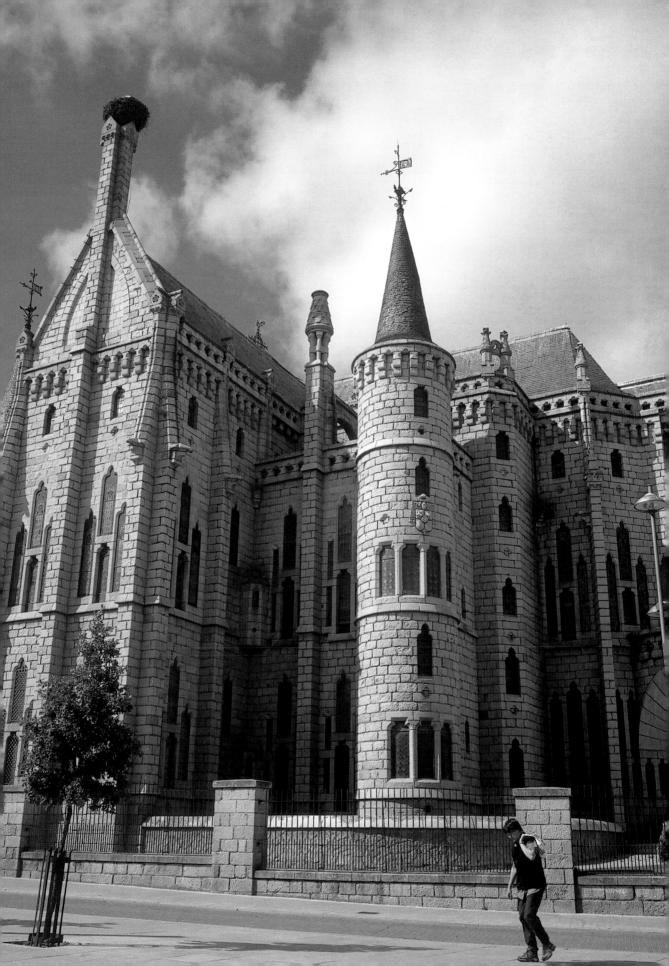

thanks to the architect's insistence and the remarkable work of the construction workers that Gaudí brought from Barcelona.

Gaudí's design called for a building with a central floor superimposed over a square and a cross. Outside it emerges from a pit along the perimeter framed by cylindrical towers from which the throne room, the chapel, the library and the reception hall jut out. Its resemblance to a mediaeval castle harks back to Gaudí's early projects with their influence from Gothic architecture.

A portico with truncated cone-shaped arches provides access to the inside, which leads to the central hall illuminated from above. This entry hall provides access to the surrounding spaces, which include those mentioned in the paragraph above. This way of organising the space is already present in the architect's previous constructions, including the Teresian Convent.

After abandoning the project, the roof of the Episcopal Palace was not built according to Gaudí's plans, and was instead commissioned

Genehmigung des von Gaudí bei der Königlichen Kunstakademie in San Fernando präsentierten Entwurfs herrührte, schritten die Bauarbeiten dank des engagierten Architekten und der von ihm aus Barcelona mitgebrachten Arbeiterschaft sehr schnell voran.

Gaudís Entwurf zeigt ein Gebäude mit einem Zentralgrundriss, in dem ein Quadrat und ein Kreuz übereinanderliegen. Äußerlich erhebt es sich aus einem von Rundtürmen flankierten Umfassungsgraben, aus denen die Anlagen des Thronsaals, der Kapelle, der Bibliothek und des Empfangssaals emporragen. Die Ähnlichkeit mit einer mittelalterlichen Burg verweist einmal mehr auf die Inspiration, die Gaudís erste Entwürfe aus der gotischen Architektur bezogen.

Der Zutritt erfolgt über einen Säulengang mit kegelstumpfförmigen Bogen, die zu einer zentralen, von oben beleuchteten Vorhalle führen. Von dort aus gelangt man wiederum in die verschiedenen umliegenden Räumlichkeiten, bei denen es sich im Wesentlichen um die zuvor genannten Einrichtungen handelt. Diese strukturierte Raumaufteilung findet sich auch

l'insistance de l'architecte et au travail remarquable des ouvriers que Gaudí fit venir de Barcelone.

Les tracés de Gaudí présentent un édifice dont le plan central est superposé dans un carré et une croix. À l'extérieur, il est bordé d'un fossé et encadré de tours cylindriques, desquelles saillent certaines pièces du bâtiment : la salle du trône, la chapelle, la bibliothèque et la salle de réception. Son aspect de château médiéval évoque une nouvelle fois l'influence de l'architecture gothique dans les premiers projets de Gaudí.

Pour accéder à l'intérieur, il faut franchir un porche d'arcs tronconiques, qui s'ouvre sur un vestibule central illuminé à la verticale. Ce vestibule conduit aux diverses pièces attenantes, y compris celles mentionnées au paragraphe précédent. Cet agencement de l'espace se retrouve dans d'autres œuvres antérieures de l'architecte, comme le couvent des Thérésiennes.

Après que l'architecte eut abandonné le projet, le toit du palais épiscopal ne fut pas exécuté selon l'idée originale de Gaudí. La direction

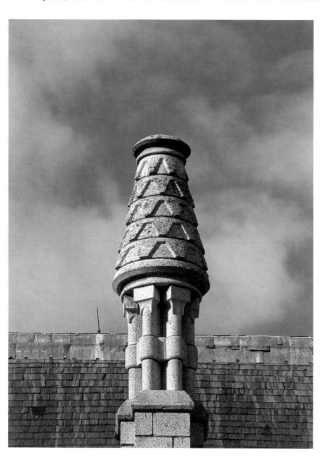

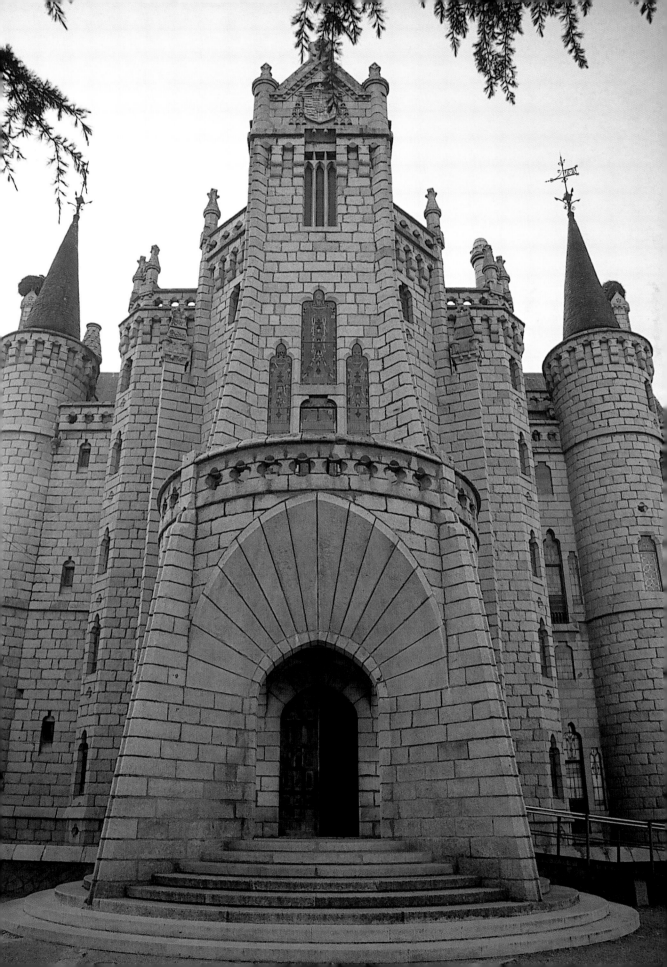

to another architect, Ricardo García Guereta, who finished construction work in 1913. In a letter dated 4 November 1893 in León, Antoni Gaudí announced his resignation from the project with these words:

"Most Illustrious Sir,

As today there is a lack of agreement in opinions and viewpoints that once existed between my respected friend, the late Prelate of the Diocese, His Excellency Joan Baptista Grau, and the undersigned, which I deem essential and indispensable for the favourable completion of the construction of the Episcopal Palace of this city, I am compelled to submit to his Illustrious Sir, president of the Diocesan Committee, my resignation as lead architect of the project…"

in früheren Werken des Architekten, wie dem Konvent der Theresianerinnen.

Nach Gaudís Abgabe des Projekts wurde das Dach des Bischofspalasts nicht im Sinne seines ursprünglichen Entwurfs errichtet, sondern einem anderen Architekten, Ricardo García Guereta, übertragen, der den Bau im Jahr 1913 fertig stellte. In einem noch heute erhaltenen Brief vom 4. November 1893 erklärte Antoni Gaudí seinen Verzicht auf die Leitung der Bauarbeiten am Bischofspalast. Das Schreiben besagt:

„Hochverehrter Herr!
Da zum heutigen Tag keine völlige Einigung bezüglich der Absichten und Einschätzungen besteht, wie sie zwischen meinem ehrwürdigen Freund, dem verstorbenen Prälat dieser Diözese, Seiner Exzellenz Herrn Doktor Joan Baptista Grau, und dem Unterzeichner herrschte und wie ich sie für die erfolgreiche Vollendung der Bauarbeiten am hiesigen Bischofspalast für grundlegend und unerlässlich erachte, sehe ich mich dazu gezwungen, Herrn I. S. in seiner Eigenschaft als Präsident des Diözesanvorstands den Rücktritt des Architekten und Bauleiters auszusprechen …"

des travaux fut remise à un autre architecte, Ricardo García Guereta, qui acheva la construction en 1913. Antoni Gaudí annonça sa démission du projet dans une lettre, datée du 4 novembre 1893 à León, en ces termes :

« Monseigneur,
Comme il y a aujourd'hui un manque d'accord des opinion et des idées, qui avait déjà existé entre mon respectable ami feu le prélat de ce diocèse, Monseigneur Joan Baptista Grau, et le soussigné, aspect à mon avis essentiel et indispensable pour l'achèvement favorable des travaux du palais épiscopal de cette ville, je me vois obligé de remettre à son Excellence, président du Comité diocésain, ma démission en tant qu'architecte en chef du projet… »

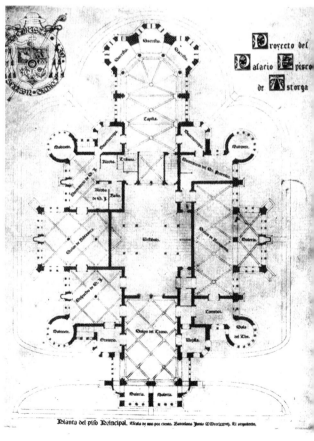

Elevation of the rear facade and floor plan of the main floor of the palace, which follow the design envisioned by Gaudí and commissioned by the bishop of Astorga.

Aufriss der rückseitigen Fassade und Grundriss des Hauptgeschosses des Palastes nach einem Entwurf, den Gaudí im Auftrag des Bischofs von Astorga anfertigte.

Coupe de la façade arrière et plan de l'étage principal du palais, selon le projet conçu par Gaudí sur commande de l'évêque d'Astorga.

e characteristic style and structures of Gothic architecture were a constant reference in the projects designed by Gaudí.

r Baustil und die gotisch anmutenden Strukturen waren ein fortwährendes Merkmal in Gaudís Entwürfen.

style et les structures propres à l'architecture gothique sont récurrents chez Gaudí.

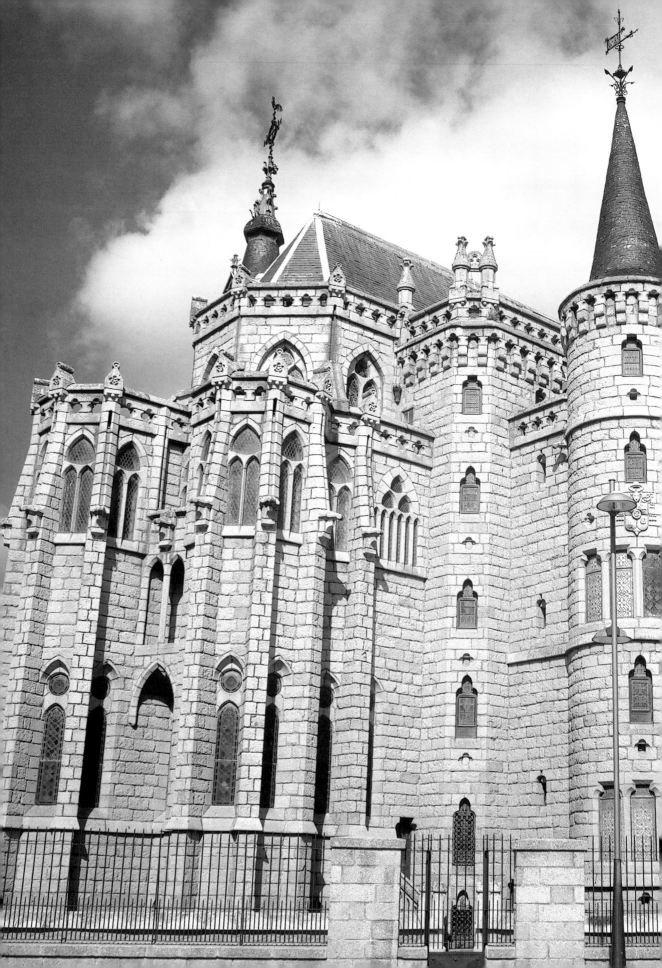

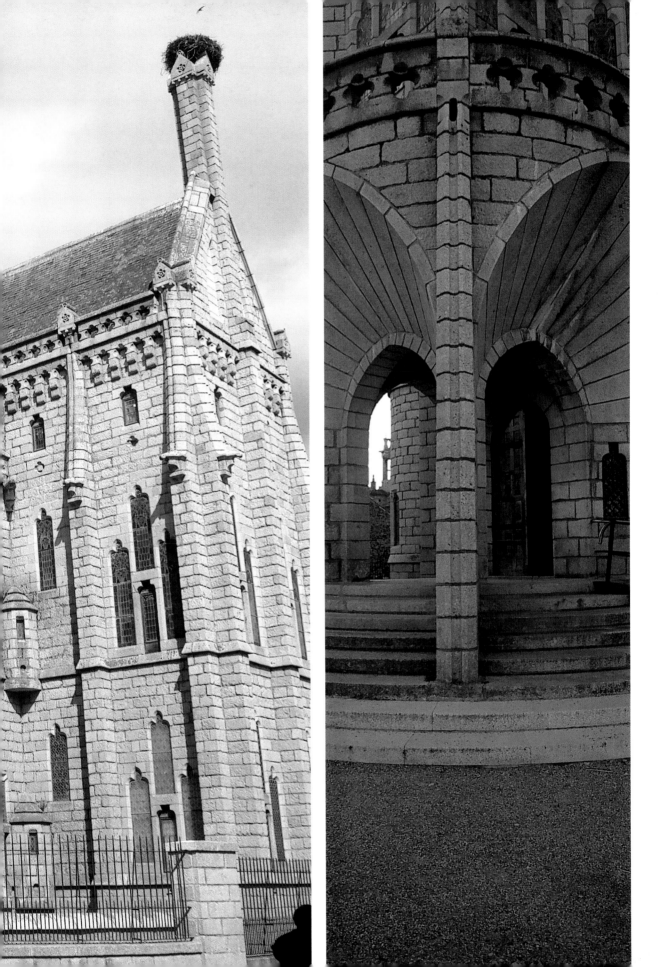

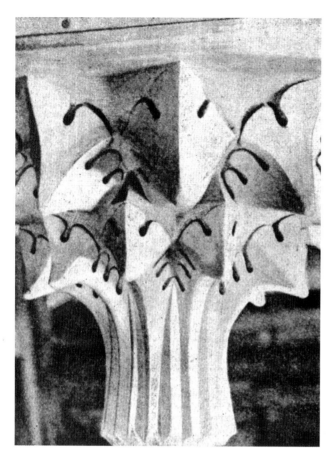

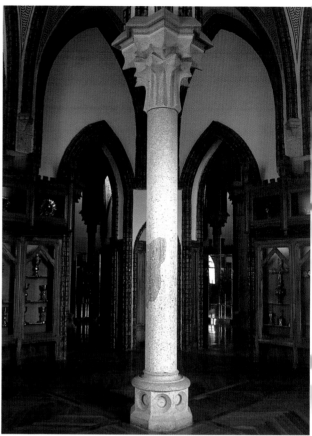

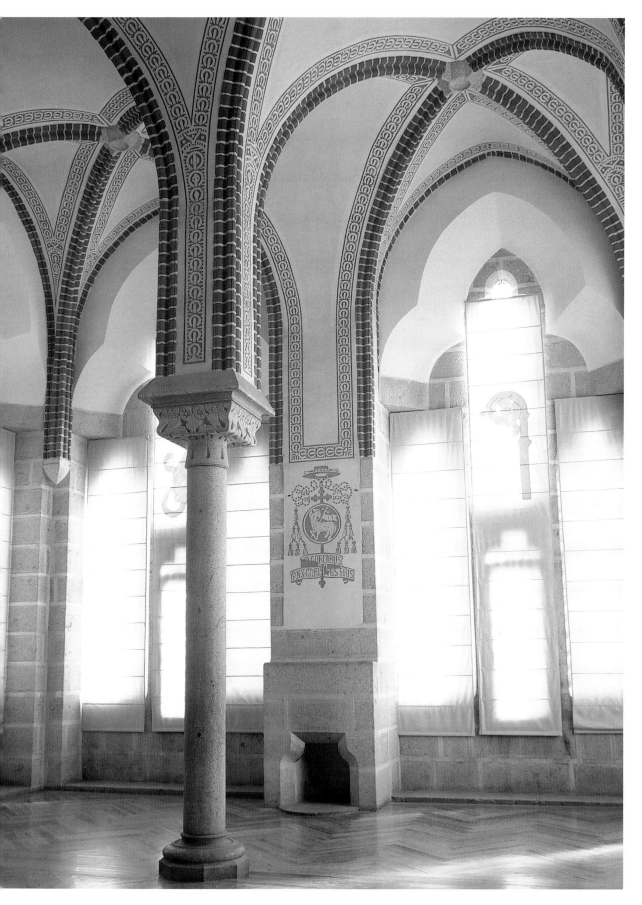

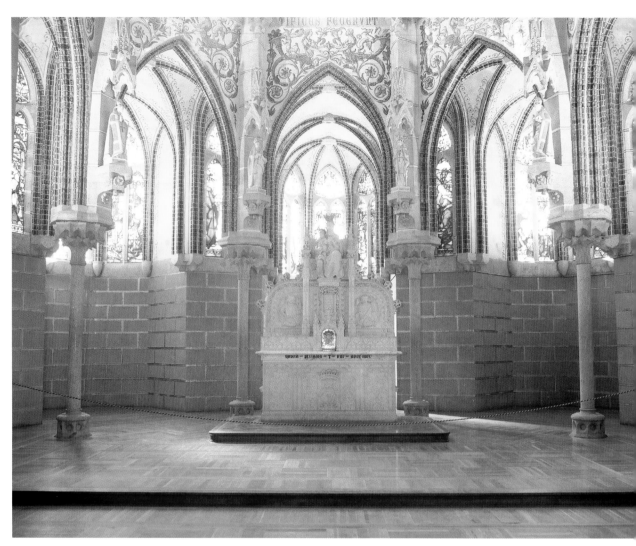

Gaudí's masterful decorative work is clearly reflected in the columns and windows in the main salon.

Die dekorative Gestaltung durch Gaudí ist deutlich an den Säulen und Verglasungen des Hauptsaals zu erkennen.

Gaudí accomplit un travail de décoration magistral sur les colonnes et les vitraux du salon principal.

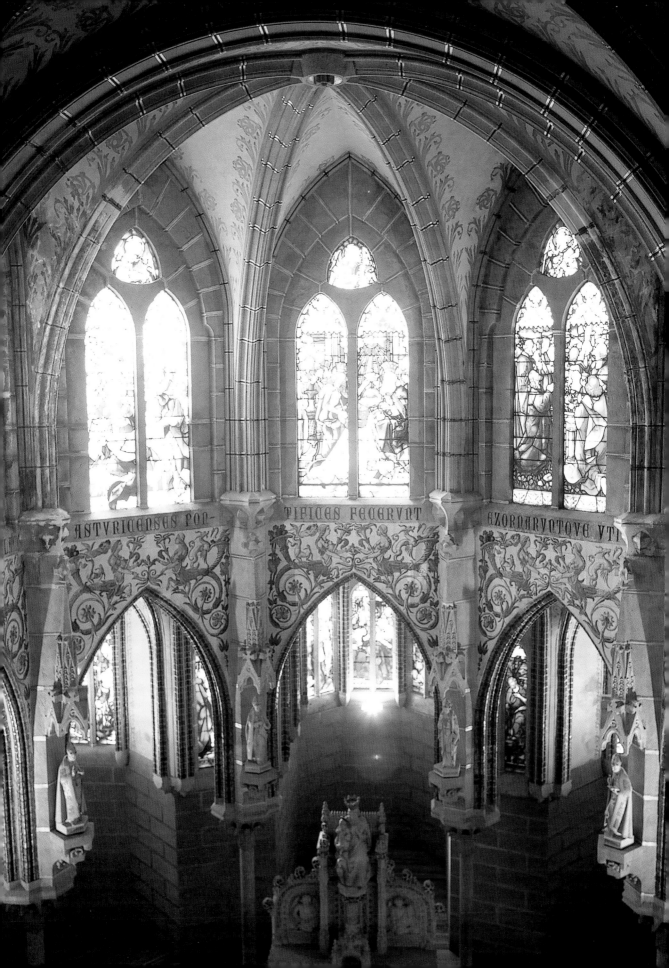

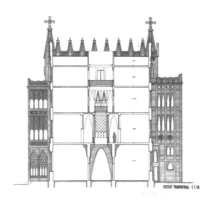

SECCIÓ TRANSVERSAL - E.Y.50

THE DECORATION OF THIS FAÇADE IS A SAMPLE OF THE GREAT ICONOGRAPHIC WORK CARRIED OUT BY GAUDÍ FOR THIS PROJECT, IN WHICH ALL THE DETAILS REFER TO SAINT TERESA, PATRON SAINT OF THE TERESIAN ORDER.

THE DECORATION OF THIS FAÇADE IS A SAMPLE OF THE GREAT ICONOGRAPHIC WORK CARRIED OUT BY GAUDÍ FOR THIS PROJECT, IN WHICH ALL THE DETAILS REFER TO SAINT TERESA, PATRON SAINT OF THE TERESIAN ORDER.

DIE DEKORATION DIESER GEBÄUDEFASSADE ZEUGT VON DER GROSSEN IKONOGRAPHISCHEN ARBEIT, DIE ANTONI GAUDÍ BEI DIESEM PROJEKT LEISTETE. JEDES NOCH SO KLEINE DETAIL VERWEIST AUF DIE SCHUTZPATRONIN DES THERESIANISCHEN ORDENS, DIE HEILIGE THERESA VON ÁVILA.

LA DÉCORATION DE LA FAÇADE DE CE BÂTIMENT ILLUSTRE LE GRAND TRAVAIL ICONOGRAPHIQUE EFFECTUÉ PAR ANTONI GAUDÍ, OÙ CHAQUE DÉTAIL ÉVOQUE SAINTE THÉRÈSE, SAINTE PATRONNE DE L'ORDRE THÉRÉSIEN.

the TERESIAN school
die schule der THERESIANERINNEN
le collège des THÉRÉSIENNES

1888-1889

The Teresian School was a project instigated by the priest Enric d'Ossó, founder of the order in 1876. He shared a number of friends with Antoni Gaudí, such as Francesc Marsal, Josep Bocabella, the man who started work on the Sagrada Família, and Joan Baptista Grau, bishop of Astorga, who had commissioned the reconstruction of the Episcopal palace. All of them exerted a strong influence on Ossó's decision to hire the architect.

When Gaudí took charge of building the school, the first floor had already been laid by an architect who remains anonymous, as his initial blueprints were destroyed during the Civil War. As a result, Gaudí was obliged to follow the existing layout established by the construction already done.

The school (1889-1894) is situated on a plot measuring 29,104 square metres on Ganduxer Street in Barcelona and consists of a free-standing rectangular block with four floors. Designed to contain three U-shaped bays, Gaudí only built the first one, which was designated as a school and residence for the religious order. The architect created an extremely austere symmetrical, longitudinal building that resembles a walled fortress in allusion to the "castle of good Christians" referred to in the writings of Saint Teresa. This air of sobriety is further accentuated by the use of brick, chosen based on the project's low budget. One of the

Die Errichtung eines Schulgebäudes für die Theresianerinnen wurde 1876 von dem Priester Enric d'Ossó, Gründer des Ordens, vorangetrieben. Der Geistliche und Antoni Gaudí hatten gemeinsame Freunde, wie Francesc Marsal, Josep Bocabella, Initiator der Arbeiten am Tempel der Sagrada Família, oder Joan Baptista Grau, Bischof von Astorga, von dem der Auftrag zum Wiederaufbau des Bischofspalastes stammte. Diese Umstände führten dazu, dass sich Ossó für Gaudí entschied.

Als dieser die Bauleitung der Schule übernahm, war das Erdgeschoss bereits von einem anderen Architekten erbaut worden, der heute unbekannt ist, weil die ursprünglichen Entwürfe während des Spanischen Bürgerkriegs vernichtet wurden. Der vorhandene Grundriss zwang Gaudí, die bereits vorgenommene Raumaufteilung in sein Projekt zu übernehmen.

Die Schule (1889-1894) befindet sich auf einem 29.104 Quadratmeter großen Grundstück in der Carrer Ganduxer in Barcelona und besteht aus einem rechteckigen Block mit einem Erd- und drei Obergeschossen. Der Gebäudekomplex war eigentlich auf drei U-förmig angeordnete Schiffe angelegt, von denen Gaudí jedoch nur das erste Schiff errichtete, das die Schule und das Wohnhaus der Nonnen aufnahm. Der Architekt schuf ein symmetrisches, längliches und nüchternes Gebäude, ähnlich einer ummauerten Festung, und spielte damit auf die in den Schriften der

Le collège des Thérésiennes est un projet promu le prêtre Enric d'Ossó Cervello, qui fonda l'ordre de sainte Thérèse d'Avila en 1876. Celui-ci avait des amis en commun avec Antoni Gaudí, dont Francesc Marsal, Josep Bocabella, le promoteur de la Sagrada Família et Joan Baptista Grau, l'évêque d'Astorga à l'origine de la reconstruction du palais épiscopal. Ces derniers usèrent d'une forte influence auprès d'Enric d'Ossó dans son choix de l'architecte pour ce projet.

Lorsque Gaudí prit la tête des travaux du collège, le premier étage avait déjà été bâti par un architecte inconnu (ses plans furent détruits durant la guerre civile), ce qui l'obligea à suivre la configuration existante déjà établie par les travaux effectués jusqu'alors.

Situé sur un terrain de 29 104 mètres carrés dans la rue Ganduxer de Barcelone, le collège (1889-1894) compte un seul bâtiment rectangulaire de quatre étages. L'ensemble devait comprendre à l'origine trois bâtiments et adopter une forme en U, mais Gaudí ne construisit que le premier de ceux-ci, destiné à recevoir le collège et la résidence des religieuses. L'architecte créa un édifice symétrique tout en longueur et d'aspect très austère à la façon d'une demeure fortifiée, en allusion au « château des bons chrétiens » que sainte Thérèse évoquait dans ses écrits. Cette impression de sobriété est renforcée par l'emploi de la

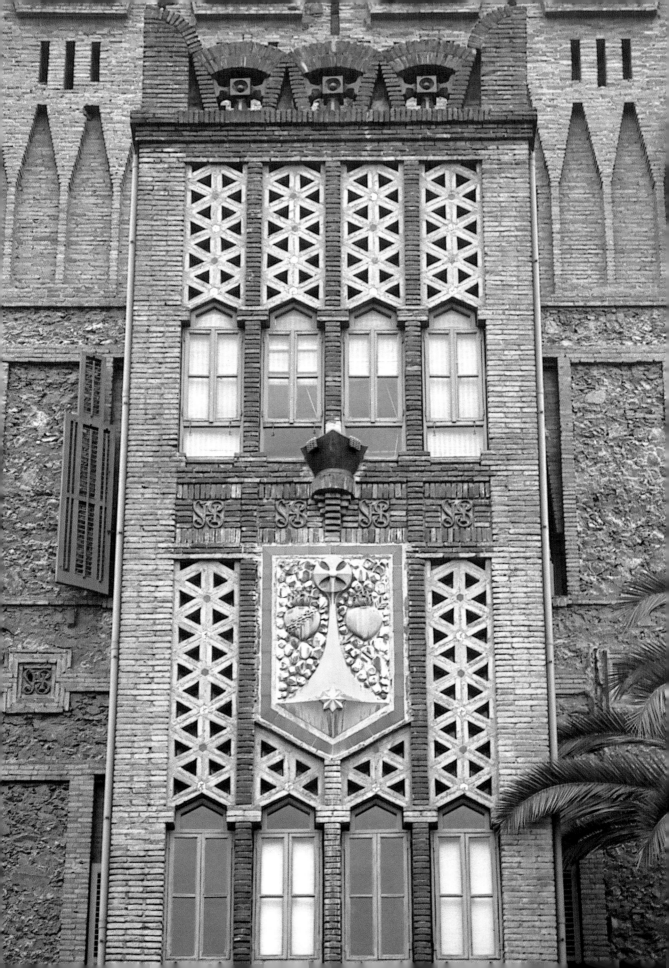

building's most interesting features is the inner peristyle, a symbolic arrangement of arches and courtyards laid out through a series of corridors parallel to the light shaft, in addition to the succession of parabolic arches that give the building a cloister-like appearance.

The exposed brick and uncut stone on the façade are building materials which fulfil a decorative function by delineating the horizontal bands of each floor. The window openings, such as those ones on the top floor, are made of red brick, also known as *totxo català* (Catalan brick).

The tall parabolic windows impose a vertical rhythm that intensifies on the top floor, with upper battlements as a type of crown. The central volume rests on a brick porch adorned with ceramic crosses. These structures serve as compositional elements that soften the severity of the structure. Gaudí placed a brick spire on each of the four corners of the building, reminiscent of the turrets of León and used to delimit the structure and give a sense of unity to the whole. Four-armed red glazed ceramic crosses painted with floral motifs sits atop

Heiligen Theresa genannte „Burg guter Christen" an. Dieser Eindruck der Genügsamkeit wird durch den Ziegelbau unterstrichen, denn das Projekt musste mit wenigen finanziellen Mitteln auskommen. Einer der interessantesten Bereiche ist das innere Peristyl, eine symbolische Anlage aus Bogen und Innenhöfen mit parallel zum Lichthof verlaufenden Korridoren. Aufgrund der Abfolge von Parabelbogen gleicht diese Anlage in gewisser Weise einem Kreuzgang.

Das unverputzte Mauerwerk und die unbearbeiteten Steine der Fassade sind Baumaterialien mit einer dekorativen Funktion, denn sie deuten die vier horizontal verlaufenden Geschossreihen an. Die Rahmen der Lichtöffnungen und die abgrenzenden Ziegelreihen, wie beispielsweise im letzten Obergeschoss, bestehen aus rotem Ziegelstein, der auch als „katalanischer Barren" bekannt ist.

Die hohen parabelförmigen Fenster verleihen dem Bau eine vertikale Ausrichtung, die im dritten Geschoss mit einem krönenden Zinnenwerk verstärkt wird. Der zentrale Gebäudeteil erstreckt sich über eine aus Ziegelstein gemauerte und mit Keramikkreuzen verkleidete

brique, matériau choisi en raison du manque de fonds pour le projet. L'une des parties les plus intéressantes du bâtiment est le péristyle intérieur, un ensemble symbolique d'arcades et de patios distribués par une série de couloirs parallèles au puits de lumière. La succession d'arcs paraboliques donne au tout un certain air de cloître.

La brique apparente et la pierre non taillée de la façade sont des matériaux de construction qui présentent en outre une fonction décorative, car ils démarquent les franges horizontales des quatre étages. L'encadrement des fenêtres et les rangées horizontales sont en brique rouge, également connue sous le nom de « totxo català ».

Les hautes fenêtres paraboliques imposent un rythme vertical qui s'intensifie au dernier étage, couronné d'un ensemble crénelé. Le volume central repose sur le porche, fait de briques et orné de croix en céramique, autant d'éléments visant à atténuer la froideur du bâtiment. À chaque coin de l'édifice, Gaudí plaça une flèche de brique, rappelant les tourelles de León, pour délimiter la structure et

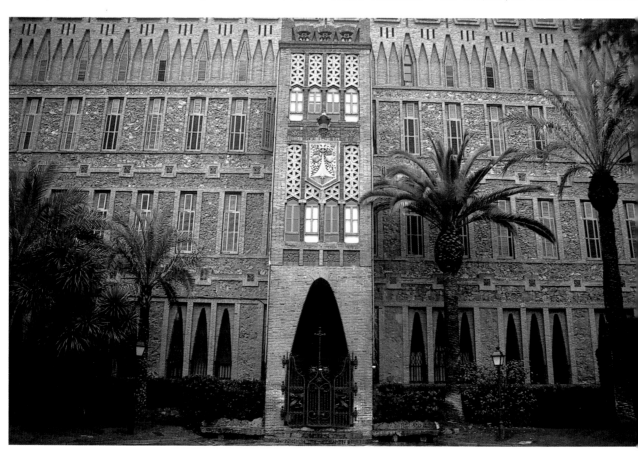

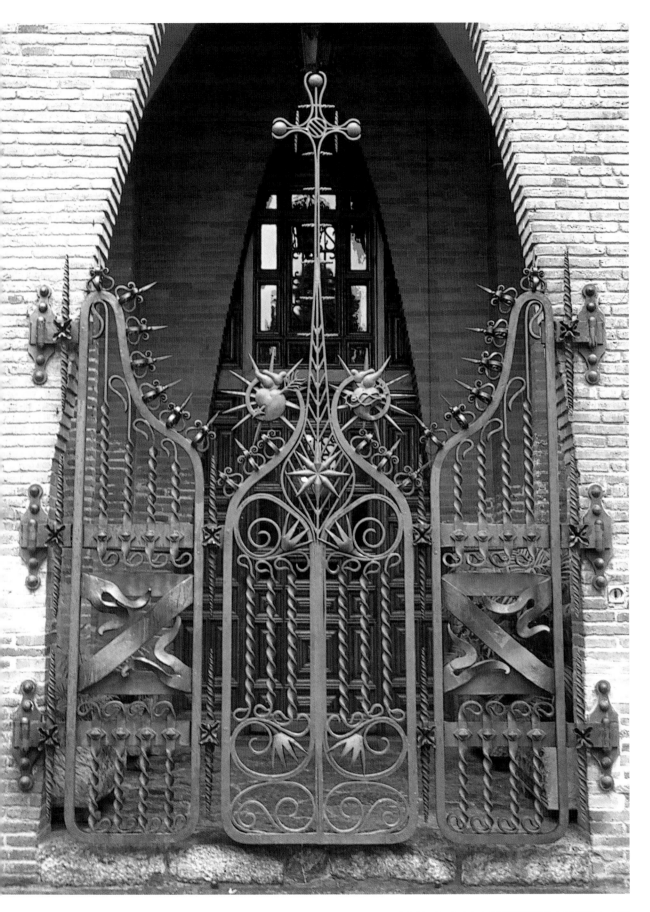

each of the spires, the only decorative element inspired by nature that the architect used in this building.

Advised by the devout Enric d'Ossó, the most prominent expert on the life of Saint Teresa, Gaudí succeeded in integrating most of the main elements of Teresian symbolism into the building, such as the fires, or the "castle," a central allegory of the writings of Saint Teresa.

This repertoire of symbols can be found primarily on the first floor, assigned to the sisters, where Gaudí used anagrams of Christ that read, "Jesus, man, saviour," inscribed onto small, square-shaped glazed ceramic plaques. The coat-of-arms representing the order of Saint Teresa was placed on the four corners of the building on Solomonic columns made of brick and ceramic. The battlements crowned by mortarboards, which disappeared during the Spanish Civil War, were restored by the architect to represent the saint's doctorate. The battlements are separated by small balustrades adorned with the letter "T" for Teresa, though they also represent Christ's cross. The image of the cypress flower topping off the four

Vorhalle. Diese baulichen Mittel dienten dazu, die Ausdruckslosigkeit des klotzigen Aufbaus zu überwinden. An den vier Ecken der Schule platzierte Gaudí gemauerte Spitzen, die an die Türmchen in León erinnern und nicht nur die Gebäudegrenzen markieren, sondern ein einheitliches Erscheinungsbild ermöglichen. Auf diesen Turmspitzen ruhen vierarmige Kreuze aus rötlich glasierter Keramik, die mit Blumenmotiven versehen sind. Sie sind das einzige von der Natur inspirierte Schmuckelement, dessen sich der Architekt in diesem Gebäude bediente.

Beraten vom Geistlichen Enric d'Ossó, der das Leben der Heiligen Theresa wie kein anderer kannte, führte Gaudí mit diesem Gebäude die wichtigsten Elemente der theresianischen Symbolik in die Architektur ein, darunter natürliche Elemente, wie das Feuer, und historische Verweise, wie auf die „Burg", die zentrale Allegorie im Werk *Die Seelenburg* der Heiligen Theresa.

Die meisten Symbole befinden sich im ersten Stock, der für die Nonnen bestimmt war. Hier ließ Gaudí Anagramme Christi mit der Inschrift „Jesus, Mensch, Erlöser" auf kleinen quadratischen Fliesen anbringen. Die Wappen des

conférer une certaine cohésion à l'ensemble. Ces flèches sont coiffées de croix à quatre bras en céramique vernissée et ornées de motifs floraux. Il s'agit de l'unique élément décoratif inspiré de la nature que l'architecte a employé dans cet édifice.

Gaudí, conseillé par le dévot Enric d'Ossó, une sommité en ce qui a trait à la vie de sainte Thérèse, parvint à introduire dans l'architecture de cet édifice grande partie des principaux éléments de la symbolique thérésienne : le feu et le « château », allégorie centrale des écrits de sainte Thérèse.

Ce répertoire de symboles se retrouve notamment au rez-de-chaussée, réservé aux religieuses. Gaudi y plaça des anagrammes du Christ, où l'on peut lire : « Jésus, homme, sauveur », inscrit sur de petits carreaux de céramique vernissée. Le blason de l'ordre de sainte Thérèse figure aux quatre extrémités du bâtiment sur des colonnes torses de brique et de céramique. Les merlons coiffés de toques doctorales, qui disparurent durant la guerre civile espagnole, mais furent remplacés par l'architecte, symbolisent le statut de docteur de

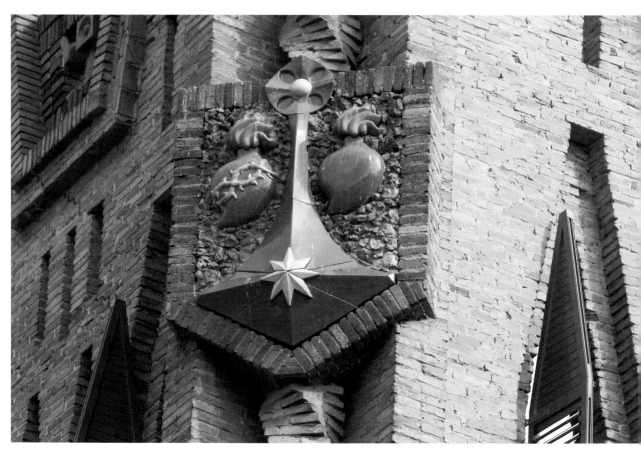

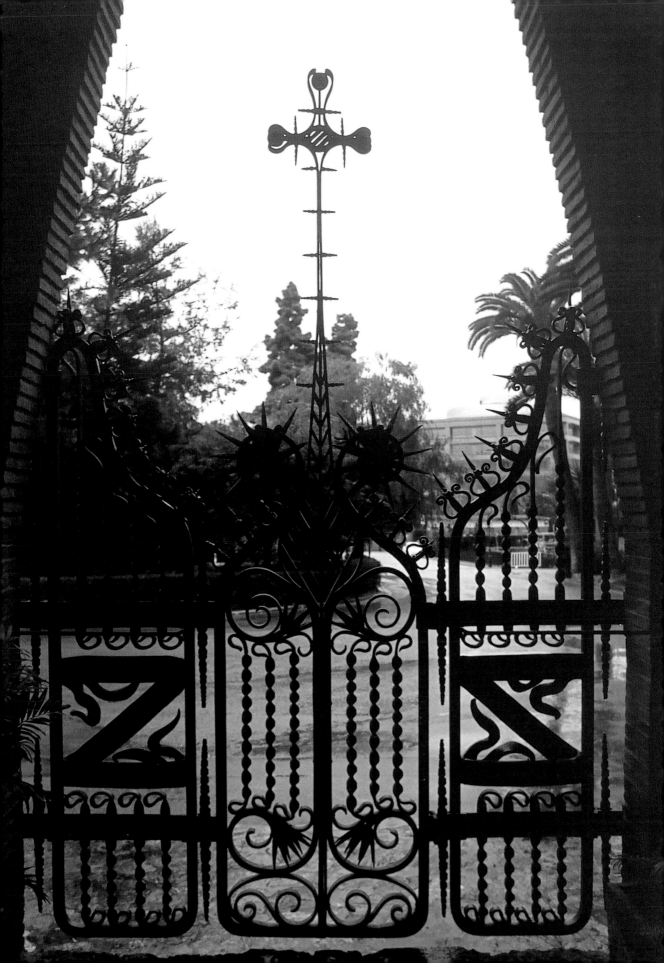

crosses is used to represent the energy and vigour of the Christian faith. This is the first time Gaudí makes use of these crosses, which later become a constant element in his buildings.

Gaudí leaves nothing to chance. He himself designed the beautiful wrought iron gates, one of which he made himself for fear of leaving it to the hands of a craftsman. It is characterised by a slender cross with a central arch representing the order's coat-of-arms, with a cross and star over Mount Carmel, as well as two hearts: one belonging to Jesus crowned by thorns and another belonging to the saint, pierced by the seraph's arrow.

Theresianischen Ordens ruhen an den vier Gebäudeecken auf so genannten salomonischen Säulen aus Ziegelstein und Keramik. Die Zinnen sind von Doktorhüten gekrönt, die während des Spanischen Bürgerkriegs verloren gingen, jedoch später wiederhergestellt wurden und den Doktortitel der Heiligen Theresa symbolisieren. Die Zinnen sind durch Balustraden voneinander getrennt, deren Durchbrüche ein „T" wie Theresa bilden und zugleich auf das Kreuz Christi anspielen. Die vier äußeren Kreuze münden in eine Zypressenblüte, ein Symbol für Energie und die christliche Kraft. Gaudí verwendete diese Kreuze erstmals als Dekorationselement, das von da an in seinen Gebäuden ständig wiederkehrte.

In Gaudís Plänen gab es keinen Platz für Improvisation. So schuf er selbst die herrlichen Schmiedearbeiten des Gitterwerks und der Gittertüren, statt sie einem Kunsthandwerker anzuvertrauen. Dabei sticht besonders ein schmales Kreuz in der Mitte des Bogens hervor, das zusammen mit dem Stern auf dem Berg Karmel und zwei Herzen – dem dornengekrönten Herzen Jesu und dem von Seraphs Pfeil durchbohrten Herzen der Heiligen Theresa – auf das Ordenswappen verweist.

la sainte. Ils sont séparés par des parapets é dés ornés de la lettre T, initiale de Thérèse évocation de la croix. Les couronnements d extrémités, quatre croix parées de la fleur cyprès, évoquent l'énergie et la vigueur de foi chrétienne. Gaudí y utilisa ces croix po la première fois, mais cet élément décora devint ensuite une constante dans ses œuvre

Gaudí ne laissa aucune place à l'improvis tion. Il façonna lui-même le beau portail en f forgé, car il n'osait déléguer cette tâche aucun artisan. Cette œuvre comporte ur croix élancée qui occupe le cœur de l'arche symbolise le blason de l'ordre, portant la cro et l'étoile sur le mont Carmel ainsi que deu cœurs, celui de Jésus surmonté d'épines celui de la Sainte, transpercé de la flèche d séraphin.

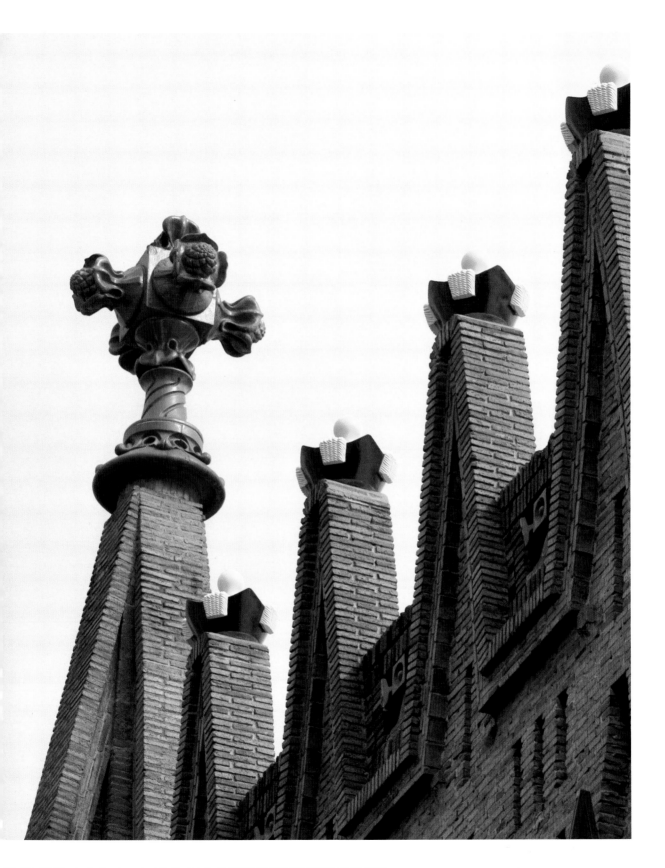

The pinnacles crowning the façade are decorated by ceramic pieces that represent the mortarboard of a doctor.

Die Zinnen, welche die Fassade krönen, sind mit einer keramischen Darstellung des Doktorhuts geschmückt.

Les pinacles qui couronnent la façade sont parés de toques doctorales en céramique.

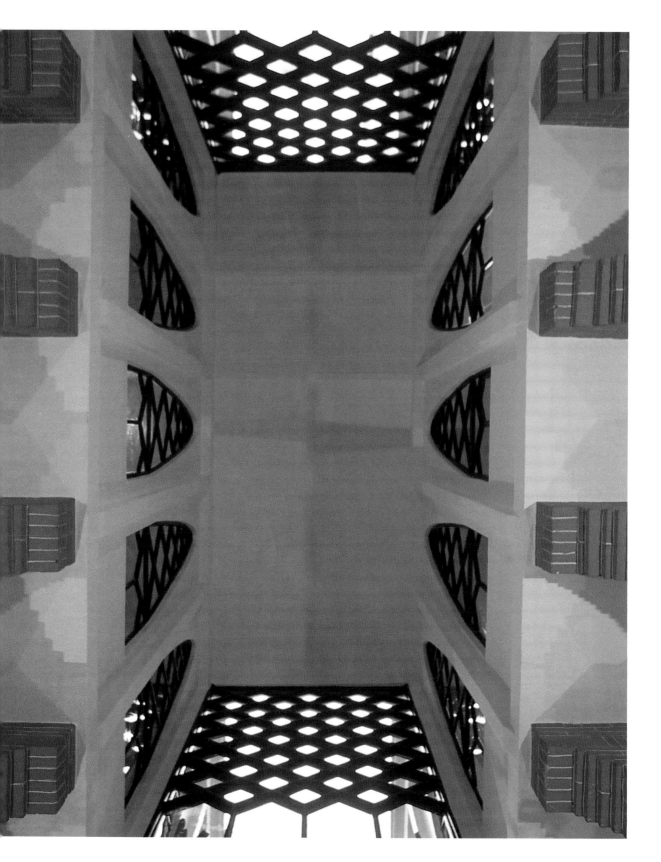

Natural light was an essential and recurring feature inside Gaudí's buildings.

Für Gaudí war das natürliche Tageslicht für die Innenbeleuchtung seiner Gebäude stets ein unabdingbarer und immer neuer Bestandteil.

L'utilisation de la lumière naturelle pour éclairer l'intérieur des bâtiments était un procédé récurrent chez Gaudi.

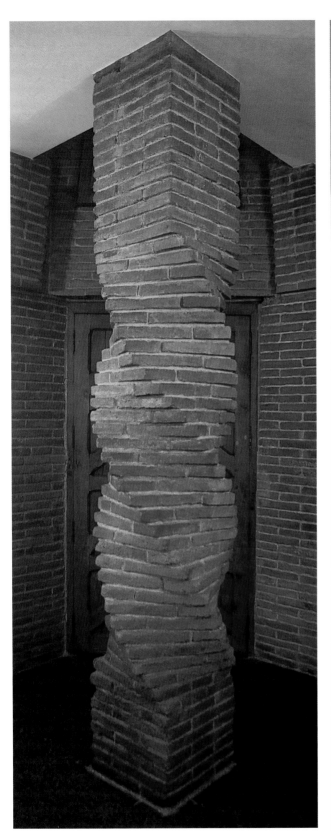
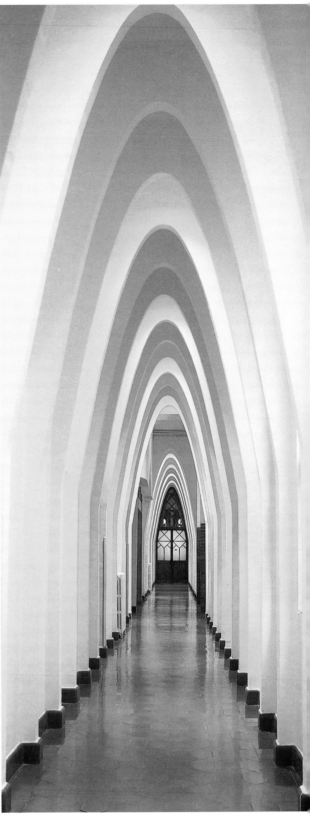

Right: View of the parabolic arches in the corridor inside the Teresian School. Left: The solid brick pillars support the weight of the building.

Rechts: Der Blick auf die Parabelbogen im Korridor der Schule der Theresianerinnen. Links: Die soliden Ziegelsäulen tragen das Gewicht des Gebäudes.

Droite : vue des arcs paraboliques d'un couloir de l'école thérésienne. Gauche : les solides piliers de brique apparente supportent le poids du bâtiment.

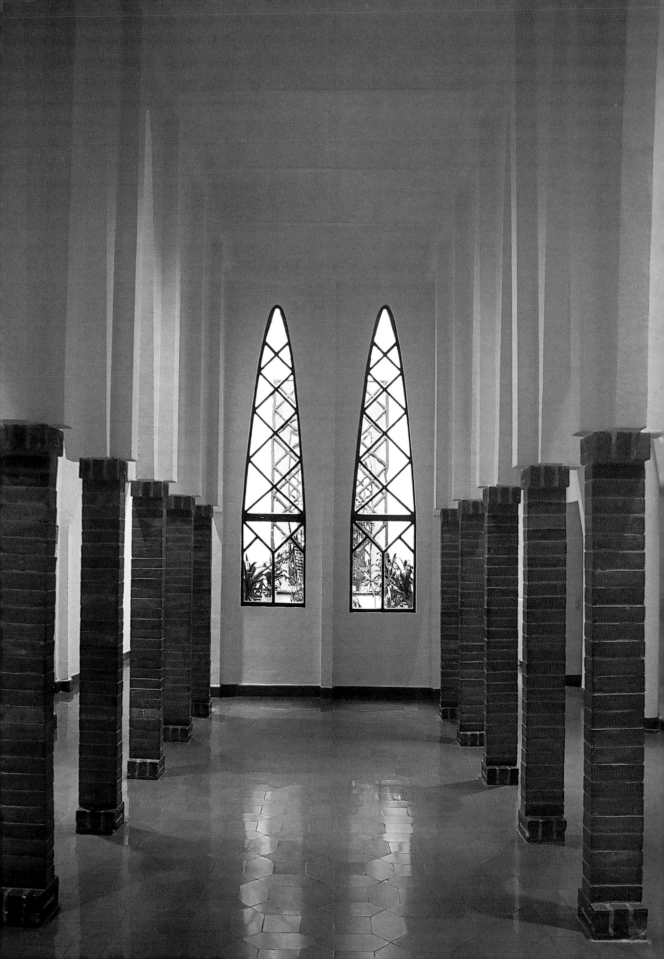

THERE ARE VERY FEW IMPORTANT WORKS BY GAUDÍ OUTSIDE OF CATALONIA. THE ARCHITECT ONLY ACCEPTED THOSE THAT WERE DIRECTLY OR INDIRECTLY COMMISSIONED BY EUSEBI GÜELL.

NUR WENIGE GROSSE WERKE GAUDÍS BEFINDEN SICH AUSSERHALB KATALONIENS, DA DER ARCHITEKT DIESE AUFTRÄGE SELTEN UND NUR AUF DIREKTE ODER INDIREKTE VERMITTLUNG EUSEBI GÜELLS ANNAHM.

IL N'EXISTE QUE TRÈS PEU D'ŒUVRES MAJEURES DE GAUDÍ HORS DE CATALOGNE. L'ARCHITECTE N'ACCEPTA CES TRAVAUX QU'EN DE RARES OCCASIONS ET TOUJOURS PAR L'INTERMÉDIAIRE PLUS OU MOINS DIRECT D'EUSEBI GÜELL.

casa BOTINES

1891-1893

Simón Fernández and Mariano Andrés, owners of a well-known textile business, decided to erect a large commercial-residentialbuilding in the centre of León as their company's headquarters. It was Eusebi Güell, with whom they had business ties, who recommended Antoni Gaudí for the project, which is popularly known as the Casa Botines (1891-1893), named after the founder of the company, Joan Homs i Botinàs. This was Gaudí's first commission outside of Catalonia.

Following the Neo-Gothic style which he had chosen for the Episcopal Palace of Astorga, Gaudí set out to create a building that would not stray from the characteristic architectural style of the surrounding houses in the city. The robust, rectangular block made of raw granite houses shops in the basement and residences on the four upper floors, as well as attics and a main floor reserved especially for the owners. The sloped roof along with the circular turrets emerging from the four corners of the first floor, help give the building a medieval feel. Despite its Neo-Gothic aesthetic, however, the building was devised by means of a highly modern construction system. Gaudí opted for a set of iron pillars with stone capitals, which provided the open, airy spaces appropriate for the building's commercial uses. Given the instability of the land on which the building rested, the architect inserted a spherical stone piece underneath each pillar to absorb the

Simón Fernández und Mariano Andrés, Besitzer einer bekannten Textilfabrik, wollten im Zentrum der Stadt León ein großes Geschäfts- und Wohngebäude als Firmensitz errichten lassen. Eusebi Güell, mit dem sie Geschäftsbeziehungen unterhielten, empfahl ihnen Antoni Gaudí für den Entwurf des Gebäudes, das im Volksmund unter dem Namen „Casa Botines" (1891-1893), abgeleitet vom ursprünglichen Begründer des Unternehmens, Joan Homs i Botinàs, bekannt ist. So kam Gaudí zu seinem ersten Auftrag außerhalb Kataloniens.

Unter Beibehaltung des neugotischen Stils, den er auch für den Bischofspalast in Astorga gewählt hatte, wollte Gaudí ein Gebäude schaffen, das nicht von der vorherrschenden Bautypologie der umstehenden hiesigen Bauten abweichen sollte. Der massive rechteckige Block aus grobem Granit beherbergt Geschäftsräume im Untergeschoss sowie Wohnungen und Mansarden in den vier obersten Etagen, während die Nobeletage den Eigentümern vorbehalten war. Das Schrägdach und die runden Türmchen, die der ersten Etage entspringen und die vier Ecken markieren, verleihen dem Gebäude sein mittelalterliches Aussehen. Ungeachtet der neugotischen Ästhetik wurde das Gebäude anhand eines sehr modernen Bausystems ersonnen. Hinsichtlich der Bautechnik entschied Gaudí, im Untergeschoss eine Reihe von Eisenpfeilern mit steinernen Kapitellen einzusetzen, welche

Simón Fernández et Mariano Andrés, propriétaires d'une société textile de renom, décidèrent de faire construire dans le centre de León un grand édifice à vocation tant commerciale que résidentielle pour y établir le siège de leur entreprise. Eusebi Güell, avec lequel ils entretenaient des relations professionnelles, leur conseilla de confier ce projet à Antoni Gaudí. Le bâtiment résultant, construit entre 1891 et 1893, reçut le nom de « Casa Botines », en hommage au fondateur de l'entreprise, Joan Homs i Botinàs. Ce fut la première commande passée à Gaudí hors de Catalogne.

Fidèle au style néogothique déjà adopté pour la construction du palais épiscopal d'Astorga, Gaudí chercha à créer un édifice relativement proche du type d'architecture prédominant dans les maisons avoisinantes. Ce bloc rectangulaire massif, fait de granit brut, héberge des dépendances commerciales au sous-sol et des appartements aux étages supérieurs, ainsi que des mansardes, le rez-de-chaussée étant réservé aux propriétaires. Le toit incliné ainsi que les tourelles circulaires qui s'élancent du premier étage et flanquent les quatre coins du bâtiment contribuent à lui conférer un aspect médiéval. En dépit de son apparence néogothique, l'édifice fut érigé à l'aide d'un système de construction très moderne. La technique de Gaudí consista à placer au sous-sol une série de piliers de fer coiffés de chapiteaux en pierre, afin de ménager un

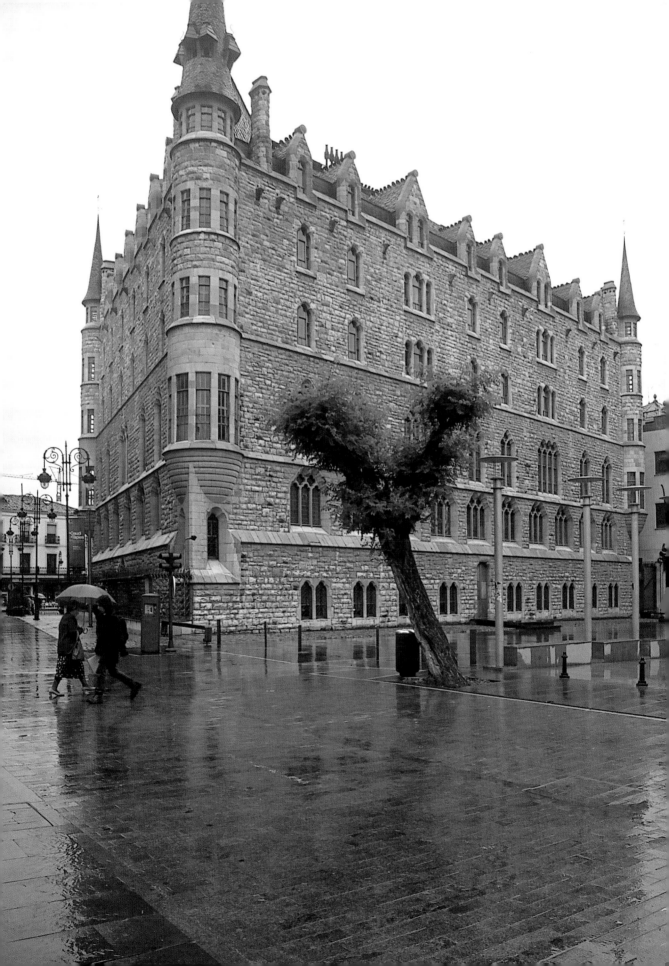

pressure and thus ensure the solidity of the building. The upper floors are supported by structural walls. This technique was heavily criticised by builders at the time, who believed Gaudí's design to be unstable. The passage of time has demonstrated that the building has never suffered from any structural problems.

The building is surrounded by a depression in the land interrupted solely by the entrances. The main door is set off by a remarkable work of wrought iron depicting a lion, in direct reference to the Castilian city, and the engraved name of the proprietor. A stone sculpture by Llorenç Matamala portraying Saint George slaying the dragon was added on 15 November 1893. Based from a letter sent on 3 November of that same year to the new bishop of Astorga and signed in León, we can gather that Gaudí was still in the city putting the finishing touches on the building.

In 1930, the acquisition of the building by a bank led to a modification that resulted in the elimination of characteristic features of the original construction. Fortunately, in 1994

entsprechend den Geschäftsaktivitäten des Gebäudes die Einrichtung großer, offener Räumlichkeiten ermöglichten. Da sich der Baugrund für dieses prächtige Gebäude als nicht sehr solide herausstellte, ließ der Architekt kugelförmige Steinmauerwerke unter den Pfeilern platzieren, um den Druck abzufangen und so die Stabilität des Bauwerks zu gewährleisten. Die oberen Geschosse stützen sich auf tragende Wände. Diese Bauweise wurde von Baumeistern jener Zeit stark kritisiert, da sie annahmen, Gaudís Werk sei nicht stabil. Die Zeit hat jedoch gezeigt, dass das Gebäude keine statischen Probleme aufweist.

Die Casa Botines ist von einem Graben umgeben, der nur von den Zugängen unterbrochen wird. Der Haupteingang wird von einer wunderschönen und zugleich wuchtigen Schmiedearbeit geschmückt, die in Anspielung auf die kastilische Stadt León einen Löwen zeigt und den Namen des Eigentümers enthält. Ferner sticht eine steinerne Skulptur hervor, ein Werk des Bildhauers Llorenç Matamala, das den Heiligen Georg beim Töten des Drachens zeigt und am 15. November 1893 angebracht wurde. Aufgrund eines Briefs an den neuen Bischof

vaste espace ouvert, bien adapté à la fonction commerciale du local. Au vu de la relative instabilité du terrain où devait se dresser ce magnifique édifice, l'architecte décida de placer une semelle de pierre sous chaque pilier afin d'absorber la pression, garantissant ainsi la solidité de l'édifice. Les étages supérieurs reposaient quant à eux sur des murs porteurs. Cette technique fut très critiquée par les constructeurs de l'époque, qui jugeaient précaire la conception de Gaudí. Mais le temps prouva le contraire, l'édifice n'ayant jamais connu de problèmes structurels.

Le bâtiment est entouré d'un fossé, qui n'est comblé qu'aux portes d'entrée. La porte principale est agrémentée d'un remarquable ouvrage de ferronnerie, où figure un lion (allusion directe à la ville de León) au-dessus du nom du propriétaire. La sculpture en pierre de Saint Georges tuant le dragon, œuvre de Llorenç Matamala, fut installée le 15 novembre 1893. Une lettre envoyée au nouvel évêque d'Astorga le 3 novembre de cette même année et signée à León prête à croire que Gaudí était encore dans la ville et qu'il procédait à la finition du bâtiment.

the new owner of the building decided to carry out a complete restoration that reinstated all the elements that had either been eliminated or altered in previous years. It was during this restoration process that a small tube containing Gaudí's original blueprints was discovered underneath the sculpture of Saint George, proving of exceptional value to the correct restoration of the building.

The inside of the house also preserves many of the elements designed by Gaudí, such as the doors, windows and balustrades.

von Astorga, der vom 3. Januar des gleichen Jahres datiert und in León unterzeichnet wurde, nimmt man an, dass sich Gaudí in der Stadt aufhielt, um die letzten Einzelheiten zur Vollendung der Bauarbeiten zu klären.

1930 wurde das Bauwerk von einem Bankinstitut aufgekauft und einigen Umbauarbeiten unterzogen, bei denen herausragende Bauelemente zerstört wurden. Glücklicherweise entschied der neue Gebäudebesitzer im Jahr 1994, alle zuvor entfernten oder veränderten Elemente zu restaurieren und wiederherzustellen. Bei diesen Renovierungsarbeiten fand man unter der Skulptur des Heiligen Georg eine kleine Röhre mit Gaudís Originalplänen für dieses Projekt. Diese Entdeckung erwies sich als sehr hilfreich für die Wiederherstellung des Gebäudes.

Im Inneren der Casa Botines sind heute noch einige der von Gaudí entworfenen Bauteile, wie Türen, Fenster oder Geländer, erhalten.

En 1930, cet édifice fut acquis par un établissement bancaire, qui y effectua des travaux d'aménagement. Au cours de ceux-ci, certains éléments marquants de la construction furent détruits. Par chance, en 1994, le nouveau propriétaire du bâtiment décida de le restaurer et de remplacer les éléments enlevés ou modifiés dans les années précédentes. Au cours de ces travaux de restauration, on découvrit sous la sculpture de Saint-Georges un petit cylindre contenant les plans originaux du projet de la main de Gaudí. Cette précieuse découverte facilita les travaux de restauration.

L'intérieur de l'édifice renferme encore aujourd'hui certains éléments conçus par Gaudí, tels que les portes, les fenêtres et les balustrades.

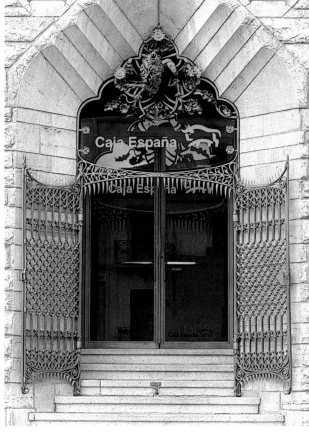

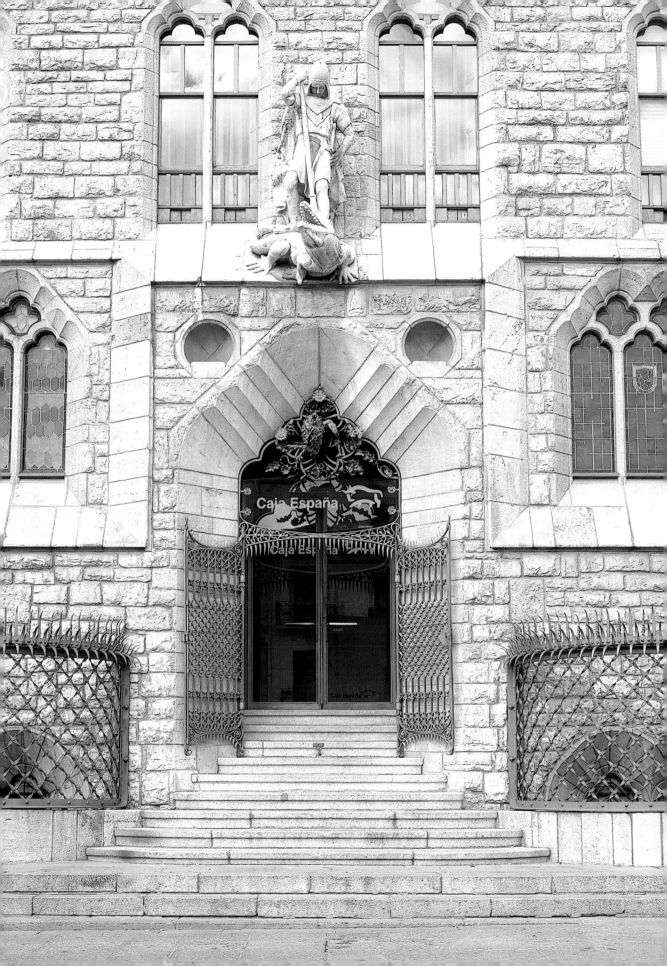

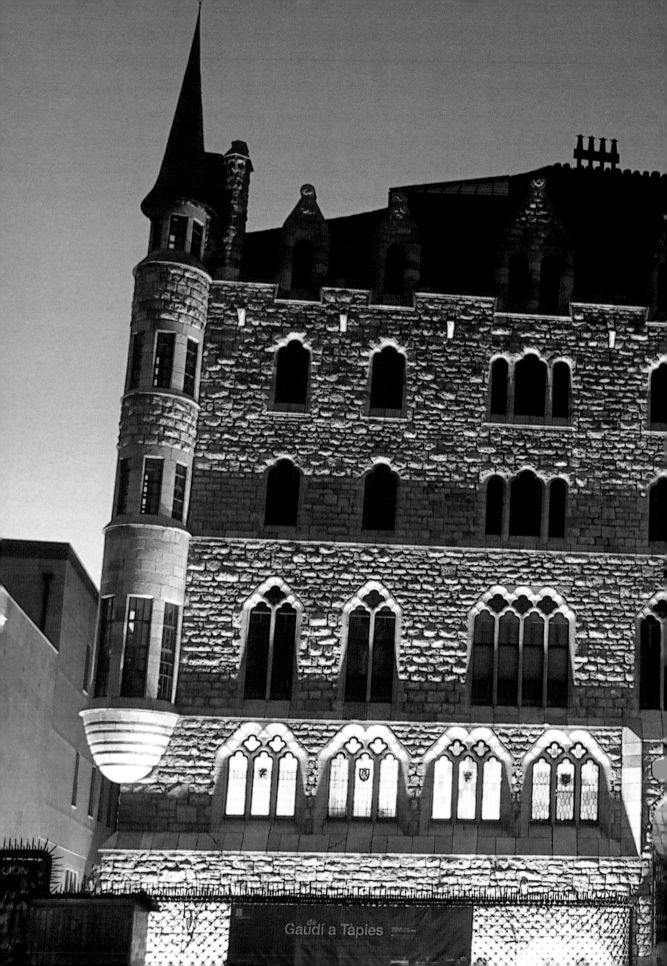

de
Gaudí a Tàpies

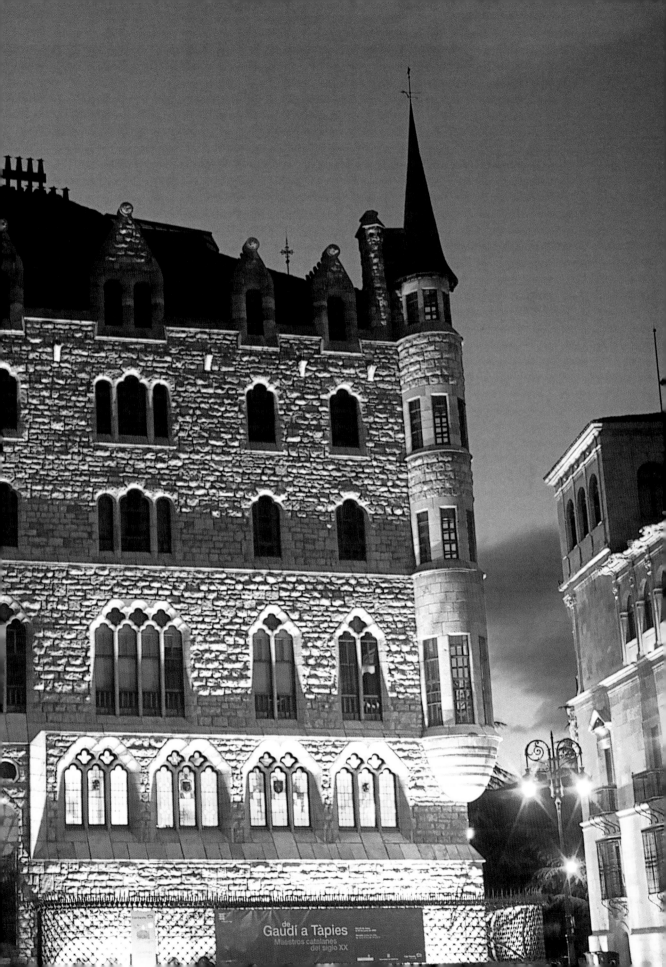

Gaudí created a robust structure comprised of iron pillars with stone capitals to support the building.

Zum Abstützen des Gebäudes richtete Gaudí im Untergeschoss widerstandsfähige Strukturen aus Eisenpfeilern mit steinernen Kapitellen ein.

Au sous-sol, Gaudí créa une structure très robuste de piliers de fer à chapiteau de pierre pour soutenir l'édifice.

In light of the specific needs of the space and its commercial nature, the architect designed an airy, spacious basement

Da dem Architekten die räumlichen Anforderungen im Zusammenhang mit der geschäftlichen Nutzung des Gebäudes bekannt waren, entwarf er ein großräumiges, offenes Untergeschoss

Conscient des besoins en espace propres à la vocation commerciale du bâtiment, l'architecte pensa un sous-sol clair et spacieux

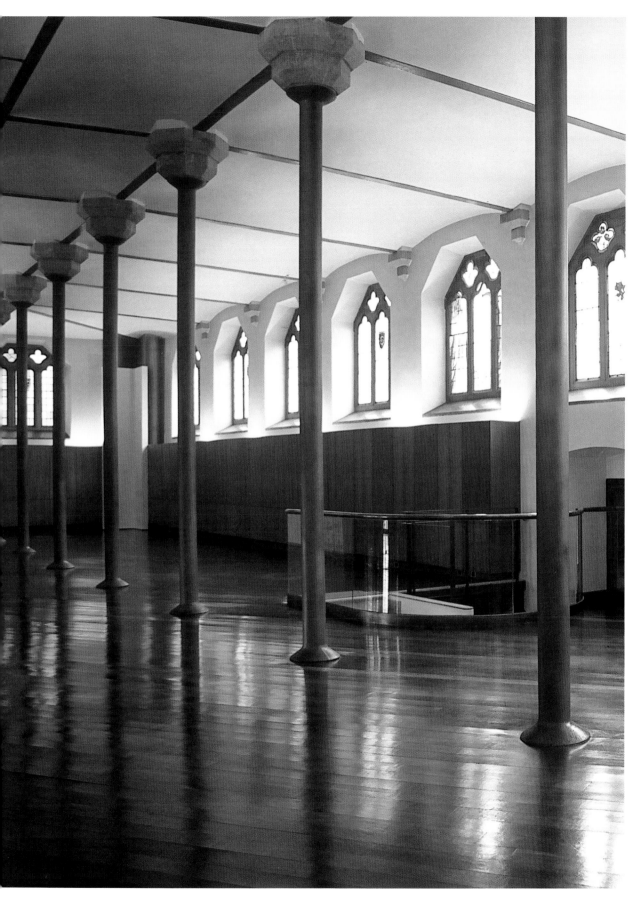

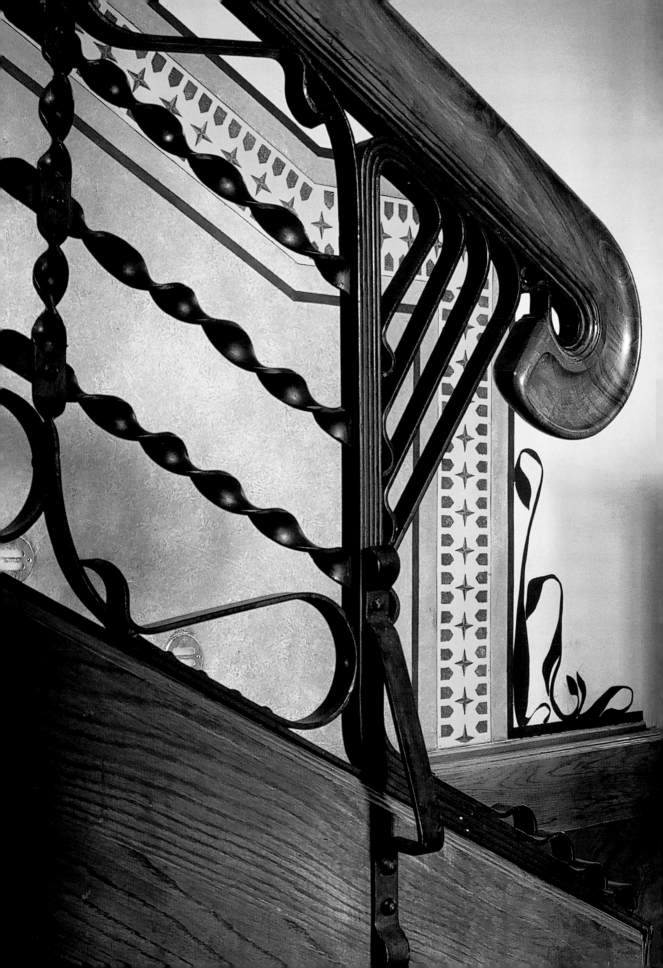

he building has several floors, such as the first floor reserved for the owners, and attic spaces covered by wooden structures.

las Gebäude besitzt mehrere Etagen, wie das den Eigentümern vorbehaltene Hauptgeschoss und die mit hölzernem Dachgebälk versehenen Mansarden.

édifice s'étend sur plusieurs étages, dont le rez-de-chaussée réservé aux propriétaires et des combles où les structures en bois sont en évidence.

SITUATED ON A CLIFF IN A PRIVILEGED AREA ALONG THE MEDITERRANEAN COAST, THIS COMPLEX WAS DESIGNED BY GAUDÍ TO HOUSE EUSEBI GÜELL'S WINERY.

AN EINEM GÜNSTIGEN STANDORT AN DER MITTELMEERKÜSTE SCHUF ANTONI GAUDÍ AUF EINER DER STEILKÜSTEN ZWISCHEN BERG UND MEER EINEN EINZIGARTIGEN GEBÄUDEKOMPLEX, IN DEM GÜELL SEIN WEINGUT EINRICHTETE.

DANS UN LIEU PRIVILÉGIÉ DU LITTORAL MÉDITERRANÉEN, SUR UNE FALAISE ENTRE MER ET MONTAGNE, ANTONI GAUDÍ CRÉA UN SINGULIER ENSEMBLE ARCHITECTURAL POUR HÉBERGER LES CAVES D'EUSEBI GÜELL.

GÜELL winery
der celler GÜELL
les caves GÜELL

1895-1897

In 1870, Eusebi Güell purchased a large tract of land with a mediaeval house situated on the Garraf cliffs along the Mediterranean coast south of Barcelona. Güell's initial idea was to convert the house into a hunting pavilion. This project, which was never built, was commissioned to Antoni Gaudí in 1882, who designed an original brick building that combined hexagonal forms and featured a Gothic/military-style tower.

Finally, in 1895, Güell decided to exploit the vineyards he had purchased and restore the *masia* (country home) and mediaeval tower on the land. Gaudí finished construction of the winery in 1897 with the help of Francesc Berenguer i Mestres (1886-1914), also born in Reus and son of one of Gaudí's first school teachers. This collaboration led to confusion over the authorship of the project, given that Berenguer had never finished his architectural studies, which, however, did not stop him from working alongside Gaudí from 1887 until the year of his death. Despite the presence of many of Gaudí's characteristic features in this building and his signing of the final design, it is difficult to determine where his work begins and that of Berenguer ends. Gaudí himself also contributed in heightening the confusion after commenting shortly before the death of his assistant that Berenguer was the mastermind of the winery project, which was, in fact, a tribute to his gravely ill colleague. However, in 1916,

Im Jahr 1870 erwarb Eusebi Güell ein mittelalterliches Gehöft und die umliegenden Ländereien. Dieser neue Besitz befand sich im Gebirgsmassiv Garraf an der Mittelmeerküste südlich von Barcelona. Güells erste Idee für dieses Anwesen war die Errichtung eines Jagdpavillons. 1882 wurde Gaudí mit diesem letztlich nie realisierten Projekt betraut und entwarf einen originellen Ziegelbau, der sechseckige Formen miteinander kombinierte und sich durch einen gotisch-militärisch anmutenden Turm auszeichnete.

Schließlich entschied Güell im Jahr 1895, die erworbenen Weinberge zu bewirtschaften und das auf dem Gelände befindliche Gehöft samt dem mittelalterlichen Turm zu renovieren. Die Bauarbeiten am Weingut wurden 1897 abgeschlossen. Sie erfolgten unter der Leitung Gaudís und mit Unterstützung von Francesc Berenguer i Mestres (1866-1914), der ebenfalls aus Reus stammte und Sohn eines der ersten Schullehrer des Architekten war. Diese Zusammenarbeit sorgte für Verwirrung hinsichtlich der Urheberschaft des Gebäudes, da Berenguer sein Architekturstudium nie zum Abschluss brachte, was ihn jedoch nicht hinderte, von 1887 bis zu seinem Tod an Gaudís Seite zu arbeiten. Der Endentwurf wurde von Gaudí unterschrieben, und auch viele Bauelemente dieses Werks tragen seine Handschrift. Nichtsdestotrotz bleibt ungeklärt, welche Arbeiten von Gaudí stammen und welche von

En 1870, Eusebi Güell acquit un ancien ma et ses terres attenantes sur les falaises d Garraf, le long de la côte méditerranéenne a sud de Barcelone. Güell pensa en premier lie utiliser ce terrain pour y construire un pavillo de chasse. La conception de ce projet, qui n vit jamais le jour, fut confiée à Antoni Gaudí e 1882. Celui-ci dessina un étonnant bâtimen en briques où s'entremêlaient des forme hexagonales et duquel s'élançait une tour d style gothique et militaire.

Finalement, en 1895, Güell décida d'exploite les vignes qu'il avait acquises et de restaurer l mas et la tour médiévale qui se trouvaient su ces terres. Le chantier de construction de l cave vinicole (achevée en 1897) fut confié Gaudí, en collaboration avec Francesc Berer guer i Mestres (1866-1914), également né Reus et fils de l'un des premiers maîtres d'éco le de l'architecte. Ce travail d'équipe prêta confusion sur la paternité de l'œuvre. Berer guer ne termina jamais ses études d'architec ture, ce qui ne l'empêcha pas de travailler, dè 1887 et jusqu'à sa mort, aux côtés de Gaud Gaudí signa le projet final et nombre d'élé ments architecturaux révèlent son influence Malgré tout, il est difficile de déterminer ave précision où commence le travail de Gaudí e où finit celui de Berenguer. Gaudí lui-mêm contribua à accroître la confusion, en affirman peu avant la mort de son assistant que Berer guer était le cerveau du projet. Il voulait en fa

Gaudí cleared up the matter upon advising the architect Amós Salvador to visit this building in Garraf, which he described as his best work.

There is only one document that confirms the authorship of the winery: the original blueprints preserved by the Municipal Historical Archive of Sitges, signed by Güell and Gaudí in 1895.

The project consisted of an elongated structure with sloped walls attached to the mediaeval house that operated as a wine cellar. Divided into three floors, Gaudí placed a chapel on the upper floor, a home for the building manager on the first floor and a coach house on the ground floor. The asymmetric façades and volumes, the discarding of round arches in favour of parabolic arches, the absence of horizontal lines (a typical Renaissance feature), and interplay of empty and filled spaces, are all characteristic of Gaudí's style and clearly evocative of medieval constructions. The parabolic arches bear a greater resemblance to pointed Gothic arches than to round Romanesque arches. A frontal view of the building shows a triangular structure accentuated by chimneys and the

Berenguer. Der Architekt selbst stiftete zusätzlich Verwirrung, da er kurz vor dem Tod seines Helfers erklärte, Berenguer habe den Entwurf für den Weinkeller geschaffen. Dies geschah zu Ehren des schwer erkrankten Mitarbeiters. Im Jahr 1916 jedoch klärte Gaudí seine Urheberschaft auf, als er dem Architekten Amós Salvador riet, das Gebäude in Garraf zu besuchen, und es als sein bestes Werk bezeichnete.

Es existiert nur ein Dokument, mit dem sich die Urheberschaft des Weinguts begründen lässt. Im Historischen Archiv der Gemeinde Sitges ist ein Grundrissplan aus dem Jahr 1895 erhalten, der von Güell und Gaudí signiert ist.

Der Entwurf sah ein längliches Gebäude mit schrägen Mauern vor, das an das alte, mittelalterliche Gehöft anschloss und als Weinkeller dienen sollte. Es war unterteilt in drei Stockwerke: Im obersten Geschoss richtete Gaudí eine Kapelle ein, im ersten Stock die Wohnung des Gutsverwalters und im Erdgeschoss die Remise. Die asymmetrischen Fassaden und Baukörper, der Verzicht auf Rundbogen und die Verwendung von Parabelbogen, die Aussparung der horizontalen Linie – ein in der Renaissance

rendre hommage à son compagnon, alors gravement malade. Cependant, lorsqu'en 1916 Gaudí conseilla à l'architecte Amós Salvador de visiter cet édifice du Garraf, il mit fin à la controverse en le décrivant comme son meilleur travail.

Il n'existe qu'un seul document attestant de la paternité des caves. Les archives historiques municipales de Sitges renferment en effet les plans originaux du projet, datés de 1895 et signés par Güell et Gaudí.

Le projet consistait en un édifice allongé aux murs inclinés, attenant à l'ancien mas médiéval qui servait de cave. Pour l'aménagement de cet espace sur trois niveaux, Gaudí décida d'installer une chapelle au dernier étage, les appartements de l'administrateur de la propriété au premier et un garage au rez-de-chaussée. L'asymétrie des façades et des volumes, l'omission de l'arc en plein cintre et l'introduction d'arcs paraboliques, tout comme l'absence de lignes horizontales (typiques de la Renaissance) et l'alternance d'espaces vides et pleins, sont caractéristiques du style de Gaudí. L'ensemble évoque certaines constructions

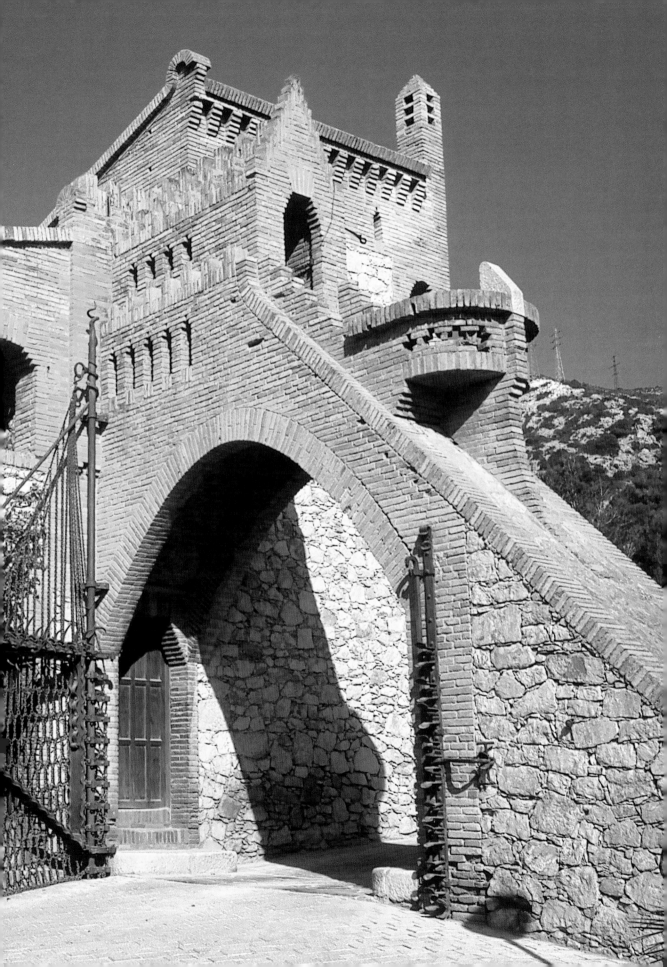

bell gable. A series of bridges was also built to connect the new winery building to the existing structures.

The guard's house situated at the entrance of the site features impressive doors decorated with heavy chains that seem to deter entry into the grounds. Expressionism is the predominant trend in the entire architectural complex, which clearly fell within the *Modernista* style.

häufig eingesetztes Mittel – und das Spiel mit leeren und ausgefüllten Bereichen weisen das Gebäude direkt als Gaudís Werk aus. Die gesamte Anlage des Celler Güell erinnert an mittelalterliche Bauwerke, und die Parabelbogen ähneln eher den gotischen Spitzbogen als den romanischen Rundbogen. Die Frontansicht des Gebäudes zeigt eine Dreiecksstruktur, die von den Schornsteinen und dem Glockenturm noch betont wird. Ebenfalls bemerkenswert ist eine Reihe von Brücken, die das neue Gebäude des Weinkellers mit den bereits vorhandenen Bauten verbinden.

Das Pförtnerhäuschen am Eingang des Weinguts sticht durch sein mit dicken Ketten verziertes Tor hervor, das den Zutritt zum Grundstück zu verwehren scheint. Der Expressionismus beherrscht die gesamte bauliche Anlage, die vollkommen dem modernistischen Stil zuzuschreiben ist.

médiévales. Les arcs paraboliques rappellent davantage les arcs en lancette gothiques que ceux en plein cintre romans. Vu de face, l'édifice présente une structure triangulaire, accentuée par les cheminées et la flèche du clocher. Une série de ponts fut également bâtie pour relier le nouveau bâtiment aux structures existantes.

À l'entrée du complexe, la maison du gardien affiche un imposant portail paré de lourdes chaînes, qui semblent vouloir interdire l'entrée. L'ensemble architectural présente un caractère expressionniste typique du style moderniste.

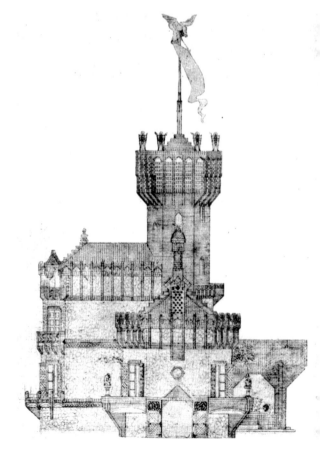

Unexecuted design by Gaudí for the hunting pavilion commissioned by Eusebi Güell for his property in Garraf.

Gaudís letztlich nicht umgesetzter Entwurf für einen Jagdpavillon, den Eusebi Güell auf seinem Grundstück in Garraf errichten lassen wollte.

Dessin de Gaudi pour le pavillon de chasse commandé par d'Eusebi Güell, pour sa propriété du Garraf et qui ne fut jamais réalisé.

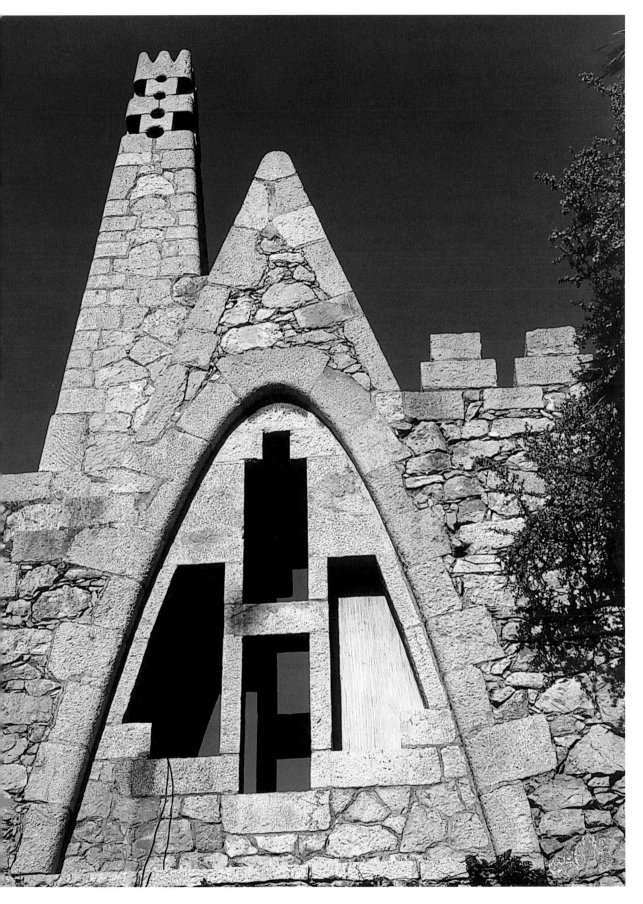

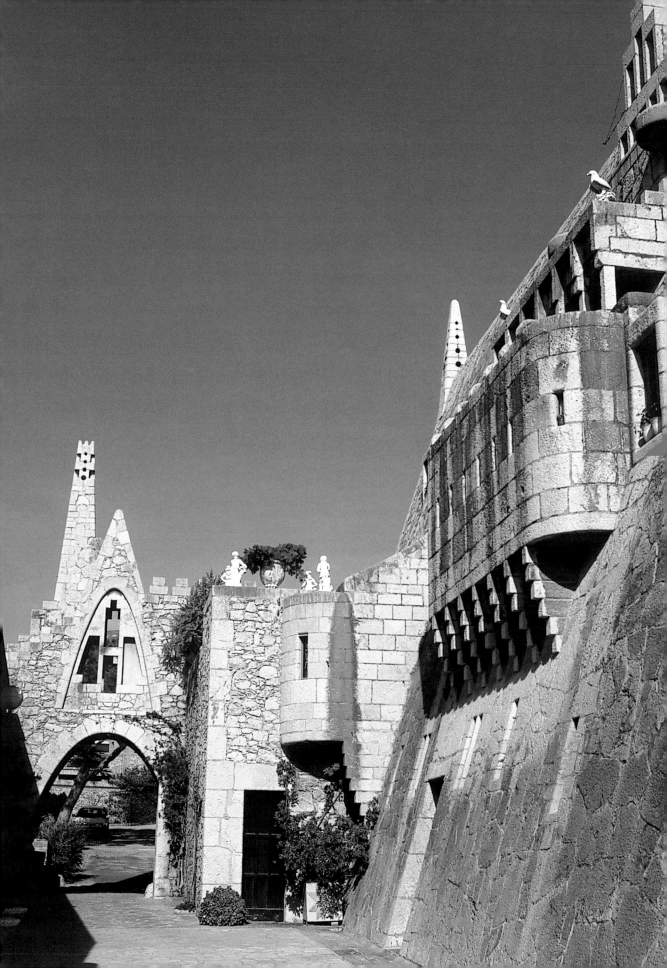

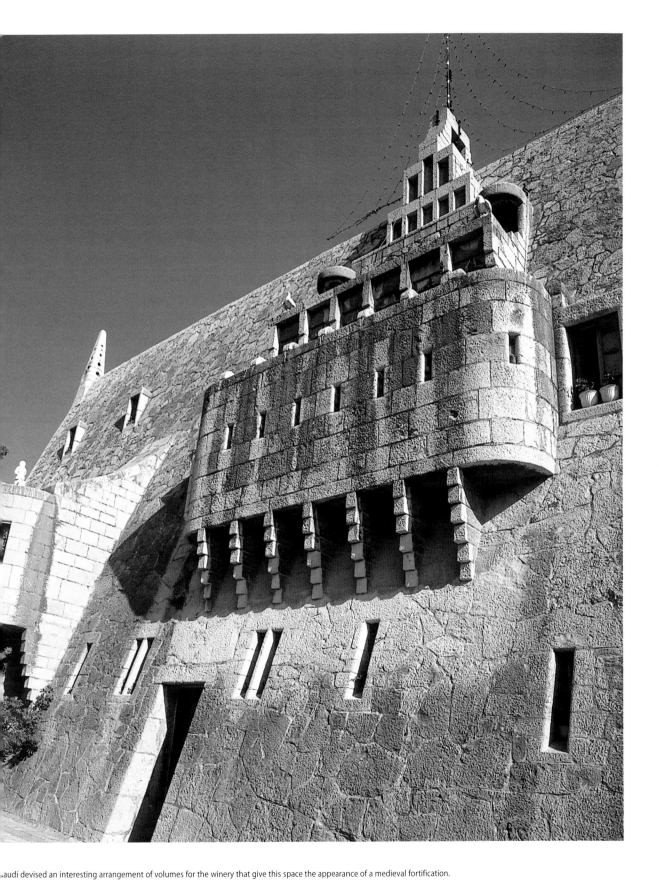

Gaudí devised an interesting arrangement of volumes for the winery that give this space the appearance of a medieval fortification.

Für die Anlage des Weinguts entwarf Gaudí eine interessante Kombination aus verschiedenen Baukörpern, die sich zu einer Art mittelalterlichen Festung zusammenfügen.

Gaudí conçut un intéressant jeu de volumes pour les caves, leur donnant un aspect de forteresse médiévale.

Label of the wine bottles produced by Count Güell in his winery in Garraf, featuring a drawing of the building designed by Gaudí.

Ein Etikett für die Weinflaschen, die der Graf Güell auf seinem Weingut in Garraf abfüllte, zeigte eine Zeichnung von Gaudís Bauwerk.

Étiquette représentant le bâtiment de Gaudi et apposée sur les bouteilles de vin produites par le comte Güell dans ses caves du Garraf.

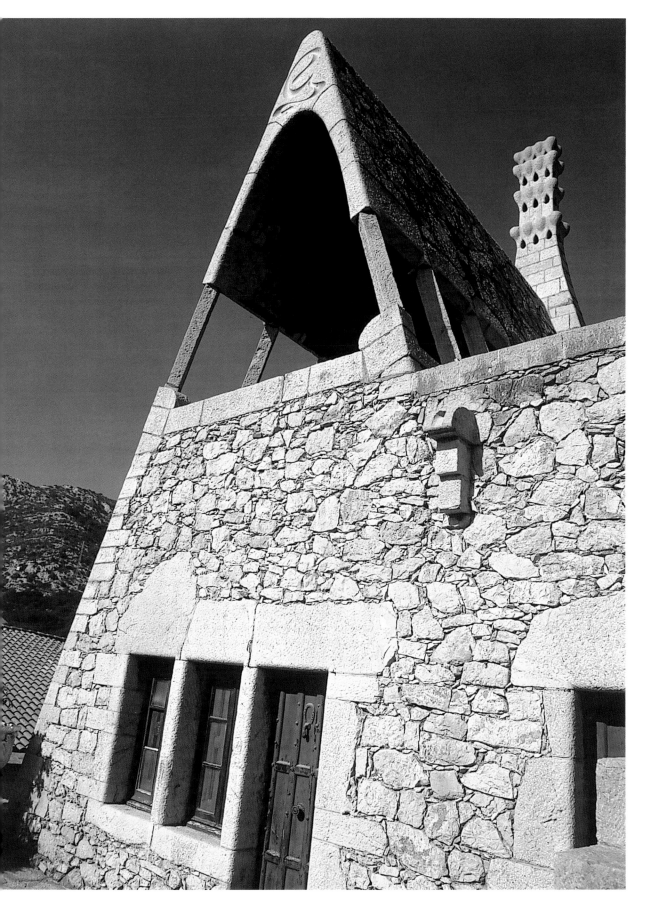

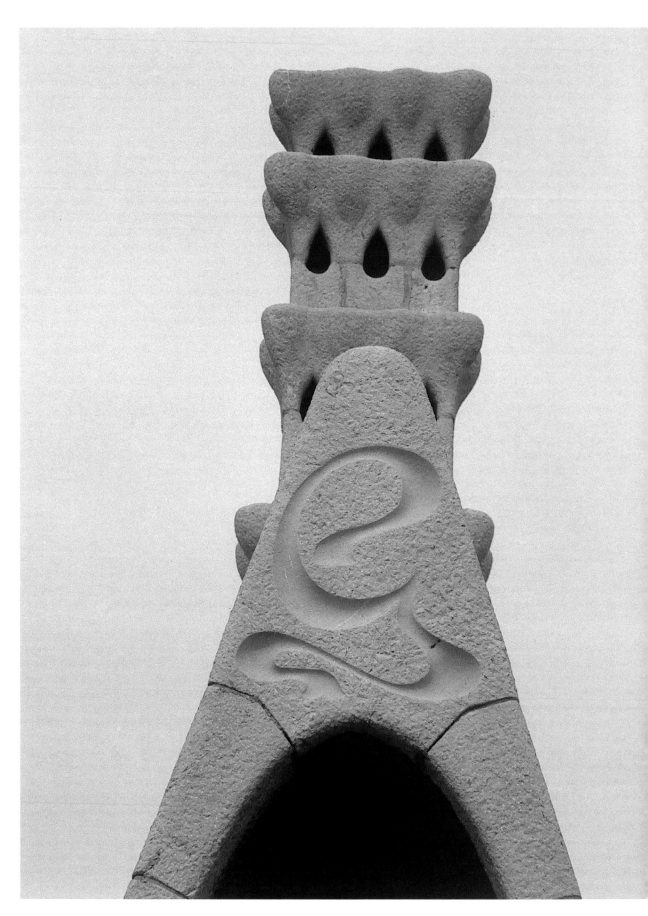

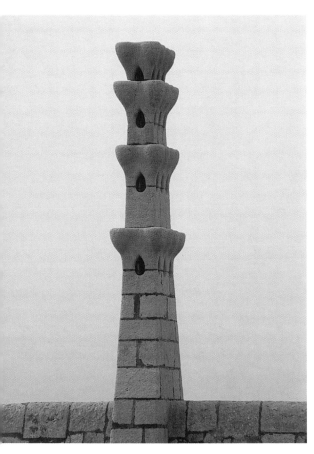

Gaudí had an astonishing imagination and skill with structural forms, rarely repeating any element. A clear example of this are the shapes adopted by the numerous chimneys that crown the buildings in the winery complex. Once again, Gaudí uses inscriptions as decoration: reference to the Güell surname can be found at several places on the façade.

Gaudís Vorstellungskraft und Fähigkeit, Strukturen zu entwerfen, waren beeindruckend. In seinen Werken wiederholt sich nur selten ein Element. Ein Beispiel dafür sind die unterschiedlichen Formen der Schornsteine, welche die Gebäude des Weinguts krönen. Einmal mehr machte Gaudí von der Schrift als Dekorationsmittel Gebrauch und schmückte die Fassade an mehreren Stellen mit Hinweisen auf den Familiennamen Güell.

Gaudí avait une imagination débordante pour les formes structurelles et ne réitérait que rarement ces éléments au fil de ses nombreuses œuvres. Preuves en sont les formes choisies pour les diverses cheminées couronnant les bâtiments des caves. Là encore, Gaudí utilisa la graphie comme élément décoratif : certains ornements de la façade font référence au nom de Güell.

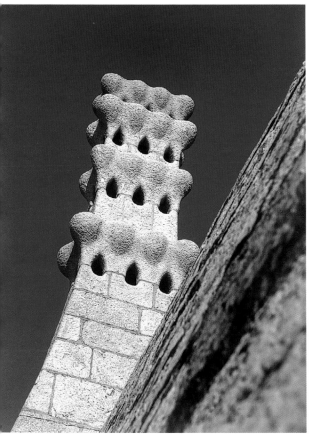

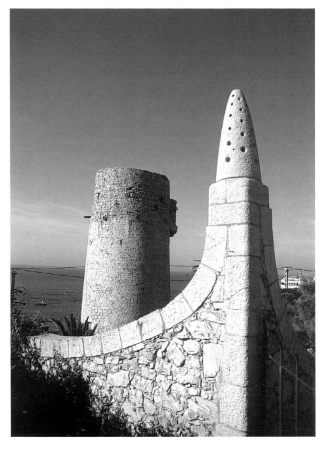

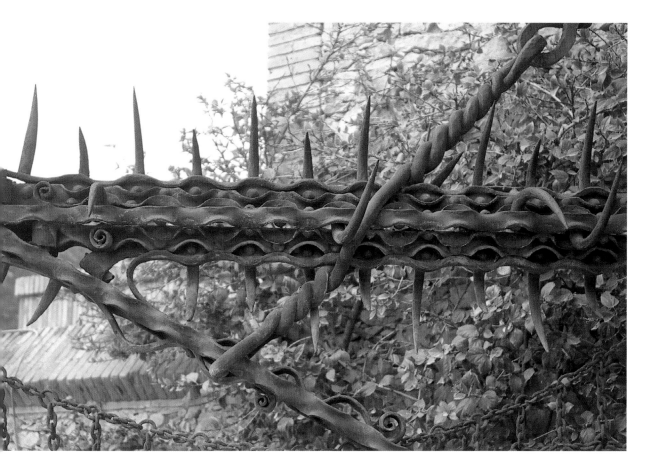

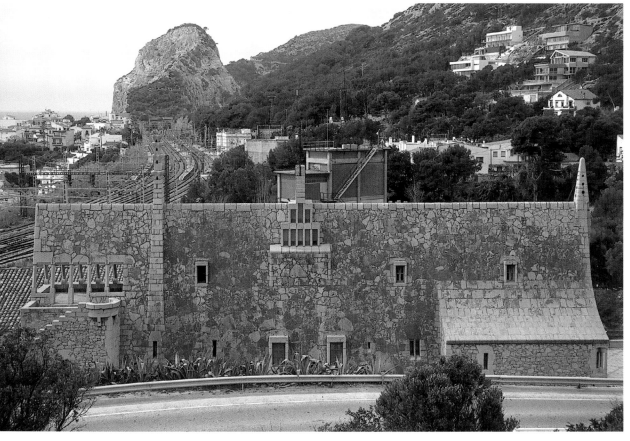

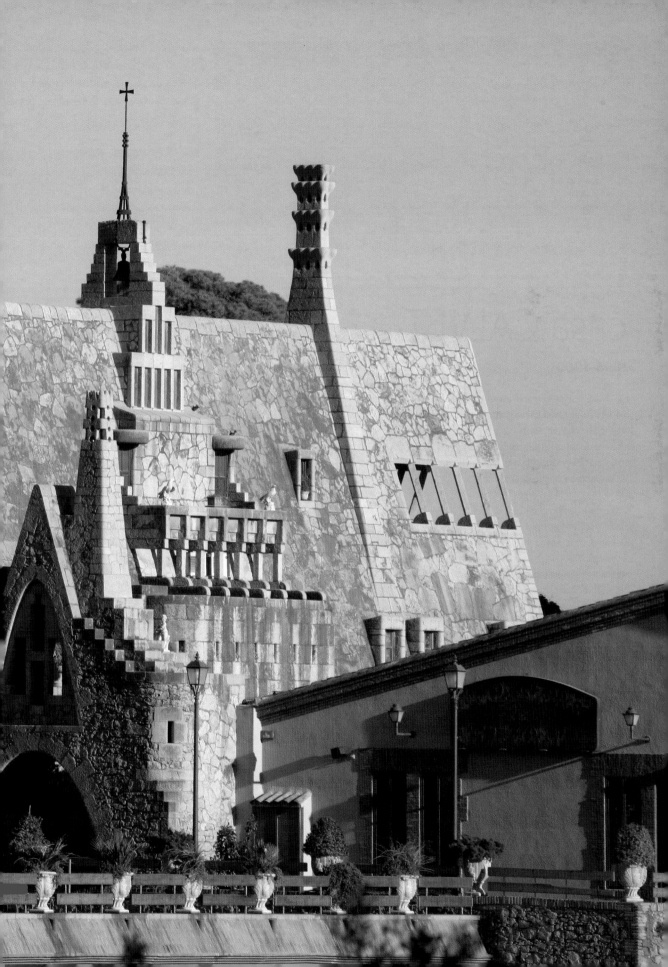

CASA CALVET WAS GAUDÍ'S FIRST RESIDENTIAL BUILDING DESIGNED WITH A SYMMETRICAL AND WELL-STRUCTURED FAÇADE THAT WAS FASHIONABLE AT THE TIME, WHICH GREATLY DIFFERED FROM THE ARCHITECT'S OTHER MORE DECORATIVE WORKS.

MIT DER CASA CALVET ENTWARF GAUDÍ SEIN ERSTES WOHNGEBÄUDE UND VERLIEH IHM GEMÄSS DEM DAMALS VORHERRSCHENDEN BAUSTIL EINE SYMMETRISCHE, GUT GEGLIEDERTE FASSADE, DIE SICH MIT IHRER ORIGINELLEN DEKORATION VON DEN ANDEREN UNTERSCHIED.

LA CASA CALVET FUT LE PREMIER IMMEUBLE D'HABITATION CONÇU PAR GAUDÍ, FIDÈLE AU STYLE ARCHITECTURAL DU MOMENT AVEC UNE FAÇADE BIEN STRUCTURÉE, MAIS QUI SE DÉMARQUE DES AUTRES ŒUVRES PLUS DÉCORATIVES DE L'ARCHITECTE.

casa CALVET

1898-1900

In 1898, the widow and owner of a textile manufacturer commissioned Gaudí to design the house of Pere Màrtir Calvet. The family requested that a residential building be built on Casp Street in Barcelona to house the office and warehouse on the ground floor.

The construction of Casa Calvet in 1900 paved the way for a new building and decorative style that would be followed by many architects. The use of baroque or rococo elements, as well as undulating coronations or the use of stone on balconies, would be a constant feature in the new buildings in Barcelona's Eixample neighbourhood. Gaudí designed a multi-level building that despite its function as a residence for several families would not lack the luxurious quality of Gothic palaces like those on Montcada Street, which had been inhabited by the nobility up until the creation of the Pla Cerdà (a comprehensive urban development plan for Barcelona).

The luxuriously decorated main floor was designated as the living quarters for the Calvet family, for whom Gaudí also designed the furnishings and decorative elements. The upper floors, which were smaller in size, were reserved as flats to let as a means of financing the house. The design had to adapt to a very narrow plot, which explains the reason for the symmetry in the design of the façade. The main façade was fashioned with carved stone,

Dieses Bauwerk, das Haus von Pere Màrtir Calvet, entsprang einem Auftrag, den Gaudí 1898 von der verwitweten Eigentümerin eines Textilunternehmens erhielt. Ganz im Sinne einer zeitgenössischen Mode ließ die Familie in der Carrer Casp in Barcelona ein Wohngebäude errichten, dessen Erdgeschoss das Handelsbüro und das Lager aufnehmen sollte.

Mit der Casa Calvet begann im Jahr 1900 Gaudí eine Bau- und Dekorationsweise, die viele andere Architekten übernahmen. Die Verwendung von Elementen aus dem Barock- und Rokokostil, von geschwungenen Mauerkronen oder von Stein in den Balkonen und Erkern prägte bald alle Neubauten in Barcelonas L'Eixample-Viertel. Gaudí ersann ein mehrstöckiges Gebäude, das trotz seiner Funktion als Wohnsitz mehrerer Familien der prunkhaften Aufmachung der gotischen Paläste nicht nachstehen sollte. So sollte es den Prachtbauten in der Carrer Montcada ähneln, welche die Adeligen Barcelonas bis zur Umsetzung des Stadtbauplans Pla Cerdà bewohnt hatten.

Das luxuriös eingerichtete Hauptgeschoss war als Wohnsitz der Familie Calvet gedacht, für die Gaudí auch das Mobiliar und die Dekorationsgegenstände entwarf. Die kleineren Obergeschosse sollten vermietet werden, um die Erhaltungskosten des Hauses zu decken. Der sehr schmale Baugrund bedingte die symmetrische Gestaltung der Gebäudefassade. Die

La veuve et propriétaire d'une entreprise textile confia ce projet, la maison de Pere Màrtir Calvet, à Gaudí en 1898. La famille fit construire un bâtiment résidentiel dans la rue Casp de Barcelone, qui devait accueillir au rez-de-chaussée le bureau et le dépôt de l'entreprise.

Avec la construction de la Casa Calvet en 1900, Gaudí ouvrit la voie à un nouveau style de construction et de décoration qu'allaient adopter de nombreux autres architectes. L'emploi d'éléments baroques ou rococo, ainsi que les couronnements ondulés et le traitement de la pierre sur les balcons et les fenêtres en saillie, devint ainsi une constante dans les nouvelles constructions de l'Eixample de Barcelone. Gaudí conçut un immeuble à plusieurs niveaux qui, en dépit de sa fonction de résidence pour plusieurs familles, n'avait rien à envier aux majestueux palais gothiques, comme ceux de la rue Montcada, où vécut la noblesse barcelonaise jusqu'à l'application du Plan Cerdà.

L'étage principal, somptueusement décoré, tenait lieu de résidence de la famille Calvet, pour qui Gaudí conçut également le mobilier et les éléments décoratifs. Les étages supérieurs, plus petits, étaient voués à être loués afin de financer la demeure. Le projet devait être exécuté sur un terrain très étroit, d'où la symétrie employée dans le dessin de la façade. L'avant, en pierre taillée, est rythmé à chaque

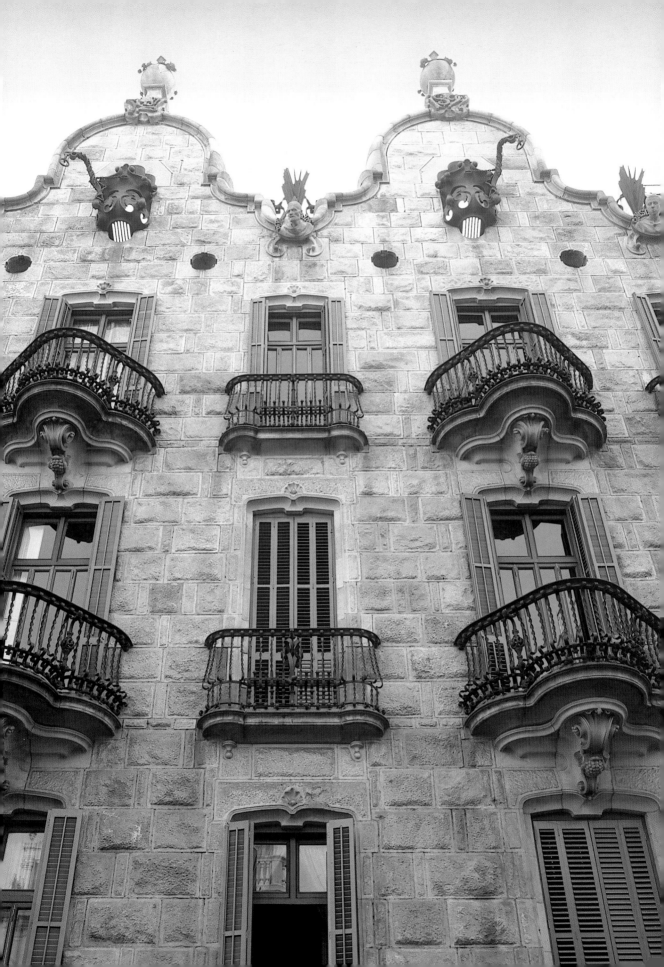

which was also used for the five balconies on each floor with an alternating inward and outward rhythm that was repeated on the building's pediments and evoke the *Modernista* features being used in the most avant-garde cities around Europe.

The elaborate tribune that marks the main floor where the owners of the building lived challenges traditional notions of symmetry in architecture. In the rear part of the first floor are a series of galleries leading to the inner courtyard which is situated on the roof of the warehouse. Gaudí's creative whims prompted him to paint one of the patio walls with the image of a waterfall and flowerpots.

The baroque influence can also be detected in the vestibule and inside staircase with Solomonic columns, spaces described by the press at that time as possessing a clear rococo influence. This staircase has various courtyards that illuminate the space and are reminiscent of Gaudí's design for Casa Batlló. The façade is decorated with symbolic references to the personal and working life of the owner's late husband, including details such as the letter "C" for

Frontfassade wurde aus behauenem Stein gefertigt und mit fünf Balkonen in jeder Etage gegliedert. Dadurch entstand eine Abfolge aus zurückgesetzten Wänden und Auskragungen, die sich in den Tür- und Fenstergiebeln des Hauses wiederholt und an die modernistischen Bautechniken in den avantgardistischsten europäischen Städten erinnert.

Der überladene Erker, der die Lage der Nobeletage und die Wohnung der Hausbesitzer anzeigt, bricht mit dem konventionellen Symmetrieverständnis. Auf der Rückseite der ersten Etage befinden sich Loggien, die zu einem großen, auf dem Dach der Lagerräume gelegenen Innengarten führen. Im Zuge seines Dekorationswunsches entwarf Gaudí für die Wand des Innenhofs eine Kaskade und Blumentöpfe.

Der barocke Stil der Dekoration spiegelt sich auch in der von der zeitgenössischen Presse als rokokoartig beschriebenen Vorhalle und Innentreppe mit ihren salomonischen Säulen wider. Diese Treppe besitzt einige Lichthöfe, die den Raum erhellen und die Lösung vorwegnehmen, von der Gaudí später in der Casa Batlló Gebrauch machte. Die Fassade ist mit Symbolen

étage par cinq balcons, tour à tour saillants et en retrait, cadence reprise par les frontons du bâtiment et qui rappelle les éléments modernistes employés dans les villes européennes les plus avant-gardistes.

L'encorbellement élaboré qui définit l'emplacement de la résidence des propriétaires de l'édifice défie les notions traditionnelles de symétrie en architecture. À l'arrière du premier étage, des galeries conduisent à une grande cour intérieure, située sur le toit du dépôt. Les caprices créatifs de Gaudí le poussèrent à peindre une cascade et des jardinières sur le mur du patio.

Le vestibule et l'escalier intérieur, en particulier les colonnes torses, illustrent bien le baroquisme de la décoration. La presse de l'époque qualifia cet endroit de rococo. Cet escalier est entouré de cours intérieures, qui permettent d'éclairer l'espace et rappellent la méthode employée plus tard par Gaudí dans la Casa Batlló. La façade est ornée d'éléments symboliques qui font référence à la vie personnelle et professionnelle du défunt mari de la propriétaire : la lettre C, initiale de Calvet, et

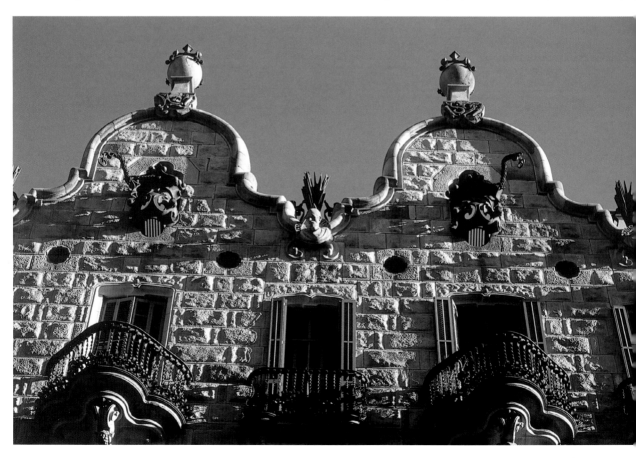

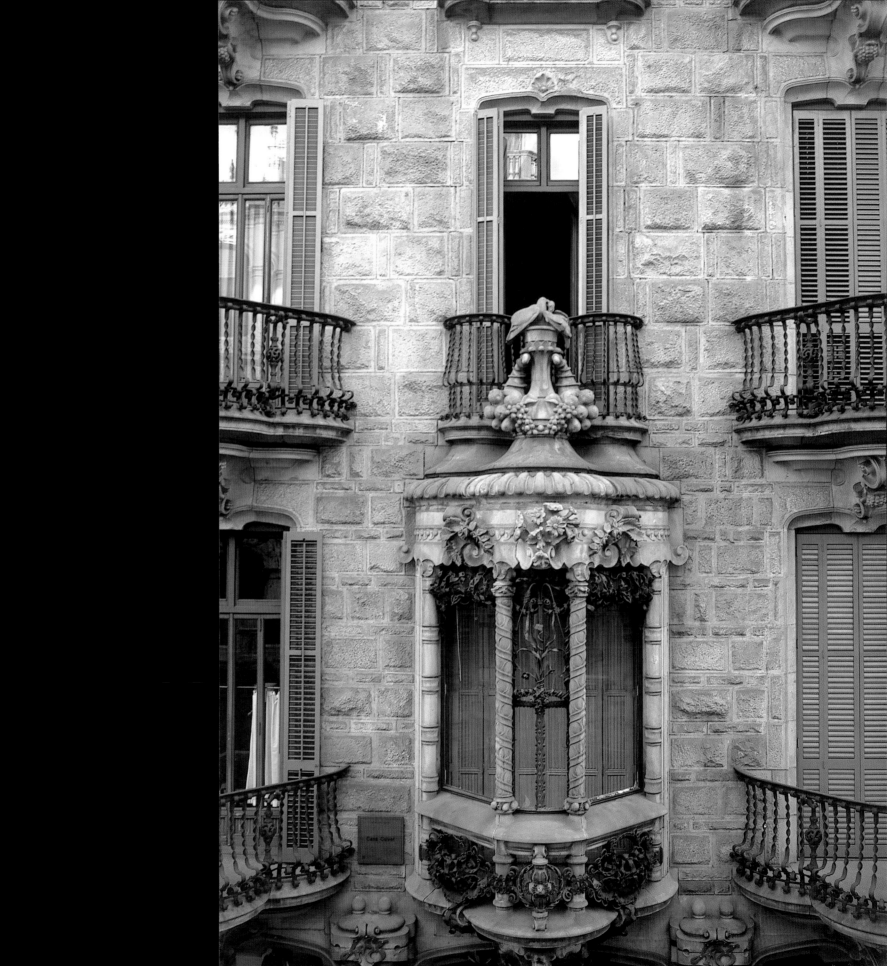

Calvet and a cypress, the symbol of perpetuity. Pere Calvet especially liked mushrooms, so Gaudí decided to incorporate them in the decoration of the building's arbour. The attached pillars on the ground floor evoke textile spools.

The upper level of the building is crowned by the heads of Saint Peter (after the owner's name), Saint Genis of Arles and Saint Genis of Rome, patron saints of Vilassar de Mar, the coastal town where Calvet had been born.

In 1899, the Barcelona town hall awarded Antoni Gaudí the annual prize for the best building of the year, in response to which Gaudí sent a letter of appreciation to the mayor of Barcelona dated 27 June 1900.

geschmückt, die auf den verstorbenen Gatten der Eigentümerin in seiner Eigenschaft als Privat- und Geschäftsmann verweisen. Dazu zählen der Buchstabe »C« als Initiale des Namens Calvet und eine Zypresse als Zeichen der Beständigkeit. Pere Calvet liebte Champignons, weshalb Gaudí entschied, sie in die Dekoration der Gartenlaube zu integrieren. Die Halbsäulen des Erdgeschosses erinnern zudem an Textilspulen.

Im oberen Teil des Gebäudes ist der Kopf des Heiligen Petrus Martyr angebracht und spielt auf den Namen des Eigentümers – Pere ist die katalanische Version des Namens Petrus – an. Außerdem sind die Köpfe des Heiligen Genesius von Arles und des Heiligen Genesius von Rom zu sehen, der Schutzpatrone des Küstenorts Vilassar de Mar, Geburtsort Calvets.

Im Jahr 1900 wurde Antoni Gaudí mit dem Preis des erstmals 1899 ausgeschriebenen Wettbewerbs für Städtische Gebäude ausgezeichnet, den die Stadtverwaltung für den besten Neubau des Jahres verlieh. Als Antwort schickte der Architekt ein mit 27. Juni 1900 datiertes Dankesschreiben.

un cyprès, symbole d'immortalité. Pere Calvet aimait beaucoup les champignons ; Gaudí décida donc de les introduire dans la décoration de la tonnelle du bâtiment. Les piliers encastrés du rez-de-chaussée évoquent des bobines de filature.

Au sommet de l'édifice, figure la tête de saint Pierre (allusion au nom du propriétaire), et celles de saint Geniès d'Arles et de saint Geniès de Rome, patrons de Vilassar de Mar, village côtier où naquit M. Calvet.

En 1900, la mairie de Barcelone décerna à Antoni Gaudí le prix annuel pour la meilleure construction de l'année. En réponse à cette récompense, l'architecte envoya une lettre de remerciements au maire de Barcelone, le 27 juin 1900.

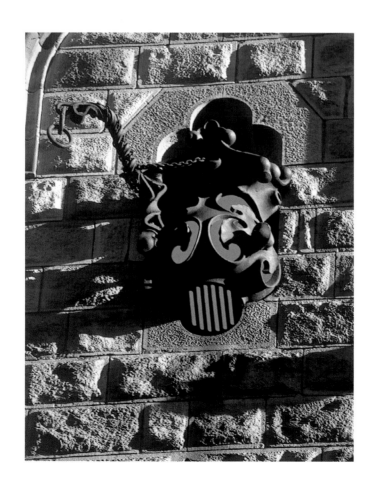

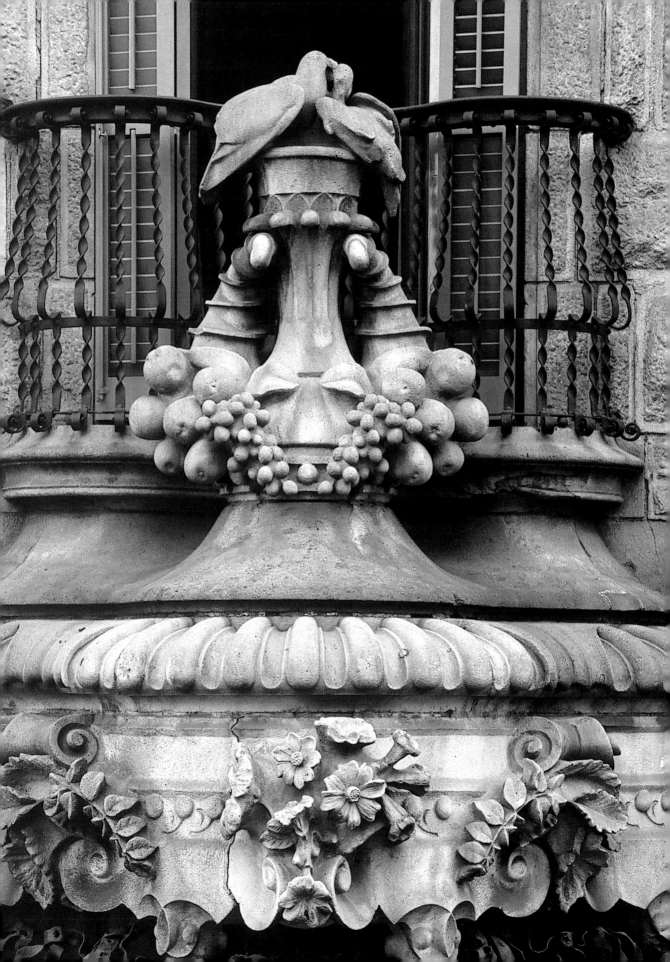

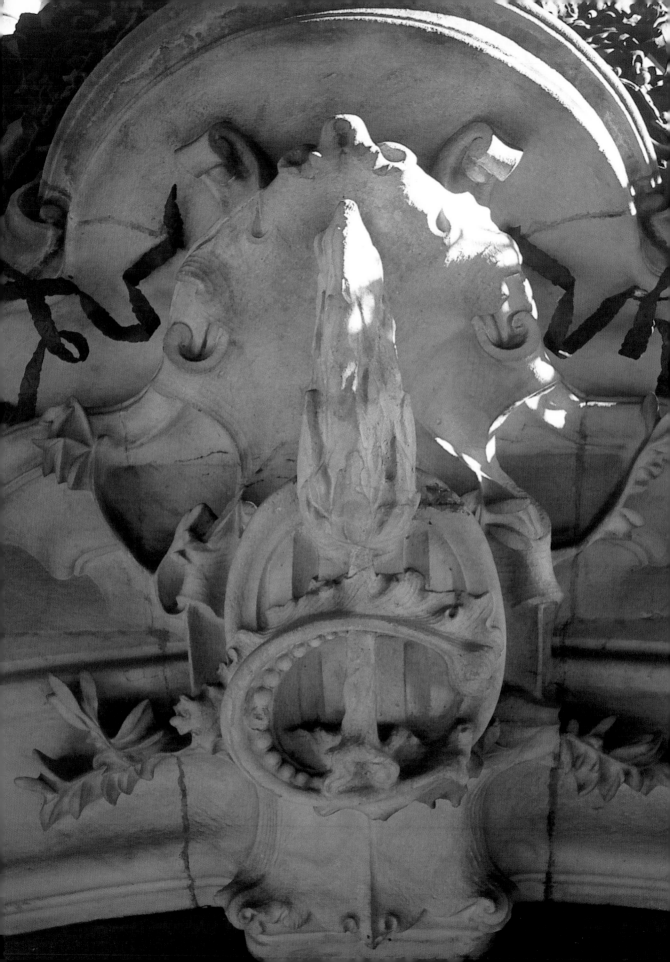

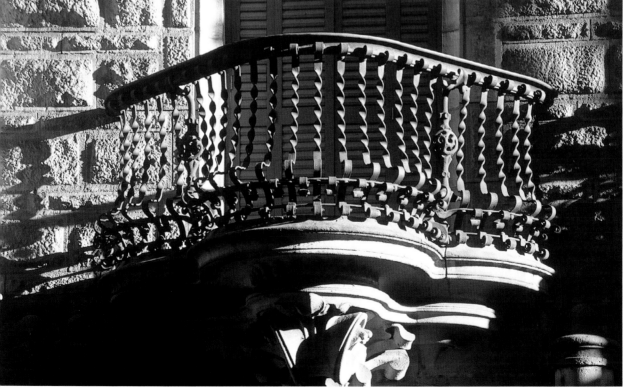

The façade features sculptural details and wrought iron.

An der Fassade fallen sowohl die plastischen Elemente als auch die interessanten Schmiedearbeiten auf.

La façade met en vedette les détails sculpturaux et le fer forgé.

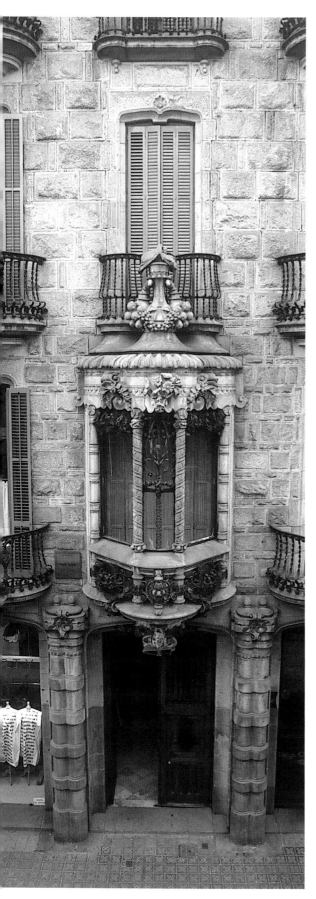

When decorating the façade with sculptures, Antoni Gaudí kept in mind Pere Calvet, the deceased spouse of the owner of the building. In homage to Pere Calvet, the architect devised a series of iconographic representations illustrating the diverse aspects of the profession, life and personality of Calvet, including saints, textile spools, cypress trees and flowers.

Mit der plastischen Dekoration der Gebäudefassade spielte Antoni Gaudí auf Pere Calvet, den verstorbenen Gatten der Hauseigentümerin, an. Als Hommage an den katalanischen Industriellen schuf der Architekt eine Reihe bedeutender ikonographischer Abbildungen von Heiligen, Textilspulen, Blumen sowie einer Zypresse, die diverse Aspekte aus dem Beruf, Leben und Wesen Calvets darstellten.

Pour choisir les sculptures de la façade, Antoni Gaudí garda à l'esprit la personne de Pere Calvet, défunt époux de la propriétaire de l'immeuble. En hommage à l'industriel catalan, l'architecte créa une série de représentations iconographique relatant divers aspects de la profession, de la vie et de la personnalité de M. Calvet : sculptures de saints, bobines de filature, cyprès et fleurs.

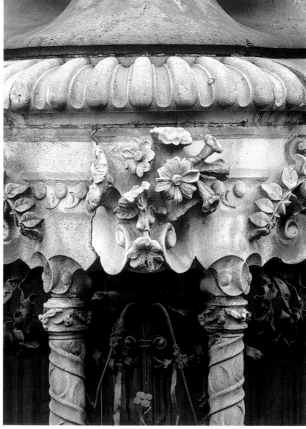

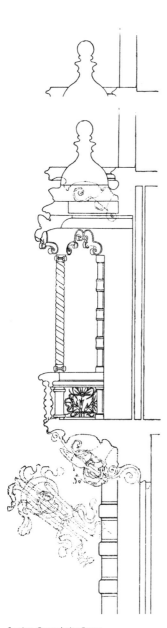

Section Querschnitt Coupe

First floor Erster Stock Premier étage

Ground floor Erdgeschoss Rez-de-chaussée

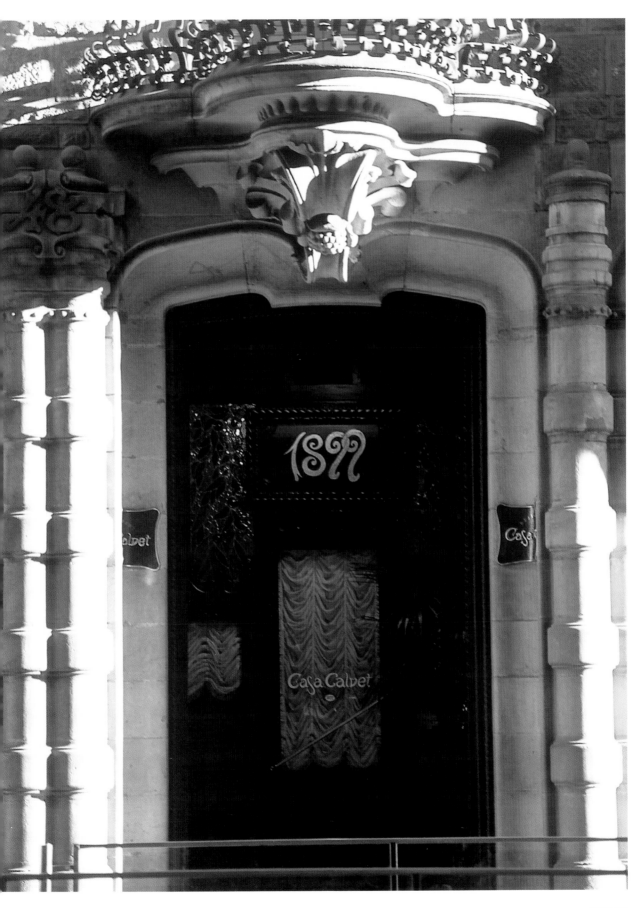

ONE OF THE MOST INFLUENTIAL FACTORS IN GAUDÍ'S WORK WAS HIS DEVOTION TO THE CATHOLIC RELIGION, WHICH IS REFLECTED IN MANY OF THE STRUCTURAL AND DECORATIVE ASPECTS OF HIS BUILDINGS.

EINER DER EINFLUSSREICHSTEN FAKTOREN IN GAUDÍS ARBEIT WAR SEINE HINGABE ZUR KATHOLISCHEN RELIGION, DIE SICH IN VIELEN ASPEKTEN – STRUKTUREN UND DEKORATIONEN – SEINER GEBÄUDE NIEDERSCHLÄGT.

L'UNE DES INFLUENCES MAJEURES DANS LE LABEUR DE GAUDÍ FUT SA DÉVOTION POUR LA RELIGION CATHOLIQUE, REFLÉTÉE DANS SES BÂTIMENTS À TRAVERS DE NOMBREUX ÉLÉMENTS TANT STRUCTURELS QUE DÉCORATIFS.

gaudí and RELIGION
gaudís RELIGIOSITÄT
gaudí et la RELIGION

Gaudí and his religious convictions are a common subject in any biography recounting this artist's life and work. His first biographers described him as a devout man with profound religious feelings. This facet of his personality, in addition to his exclusive devotion to building the Sagrada Família church, have led Christian sectors in Catalan society to petition the Vatican to beatify Antoni Gaudí.

Since the beginning of his career as an architect, Gaudí kept up intense relations with Catholic Church entitles. The commissions he received included decorating the chapels of the Jesús-Maria schools of Tarragona and Barcelona, as well as more substantial projects such as the Episcopal Palace of Astorga or the renowned Sagrada Família church in Barcelona. When designing these works, Gaudí held conversations with influential figures such as the Bishop of Astorga, Joan Baptista Grau, after whose death Gaudí suffered a severe religious crisis that led him to fast to the point of endangering his life. He abandoned his crusade under the advice of the future bishop of Vic, Josep Torras i Bages, who from that moment on became Gaudí's new spiritual guide.

Back in 1892, the Marquis of Comillas had commissioned Gaudí to construct a building for the Franciscan Catholic Missions in Tangier, Africa. The architect felt very involved in this goal and designed a large fortification that

Gaudís Religiosität wird häufig in den Büchern über sein Leben und Werk behandelt. Bereits seine ersten Biografen beschreiben ihn als einen frommen und tief religiösen Menschen. Dieser Charakterzug, der vor allem seiner Hingabe bei der Errichtung des Temple Expiatori de la Sagrada Família – des Sühnetempels der Heiligen Familie – zugeschrieben wird, hat einen christlichen Sektor der katalanischen Gesellschaft bewogen, den Vatikan um die Seligsprechung Antoni Gaudís zu bitten.

Von seinen Anfängen als Architekt an unterhielt Gaudí stets enge Beziehungen zu diversen Kirchenkreisen. Beispiele hierfür sind die Dekorationsaufträge für die Kapellen der Jesús-Maria-Schulen in Tarragona und Barcelona, aber auch umfangreichere Projekte, wie der Bischofspalast in Astorga und die Sagrada Família in Barcelona. Zur Vorbereitung der entsprechenden Entwürfe führte Gaudí Gespräche mit wichtigen Persönlichkeiten wie dem Bischof von Astorga, Joan Baptista Grau. Nach Graus Tod im Jahr 1894 verfiel Gaudí in eine schwere religiöse Krise, die ihn veranlasste, so streng zu fasten, dass er sich in Lebensgefahr brachte. Er änderte dieses Verhalten auf Rat des späteren Bischofs von Vic, Josep Torras i Bages, der von da an sein neuer geistlicher Leiter wurde.

Jahre zuvor, im Jahr 1892, hatte der Markgraf von Comillas Gaudí mit einem Entwurf für das Gebäude der Katholischen Franziskaner-Mission

Les convictions religieuses de Gaudí sont un thème récurrent dans tout livre traitant de la vie et de l'œuvre de l'artiste. Ses premiers biographes le décrivent déjà comme un homme pieux ayant de profonds sentiments religieux. Ce trait de caractère, ainsi que son dévouement pour la construction de l'église de la Sagrada Família, a poussé certains secteurs chrétiens de la société catalane à demander au Vatican l'ouverture d'un procès en béatification d'Antoni Gaudí.

Dès ses débuts comme architecte, Gaudí maintint d'étroites relations avec les autorités de l'Église catholique. Celles-ci furent à l'origine de certains de ces projets, des plus simples (décoration des chapelles des écoles de Jesús-Maria de Tarragone et de Barcelone), aux plus imposants (palais épiscopal d'Astorga et Sagrada Família de Barcelone). Pour mener à bien ces travaux, Gaudí dialoguait avec des personnalités influentes, dont l'évêque d'Astorga, Joan Baptista Grau. À la mort de Grau en 1894, Gaudí traversa une profonde crise religieuse et fit un jeûne tellement strict que sa vie fut mise en danger. Il abandonna sa croisade sur le conseil du futur évêque de Vic, Josep Torras i Bages, qui devint dès lors son nouveau guide spirituel.

Quelques années auparavant, en 1892, le marquis de Comillas chargea Gaudí de la conception d'un bâtiment pour les missions catholiques franciscaines à Tanger, en Afrique.

symbolised the strength of the Christian faith in Arab lands. Despite the significance of the project, which is regarded as the precursor to bolder architectural designs, and the architect's enthusiastic efforts, the "great castle" was never built (see photo below). Nevertheless, Gaudí was able to travel to Tangier with Franciscan monk José Lerchundi to familiarise himself with the site where he was to erect the building. During his stay in Muslim lands, Gaudí once again experienced the union of two of his major influences: the Mediterranean and Arabic art.

Although Gaudí's original drawings were lost in the fire that broke out inside the Sagrada Família in 1936, a record of them exists in a photograph published by Josep Francesc Ràfols in his biography of the architect. The similarities to the Sagrada Família are clearly evident, in particular the use of numerous parabolic towers.

In 1899 Gaudí was welcomed as member of the Sant Lluc Artistic Circle, a Catholic entity founded in 1893 by the Llimona brothers. The religious ideology of the group, comprised of

im afrikanischen Tanger beauftragt. Der Architekt engagierte sich sehr für dieses Projekt und entwarf eine große Festung, welche die Stärke des christlichen Glaubens auf arabischem Boden symbolisieren sollte. Trotz der Bedeutung dieses Vorhabens, das als Vorläufer gewagterer Bauten gilt, und trotz der Vorfreude und Hingabe des Architekten wurde „die große Burg" nie verwirklicht (siehe Foto unten). Gaudí konnte jedoch zusammen mit dem Franziskaner José Lerchundi nach Tanger reisen, um den Baugrund für das Gebäude zu besichtigen. Während dieses Aufenthalts in einem moslemischem Land erlebte er die Verschmelzung zweier seiner größten Einflüsse: des Mittelmeerraums und der arabischen Kunst.

Gaudís Entwürfe für dieses Projekt wurden bei einem Brand in der Sagrada Família im Jahr 1936 zerstört, sind jedoch dank eines Fotos bekannt, das J. F. Ràfols in der Biografie des Architekten veröffentlichte. Es zeigt deutliche Ähnlichkeiten mit der Sagrada Família, besonders in der Verwendung zahlreicher parabelförmiger Türme.

Im Jahr 1899 wurde Gaudí Mitglied des Künstlerkreises Cercle Artístic de Sant Lluc, einer

L'architecte se sentit très engagé dans ce projet et projeta une grande fortification symbolisant la force de la foi chrétienne en terre arabe. En dépit de l'envergure du projet considéré comme le précurseur de ses concepts structurels audacieux, et malgré l'enthousiasme et la détermination que l'architecte y avait investis, « le grand château » ne fut jamais bâti (voir photo ci-dessous). Gaudí s'était rendu à Tanger avec le franciscain José Lerchundi pour connaître le lieu où l'édifice devait être érigé. Durant ce séjour en terres musulmanes, l'architecte put observer l'union de deux de ses plus fortes influences : la Méditerranée et l'art arabe.

Les croquis que Gaudí effectua pour ce projet disparurent dans l'incendie de la Sagrada Família en 1936, mais sont connus grâce à une photographie publiée par Josep Francesc Ràfols dans la biographie de l'architecte. Les similitudes avec la Sagrada Família, dont en particulier les nombreuses tours paraboliques, sont flagrantes.

En 1899, Gaudí devint membre du Cercle Artistique de Sant Lluc, une association

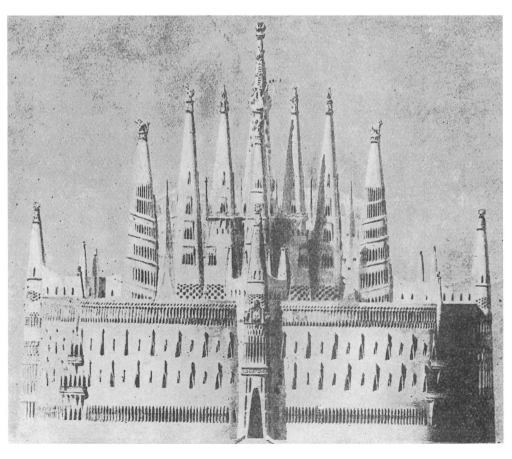

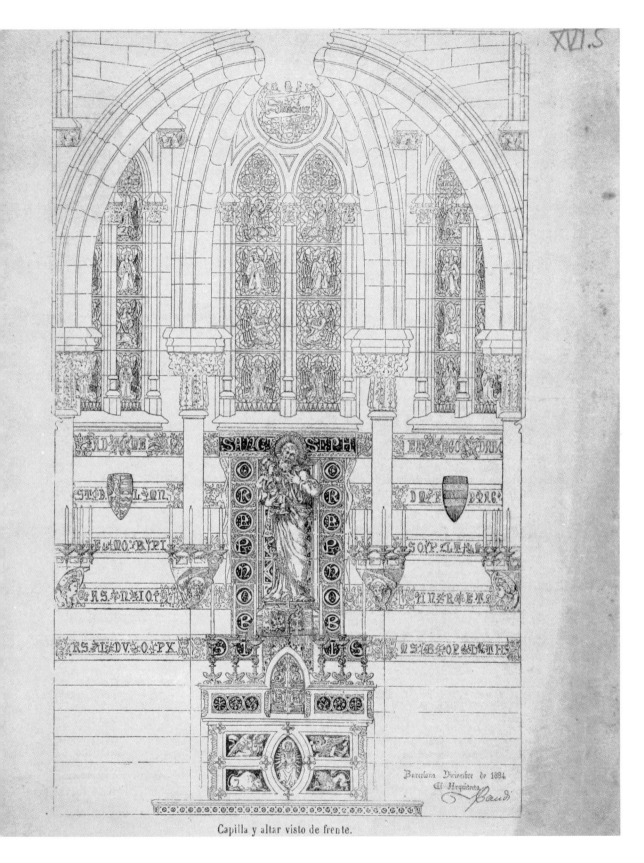

Capilla y altar visto de frente.

A drawing by Gaudí in 1884 showing the decoration for a chapel dedicated to Saint Joseph, displaying a markedly Gothic influence.

Gaudís 1884 entstandener Entwurf für die Dekoration einer dem Heiligen Josef gewidmeten Kapelle in ausgeprägt gotischem Stil.

Dessin effectué par Gaudí en 1884 pour la décoration d'une chapelle consacrée à saint Joseph, à l'influence gothique marquée.

many important figures from the cultural and artistic scene of the day, was led by Torras i Bages, who exercised a strong influence over Gaudí. It was at this time that the architect also joined the Spiritual League of the Virgin of Montserrat, which brought together the Catholic and Catalanist sector and was also led by Torras. It was in 1900 when Gaudí initiated the project for the First Glorious Mystery of the Monumental Rosary of Montserrat. Gaudí depicted a Calvary scene with the empty Holy Sepulchre inside a cave hovered over by a bronze sculpture of Christ resurrected, created by Josep Llimona. The figures of the three Marys, the work of sculptor Renart, also stand out. The project was executed by Josep Bayó, a contractor with whom Gaudí would work on future buildings such as Casa Milà. Joan Rubió i Bellver was made project foreman.

katholischen Institution, die 1893 von den Brüdern Llimona gegründet worden war. Verantwortlich für die religiöse Ideologie dieser Gruppe, zu der namhafte Persönlichkeiten aus den kulturellen und künstlerischen Kreisen jener Zeit zählten, war Torras i Bages, der einen starken Einfluss auf Gaudí ausübte. In diesen Jahren trat der Architekt auch dem Verband Lliga Espiritual de la Mare de Déu de Montserrat bei, der den katholischen Sektor des Katalanismus vereinte und von Torras selbst geleitet wurde. Im Jahr 1900 begann Gaudí den Entwurf für das erste Glorreiche Geheimnis des so genannten monumentalen Rosenkranzes auf dem Berg Montserrat. Dazu schuf er in einer großen Grotte des Bergs eine Szene des Kreuzwegs, die das leere Heilige Grab und im oberen Bereich der Mauer die Gestalt des auferstandenen Christus, eine von Josep Llimona gefertigte Bronzestatue, zeigte. Daneben sind die drei Marien zu sehen, die ein Werk des Bildhauers Renart sind. Der Entwurf wurde von Josep Bayó umgesetzt, mit dem Gaudí auch bei weiteren Werken, wie der Casa Milà, zusammenarbeitete. Die Bauleitung wurde Joan Rubió i Bellver übertragen.

catholique fondée en 1893 par les frères Llimona. L'idéologie religieuse de ce groupe, composé notamment de grands noms de la vie culturelle et artistique de l'époque, se devait à Torras i Bages, qui exerça une forte influence sur Gaudí. Au cours de ces années, l'architecte s'associa également à la Ligue spirituelle de la Mare de Déu de Montserrat, qui regroupait le secteur catholique du catalanisme et que dirigeait également Torras. En 1900, Gaudí amorça le projet du premier Mystère glorieux du Rosaire à Montserrat. Dans une grotte de montagne, Gaudí reproduisit une scène du Calvaire où figurait le Saint Sépulcre vide et, en haut du mur, le Christ ressuscité, sculpture de bronze réalisée par Josep Llimona. Les trois Maries, œuvres du sculpteur Renart, sont également remarquables. Le projet fut exécuté par Josep Bayó, avec qui Gaudí travailla sur d'autres œuvres, notamment la Casa Milà. Quant à la direction des travaux, elle fut remise à Joan Rubió i Bellver.

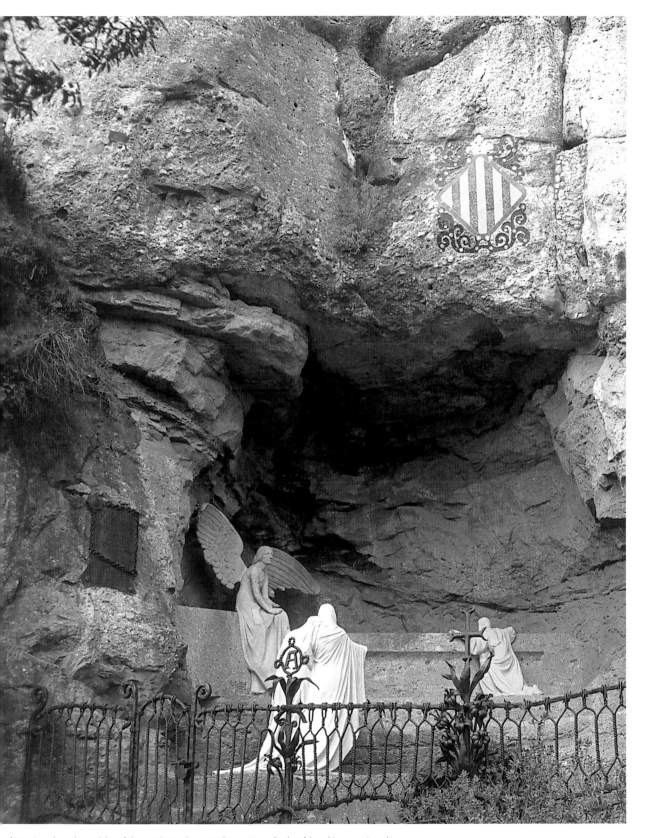

In this project, the architect did not fail to emphasise the nationalist sentiment Catalans felt to this mountain and its monastery.

Bei der Gestaltung dieses Werks vergaß der Architekt nicht, auf das nationalistische Gefühl hinzuweisen, das dieser Berg und das zugehörige Kloster bei den Katalanen hervorruft.

L'architecte n'omit pas d'illustrer dans cette œuvre le sentiment nationaliste que cette montagne et son monastère inspirent aux catalans.

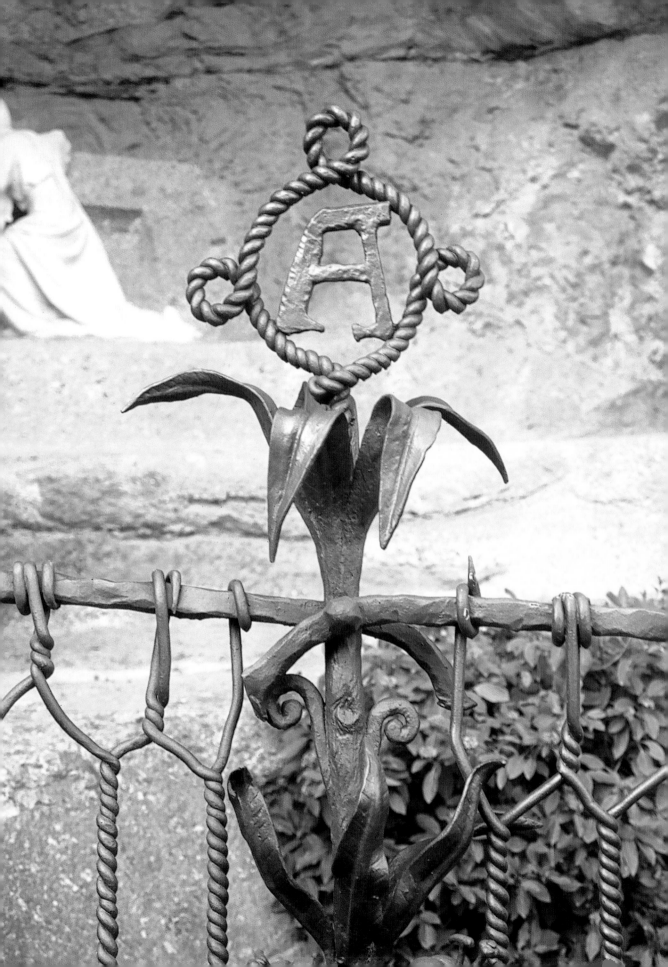

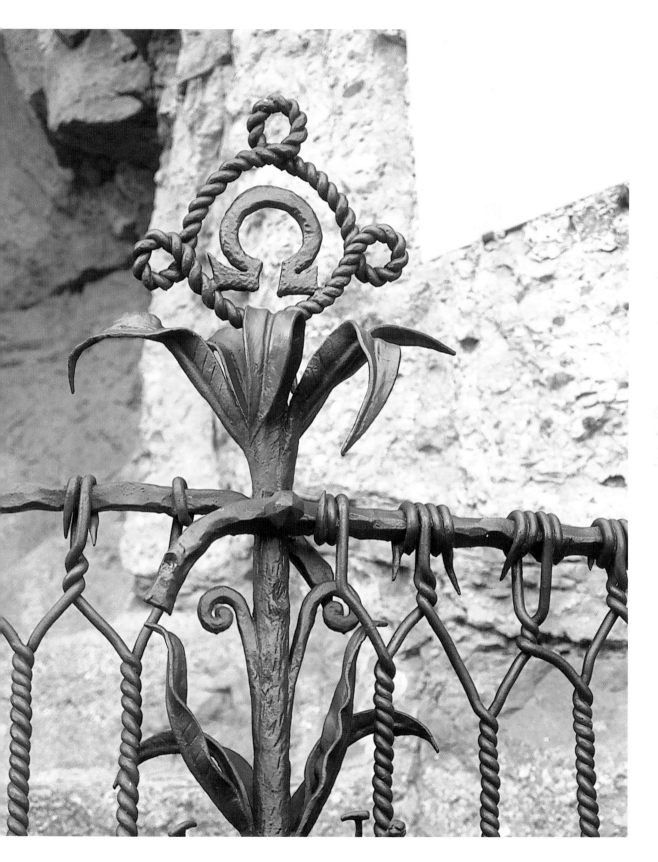

With a meticulous attention to detail, Gaudí adorned the gateway with the alpha and omega signs, symbols of the beginning and end of life.

Gaudí, dem kein Detail entging, brachte auf dem Absperrgitter die Zeichen Alpha und Omega als Symbole für Anfang und Ende des Lebens an.

Gaudí, qui ne négligeait aucun détail, plaça sur la grille les signes alpha et oméga, symboles du commencement et de la fin de la vie.

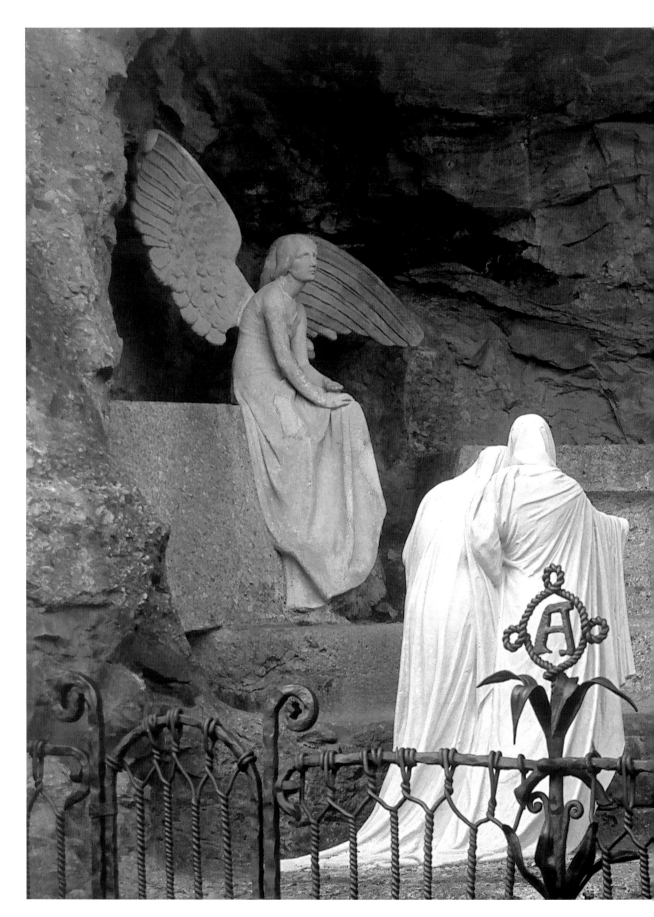

For the design of the First Glorious Mystery, Gaudí worked with the great modernist sculptor Josep Llimona, who created the realistic figures portraying the three Marys, who went to Christ's tomb and found it open and empty. Only the presence of the angel, a serene, beautiful sculpture, alerted them to Jesus's resurrection.

Für den Entwurf des ersten Glorreichen Geheimnisses zählte Gaudí auf die Mithilfe des großen modernistischen Bildhauers Josep Llimona, der die höchst lebensechten Skulpturen schuf. Sie stellen die drei Marien dar, die Christi Grab aufsuchten und es unverschlossen und ohne den Leichnam vorfanden. Lediglich die Anwesenheit des Engels, einer Skulptur mit wunderschönen, gleichmütigen Zügen, machte sie auf die Auferstehung Jesu aufmerksam.

Pour le projet du premier Mystère glorieux, Gaudí travailla avec le grand sculpteur moderniste Josep Llimona. Ses sculptures, traitées avec un grand réalisme, représentent les trois Marie qui trouvèrent ouvert et vide le tombeau du Christ. Seule la présence de l'ange, sculpture d'une beauté et d'une sérénité étonnante, leur révéla la résurrection de Jésus.

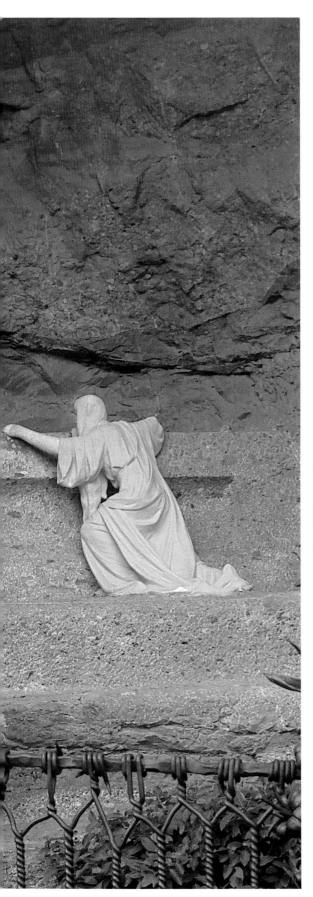

In recent years, there has been much speculation with regard to the possibility of Antoni Gaudí being beatified. There is no doubt that the Catalan architect demonstrated unswerving religious faith and dedicated part of his life to building the Sagrada Família, yet there is no evidence of any miracle attributed to Gaudí that would call for the initiation of the process of beatification.

In den letzten Jahren wurde viel über eine mögliche Seligsprechung von Antoni Gaudí geschrieben und spekuliert. Es ist unbestreitbar, dass er in vielerlei Hinsicht eine starke Religiosität bewies und einen Teil seines Lebens der Errichtung des Tempels der Sagrada Família widmete. Nichtsdestotrotz konnte Gaudí noch kein Wunder zugeschrieben werden, um die nötigen Schritte in die Wege zu leiten.

Ces dernières années, beaucoup d'encre a coulé sur la possibilité de béatifier Antoni Gaudí. On ne peut nier que l'architecte catalan faisait preuve d'un sentiment religieux profond et qu'il consacra une grande partie de sa vie à la construction de la Sagrada Família. Cependant, aucun miracle justifiant l'ouverture d'un procès en béatification ne lui a encore été attribué.

BUILT IN HOMAGE TO THE MEDIAEVAL KING MARTIN I THE HUMANE, WHO ONCE LIVED ON THE SAME LAND, THIS UNIQUE BUILDING DESIGNED BY GAUDÍ POSSESSES THE AIR OF A GRAND MEDIAEVAL PALACE.

ZU EHREN DES MITTELALTERLICHEN KÖNIGS MARTIN DER MENSCHLICHE, DER DAS ANWESEN BEWOHNT HATTE, ENTWARF ANTONI GAUDÍ DIESES ORIGINELLE GEBÄUDE, DAS DEN GROSSEN MITTELALTERLICHEN PALÄSTEN IN NICHTS NACHSTEHT.

EN HOMMAGE AU ROI MARTIN Iᵉʳ L'HUMAIN, QUI RÉSIDA SUR CES TERRES, ANTONI GAUDÍ CONÇUT CET ÉDIFICE ORIGINAL, QUI N'A RIEN À ENVIER AUX GRANDS PALAIS MÉDIÉVAUX.

BELLESGUARD

1900-1909

After the death of Joan Baptista Grau, bishop of Astorga, his heirs decided to sell some of the properties that had been owned by the bishop. Among the numerous estates, the most remarkable one was situated on an extensive tract of land that had once harboured the summer palace of the last king of the Catalan-Aragonese crown, Martin I the Humane. The king purchased the estate in 1408 and named it Bellesguard in acknowledgement of its splendid views of Barcelona, choosing it as the site of his wedding with Margarida de Prades.

Nearly six centuries later, Gaudí advised Lady Maria Sagués, Jaume Figueras' widow, to purchase the land. Given the illiteracy of the new owner, it was Gaudí who signed the purchase deed for the house.

When the architect began construction in 1900, all that remained on the site were two Gothic towers and part of a wall, all of them in the Gothic style. These architectural treasures served as inspiration to Gaudí, yet they neither restricted him nor impeded him in his design. As a tribute to the first owner of the land, Gaudí conceived a design that clearly evoked that of a 15th century mediaeval castle, as demonstrated by the semicircular arched doorway typical of Catalan civil Gothic constructions.

The building adopts a symmetric arrangement of windows and clearly defined volumes

Nach dem Tod des Bischofs von Astorga, Joan Baptista Grau, boten die Erben einige seiner Besitztümer zum Verkauf an. Zu seinen Anwesen zählte auch ein großes Grundstück, auf dem sich einst der Sommerpalast des letzten Königs der katalanisch-aragonesischen Krone, Martin der Menschliche, befunden hatte. Der König hatte dieses Landgut 1408 erworben und ihm in Anerkennung der dort bestehenden herrlichen Aussicht auf Barcelona den Namen Bellesguard – katalanisch für „schöne Aussicht" – verliehen. Hier, in dieser Burg, vollzog er auch den Bund der Ehe mit Margarida de Prades.

Fast sechs Jahrhunderte später empfahl Gaudí Maria Sagués, der Witwe von Jaume Figueras, das Anwesen zu kaufen. Da die neue Eigentümerin weder lesen noch schreiben konnte, war Gaudí selbst damit betraut, die Kaufurkunde zu unterschreiben.

Als der Architekt im Jahr 1900 mit den Bauarbeiten begann, standen auf dem Gelände lediglich zwei Türme und ein Mauerrest, allesamt im gotischen Stil. Die architektonischen Überreste inspirierten Gaudí, stellten jedoch keinerlei Hindernis für die Verwirklichung seines Projekts dar. Als Hommage an den ersten Besitzer des Anwesens zeigte Gaudís Entwurf eine mittelalterliche Burg aus dem 15. Jahrhundert, wie die Wahl einer Eingangstür mit Rundbogen, eine für gotische Zivilbauten in Katalonien charakteristische Form, belegt.

À la mort de l'évêque d'Astorga, Joan Baptista Grau, ses héritiers mirent en vente certaines de ses propriétés. Parmi celles-ci se trouvait un vaste terrain, qui accueillit en son temps le palais d'été du dernier roi d'Aragon de la dynastie catalane, Martin Iᵉʳ l'Humain. Le roi avait acquis ce terrain en 1408 et décida de l'appeler Bellesguard (belle vue), en raison du magnifique panorama qu'il offrait de Barcelone. Ce fut dans ce château qu'il épousa Margarida de Prades.

Près de six siècles plus tard, Gaudí recommanda à Mme Maria Sagués, veuve de Jaume Figueras, l'acquisition du terrain. Comme la nouvelle propriétaire ne savait ni lire ni écrire, Gaudí fut lui-même chargé de signer l'acte d'achat de la propriété.

Lorsque l'architecte amorça les travaux en 1900, le terrain était occupé par deux tours et un pan de mur de l'ancien château, de style gothique. Ces éléments architecturaux inspirèrent l'architecte, sans entraver pour autant l'accomplissement de son propre projet. En hommage au premier propriétaire des lieux, Gaudí souhaita manifestement évoquer un château du XVᵉ siècle, comme l'indique le choix de la porte d'entrée, terminée par un arc en plein cintre, forme structurelle caractéristique des constructions gothiques catalanes.

Les fenêtres sont symétriques et les volumes bien définis, grâce à une structure

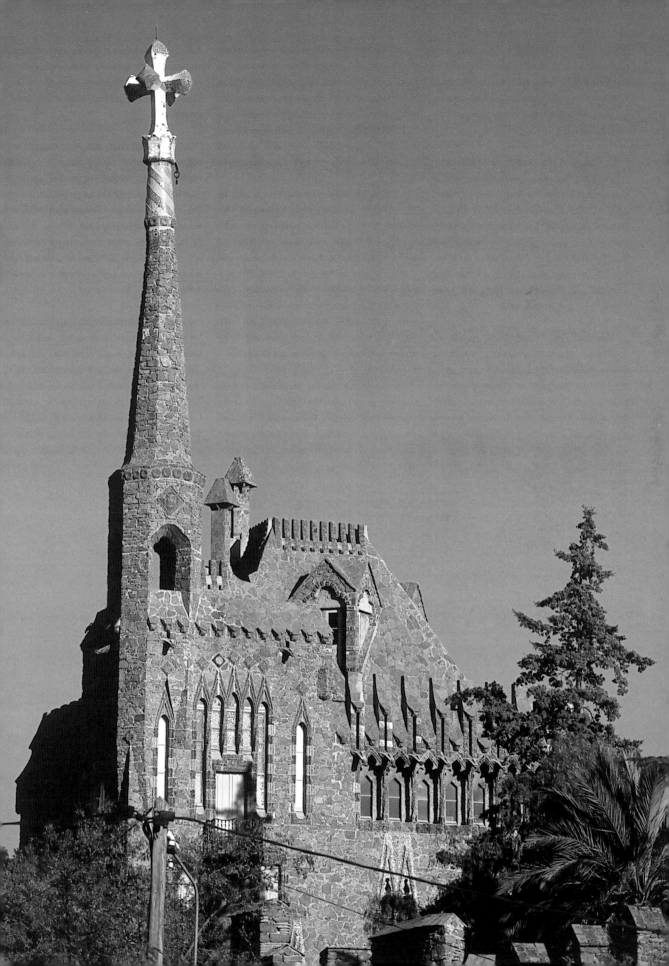

obtained by integrating a cubic structure crowned by a horizontal band of windows and battlements, a truncated pyramid-shaped lookout point and a rectangular prism containing the stairwells leading to the belfry and the four-armed cross.

The beauty of the exterior dissipates upon entering the building, where the ceilings in the various halls are designed using a different system of brick arches and vaults. Notable features include the soaring vestibule and the attic, as well as the stairway in the entrance leading to the upper floors, which is illuminated by vividly-coloured rose windows and a crystal and wrought iron lamp that takes centre stage in the entry hall.

Gaudí's last intervention in this project was the construction of a viaduct, which he designed after having discovered a path crossing through the heart of the royal grounds leading to the Sant Gervasi cemetery. In 1903, the owner of the house requested permission to modify the route of the path to the cemetery, which was accepted under the condition that she finance the changes herself.

Auffällig sind die symmetrisch angeordneten Fenster und eine wohl definierte Raumverteilung anhand eines würfelförmigen Baus, gekrönt von einem Fries aus Fenstern und Zinnen, einem pyramidenstumpfförmigen Aussichtsturm sowie einem rechteckigen Prisma mit dem Treppenhaus, dem sich ein hoher Glockenturm mit vierarmigem Kreuz anschließt.

Die reizvolle äußerliche Gestaltung wird im Inneren des Gebäudes nicht fortgesetzt. Hier weisen die verschiedenen Hallen ein anderes System aus Bogen und Ziegelgewölben auf, wobei besonders die hohe Eingangshalle und das Dachgeschoss hervorzuheben sind. Ebenfalls erwähnenswert ist der Gebäudeeingang mit einer durch schöne, bunte Rosettenfenster erhellten Treppe zu den Obergeschossen sowie einer Lampe aus Kristall und Schmiedeeisen, die im Eingangsbereich alle Blicke auf sich zieht.

Gaudís letzter Schritt in diesem Projekt bestand darin, ein Viadukt zu entwerfen, nachdem er festgestellt hatte, dass der Weg zum Friedhof von Sant Gervasi mitten durch das ehemalige königliche Anwesen verlief. Im Jahr 1903 beantragte die Hauseigentümerin

cubique parachevée d'une frange horizontale crénelée, d'un mirador troncopyramidal et d'un prisme rectangulaire abritant les escaliers menant au beffroi coiffé d'une croix à quatre bras.

La beauté extérieure diffère de l'aspect intérieur du bâtiment, où les plafonds des différentes pièces répondent à des systèmes distincts d'arcs et de voûtes en briques. Le spacieux vestibule et les combles sont particulièrement remarquables, tout comme l'escalier du hall d'entrée menant aux étages supérieurs qui est éclairé par de belles rosaces aux couleurs vives et une superbe lampe en verre et en fer forgé.

La dernière intervention de Gaudí sur ce projet fut la réalisation d'un viaduc, qu'il conçut après avoir constaté que le chemin qui conduisait au cimetière de Sant Gervasi passait au beau milieu de l'ancienne propriété royale. En 1903, la propriétaire de la demeure demanda l'autorisation de modifier le tracé du chemin du cimetière ; la permission lui fut accordée, sous réserve qu'elle finançât les travaux. Gaudí fit donc une déviation hors de l'enceinte de

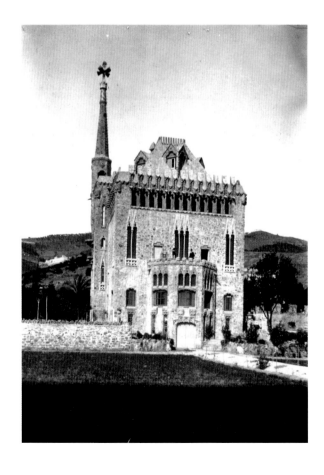

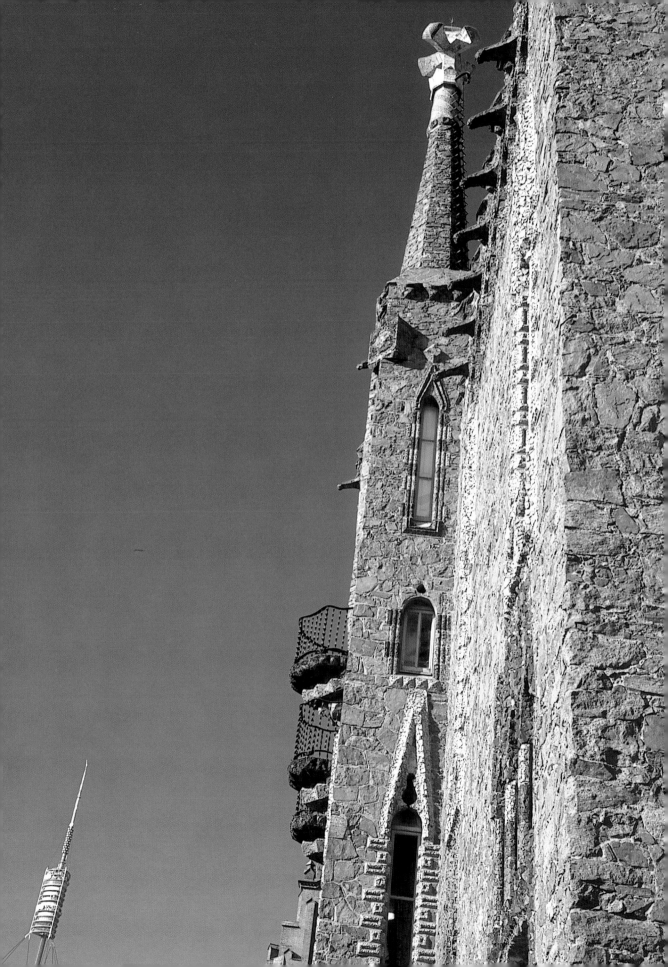

Gaudí thus rerouted the path outside the Bellesguard walls and built heavy pillars next to the retaining wall along the path so that it would remain at the same height as the house and save one of the streams that flowed from the Collserola hills. The sloped pillars evoke the footprints of an elephant herd, displaying the architect's ongoing inspiration drawn from the animal world.

The high structural quality lent by the brick and stone used to build the impressive viaduct led Gaudí to use these materials once again in the Park Güell.

Although there has been awareness of this viaduct for many years, the project gradually came to be overlooked as a result of its deteriorated condition. After several years of efforts, a restoration of the viaduct was submitted in 2006 showcasing this interesting structure created by Gaudí.

eine Genehmigung, um den Verlauf des Friedhofswegs zu ändern, die ihr mit der Bedingung ausgesprochen wurde, sie müsse die Kosten übernehmen. So entschied Gaudí, den Weg außerhalb der Grundstücksmauern von Bellesguard zu verlegen. Zur Überquerung eines der Sturzbäche des Collserola-Gebirges und um den Weg dem Stil des Gebäudes anzupassen, ließ er schwere Pfeiler an der Stützmauer des Viadukts anbringen. Diese schräge Pfeilerstruktur ähnelt den Beinen einer Elefantenherde und stellt eine von der Tierwelt inspirierte Gestaltung dar, wie sie häufig in Gaudís Werken zu finden ist.

Angesichts der guten Tragwirkung der für das eindrucksvolle Viadukt genutzten Baumaterialien – Ziegel und Stein – entschied Gaudí, diese im Park Güell erneut einzusetzen.

Die Existenz dieses Viadukts war zwar bekannt, doch wurde dem Bauwerk wegen seines schlechten Erhaltungszustands lange Zeit keinerlei Beachtung geschenkt. Nach jahrelanger Arbeit wurde seine Wiederherstellung im Januar 2006 abgeschlossen und gab den Blick auf die interessante, von Gaudí entworfene Struktur frei.

Bellesguard. Pour que le chemin se trouve à la même hauteur que la maison et franchisse l'un des torrents dévalant les pentes de Collserola, il érigea d'épais piliers près du mur de soutènement. Ces piliers inclinés évoquent les pattes d'un troupeau d'éléphants, démontrant là encore l'inspiration constante que l'architecte puisait dans le monde animal.

La grande qualité structurelle offerte par les matériaux de construction (brique et pierre) utilisés pour la réalisation de l'impressionnant viaduc conduisit Gaudí à les employer à nouveau dans le parc Güell.

Malgré la qualité du travail, le viaduc tomba progressivement dans l'oubli en raison de son mauvais état de conservation. Après une restauration poussée, il put à nouveau être contemplé dans toute sa splendeur en janvier 2006.

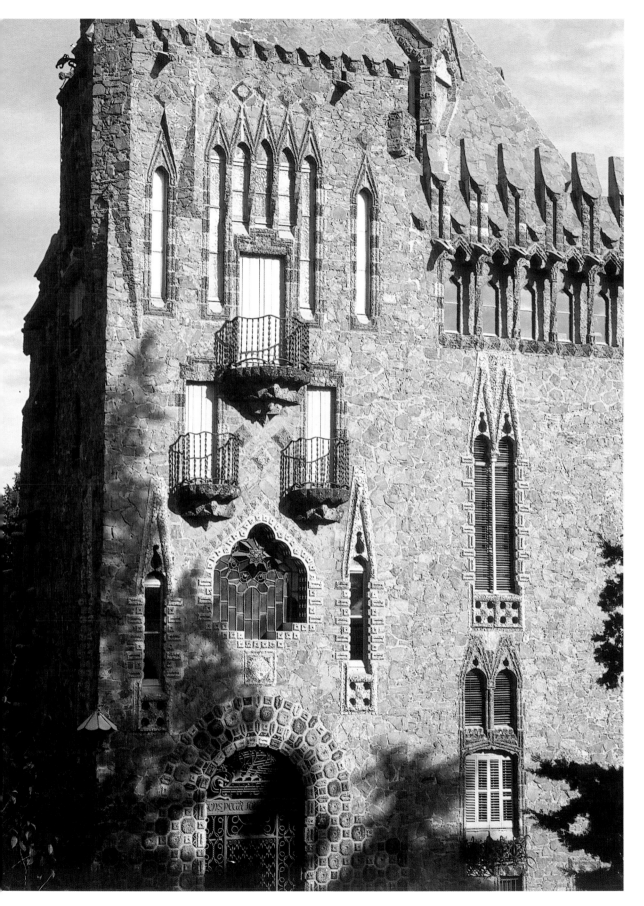

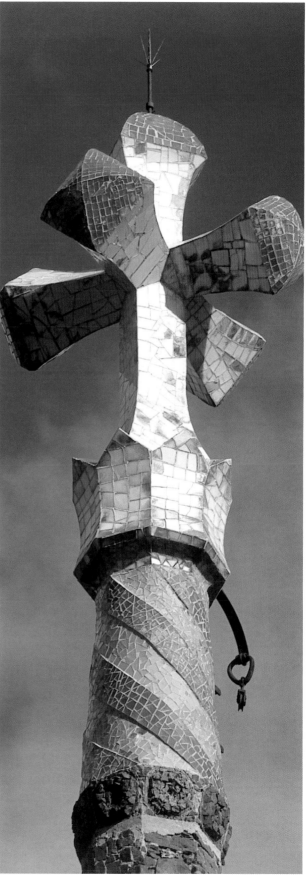

In keeping with his faith and the deeply rooted Catalan tradition of placing an ornamental soffit on the door to welcome visitors, Antoni Gaudí designed a wrought iron grille displaying a phrase from the scripture: "Hail Mary, conceived without sin." He also created an austere decoration for the interior.

Gemäß einer tief in der katalanischen Kultur verwurzelten Tradition, an der Tür einen Willkommensgruß für die Gäste anzubringen, entwarf Antoni Gaudí im Sinne des christlichen Gedankens für den Haupteingang des Hauses ein originelles schmiedeeisernes Gitter mit dem Satz: „Ave Maria Puríssima. Sens pecat fou concebuda" – katalanisch für „Gegrüßet seist Du, reinste Maria. Ohne Sünde wurdest du empfangen". Im Inneren des Gebäudes schuf der Architekt eine sehr schlichte Dekoration.

Conforme à sa foi chrétienne et à une tradition profondément ancrée dans la culture catalane qui consistait à placer sur la porte un ornement souhaitant la bienvenue au visiteur, Antoni Gaudí dessina pour l'entrée principale de la maison une grille en fer forgé où l'on peut lire une phrase de la Bible, « Ave Maria Puríssima. Sens pecat fou concebuda » (Ô Marie, conçue sans péché). À l'intérieur de la demeure, l'architecte créa également une décoration austère.

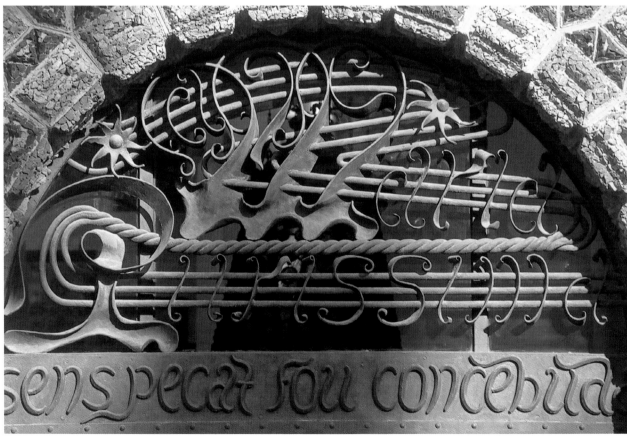

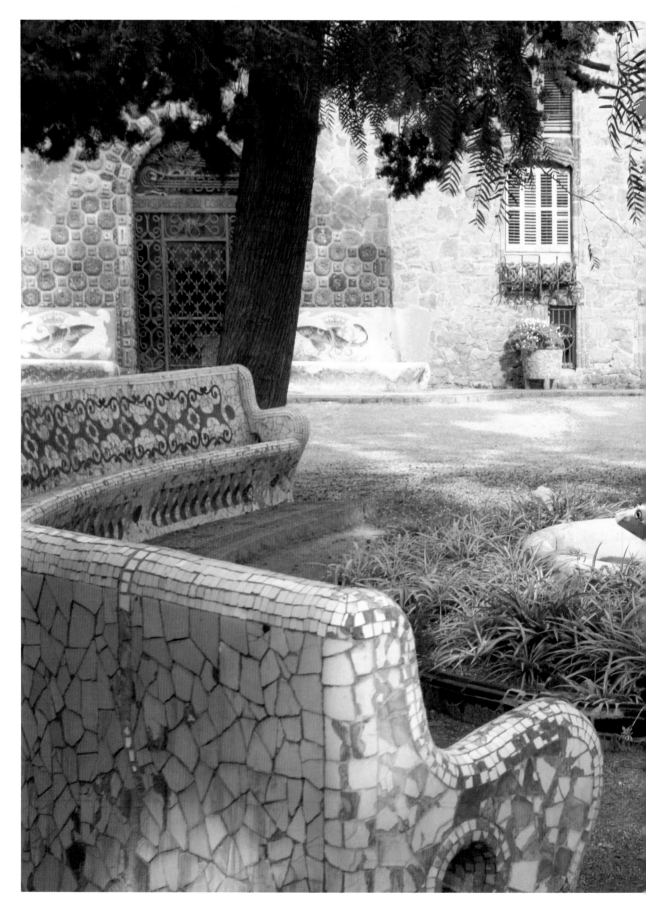

The façade features a ceramic panel that bears the name of the house, as well as an interesting stone decoration.

An der Fassade ist dieses Keramikschild mit dem Namen des Hausbesitzerssowie einer interessanten Rahmendekoration aus Stein zu sehen.

Sur la façade, ce losange de céramique encadré d'un ouvrage décoratif en pierre porte le nom de la maison.

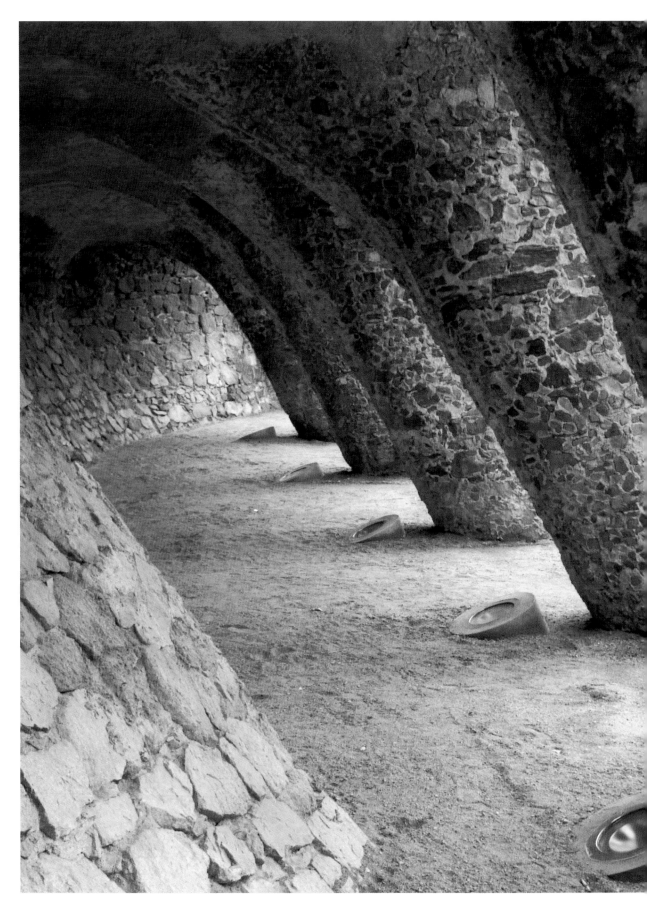

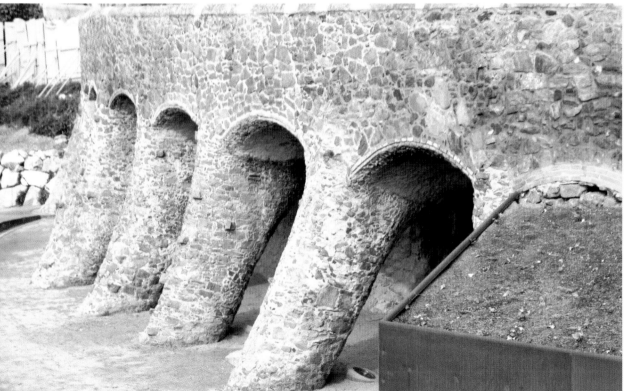

Natural elements like the feet of an elephant herd inspired Gaudí when he designed the viaduct.

Natürliche Elemente wie die Beine einer Elefantenherde dienten Gaudí als Inspiration für das Viadukt.

Les éléments naturels, tels que les pattes d'un troupeau d'éléphants, inspirèrent Gaudí lorsqu'il dessina le viaduc.

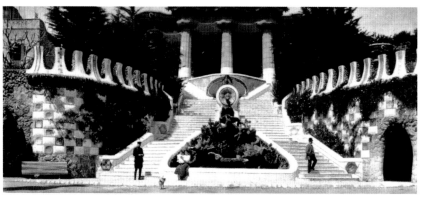

THE ARCHITECTURAL AND ARTISTIC COMPLEX OF PARK GÜELL IS ONE OF THE MOST IMPORTANT WORKS OF THE HISTORY OF CATALAN ART. COUNT GÜELL DID NOT HESITATE TO ENTRUST SUCH A MOMENTOUS PROJECT TO GAUDÍ'S GENIUS.

DIE ARCHITEKTONISCH-KÜNSTLERISCHE EINHEIT DES PARK GÜELL IST EINES DER BEDEUTENDSTEN WERKE IN DER KATALANISCHEN KUNSTGESCHICHTE GRAF GÜELL ZÖGERTE NICHT, DAS GENIE GAUDÍ MIT SEINER VERWIRKLICHUNG ZU BEAUFTRAGEN.

LE COMPLEXE ARCHITECTURAL ET ARTISTIQUE DU PARC GÜELL EST L'UNE DES ŒUVRES LES PLUS IMPORTANTES DE L'HISTOIRE DE L'ART CATALAN. POUR UN PROJET DE CETTE ENVERGURE, LE COMTE GÜELL, SON PROMOTEUR, N'HÉSITA PAS À FAIRE APPEL AU GÉNIE DE GAUDÍ.

park GÜELL

1900-1914

In keeping with the prevailing innovative trends in Europe at the time, Eusebi Güell decided to develop a residential complex with characteristics similar to the garden-cities being created in the outskirts of London during the late 19th century. In 1899, Güell purchased seventeen hectares of land in the area known as Muntanya Pelada (Bald Mountain) in the Salut neighbourhood in the district of Gràcia. His residential garden complex was targeted at wealthy families seeking a peaceful home away from the hustle and bustle of the city. The Anglo-Saxon influence was evident in his choice of the word "park," in English, for his project. Despite the efforts made by Gaudí and Güell to make their dream come true, the project was a failure. After the death of Count Güell in 1917, his heirs offered the land to the Barcelona town hall, which purchased the property in 1922.

Gaudí was commissioned to develop this complex, which initially comprised sixty plots designated for building individual houses. The only ones that were actually built are the show house and the house for Gaudí's father that is presently home to the Gaudí Museum. In 1906, Gaudí moved in there with his father and his niece Rosita. Eusebi Güell also set up house in the main building in the park.

Gaudí's aim was to integrate the urban complex into the landscape by altering the surroundings as little as possible. In response to

Eusebi Güell folgte den innovativen Strömungen Europas und entschied, in Barcelona eine Wohnsiedlung ähnlich der Gartenstädte anzulegen, wie sie an Londons Stadtrand während der letzten Jahre des 19. Jahrhunderts entstanden waren. Daher erwarb Güell 1899 17 Hektar Baugrund in einer als „La Muntanya Pelada" – „Der kahle Berg" – bekannten Gegend im Stadtviertel Salut in Gràcia. Das Projekt eines begrünten Wohngebiets war für vermögende Menschen gedacht, die dem städtischen Tumult entfliehen wollten. Der Einfluss des englischen Vorbilds wurde schon mit der Wahl des englischstämmigen Wortes *park* als ursprünglichem Projektnamen deutlich. Trotz des Engagements und der Bemühungen, die Gaudí und Güell in die Verwirklichung dieses Traums steckten, scheiterte das Vorhaben. Nach dem Tod des Grafen Güell im Jahr 1917 boten seine Erben den Baugrund der Stadtverwaltung von Barcelona zum Kauf an, die ihn 1922 erwarb.

Gaudí erhielt den Auftrag, die Grundausstattung dieses Wohnkomplexes zu gestalten, der aus 60 Parzellen zur Errichtung einzelner Häuser bestand. Letztlich wurde nur das Pilothaus, das Wohnhaus von Gaudís Vater, erbaut, in dem sich heute das Gaudí-Museum befindet. 1906 zog Gaudí zusammen mit seinem Vater und seiner Nichte Rosita in den Park, und auch Eusebi Güell richtete seinen Wohnsitz im Hauptgebäude des Parks ein.

Eusebi Güell, attentif aux tendances novatrices qui prédominaient en Europe, décida de créer un complexe résidentiel à Barcelone, de caractéristiques similaires aux cités-jardins qui florissaient à la toute fin du XIXᵉ siècle dans la périphérie de Londres. En 1899, il acheta à cette fin 17 hectares de terrain dans la zone connue sous le nom de « Muntanya Pelada » (montagne pelée), dans le quartier de la Salut de Gràcia. Son projet, combinant zone résidentielle et espaces verts, s'adressait aux classes aisées qui souhaitaient échapper au tumulte de la ville. L'influence anglo-saxonne se reflète dans le choix du mot anglais « *park* » pour faire référence au complexe. En dépit de la détermination et des efforts de Gaudí et de Güell pour réaliser ce rêve, le projet fut un échec. En 1917, à la mort du comte Güell, ses héritiers proposèrent les terrains à la mairie de Barcelone, qui les acquit en 1922.

Gaudí fut chargé d'aménager ce complexe qui comptait à l'origine 60 parcelles destinées à recevoir des maisons individuelles. Les seules qui furent construites sont la maison témoin et la résidence du père de Gaudí qui héberge aujourd'hui le musée Gaudí. En 1906, Gaudí s'y installa avec son père et sa nièce Rosita. Eusebi Güell y établit également sa résidence, dans l'édifice principal du parc.

Gaudí voulait intégrer ce projet urbanistique complexe en altérant aussi peu que possible le paysage. L'architecte résolut le problème posé

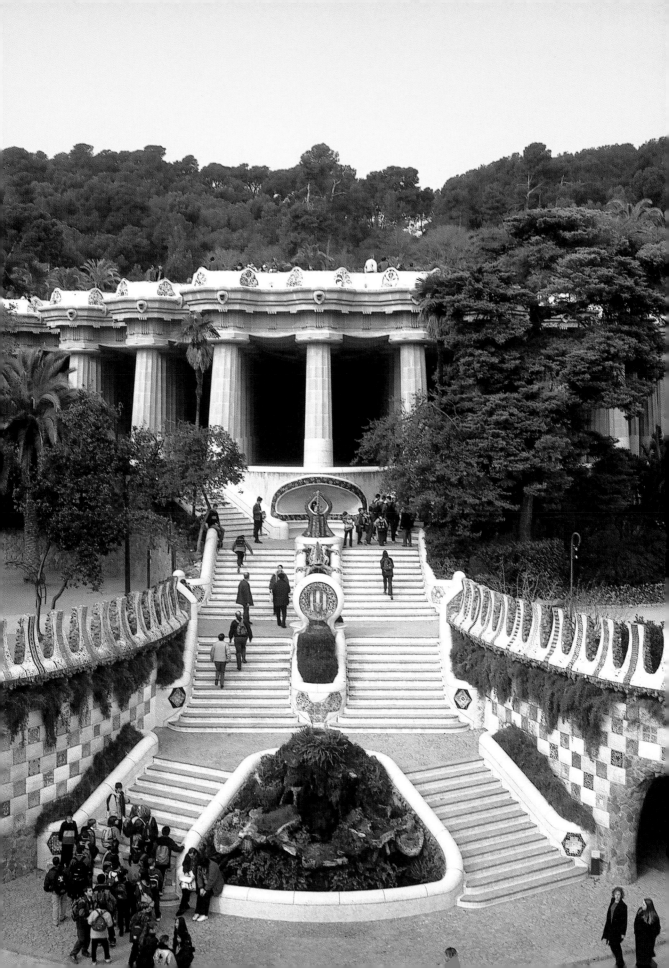

the steep slope of the land, the architect created sinuous paths and built viaducts featuring forms inspired by nature. The grounds are delimited by a wall interrupted by the main entrance, which is flanked by two pavilions: one reserved for services and the other assigned as the concierge's home. Both buildings display rustic masonry decorated with medallions and edged with glazed ceramics, *trencadís*, a covering that is also found on the roof and the tower, which is surmounted by a large cross.

The main entrance to the park is theatrically emphasised by a double staircase leading to the Column Room. This space is decorated with a variety of symbolic elements. The grotto-like cascade is surmounted by another fountain in which the multicoloured *trencadís* technique portrays the flag of Catalonia and the head of a dragon. Behind it is the entire dragon, which has become one of the most iconic images of Gaudí's oeuvre. The purpose of this colourful sculpture is to act as a water fountain for the water overflowing from the water tank of the complex. At the staircase landing, a three-armed *trencadís* figure representing three snakes clearly refers to the pythoness of

Gaudí wollte das komplizierte Städtebauprojekt in die Landschaft integrieren und diese möglichst unverändert lassen. Wegen des starken Gefälles des Terrains griff der Architekt auf gewundene, den Höhenlinien angepasste Wege sowie auf von der Natur inspirierte Brücken zurück. Die Anlage umgibt eine Mauer, die vom Haupteingang unterbrochen wird, wo sich zwei Pavillons für Toiletten und Pförtner befinden. Die beiden fast kreisförmigen Gebäude besitzen ein rustikales Mauerwerk, das mit Medaillons und Einfassungen aus Fliesen dekoriert ist. Diese so genannte *Trencadís*-Verkleidung wurde auch für die Dächer und den Turm verwendet, den ein großes Kreuz krönt.

Der Haupteingang des Parks wird durch eine Doppeltreppe theatralisch hervorgehoben, die zur Sala Hipóstila, einer Säulenhalle mit einer Reihe symbolträchtiger Dekorationselemente, führt. Die grottenähnliche Kaskade weist einen Brunnen auf, an dem Kataloniens Flagge und ein Drachenkopf ebenfalls in der vielfarbigen *Trencadís*-Technik gestaltet abgebildet sind. Dahinter befindet sich die vollständige Drachendarstellung, eines der bekanntesten Werke Gaudís. Diese farbenfrohe Skulptur dient

par la forte déclivité du terrain en traçant des chemins sinueux qui épousaient les courbes de niveau et en construisant des viaducs aux formes inspirées de la nature. Le parc est délimité par un mur, interrompu à l'entrée principale où se dressent deux pavillons : l'un destiné aux services, l'autre au concierge. Ces deux édifices, de forme arrondie, présentent des murs en maçonnerie rustique, ornés de médaillons et de rebords en céramique vernissée *(trencadís)*, revêtement qui se retrouve sur les toits et sur la tour, terminée par une grande croix.

L'entrée principale du parc est rehaussée par un double escalier menant à la salle hypostyle, ou salle des colonnes. L'espace est agrémenté d'une variété d'éléments à caractère symbolique. La cascade en forme de grotte est surmontée d'une deuxième fontaine reproduisant le drapeau de la Catalogne et une tête de dragon à l'aide de la technique du *trencadís*. Le troisième élément représente un dragon qui devint l'une des figures les plus représentatives de l'œuvre de Gaudí. Cette sculpture colorée sert de fontaine pour évacuer le trop-plein du réservoir du complexe. Sur le palier

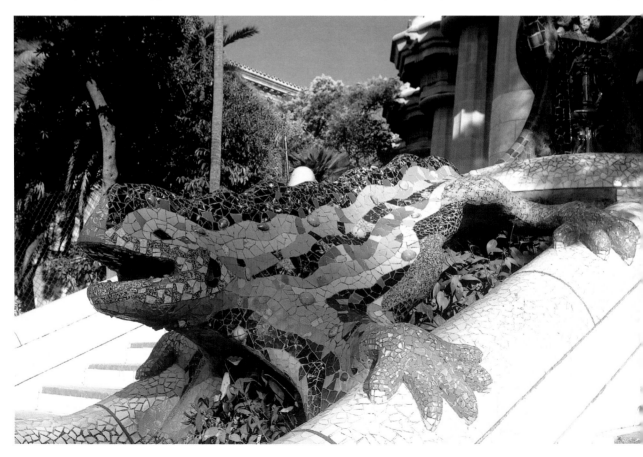

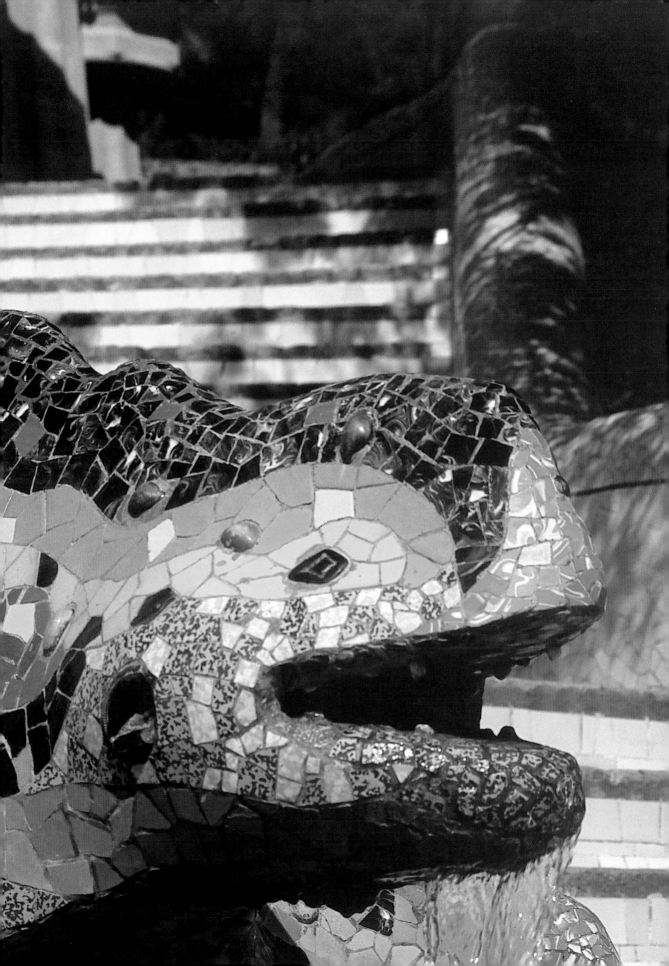

Delphos, a city in ancient Greece which many historians believe to be the source of inspiration for Park Güell.

When entering the Column Room, envisioned as a covered market square for the garden-city, visitors are amazed at the 86 monumental Doric columns measuring six meters in height and built with artificial stone capable of withstanding heavy loads, such as the esplanade above it. The pillars conceal internal tubes that collect rainwater from the esplanade and conduct it to a communal water tank. The empty spaces generated by the four missing columns were decorated with *trencadís* medallions by Josep Maria Jujol and evoke the four seasons.

The esplanade situated above, originally named the Greek Theatre by Gaudí, is a spacious outdoor space bordered on one side by a bench covered with *trencadís* that looks out towards the sea, and on the other side by natural caves that serve as storage areas. The theatre was envisioned as a space for social and cultural activities, while the bench functions as a both railing and viewing platform and was designed to adapt to the body and be functional at the

als Art Wasserspeier, aus dem das überschüssige Wasser der Parkzisterne abfließt. Auf dem Absatz, an dem sich die Treppe erneut unterteilt, steht eine dreiarmige Figur mit *Trencadís*-Dekoration, die drei Schlangen darstellt. Sie ist eine klare Anspielung auf die Orakelpriesterin Pythia in Delphi, jener Stadt im antiken Griechenland, in der viele Historiker die Inspirationsquelle des Park Güell sehen.

Erreicht man die als überdachter Markt der Gartenstadt angelegte Säulenhalle, so überrascht die eindrucksvolle Größe der sechs Meter hohen 86 dorischen Säulen aus verputztem Kunststein, die einem großen Gewicht standhalten. Schließlich müssen sie den darüber gelegenen Platz tragen. Innerhalb dieser Stützpfeiler befinden sich versteckte Rohre, die das Regenwasser des Platzes in eine Gemeinschaftszisterne ableiten. Der Freiraum, der durch das Fehlen von vier Säulen entsteht, ist mit Deckenmedaillons im *Trencadís*-Stil dekoriert, die von Josep Maria Jujol geschaffen wurden und die vier Jahreszeiten abbilden.

Über der Säulenhalle befindet sich eine Anlage, die Gaudí in seinem ursprünglichen

suivant, une sculpture à trois bras également faite de *trencadís* représente trois serpents, une allusion à la pythie de Delphes. Selon de nombreux historiens, cette ville de la Grèce antique fut une source d'inspiration pour le parc Güell.

Lorsqu'il pénètre dans la salle hypostyle, conçue pour accueillir le marché couvert de la cité-jardin, le visiteur est émerveillé par l'imposante structure de 86 colonnes doriques de six mètres de haut en pierre artificielle. Ces colonnes supportent le poids considérable de l'esplanade qui les recouvre et recèlent des tubes servant à récupérer l'eau de pluie tombée sur la place pour alimenter un réservoir à usage communautaire. Les espaces vides laissés par les quatre colonnes manquantes furent parés de médaillons de *trencadís* évoquant les quatre saisons, œuvre de Josep Maria Jujol.

Au-dessus de la salle des colonnes, se trouve l'esplanade que Gaudí avait à l'origine baptisée le Théâtre grec. Cette place est délimitée d'un côté par un banc de *trencadís* et de l'autre, par des grottes naturelles servant d'entrepôts. Le théâtre était destiné à accueillir

Drawing by Gaudí of a design for one of the pavilions at the entrance to the park. The architect included his characteristic cross.

Gaudís Entwurf für die Gestaltung eines der Pavillons am Parkeingang, der das charakteristische Kreuz aufweist.

Ébauche de l'un des pavillons de l'entrée du parc, effectuée par Gaudí. L'architecte y inclut sa croix caractéristique.

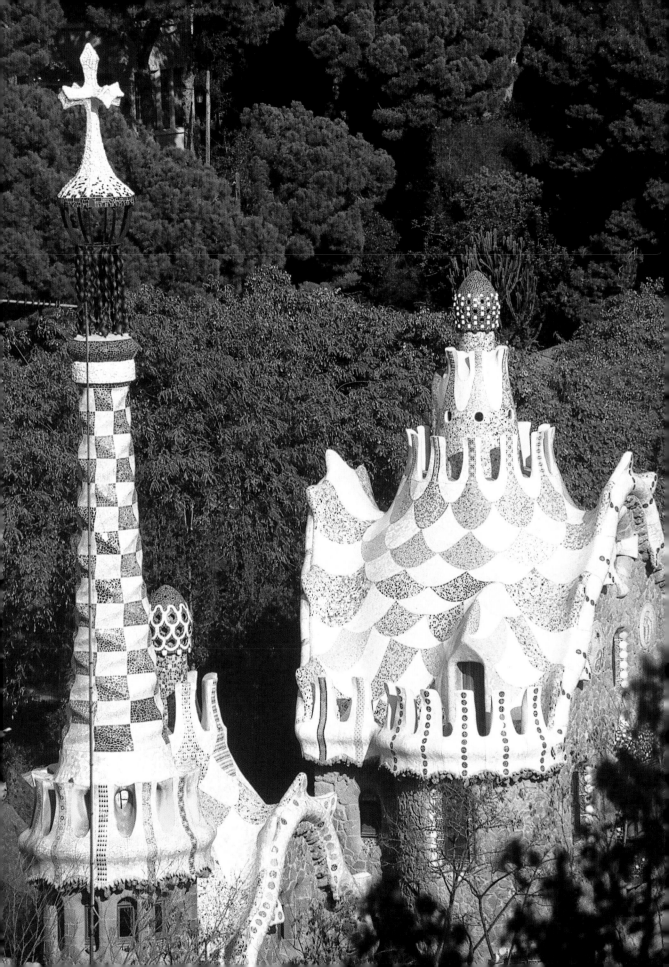

same time. For the bench, Gaudí employed shards of glass, ceramic, tiles, plates and cups. In conjunction with Jujol, Gaudí accomplished what is regarded by some to be the first abstract work in the history of art.

Various religious elements can be found within the complex, such as in the reliefs featuring crosses that decorate the façade of the concierge's home, the monumental cross that crowns the service pavilion, the 150 stone spheres measuring nearly one-meter in diameter situated on the main path, which represent the beads of a rosary, and finally the hillock with three crosses.

Entwurf als Griechisches Theater bezeichnete. Es besteht aus einem Platz, der auf der zur Meer zeigenden Seite von Bänken mit *Trencadís*-Dekoration und auf der Bergseite von natürlichen Höhlen begrenzt wird, die als Lager dienen. Das Theater war für gesellschaftliche und kulturelle Veranstaltungen vorgesehen. Die als Geländer und zugleich als Aussichtspunkt genutzte Bank wurde von Gaudí geschaffen, um einen perfekten Sitzplatz zum Ausruhen mit einer zusätzlichen Funktionalität zu verknüpfen. Bei ihrer Verwirklichung griff Gaudí auf zahlreiche Materialien, wie Glas, Keramik, Fliesen, Teller und Tassenscherben, sowie auf die Unterstützung Jujols zurück. So schufen die beiden Künstler eine Bank, die als erstes abstraktes Werk in der Kunstgeschichte gilt.

Die Anlage enthält verschiedene religiöse Symbole, wie die Kreuzreliefs am Pförtnerhaus, das riesige vierarmige Kreuz auf dem kleinen Toilettenpavillon, die im Sinne von Rosenkranzperlen angelegten, beinahe einen Meter Durchmesser aufweisenden einhundertfünfzig Steinkugeln am Hauptweg oder der Hügel mit den drei Kreuzen.

divers événements sociaux et culturels et le banc, qui fait office de parapet et de plate-forme d'observation, fut conçu pour être à la fois fonctionnel et confortable. Gaudí employa de nombreux matériaux dans la construction ce banc : fragments de verre, de faïence, de carreaux, d'assiettes et de tasse. Avec le concours de Jujol, il réalisa ce qui est considéré comme la première œuvre abstraite de l'histoire de l'art.

Le parc abrite divers éléments religieux, dont les croix en relief ornant la façade du pavillon du concierge, l'imposante croix coiffant le pavillon des services, les cent cinquante sphères en pierre de près d'un mètre de diamètre qui jalonnent l'allée principale, représentant les grains du rosaire, et la colline aux trois croix.

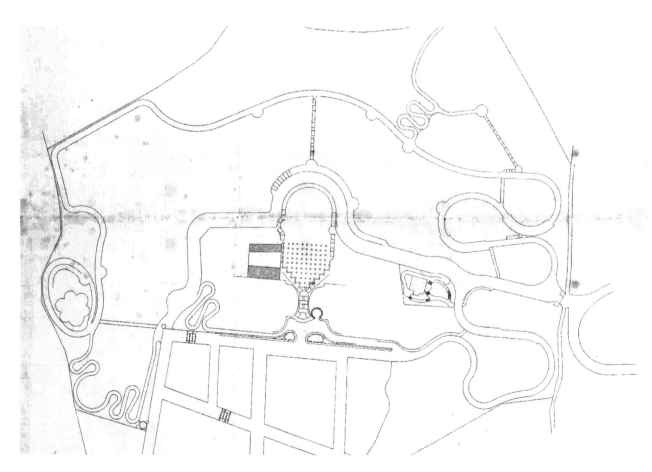

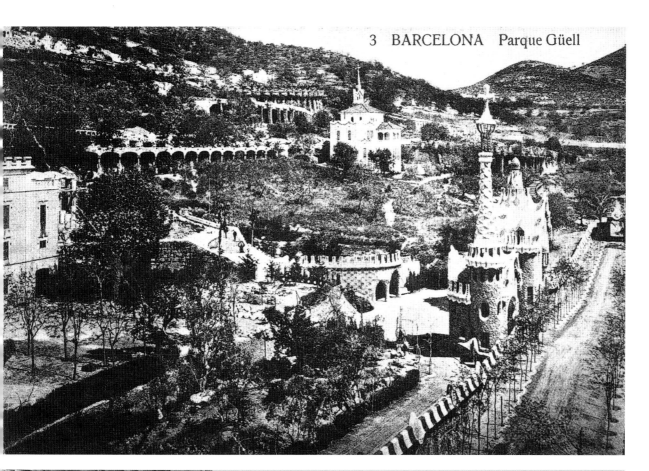

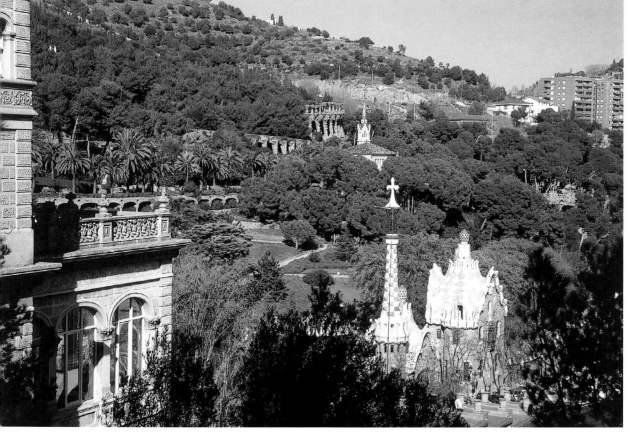

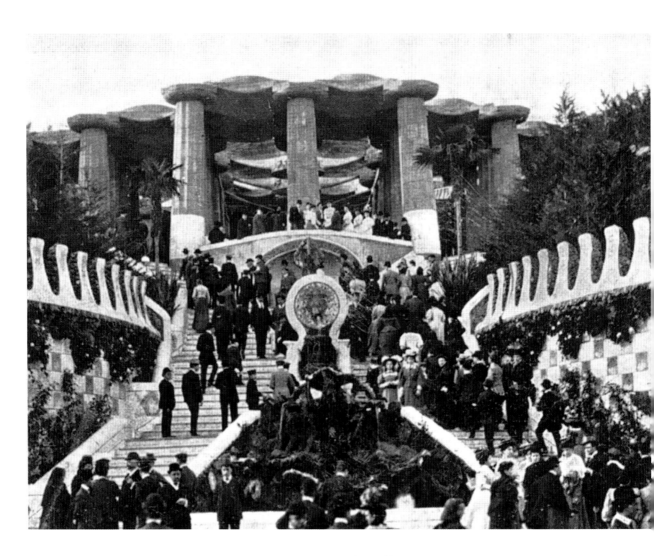

The final work on the park, especially the esplanade and bench over the Column Room, aroused great public expectations.

Bereits vor Vollendung des Platzes und der Bank auf der Säulenhalle rief der Park großes Interesse hervor.

Les derniers travaux du parc, tout particulièrement l'esplanade et le banc situés au-dessus de la salle des colonnes, suscitèrent beaucoup d'intérêt de la part du public.

After it was officially opened, Park Güell became one of the most popular venues for a variety of events.

Nach seiner Eröffnung wurde der Park Güell zu einem der beliebtesten Orte für Großveranstaltungen.

Après son ouverture officielle, le parc Güell devint un lieu de prédilection pour une foule d'évènements.

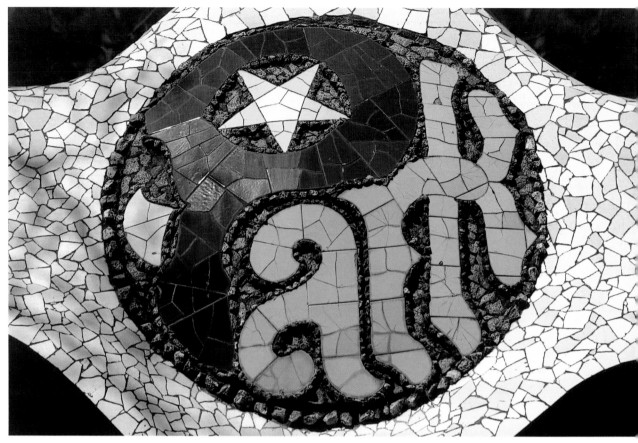

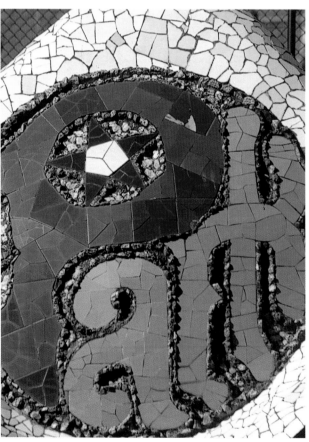

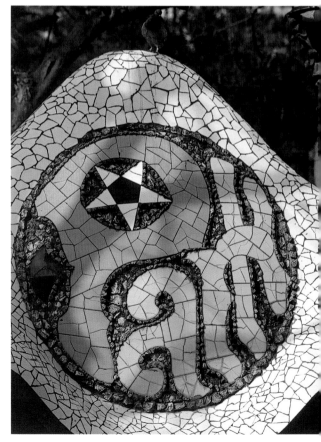

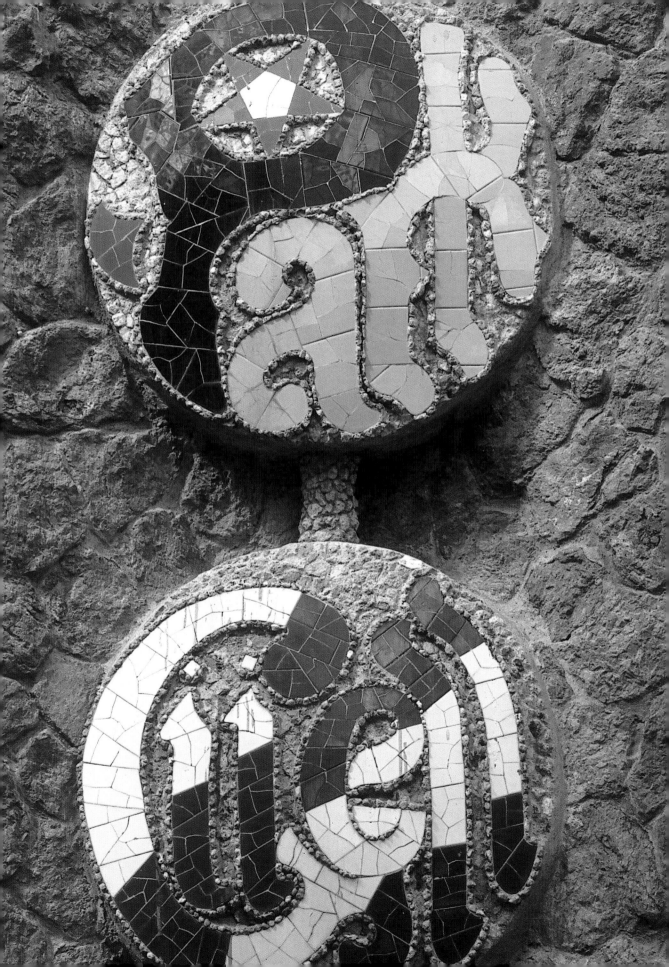

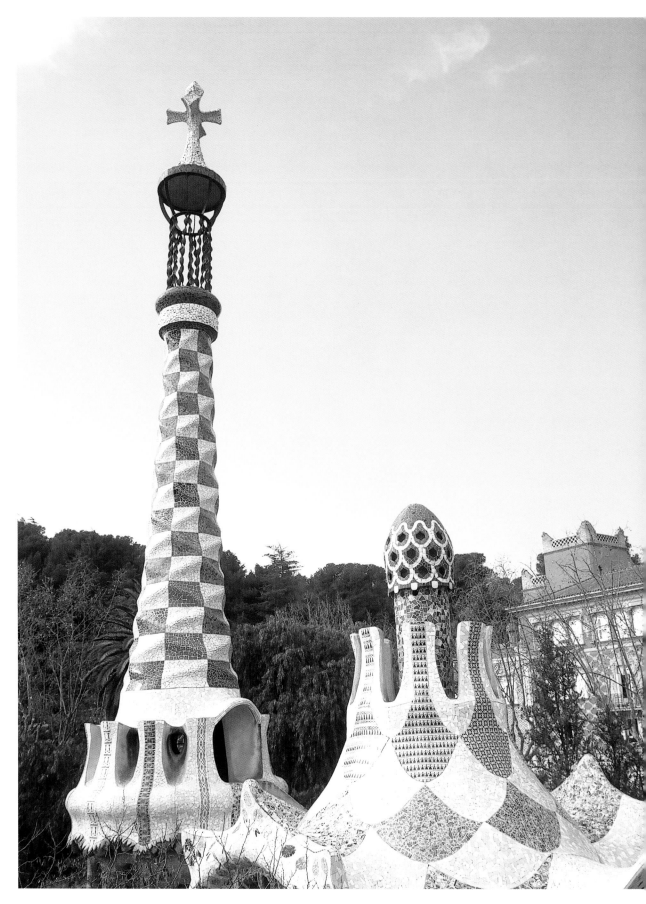

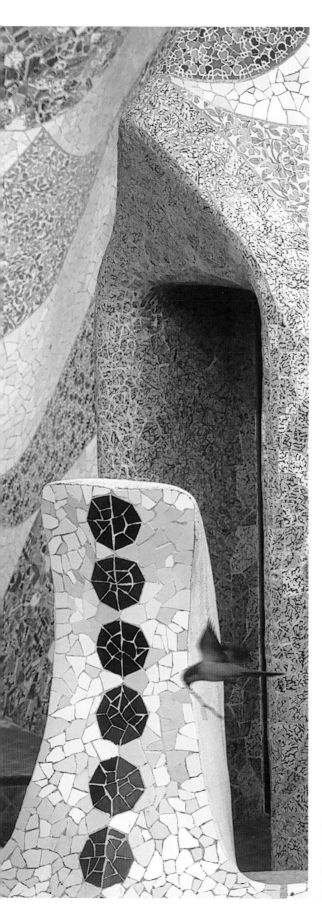

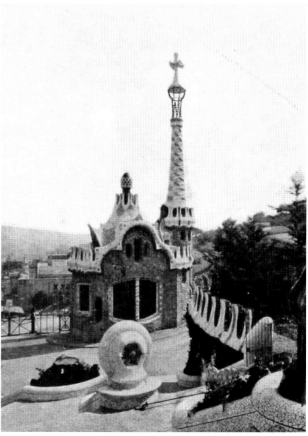

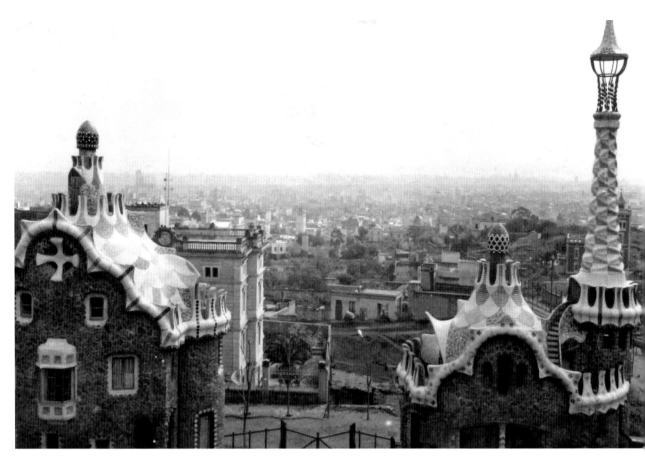

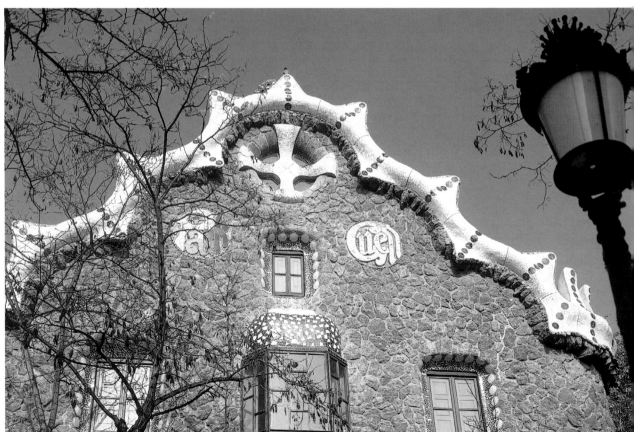

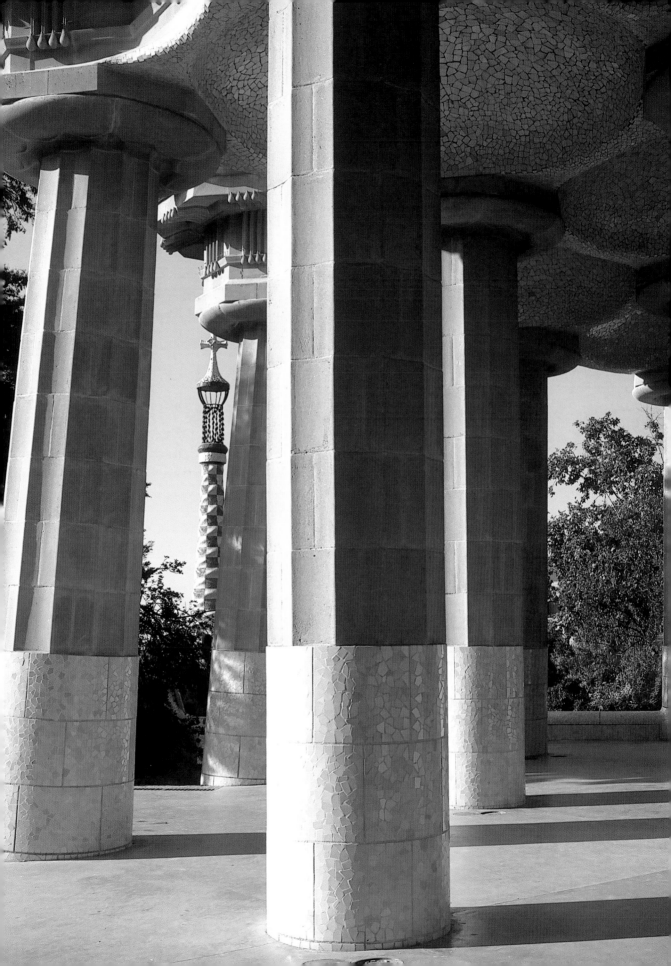

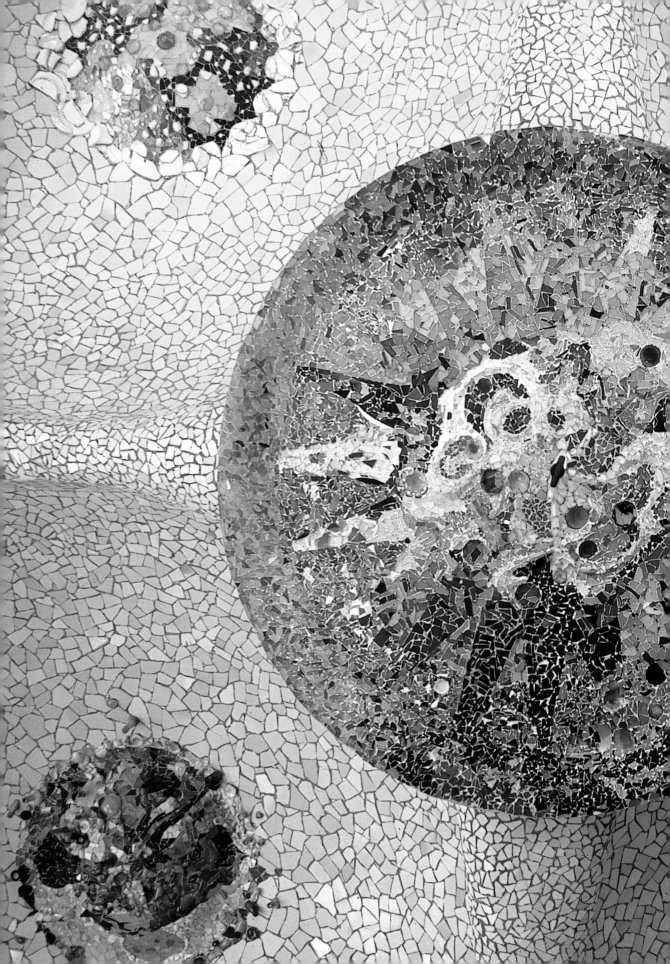

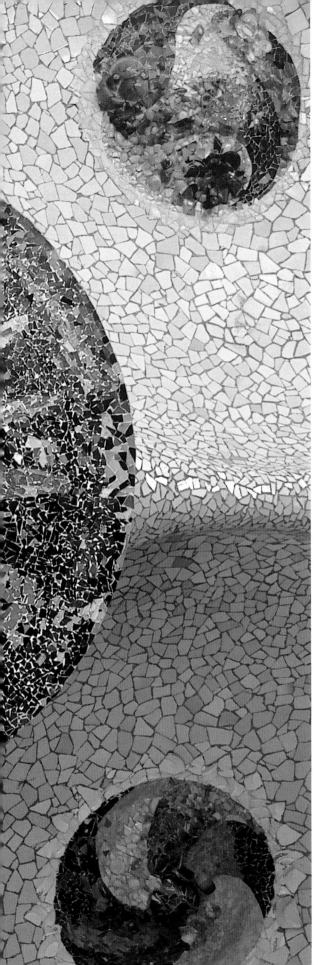

The ceiling of the Column Room features one of the greatest artisanal works of the entire park. Gaudí worked with one of his prime followers, Josep Maria Jujol, to fashion this spectacular work of *trencadís*. The most outstanding decorative elements in this room are the spaces that were to be occupied by the capitals of the columns, which were ultimately decorated using extremely colourful ceramic.

Die Decke der Säulenhalle ziert eine der bedeutendsten kunsthandwerklichen Arbeiten des gesamten Parks. Für diese beeindruckende *Trencadís*-Dekoration zählte Gaudí auf die Unterstützung eines seiner größten Anhänger, Josep Maria Jujol. Die herausragenden Schmuckelemente dieses Raums sind jene Stellen, die ursprünglich für die Säulenkapitelle gedacht waren und wo schließlich farbenprächtige Keramikbilder angebracht wurden.

Le plafond de la salle des colonnes comporte l'un des plus grands travaux d'artisanat du parc. Pour exécuter cette composition spectaculaire de *trencadís*, Gaudí recourut à l'un de ses plus fidèles disciples, Josep Maria Jujol. Les éléments décoratifs les plus frappants de cette salle figurent aux endroits initialement réservés aux chapiteaux des colonnes. Ces espaces furent finalement décorés avec une céramique très bigarrée.

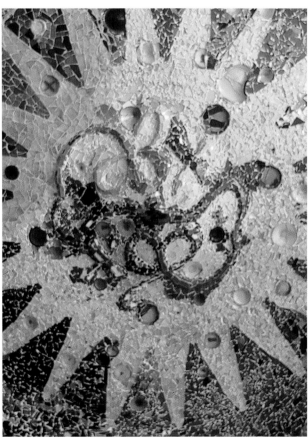

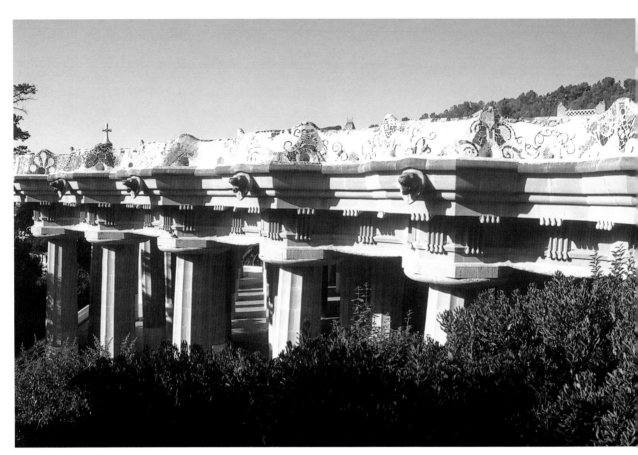

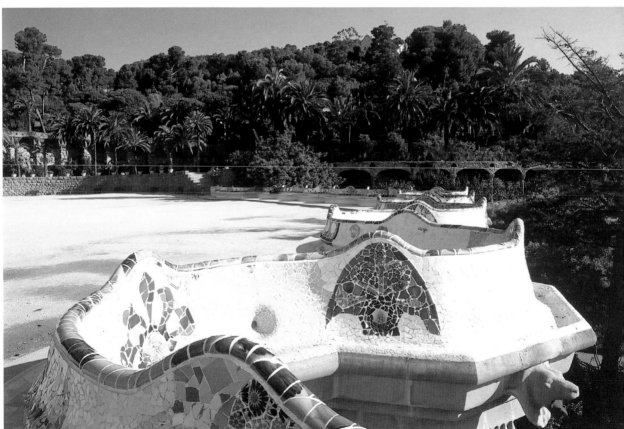

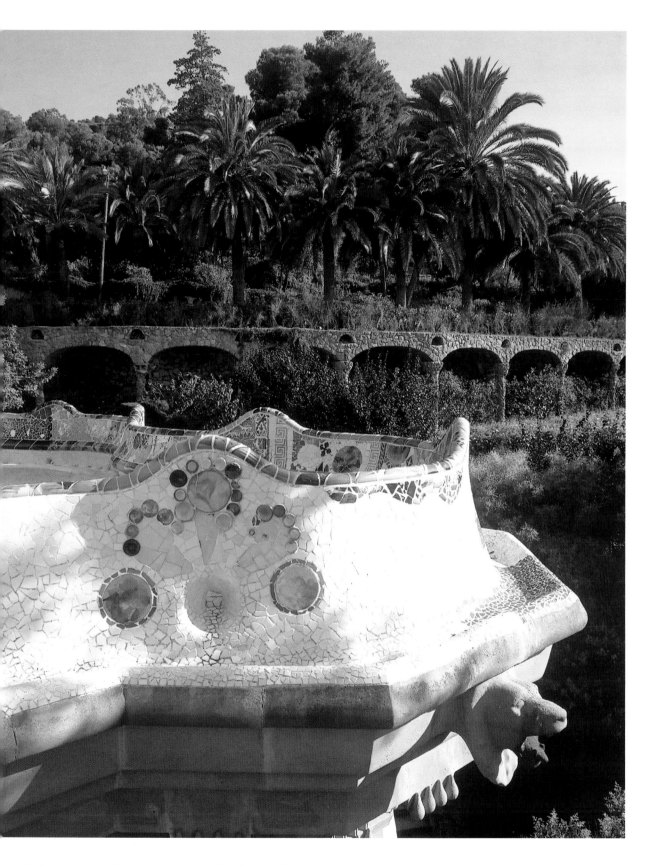

nteresting chromatic and textural contrasts can be seen throughout the entire park.

ei einem Rundgang über das gesamte Gelände kann man die interessanten Kontraste aus Farben und Texturen erkennen.

On peut voir partout dans le parc d'intéressants contrastes de couleurs et de textures.

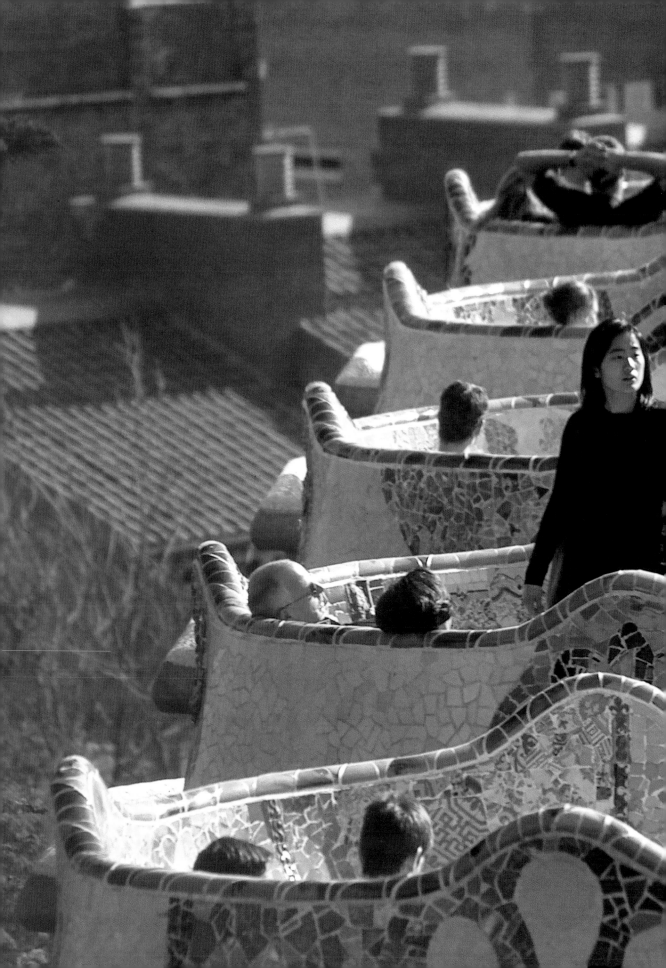

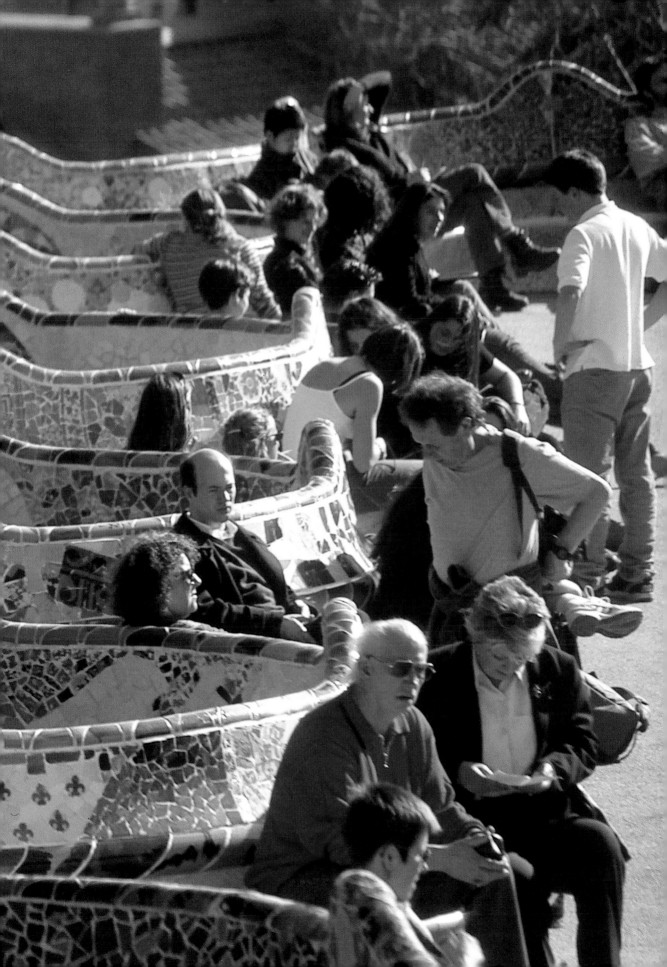

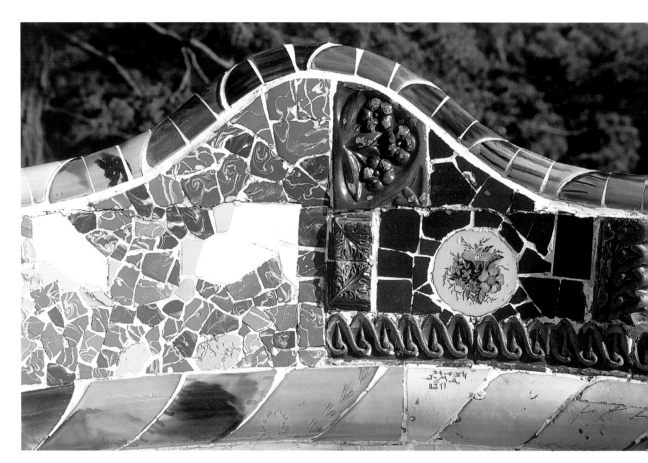

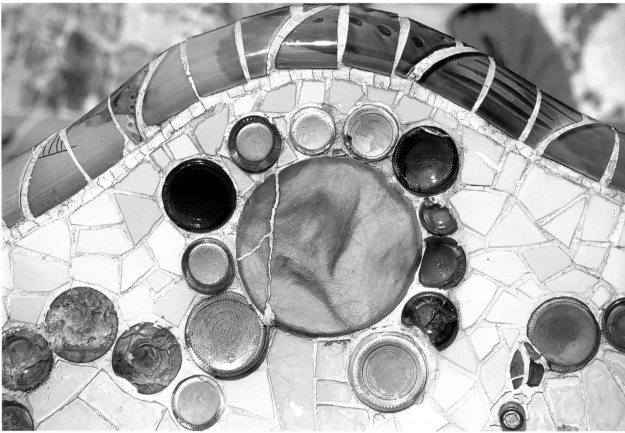

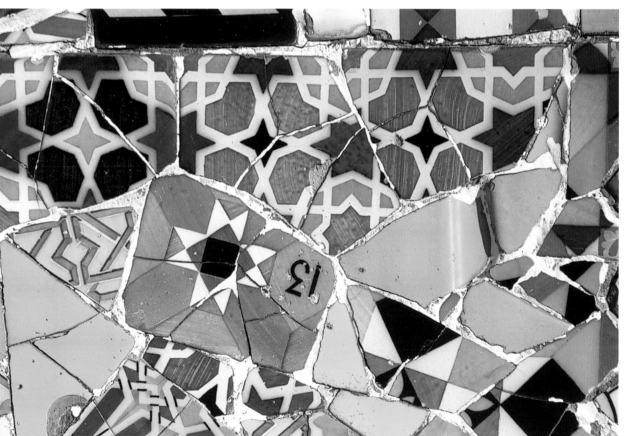

Étude d'équilibre.

Sketches for the covered passages created by the retaining wall and for the columns that support the park's viaduct.

Entwürfe für die überdachten Durchgänge, die die Stützmauer bilden, sowie für die Säulen, auf die sich die Überführung im Park stützt.

Esquisses des passages couverts formés par le mur de soutènement et des colonnes portant le viaduc du parc.

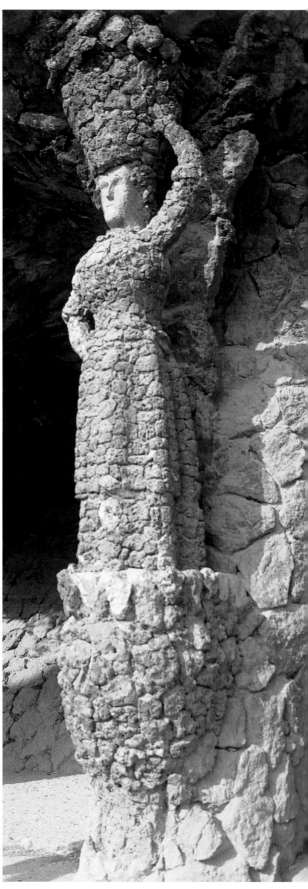

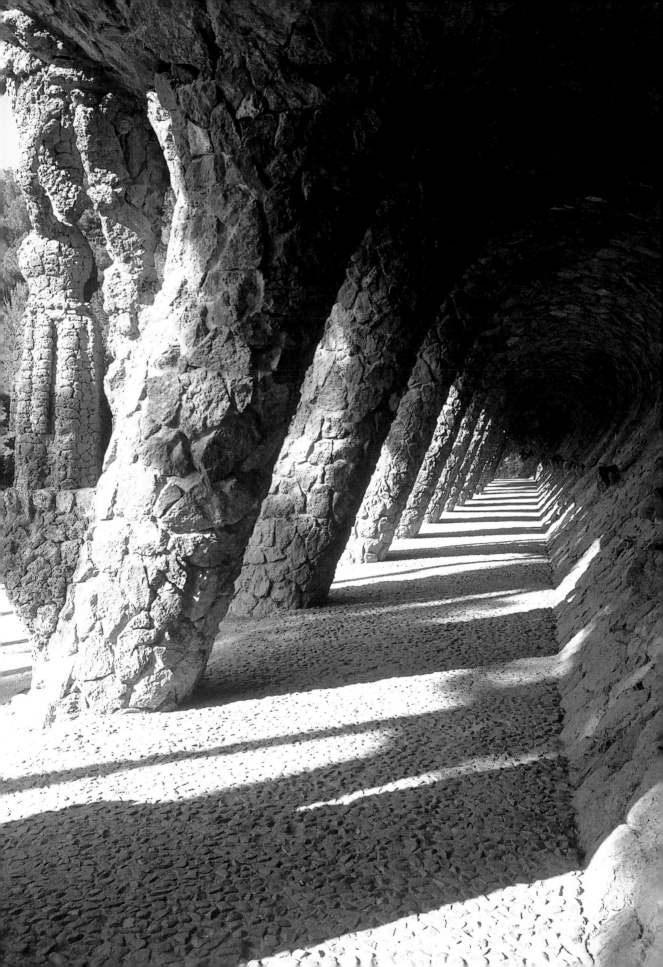

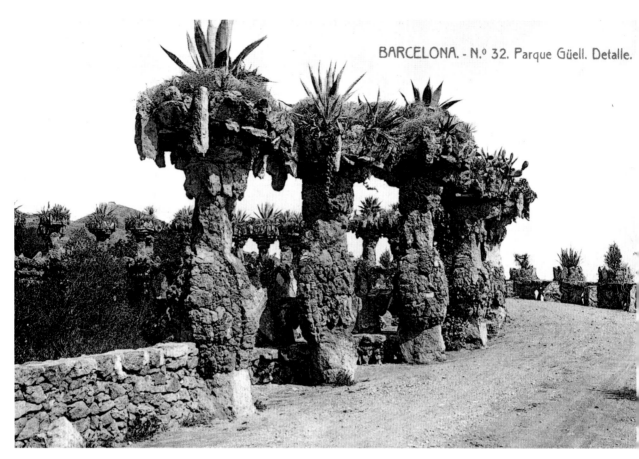

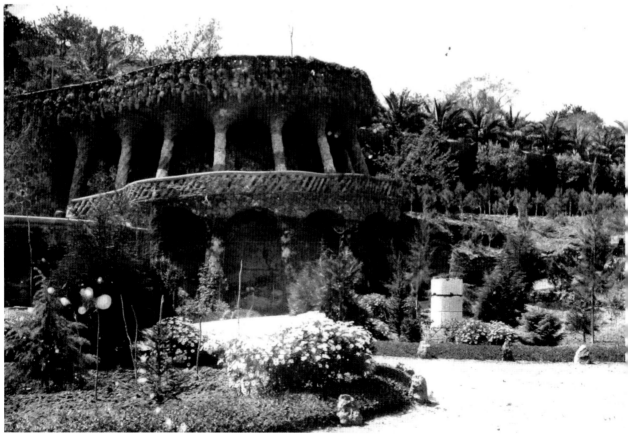

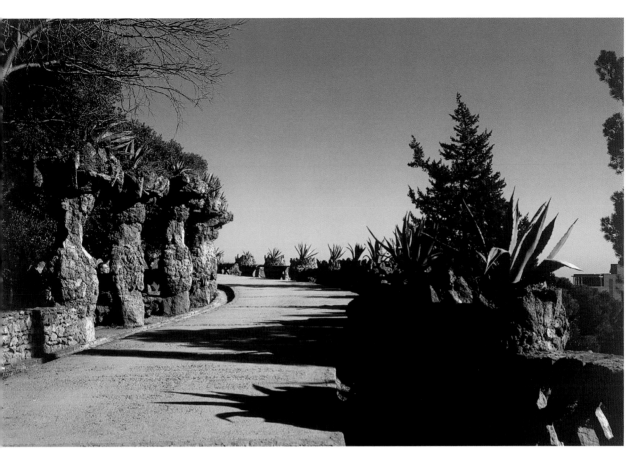

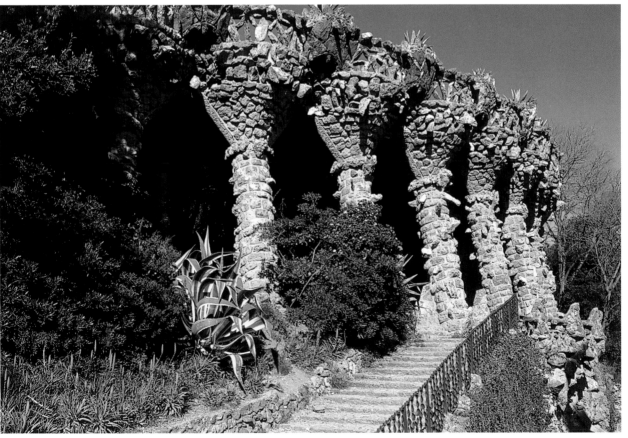

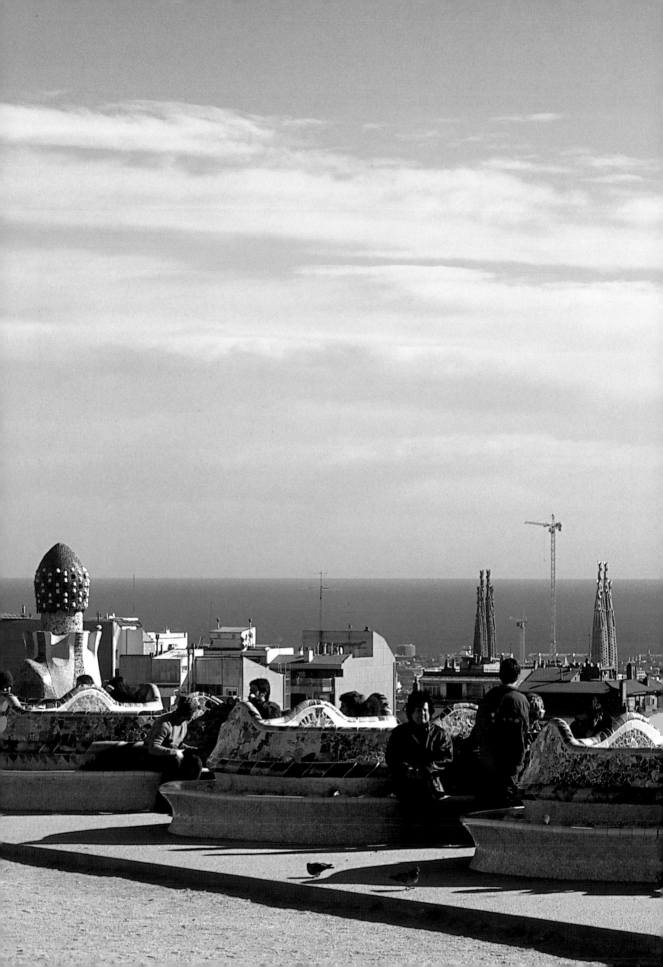

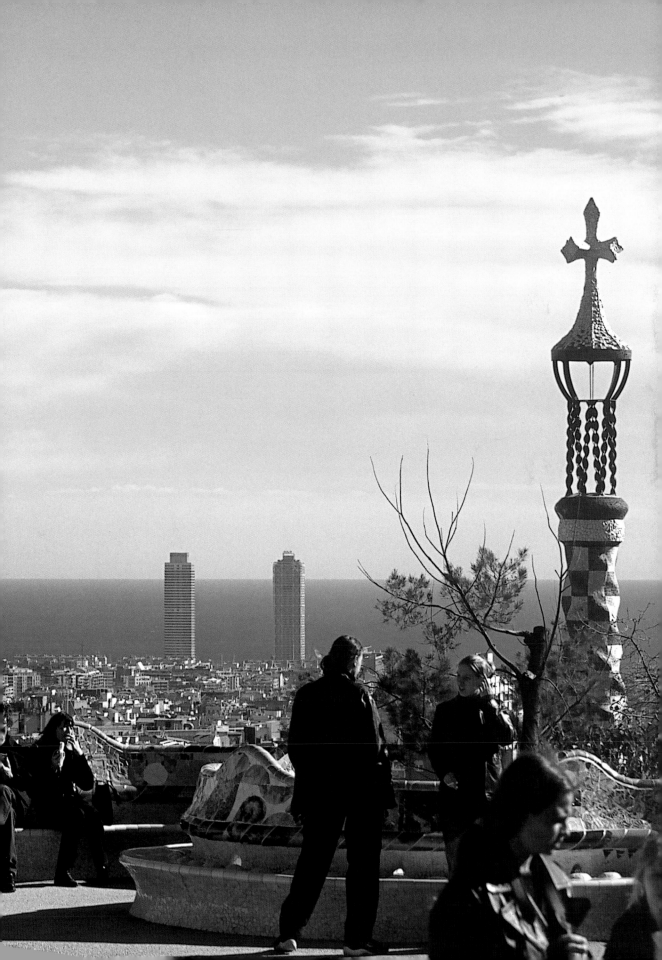